Indian Crafts of Guatemala and El Salvador

INDIAN CRAFTS

of Guatemala and El Salvador

+ + +

BY LILLY DE JONGH OSBORNE

UNIVERSITY OF OKLAHOMA PRESS : NORMAN

By Lilly de Jongh Osborne

Textiles of Guatemala (New Orleans, 1935)
Four Keys to El Salvador (New York, 1956)
Así es Guatemala (Guatemala, 1960)
Four Keys to Guatemala (with Vera Kelsey, New York, 1961)
Indian Crafts of Guatemala and El Salvador (Norman, 1965)

*The publication of this volume
has been aided by a grant from The Bollingen Foundation*

Library of Congress Catalog Card Number: 65–11242

Dedicated to my Son
Stanley de Jongh Osborne

FOREWORD

Penelope's promise to marry one of her suitors once she had finished weaving Laertes' great robe and her ruse of undoing each night what she had woven that day is a story still vivid nearly three thousand years after it was first told. We enjoy the ruse, but few of us bother our heads with thoughts about the loom or the uncompleted textile on it.

Students of weaving—if I may make an outrageous generalization—seem to fall into two types, and I have imagined a representative of each making notes on Penelope's work.

First there is the technical expert. I see her enter that Ithacan hall, brushing aside the suitors as of no account; she is a decidedly masculine lady and knows a drone when she sees one. With a brief nod to Penelope as a sort of by-your-leave, she removes the loom to a well-lit spot, where, whipping out a magnifying glass, she carefully counts the threads to the square inch and enters the information in her notebook with details of the design. There are subsequent visits, and the chapter closes with a paragraph in Miss Technician's

so correct but so dull final report, *Weaving in the Ionian Islands*. The paragraph reads:

Penelope' wife or widow of Odysseus, former king of Ithaca, an accomplished weaver. Garment on her loom of the over-one-under-one sub-group of warp-face fabric with sixty warps by thirty-six wefts per inch. Piece has unusual brocaded design of winged sandals, staff, and broad-brimmed hat, not observed in products of other Ionian Islands weavers. A decidedly slow weaver. Number of young men loitering in her house may account for her lack of concentration.

Secondly, there is the textile expert, interested in the subject not only for the various techniques but also because it is something very alive which affects the lives of all in contact with it. Her relations with Penelope would be very different. The mists of time recede, and that second student ceases to be an imagined wraith. She takes the form of the writer of this book. Mrs. Lilly de Jongh Osborne is a rather formidable title for a very gracious lady, so I will refer to her as Doña Lilly, the name by which she is affectionately known from one end of Guatemala to the other.

In no time flat Doña Lilly and Penelope are chatting away about weaving, spinning, and dyes and about cabbages and kings. The kings in this case are Odysseus and his father, Laertes, and Doña Lilly soon learns that the piece being woven is really a funeral shroud for the latter, and, of course, she also has the Greek name for that garment. Visiting Penelope again next morning, Doña Lilly notes with her keen eye for detail that the piece on the loom is not so long as it was yesterday, and soon the story of the hoodwinking of the importunate suitors is shared. One secret leads to another. As Doña Lilly had surmised, that brocaded design of winged sandals, staff, and broad-brimmed hat indeed refers to Mercury, and it is soon another shared confidence that with his known eloquence he has won Penelope's favors. A husband, absent for twenty years and dallying with Calypso for eight of them, may find the home fires tended by hands which are not completely chaste when he does finally return.

This little fable must not be carried too far; it is to illustrate

the human and infinitely rich side of Doña Lilly's interest in textiles and other crafts, not to make her out a busybody. Miss Technician's thread count is important, but man cannot live by bread alone; and for that reason the information Doña Lilly obtained from Penelope is far more satisfying.

Mrs. Osborne, born in Costa Rica of Dutch parents, has lived her entire life in Central America, since 1905 in Guatemala with an interlude in neighboring El Salvador. Plenty of people live their spans in a land without understanding it. Doña Lilly is not among them; from her earliest years she has had a sympathetic understanding of the Indian and pleasure in his ways so that her eyes were early opened to that other culture living beside, but apart from, her own.

Sympathetic interest is not enough to develop a first-class observer; there has to be material to be observed. Indian Guatemala in past decades has yielded, in some cases willingly, in others most unwillingly, to our present-day material culture, and yielding has entailed surrender of the Indian heritage. Doña Lilly was fortunate— and we share her fortune—that her interest in Indian life, and above all Indian weaving, was fully developed long before the Indian took to buses, and village and individual began to slough cultural personality. Isolation preserved the Indian life, but it made research very difficult. Those who see the magnificent de Jongh Osborne collection of textiles in University Museum, Philadelphia, can have little idea of the difficulties of travel in the remoter parts of highland Guatemala which the collector faced in the first two decades of this century.

In those days throughout Indian Guatemala one could tell a woman's village from her costume—no two were alike—and to a large extent that was true also of men's costumes. A few years ago I was profoundly shocked to see a Quiché Maya burning copal incense and praying on the steps of the church of Santo Tomás Chichicastenango clad in blue jeans and a red turtle-neck sweater. Even twenty-five years ago such a break with custom would have been unthinkable in that very conservative town. Opportunities which Doña Lilly had return no more; we are more than thankful that she was there to seize them.

Curiosity slakes its thirst at every source. To learn the why's of Indian ways Doña Lilly has not confined her explorations to mule-back journeys into remote corners, but she has traveled into the past, for only by comprehending the past can one understand the present. An example of this kind of research interested me as an illustration of thoroughness.

Women in a part of the Alta Verapaz, in the northern Guatemalan highlands, weave *huipiles* (blouses) of a gauze so open-meshed that it looks like mosquito netting. Mrs. Osborne with great acumen —and "a little bit of luck"?—noted in a vast three-volume report of the Dominican province of Guatemala and Chiapas a single sentence telling how the missionary friars of the seventeenth century cut up their mosquito nets to make clothes for the near-naked Chol Maya they had converted. She pounced on this and developed the theory that those present-day gauze *huipiles* derive from copies of the improvised garments of mosquito netting. I'm not sure that her theory is correct, but it certainly rates full marks for careful research and for ingenuity.

As the reader turns the pages of this charming, knowledgeable book, he will become increasingly aware of the grace and beauty and the vitality of the Indian arts and crafts of those mountainous lands of Guatemala and El Salvador, and he will perceive very similar qualities in the lady through whose eyes he sees them. That is not strange, and there is a ready explanation: for sixty years, like oak and mistletoe, she and the highland Maya Indians have been growing together, each year more closely entwined.

J. ERIC S. THOMPSON

Ashdon, Saffron Walden,
England
St. George's Day, 1965

PREFACE

THE INDIAN CULTURES OF GUATEMALA and El Salvador are among the most interesting and colorful in the Western Hemisphere. The great changes which have occurred during the first half of the twentieth century, however, have had an effect upon even the most distant mountain regions, and there is a definite need to record as much about the native arts and crafts as possible before they are finally lost.

Since the making of textiles is the major native craft in which the Indians still engage, I have devoted more than half the book to the textiles of Guatemala and El Salvador, the articles made from them, and the materials and techniques of manufacture. I have also endeavored to present, at least in outline, a picture of other arts and crafts of these Indians as I have come to know them during my many years of residence in this part of the world.

From people all over Central America and the United States I have received the most generous and willing co-operation in assembling the material for this book. To one and all I extend my sin-

cere appreciation and thanks for their kindness in helping me with their knowledge and for permission to use their illustrations.

Special thanks are due to persons who have given me particular aid. Miss O. Settles, associate professor in the Department of Textiles and Clothing, Iowa State College, assisted me with the chapter on weaving techniques. I am indebted to the following individuals and commercial photographers for their generous contributions to the illustrative material for this volume.

Foto Alvarez: Plates 17, *a;* 19, *a;* 20, *b;* 37, *b, c.*

Foto Arte: Plates 15, *a;* 21, *a, b.*

A. Biener: Plates 11, *a, d;* 22, *c;* 24, *a;* 29 *a;* 33, *d.*

Carnegie Institution, Washington, D.C.: Plate 1.

J. J. Dosy: Plate 17, *b.*

Eunice Foster: Plates 13, *b;* 14 *c, d.*

Francis Gall: Plate 11, *c.*

Joya Hairs: Plate 31, *b.*

S. M. June: Plates 2, *b, c;* 8, *b;* 16, *a;* 22, *a;* 33, *a;* 35, *a.*

LeGrand and Co.: Plates 23, *b;* 26, *b;* 29, *b.*

F. Webster McBryde: Plates 2*a;* 3, *a, b, c;* 6, *a;* 8, *a, c;* 17, *c;* 33, *b;* 34, *c.;* 37, *a;* 38, *a.*

S. W. Miles: Plates 18, *a;* 24, *b.*

National Tourist Bureau, Guatemala City: Plate 18, *b.*

Ted Needham: Plate 28, *a.*

A. Salazar: Plate 39, *b, c.*

Miss O. Settles: Plates 11, *b;* 13, *a, c, d;* 14, *a, b;* 27, *b.*

Foto Sittler: Plates 9 and 10.

Miss Helen S. Williams: Plates 5; 7, *a;* 22, *b;* 25, *a, b;* 36, *c.*

Special thanks are also due the Bollingen Foundation, which supplied funds to assist in the publication of this work; and Vaun Gillmor, of that institution, for her help and encouragement; J. Eric S. Thompson, who read the entire manuscript and offered valuable suggestions; Joya Hairs, who made color transparencies for many of the color illustrations; and Mrs. Natalie B. Stoddard, who revised and edited the manuscript before it was submitted for publication and who assumed the burden of reading proofs and making the index.

The legends of the black and white plates will recall to the reader those areas in the text which discuss the costumes, or features

of costumes which are illustrated. The colored plates will convey an idea of the range of color, applied decoration, and regional differences which occur in native costume of the Indians of Guatemala and El Salvador.

Lilly de Jongh Osborne

Guatemala City, Guatemala
May 20, 1965

CONTENTS

Contents

ILLUSTRATIONS

after page 234

COLOR PLATES

COSTUMES OF GUATEMALA
(*Water Colors in Black and White*)

Maps

PART I

* * *

Textiles

I

*

Introduction

THE INDIAN POPULATION OF CENTRAL AMERICA has survived in
relatively large numbers, a factor which has undoubtedly contrib-
uted to the preservation of their native culture. An exact figure for
each country is not always available, nor are those which are avail-
able necessarily correct. In some countries the *ladinos,* those people
of mixed blood who wear European clothing, follow Spanish cus-
toms, and habitually speak Spanish, are included as Indians in the
census count. In some countries the Indians live in inaccessible
regions of forest and mountain, and their census is at best difficult.
There are other reasons, of course, one of them being the taciturn
nature of the Indians resulting from the centuries of oppression they
have suffered at the hands of alien peoples. At the present time
Indians are said to comprise more than half of the some three mil-
lion inhabitants of Guatemala and approximately 7 per cent of the
population of El Salvador.

The geographic locations of tribal members of the various lin-
guistic stocks which are native to Central America are, in some in-

3

stances, so widely separated that in order to show their total distribution, one has to include all the Central American countries. Thus, although our concern of the moment is only with two of these countries, Guatemala and El Salvador, it is obvious that the native Indian population of Central America originally knew no such political boundaries. Their geographic areas were determined centuries ago, long before the Europeans arrived on their shores and disrupted their cultures. There is a wide variation in their tribal backgrounds, and remnants of the many tribal groups which originally moved up and down this great land bridge between two continents are scattered widely over Central America. Such tribal groups have tended to be cohesive because of custom and language barriers, living within their present geographic limits and following their traditional customs of everyday living. A brief description of the distribution of these groups in Guatemala and El Salvador, broken down by linguistic stocks, which seems to be the most successful way of subdividing the Indian population, will give the reader some idea of the tremendous variation in the peoples who inhabit these countries. When one considers the number of tribal groups and their wide distribution, one realizes the number of craft traditions there are to investigate.

Although people of varying linguistic groups tend to be cohesive and fail to mix to any extent with other than their own people, several Indian villages in Guatemala are populated by people of mixed blood. The inhabitants here represent an admixture of Spanish, Negro, German, Carib, or other foreign strains. Despite this intermarriage with other ethnic groups, the villagers have kept their Indian ways instead of becoming *ladinos*. There are still a few purely Indian communities, however, in which the old traditions, styles of dress, and languages of individual tribal groups are preserved. The common language of these people and the means by which they communicate with their neighbors is *Castilla*, the name by which the Indians call the Spanish language and which they have learned more or less correctly according to their ability to pronounce it.

The native ethnic backgrounds from which the modern Indians are derived have influenced the development of their arts and crafts. The majority of the Indians to be found in Guatemala belong

to the Maya-Quiché linguistic stock, of which the most important groups are Quiché, Cakchiquel, Tzutuhil, Mam, Chuj, Ixil, Pokomán, Chol, Chorti, Kekchi, and Pokonchí. Several villages, however, are inhabited by Indians descended from Mexicans such as the Nahua (or Pipil) and Tlaxcalán. The latter arrived with the Spanish conquerors, while the Nahuas came earlier. Along the Atlantic Coast of Guatemala, especially around Livingston, there are small groups of Caribs, now admixed with Negroid stock, who are comparative latecomers. The geographic distribution of these tribal groups is of interest, for it has changed relatively little in three and one-half centuries, and the lack of migration has had a considerable influence on maintenance of tradition. Each of these tribal groups follows its own customs, even though they may live side by side.

The greatest concentration of the Quiché occurs in the departments of Quezaltenango and El Quiché. They also live along the western shores of Lake Atitlán, in a small section of northern Sololá, and in the departments of Mazatenango and Retalhuleu, where colonies of Quiché settled in pre-Columbian times. Quiché people living around Chichicastenango are known as Maxeños, after Tomás, the patron saint of Chichicastenango as well as the given name of most of the men.

The Cakchiquel are to be found in the departments of Guatemala, Sololá, Chimaltenango, and Mazatenango. The Sacatepéquez are a group of Cakchiquel which split off from this tribe two centuries before the Conquest. Although called Sacatepéquez, they are properly Cakchiquel, and are to be found in the departments of Guatemala and Sacatepéquez.

The Tzutuhil live around the southern end of Lake Atitlán in the department of Sololá. The Mam occupy most of the departments of Huehuetenango and San Marcos. They are also found in a small section of western Totonicapán and eastern Quezaltenango. Chuj peoples are found in the department of Huehuetenango, living in villages in the Cuchumatanes Mountains. Ixil villages occur in the northern part of the department of El Quiché. The Pokomán live mainly in the departments of Jalapa and northern Jutiapa, although they also inhabit scattered villages in the western part of the department of Guatemala.

The Chol lived in the southeastern section of El Petén and the greater part of Izabal and northern Zacapa; the Chorti, the departments of Zacapa and Chiquimula. The Kekchi inhabit most of northern and eastern Alta Verapaz, while the Pokonchí live in southern Alta Verapaz.

In addition to these groups of some size, there are lesser groups such as the Lacandón, who inhabit northern and western El Petén; the Mopán, found in the eastern section of El Petén; and the Uspanteca, living in the northeastern part of El Quiché.

The Pipil are found here and there throughout Central America, mostly on the Pacific slopes. They immigrated from Mexico before the Conquest, and lived or now live in the departments of Baja Verapaz, eastern Jutiapa, southern Escuintla, eastern Santa Rosa, and western Chiquimula in Guatemala. In El Salvador they live in the departments of Sonsonate, San Salvador and La Paz. The Tlaxcalár, also Mexican in origin, dwelled in both Guatemala and El Salvador.

The Indians of El Salvador belong mostly to the Pipil and Nahua groups, with a small percentage of Maya-Quiché, Lenca, and Chorotega (the latter said to be of Mayan descent). In both Guatemala and El Salvador a small group of Xinca Indians who have never been thoroughly studied lives along the Pacific Coast. The Nahua and Pipil constitute by far the largest groups of Indians now native to El Salvador and are to be found in such villages as Izalco, Nahuizalco, Panchimalco, and the Costa del Balsamo. In Sensembra (populated by Chorotega and Lenca) many old customs survive. Most of the Lenca and Chorotega live in scattered villages throughout the department of San Miguel and in northern villages of the country, although the heaviest populations of these people are to be found in countries to the south of El Salvador.

The majority of the Central American Indians live in small villages scattered over fertile plains and mountain plateaus where the soil is suitable to the culture of corn, the staple of their diet. Indians who live in larger communities usually congregate in suburbs called *barrios*, where they settle in preference to mixing with the *ladino* families occupying the center of town. The villages are composed of thatched huts, varying in shape according to the cus-

tom of the tribe and the region where it lives. Each family has a small piece of land on which to grow its corn. They may also own a few chickens, a dog, a pig, and if the householder is a trader, a mule or horse. Those who inhabit mountain villages keep herds of sheep, whose wool they process themselves for textiles for home use or trade to large towns such as Momostenango, where the raw wool is processed commercially by *ladino* craftsmen.

A clear-cut social structure exists within each Indian village. There are three distinct and carefully preserved classes, which may be easily distinguished by their clothing, later described. The highest of these classes are the *principales*, the nobility. To the *principales* belong the Indians who are descended from caciques and other high officials of the ancient Indian cities like Utatlán (Quiché), Zaculeu (Mam), and Iximché (Cakchiquel). From this group generally come the men and women who form the *cofradías*, or sodalities, and officials of the civil and ecclesiastical government. The *principales* wear better, more elaborate clothing than the lower classes, and it is on their textiles rather than on those of the lower classes that the tribal emblems appear. Their pride and dignity command respect from one and all.

The *medianos*, those of the middle class, provide the local craftsmen and traders with other communities. The latter are regarded as wise men because of their experience with the outside world. While they wear tribal costumes in their native villages, they are quite likely to discard these for plain white clothing when traveling in the line of business.

To the *plebeyos*, the lowest class, belong the *mozos*, those Indians who work in the fields, trot long distances under incredibly heavy burdens, or sell all kinds of small wares and produce in the weekly markets. From this group are recruited some of the *chajales*, servants of the priest of the village church, whom they must serve for a year. The *chajales* clean the priest's house, carry burdens for him to and from distant villages, and become for that year of service part and parcel of his household, obeying his every command.

This brief description of the racial heritage and social structure of the modern Indians of Guatemala and El Salvador should be kept in mind by the reader in his evaluation of the handiwork

later described, for although predominantly Indian in character, it may also show Spanish influence as well as modern ideas flavored by Indian imagination.

The Indian and his crafts are bound together by the bonds of custom and tradition. It is impossible to understand his techniques of manufacture as well as the products thereof without understanding the Indian himself. This is a difficult undertaking at best, for he is secretive and superstitious and loath to impart such information as touches upon his life, his traditions, and hence, his crafts.

The havoc caused by the impact of a more complex civilization upon a relatively primitive culture has further hindered this undertaking. The Indian has been catapulted from an era of ancient custom and handicrafts into one of complex machinery, rapid transportation, and standardized clothing. Is it any wonder, then, that the Indian's crafts reflect his life by becoming an incomprehensible jumble of the ancient and the modern? Indeed, the changes effected in the past few years are seemingly greater than those occasioned by the arrival of the Spanish and make it imperative to record as many of the technics of Indian handicrafts as possible before they vanish entirely.

Ancient beliefs are still strong, however, and show up distinctly in the crafts of these Central American peoples. Before the Conquest, the Indians worshiped nature and by means of symbolism incorporated into their crafts many manifestations of their natural surroundings. Although the friars suppressed these heathen practices wherever possible, the ancient gods were still worshiped under the guise of Christian symbols. During the Colonial period pagan customs survived in Christian festivals, concealed under the formal ritual of the Catholic church, for the secular clergy neither understood the Indian languages nor attempted serious missionary work. The Mercedarian friars were seldom good linguists. The Franciscans, who were the first on the scene and administered the larger part of what is now Guatemala, frequently complained of the difficult Indian dialects and found it necessary to evolve a vocabulary with which to make headway in their proselyting. On the other hand, the Dominicans administering the regions of Verapaz and Sacatepéquez (the eastern Cakchiquel and Ixil) were most successful linguists

8

and sympathetic with their Indian charges, but they also lamented their failure to eliminate pagan rites and tolerated or ignored customs which they considered harmless. So long as the Indians were modestly covered, the priests remained oblivious to the symbolism which has continued to flourish to the present day. Consequently, probably more paganism has survived in Guatemala than in any of the other Central American countries, and the student finds a vast field wherein to study Indian cultural survivals.

Traditions and lore, customs and individuality in the crafts are changing or disappearing, however. Modern, well-made roads bring the Indian easily and rapidly to the outside world. Gradually both his mode of life and his arts and crafts are succumbing to its influence. Many of the arts and crafts have had no new impetus for centuries, for the craftsmen have no reason to increase the beauty of their products or extend their uses. With the possible exception of textile making, most of the crafts have degenerated lamentably during the past few years. Of all the crafts that have survived, the production of textiles in Guatemala is the most worthwhile because it is the most complex and diversified.

The distribution of native costume in Guatemala encompasses about two hundred villages wherein either men or women, or both, still wear their tribal dress. Within these villages, however, there are local variations in dress, bringing the total number of costumes to over five hundred in Guatemala alone, some of which are represented by very few examples. These costumes are gay and colorful, largely hand woven, and each village has its characteristic styles and color combinations. Many of the designs appearing on these textiles are very old, similar in form to those used by their ancestors centuries ago, and while the weaver of today may know how to make them as her ancestors did, she may no longer know their original meaning.

In addition to textiles for clothing, the Indians weave blankets, make distinctive pottery, finish intricately the gourds and other vegetal containers they use along with the pottery, and weave baskets, mats, and hats. It is these items of material culture and their manufacture which will be described in the following chapters.

II

*

Background of Costumes

BEFORE EMBARKING upon a detailed discussion of Indian dress, it would be well to summarize for the reader the background of the costumes in these countries. Side by side with the latest adaptations of Western dress are to be found survivals of the earliest forms of costume based on the need for warmth, ornament, or a place to stow small items on the person to leave the hands free for the chase or defense, and symbolic ornamentation or cut of costume whereby the Indian of preconquest times proclaimed his office, class or rank. Franz Boaz says, "The attempts of apes to cover themselves with leaves suggest the beginning of the use of more permanent coverings."[1] Like the lower primates, men of the Guatemalan lowlands today cover themselves with huge leaves as a protection from the rain or sun of these tropical latitudes.

The forerunner of decorated clothing was body paint. Archaeological excavations in Central America have yielded numerous clay stamps (*rodillos*) and cylinders for impressing paint on the hu-

[1] *General Anthropology*, 265.

man body in geometric designs. Warriors in pre-Conquest times daubed red and yellow paint on their bodies to frighten their enemies. Paint has also been used as a protective covering. For centuries before the Spanish Conquest, the Lacandón Indians painted their bodies with a thick black powder. Every morning they took a handful from a clay jar, spat on it, and rubbed the paste into their bodies as a protection against noxious insects. Paint, however, is not as effective as clothing because it must be renewed often and does not offer sufficient protection against the elements.

Thus the first real clothing came into being in the form of animal skins. Nomad tribes used the skins of the animals which had been killed for food. The skins, tied around the waist with a string of vegetal fiber or a liana growing conveniently at hand, protected them against the changes of weather and the sting of jungle insects. Skins are still worn by the Lacandón Indians for warmth. Howler monkey skins and sheepskins are used by Todos Santos men to protect their clothing from soil and wear.

The forerunner of the modern *huipil* (women's blouselike garment) was a piece of fiber cloth split in the middle to go over the head, a kind of garment developed by many primitive people the world over at an early stage of costume history. For example, the *mitah*, worn by Egyptian women, was a piece of striped cloth, split in the middle to pass over the head. It left the arms bare but covered the body from neck to ankles.[2] In Central America the *huipil* was formerly worn by men as well as women. This garment, with only occasional variations in length and width from its early form, is now worn generally by Indian women in Guatemala. The *huipil* most closely resembling the earliest form known is that made of maguey fiber (*ixtle*) or the sacking worn by Lacandón men.

Belts and sashes give support to the body and secure the clothing around the waist, as well as provide a place to carry implements, money, a fetish, or other personal belongings. Nowadays Indian merchants in particular use their belts and sashes as such receptacles. Sashes also provide an excellent medium for displaying symbols of class, descent, rank, or personal love of decoration. The sashes of

[2] Henry F. Lutz, *Textiles and Costumes Among the Peoples of the Ancient Near East*, 154, 171, 174, 191, 192.

Concepción Chiquirichapa, Chichicastenango, San Juan Sacatepéquez, and the Ixil villages in particular are used for these purposes.

According to Indian legend, the loincloth developed from the sash, although it would be more likely that the progression went the other way. Lower-class Indians wore this garment alone up to the beginning of the nineteenth century. The loincloth is simulated in present-day clothing by sashes or the cut of the woolen overtrousers (Tacaná).[3]

Elaborate costumes were depicted in minute detail by Mayan artisans, whether the figure was sculptured in stone or painted on frescoes or pottery. A striking example is the wall paintings discovered at Bonampak. Deities, priests, chieftains, and high-ranking individuals are shown wearing, in addition to their clothing, bracelets and anklets of precious stones; lip-, nose-, and earplugs; sandals made of soft deerskin and richly decorated with feathers, stones, and other materials. Covering for the lower part of the body, whether a straight, apron-like piece that hung back and front from a wide sash, or a draped garment, consisted of woven material embellished with feathers, colored embroidery, precious stones or metals. Covering for the upper body was equally well decorated or decorative, whether it was a simple *huipil* or many heavy necklaces of shells, beads, jade, or metals set with jewels. Necklaces, pendants, bracelets, and anklets of animal teeth and carved jade or jadeite were particularly popular. Wide sashes were heavily embellished and finished with long fringes and tassels. Fringes appeared on all parts of the costume, especially on the edges of capes and mantles. Netting also was used for embellishment. The costume was completed by spectacular headdresses comprised of huge bunches of feathers, elaborate ribbons wound around the head to form enormous turbans, strips of cloth, stones, and fiber coils.

A magnificent example of the flamboyancy of Mayan costume is represented by the figure on Stela H at the Copán ruins. The figure's dress displays every possible decoration combined with cloth woven in different techniques. Such elegance was the privilege of the higher classes, the lower classes wearing only a coarse fiber loincloth or

[3] Town names appearing in parenthesis indicate that there the article described is characteristic of native dress.

nothing at all. Warriors were depicted wearing quilted cotton armor.[4] Now and then a figure appears to have been dressed in short, bloomer-like trousers, many of which also seem to have been quilted and which apparently are the forerunners of the present short Indian trousers.

When the centers of Mayan civilization fell and the people moved toward the north (Yucatán), their culture mingled with others from the Mexican highlands and lost much of its unique character. Many characteristics of the dress of their descendants suggest Mayan costume, as, for example, the use of brilliant color and intricate pattern and cut. Such survivals are the *refajo* (skirt) tightly wound around the woman's figure and the large cloth coils, tassels, fringes, bands, and other head decorations for daily or ceremonial wear (Quezaltenango, San Sebastián, Santo Domingo Xenacoj, Totonicapán, San Juan Sacatepéquez [*confradía*], and particularly Santiago Atitlán and Tamahú). No less strikingly Mayan is the woolen *tocoyal* (headdress) worn about the head, the ends of which, standing away from the head in all directions, give the impression of a feather headdress (in San Juan Sacatepéquez); or the huge turban made of wool strands (San Pedro Sacatepéquez G.,[5] and Mixco). The headdress worn by painted figures on the pottery from Uaxactún has its modern counterpart in the headdress of men taking part in *confradía* ceremonies.

Fringed, twisted, netted, and tasseled belt ends are to be seen daily on the Indians in the towns and villages in Guatemala (San José Nacahuil, Santiago Sacatepéquez, Chichicastenango, and Cotzal). Whether worn by men or women, they all recall similar early Mayan articles. The rosette on the front of the men's costume in

[4] Mary Butler, *A Study of Maya Mouldmade Figurines*, 647; Bernal Díaz del Castillo, *Verdadera y notable relación del descubrimiento y conquista de la Nueva España y Guatemala*, 5.

[5] This name causes confusion. In olden times there was a kingdom called Zacatepéquez or Sacatepéquez, a subdivision of the Cakchiquel kingdom, the principal village being San Pedro Ayampuj or Yampuj. The villages included in this group were San Pedro Sacatepéquez, San Juan Sacatepéquez, Santiago Sacatepéquez, and San Lucas Sacatepéquez. The first two villages now belong to the department of Guatemala, the others to the department of Sacatepéquez. In addition, there are two villages called San Pedro Sacatepéquez and San Antonio Sacatepéquez in the department of San Marcos. In the following pages San Pedro Sacatepéquez in San Marcos is designated as San Pedro Sacatepéquez (S.M.); San Pedro Sacatepéquez in the department of Guatemala as San Pedro Sacatepéquez (G.).

Chichicastenango is like the one worn by the figure on Stela 8 at Naranjo. Present-day textiles woven in the so-called mat design (Chichicastenango, San Pedro Sacatepéquez [G.], and San Pedro Ayampuj *huipiles*) are comparable to the coverings on figures carved on Stela H at Quiriguá.[6]

Very few textiles have survived the centuries of heat and humidity of the lowlands. Some have been discovered, however, in association with other artifacts. One was found by Franz Blom in a clay pot. Another small remnant found at Uaxactún by A. Ledyard Smith, of the Carnegie Institution of Washington, has been classified as a twill. Two other textiles came to light in an hermetically sealed clay receptacle in a cave in the region of Ocosingo, Mexico. One was a piece of brown cotton with decorations in tan done in a true batik technique, and the other was a whitish cotton cloth with beautiful red and blue floral decorations which were painted on the textile after it was woven.

Textile techniques were discovered in archaeological sites in Guatemala from imprints made directly on wet clay or mud. Outstanding are the ones found at Uaxactún in the department of El Petén. Burials 40 and 43 in Structure A–V contain imprints of a textile possibly woven in gauze technique, much like net and decidedly similar to the textiles woven in that technique at the present time in Alta Verapaz. Imprints of cloth fragments adhered to the left elbow of a skeleton (Burial 28 of the same site). They appear to be in a canvas weave—warp yarns in pairs, two up and two down, crossed by a single filler yarn. There has also been found a piece of clay clearly showing textile imprints that look like a canvas of large loose yarns.[7]

A group of interesting textile imprints was found in 1939 by Mary Butler, of the University of Pennsylvania Museum, near Finca Santa Adelaida, situated close to the Atitlán volcano in the department of Suchitepéquez. On quantities of flat clay plates (*comales*) distinct textile imprints could be distinguished. They were evidently made by impressing a textile on the wet clay surface of the dish to

[6] Sylvanus G. Morley, *Giudebook to the Ruins of Quirigua*, 61.

[7] A. Ledyard Smith, "Report on the Excavations at Uaxactún During 1935," a MS report to the Guatemalan government, 115–17.

decorate it. One shows the seam of the textile; another shows what might be classified as a leno weave, and a third indicates a duck technique. Among the many others are imprints of textiles in plain and gauze weaves.

A number of copper bells were found in 1941 on the banks of the Motagua River near Quiriguá and given to the Guatemalan National Museum. They bear very clear imprints of the textiles in which they were apparently wrapped before being buried.

From such evidence we conclude that the prehistoric weavers were cognizant of most of the techniques currently known today among Indian weavers, who work with the same types of primitive spindle, warping frame, and hip-strap loom as were used centuries ago. Many points of similarity exist between the present-day and early Mayan costumes, particularly among those of ancient Mayan dignitaries and modern Indian women. Until the Conquest, the Indians of higher rank dressed in very ornate costumes, while only a simple loincloth was worn by the lower classes. Thereafter we look to historians for our knowledge of Indian costume of the Colonial period.

Some items of European dress were incorporated early into Indian costume. The Indian, conservative in respect to change, adopted only those items of European clothing which he apparently deemed useful. Some elements of dress, which at first glance seem to be purely Spanish, are in reality just a clever modification of the traditional Indian costume.

Inventories of Indian costumes and customs were ordered by Philip II of Spain in a royal warrant issued in Badajoz, September 23, 1580 (*Libro I de Cedulas Reales de la Secretaria de Camera*, f. 398). The historians of that day were sometimes indefinite in their descriptions, and subsequent writers were consequently vague. Writing between 1690 and 1699, Fuentes y Guzmán[8] records that a distinction was made between the tribes of Indians known as *bárbaros* and *políticos*. The *bárbaros* were Indians who were nude or almost naked and lived in the forests and outskirts of the fortress-cities. These the Spanish priests persuaded to cover themselves with leaves

[8] *Recordación florida, discurso historial y demonstración natural, material, militar y política del reyno de Guatemala*, 390–92.

or grasses. Fuentes y Guzmán goes on to say that the *bárbaros* painted their bodies black and used a liana as a G string, in which they tucked their rude hunting implements. The *plebeyos* or *maceguales*, low-caste Indians living in large populated centers, wore a loincloth over their black-painted bodies (Lacandón Indians). This textile, made of tree fiber, was said to have had the color and texture of soft chamois. Before cloth was made of the fiber, it was soaked in a river for several days and then pounded until soft and pliable. Others belonging to this social stratum wore a one-piece, rough, thick garment woven of fibers other than cotton. This garment had a hole for the head and was open at the sides. The lower part of the front was passed between the legs toward the back and vice versa, thus forming a double loincloth securely fastened at the waist by another fiber textile. This author remarks that it was a style of dress still much used by the poor people at the time he wrote (late seventeenth century).

The *plebeyos*, he continues, usually used henequen fiber to weave their costumes. Servants working in the households of the upper classes were privileged to use garments woven of cotton but with no color or design whatsoever. The appearance of the servants in their white cotton costumes was described as unclean and far from neat. The lower-class people wore their hair cut very short without ornaments of any kind.

The upper classes, or *principales*, wore colored cotton garments with many designs incorporated in the material, blue and red on a white background being most prevalent. The material was very fine and closely woven. The costume consisted of a short, one-piece garment worn over a pair of very thin, knee-length drawers trimmed with either fringe or other decorations around the edge. A dark, heavy, decorated pair of trousers, split to the thigh, permitted the display of about eighteen inches of these decorated undergarments. The legs were bare, the feet shod in sandals made of coarse, woven fiber, held by a string which passed inside the big toe and fastened around the ankle. The hair was always worn long, either hanging down the back, caught up with a woven ribbon, or braided with blue and red ribbons and finished by large bows or tassels in red or blue. The latter hairdress was the privilege of the military

captains of higher social rank. Around the waist was worn a long, colored sash with a wide end hanging down in front. The most striking part of the costume was the large cape, translucent and beautifully made with many bird and animal designs woven into the textile, the edges finished with fringes, nets, tassels, and other trimmings. A distinction for officeholders was the staff carried by the judges, whose office was also indicated by distinctive symbols on their costume. He further points out that the sleeves or surplus material were caught up by very finely woven cotton bands in blue or, less frequently, red (*chuchumite*, a term applied to both red and blue dyes in the Colonial period). Those of highest rank wore the most elaborate costumes.

According to Antonio de Remesal,[9] the women allowed their hair to hang loose and wore a long piece of cloth wound around the waist which fell to the middle of the leg or ankle—the forerunner of the *refajo*. Such a garment, as worn by nomadic Indians, was made of either rough fiber or plain cloth and was fastened at the waist. Women of other classes wore the cloth or a short *refajo* made of either finer fiber or cotton, depending upon their rank and class. The cotton textiles were often striped. This author also speaks of the beautiful, finely woven ribbons and plumes the men inserted in their hair. The higher classes were distinguished by their fine, closely woven bands crossed around the neck and under each breast, and thrown over the shoulders so that the long ends fell elegantly down the back. The head was covered with a cloth, the ends crossed in front over the breasts and firmly tied at the back. These white cotton textiles were a joy to the priests, for the women they converted to the Christian faith entered church thus discreetly covered. The women of the highest class wore their hair decorated by colored ribbons bearing symbolic figures. Others wore their hair twisted around the head with many black, red, or blue cotton strands which formed *rodetes*, a kind of turban knotted over the forehead with the varicolored strands of cotton.

Ximénez[10] regarded the women as ugly and described them

[9] *Historia general de las Indias occidentales, y particular de la governacion de Chiapa y Guatemala*, 588.
[10] *Historia de la Provincia de San Vicente de Chiapas y Guatemala de la orden de predicadores*, I, 301.

as barefooted with their hair hanging loose. A scant cloth badly fastened around the waist showed the navel and extended above the knees so that he felt it shameful to look at them. Sometimes they covered themselves with a dirty cloth. Other women of higher rank wore sleeveless *huipiles* which covered the whole body. These *huipiles* were white with red and yellow roses, a very beautiful costume. This author's description of the men's costumes suggests the present-day woman's attire.

A Spanish friar, Matías de Córdoba, lamented[11] that the Spaniards and mulattos were much better dressed than most of the Indians. He gives a few details about the Spanish clothing and mentions orders issued from Spain, requiring all Indians and *ladinos* to be shod like the Spaniards but without recourse to violence.

From even these casual and incomplete descriptions, it is clear that the Indian men were more resplendently dressed than the women.

José Milla stated in his book[12] (1879–97) that in eastern Guatemala the Indians defending their strongholds against the Spanish *Conquistadores* wore *pampanillas* (large leaves) around the waist. The word degenerated in time to *campanillas* (bells). Many puzzling references to bells with which the Indians clothed themselves still exist, and later-day historians have perpetuated the error.

When Columbus first encountered the mainland Indians coming to meet him in dugouts, he remarked that they looked much more civilized than the Cuban Indians he had just seen. The friars, too, were pleased that the Guatemalan Indians were more decently clad than those they had met in northern Mexico (Sinaloa), who were either completely nude or scantily covered with leaves or grass. Some of the men of the higher classes wore very full, short, white cotton skirts, without any buttons or strings to secure them. These were beautifully woven with colored designs in the textile, and as the looms were narrow, these full skirts were divided according to the widths of the materials. Others wore the short, loose, one-piece shirt over very short cotton trousers.

The friars were not pleased at all, however, with the jewelry

[11] *Utilidades de que todos los Indios y Ladinos se vistan y calcen á la Española, y medios de conseguido sin violencia, coacción, ni mandato,* 6, 10, 15, 16.
[12] *Historia de la América Central,* I, 89.

affected by high-class Indians—nose rings, earplugs, and lip orna-
ments which were worn in the lower lip and hung almost to the
chest. The priests had to use much persuasion to induce the Indians
to discontinue this disfiguring habit. All kinds of jewelry were worn
by both sexes; large earrings and chains continued to be worn for
many years. The modern Indian woman still loves jewelry and wears
as much as she can.

The Indians' use of gold and silver threads in their textiles came
to an abrupt halt on October 25, 1563, when a royal warrant or-
dered "that no person, man or woman, be allowed to wear any tex-
tile that was brocaded . . . nor one that had gold or silver in its
weaving . . . even if these threads were false imitation . . . as also
it was prohibited that silver or gold should be used for the cloths
that were used on horses and mules."[13]

As time went on, costumes gradually changed a little, and the
wide Spanish skirt, *refajo* or *corte plegado*, was adopted. The wide,
pleated skirts now worn by some women and adopted more and
more by others seem to convey to the Indian mind some idea of
"civilization," but exactly how is hard to understand. For example,
a young woman whose mother wore a very tightly wrapped skirt
said that her father wished her to be "civilized" and therefore had
obliged her to wear the pleated skirt.

Whether trousers were worn in pre-Spanish and early Colonial
days is still open to question. Several figures on paintings, carvings
or clay figurines are shown wearing short, bloomer-like trousers or
textiles so draped. It was not difficult to convert the wide, apron-
like affairs hanging down in front and back into trousers once the
Indian had observed the Spanish garb. The middle part was slit and
sewed together for the legs while the sides were left open to form
the split trouser so much in vogue in the sixteenth century. Long
trousers were a later adaptation. The Indian has made many modifi-
cations of both types. The white cotton undertrousers, finished at
the calf or ankle with a fringe, continued to be worn under heavy
woolen trousers but only as a privilege of the higher classes and
religious or civil officials.[14]

[13] *Prontuario de cédulas reales,* 160.
[14] *Central America.* The frontispiece of this book shows a costume worn by
Indian officials of that time.

Items from priests' and nuns' habits were incorporated into Indian dress, particularly the long robes. Elements of Indian dress distinctly of Spanish origin were long sleeves, shoes, hats, and coats of Spanish peasant or modern fashion. Capes were very much in style among the Colonials; the woolen *capa española* worn by the *caballeros* was adopted for Indian ceremonial use, although a cape was already part of the Indian costume.

Before and after the Conquest, immigrations of Mexican tribes, especially the Tlaxcalan followers of Pedro de Alvarado, were reflected in certain details of the indigenous Indian costumes. The belts and some of the textiles from San Miguel Totonicapán have a distinctly Mexican appearance, particularly those from Tehuantepec. The belt and headdress of the *cofradía* costume in Mixco also reflects Mexican Indian costume tradition, as do the ceremonial wool *tocoyales*.

Despite these numerous adaptations of detail of foreign dress, there was very little of Spanish costume of the Colonial period which was adopted per se. Indian attire has retained most of its native individuality until very recently.

III

*

Materials Used for the Manufacture of Textiles

O F THE THREE FIBERS—COTTON, WOOL, AND SILK—found in Indian textiles, cotton is by far the most commonly used in Guatemala and El Salvador. Some plant fibers, among them maguey and hizote, are used in conjunction with cotton or wool as stiffening for belts and head ribbons, and alone for bags, horse trappings, nets, hammocks, and ropes. More recently, rayon has been utilized also. In pre-Conquest times, colorful feathers and gold and silver threads were woven decoratively into the textiles, but this custom is long since a thing of the past. Silk, linen, and wool, were introduced by the Spaniards. Every effort was made on the part of the Spaniards to cultivate flax in the colonies, but linen textiles were never as plentiful as those made of cotton.

Although cotton is easily grown, the supply does not quite meet the demand, and some cotton is imported. Many Indian weavers are glad to escape the tedious ginning and spinning and purchase machine-spun cotton thread in hanks ready to weave. More and more cotton is now being grown in Guatemala to meet an ever in-

creasing demand, however. The Indians are going back to weaving their own thread because they have found that commercial silks and other colored yarns do not withstand repeated washing.

Wool is also used extensively, especially by the Indians who dwell in the cold highlands. Silk and rayon are used for specific purposes or articles, and neither has replaced cotton and wool as a major fiber. *Seda floja*, untwisted silk from China, has been imported since the Conquest and was formerly used by the Indians in their finest textiles.

In the pre-Columbian period colored cotton is said to have been grown in Mexico and in the lowlands of Guatemala. The legend of the culture hero, Quetzalcóatl, tells us that "They sowed and gathered cotton of all colors as, for instance, red, bright red, yellow, purple, whitish, green, blue, dark brown, gray, (dark) orange and tawny; these colors of the cotton were natural as thus the cotton grew."[1] There may have been some element of truth in this, for when I was living in the Mazatenango region about thirty years ago, a dark cotton—almost blue black—was sparsely cultivated.

The first recorded European reference to cotton in America was made by Columbus. On his fourth voyage he was met in the Bay of Honduras by Indians in dugouts laden with assorted gifts. "Afterwards they [the natives] came swimming to the ship's boat where we were. And they brought us parrots and cotton-thread in skeins . . . so that I saw sixteen skeins of cotton given for three Portugese *centis*, and there were more than twenty-five pounds of spun cotton in them. . . . It [cotton] grows here in this island, but for a short time I could not believe it at all."[2] Columbus also states that the Indians were wearing cotton clothing and that their dugouts were equipped with cotton shelters to keep off the sun.[3]

COTTON

According to Indian legend, the Guatemalan Indians were introduced to cotton by Hunahpú, eighth king of the Quiché. (His twelfth lineal descendant, Tecun Uman, occupied this throne at

[1] Bernardino de Sahagún, *A History of Ancient Mexico*, 179–80.
[2] Carnegie Institution of Washington, "Textile Arts of the Guatemalan Natives," *News Service Bulletin*, No. 3, Washington, D.C., 1935, p. 161.
[3] Diaz del Castillo, *Verdadera*, I, 7.

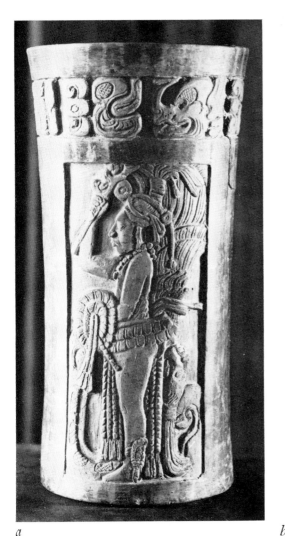
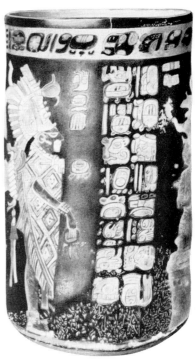

a *b*

Plate 1. a. Brown clay vase found at La Rabida near San Salvador, showing Mayan clothing. *b.* Cylindrical polychrome vase from Uaxactún, Guatemala, showing another Mayan costume.

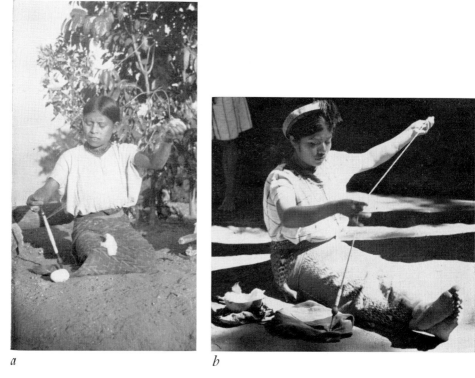

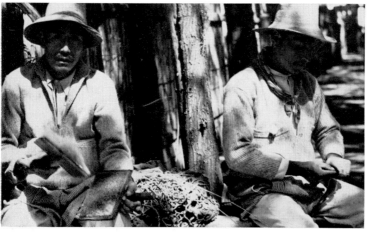

Plate 2. a. Woman spinning cotton, San Pedro Laguna. *b.* Woman spinning cotton, Santiago Atitlán. *c.* Carding wool, Tacaná.

b

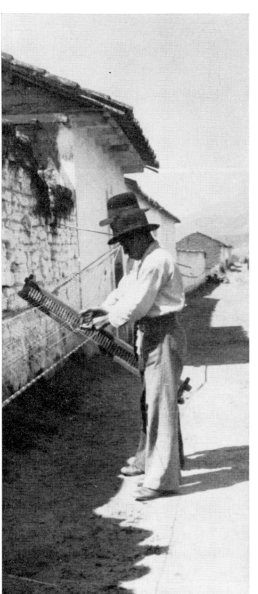

Plate 3. a. Arranging tie-dyed warp yarns for foot loom, Salcajá. *b.* Cleaning, spinning, and weaving wool, Momostenango. *c.* Spinning and arranging wool for the loom, Momostenango.

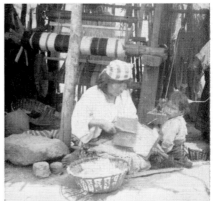

a

c

Plate 4. Woman of Santiago Atitlán using hip-strap loom.

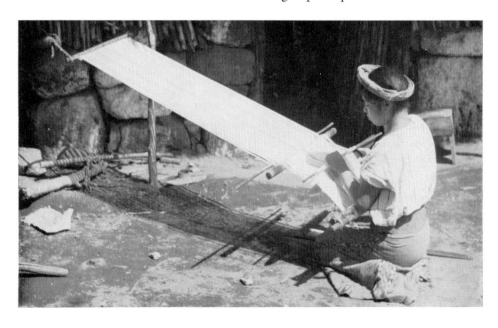

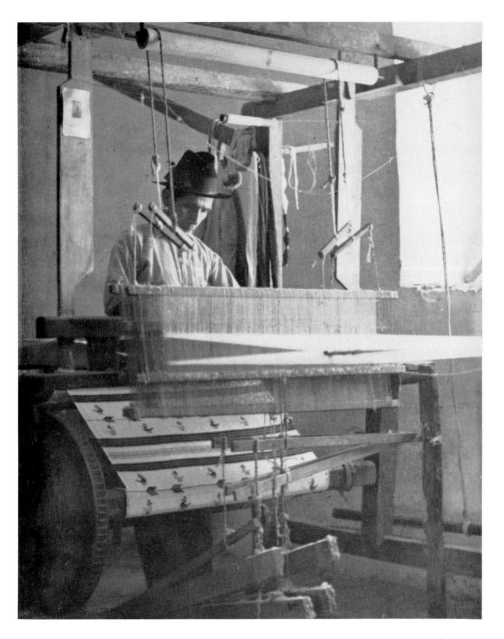

Plate 5. Foot loom, Antigua.

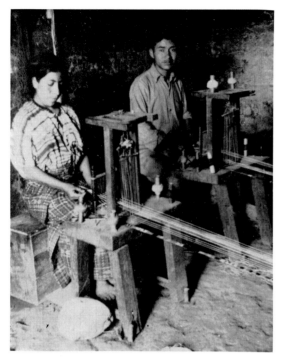

Plate 6. a. Loom for weaving headbands in tapestry technique, San Miguel Totonicapán. *b.* Belt loom, Totonicapán.

a

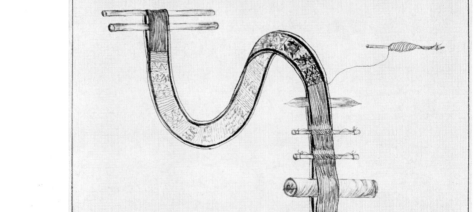

b

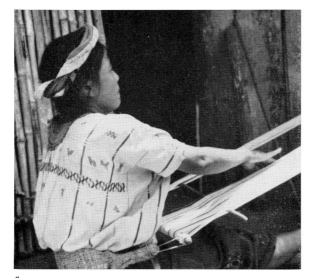

a

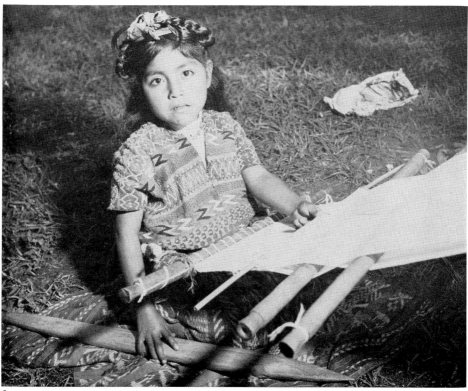

b

Plate 7. *a.* Weaving on a hip-strap loom, Santiago Atitlán. *b.* A little girl learns to handle the hip-strap loom, San Antonio Aguas Calientes.

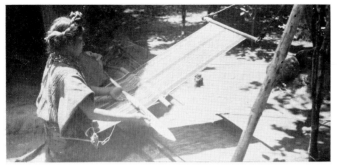

a

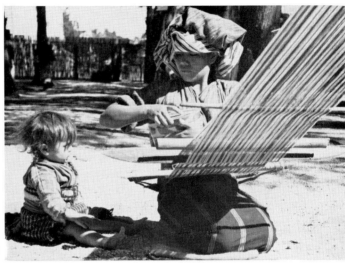

b

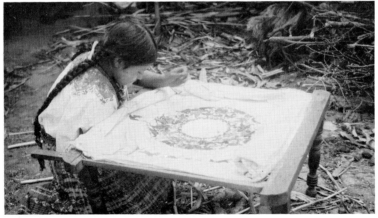

c

Plate 8. *a*. Weaving in Panajachel. *b*. Weaving in Patzún. *c*. Embroidering a *huipil* with needle and silk thread on hand-woven foundation material, San Andrés Xecul.

the time of the Conquest.)[4] This king is also said to have colonized the Pacific lowlands in the regions around the present towns of Mazatenango and Retalhuleu with Quiché and Cakchiquel Indians from the highlands for the purpose of growing cotton. Many of the descendants of these two tribes are still to be found in the lowland regions of this area. Although cotton may have been cultivated on a large scale here under the direction of Hunahpú, cotton garments were worn long before his time. Woven textiles are represented on Mayan stone carvings, and actual textile fragments in many and complicated weaves have been recovered from various archaeological sites.

After the Conquest, cotton textiles (then woven by women) were one of the most important items on the Indian tribute lists.[5] These were shown in the codices as rolls of cloth, called *mantas* by the Spaniards. Fuentes y Guzmán[6] mentions that cotton carpets dyed with *chuchumite* were used for processions to keep the feet of the dignitaries from touching the ground. The Spaniards used Indian cotton for sailcloth, bridles and horse-trappings, the last two dyed purple with *Purpura patula* L. & Lam.[7]

Although cotton was growing abundantly when the Spaniards arrived, it was evidently of an inferior grade. The Spaniards soon sent to China for new seed, which so improved the native strain in both quality and quantity that cotton growing became one of the principal bases of the native economy during the Colonial period. The Indians' talent for weaving was developed into a profitable industry. Quantities of raw material were exported to Spain, and much was woven for use in the colonies.

Toward the middle of the eighteenth century so much cotton was being grown that a great part of the population was engaged in this work. Overproduction ensued, frequently no buyers appeared, and prices fell so low that most of the crop was left to rot on the

[4] Domingo Juarros, *Compendio de la historia de la ciudad de Guatemala*, II, 9.
[5] Diego de Landa, *Relación de las cosas de Yucatán*, 352.
[6] *Recordación florida*, I, 18.
[7] A mollusk of shallow Atlantic coastal waters. A subspecies, *P. pansa* Gould, is found on the Pacific side from western Mexico to Colombia. Both species were collected by the Indians of Central America and milked of their purple dye, the shellfish afterward returned to their rocks to be revisited later. It is the Pacific variety which the author has seen used.

ground. To counteract this waste, the old tribute system was revived and strictly enforced from 1756 to 1760. Out of this tribute system grew the Spanish *encomiendas*. The Indians of distant villages and hamlets sent their headmen into the large towns to obtain raw cotton for spinning and weaving, and each villager was given four *arrobas* (one hundred pounds) of raw cotton. From this cotton he was required to produce either one *arroba* (twenty-five pounds) of spun cotton yarn, which the Spaniards then had woven to suit themselves,[8] or three short, narrow, coarsely woven mantles, called Sacatepéquez mantles. For each *arroba* worked, they received an advance payment of six pesos and two reales. The Spaniards did not always profit by this inducement of money in advance, because the Indians were often slow to return the finished work, and if a weaver died, the relatives were reluctant to admit the debt. Despite the reluctance on the part of the Indians to participate in this system, the high quality of Guatemalan cotton was thus maintained, and only a century ago great quantities of it were still being exported.

In Guatemalan agriculture, cotton is second in importance only to food crops. Two kinds of cotton, both native to America, are grown and much prized for Indian textiles. These two varieties are the ordinary white cotton (*Gossypium hirsutum* L.), a short-staple cotton, and that called *cuyuscate* or *ixcaco* (*Gossypium mexicanum* Tod.), of a tawny brown color which needs no dyeing when used for all-brown textiles. The latter is so highly valued by the Indians that whenever possible it is woven into some part of their ceremonial costumes. Quantities of *cuyuscate* are still cultivated in the lowlands, but I am told that the quality is not to be compared with that of former years, as it is difficult to procure new seed. Cotton grown from Mexican seed, though imported in pre-Columbian times into Guatemala, is said not to equal that grown in Peru, the country which was the original source of this cotton and which now prohibits the exportation of the seed. Recently white cotton has been extensively cultivated in El Salvador. It is of excellent quality and has found a ready market both there and in Guatemala.

The hand preparation of cotton for spinning is time consuming as well as tedious. The raw cotton must be cleaned of seeds (laid

[8] Antonio Batres, *La América Central ante la historia*, II, 384.

aside for planting) and other foreign materials so the finished product will be clear and uniformly textured. (White cotton which has not been well cleaned is a creamy color with small black specks, the bits of unremoved seed coats. After repeated washings, however, the cloth becomes pure white with a pretty mottled surface.) The fiber is ginned by the primitive method of beating with two wooden sticks, one held in each hand of the preparator who manipulates them so rapidly that she produces a rhythmic sound that can be heard for quite a distance. The base on which the fiber is beaten is, for example, a hard cushion of well-packed dried cornhusks covered with a deerskin or goatskin, smooth side up. This beating loosens the fibers and prepares the cotton for the spindle (*huso* or *malacate*).

Spinning is still done by the same primitive method which has been used for centuries. The spindle is a stick about one-half yard long with a whorl four or five inches from the lower end. The whorls are made of clay or wood, now plain but in pre-Conquest and early Colonial times elaborately ornamented with symbols and designs. The spinner rests the lower, pointed end in a clay dish (*escudilla*), a gourd (*guacal*), or a large seashell (*concha*, used in Panchimalco). (Ancient histories tell of golden dishes used for this purpose by rich women.) Spindles may also be rested on the ground, but the spinning does not progress as rapidly. The woman sits or squats on the ground and turns the spindle with one hand, feeding the raw cotton to it with the other from the supply lying over her shoulder or in a *guacal* or small basket. Diligent at her work, she spins everywhere; at home or at market while she waits to sell her wares, seemingly paying little attention to her work as she gossips with her neighbors. In the warmer latitudes the weaver keeps beside her a large cone of chalk (*tizate*) over which she passes her hands frequently to dry them.

Once the cotton has been spun, it is ready for the reel (*hilvanadora*; also often called *malacate*). Although it may vary in size and shape from village to village, the most common reel resembles a lamp with too large a shade. The base is two crossed pieces of wood, in the center of which is a hole for the upright. Sometimes a reel will be set on a stool instead of such a base. The uprights and crossbars of the reel on which the thread is wound from the spindle are

made of long, thin pieces of wood or split bamboo and lashed with string, the whole being hung from the top of the upright as a lamp shade pivots on its bulb. The reel must be kept whirling as the woman feeds it the thread from the spindle. This *hilvanadora* is also used for the processing of wool.

From the reel the thread is transferred to a warping frame (*urdidor*) of which there are many types, all simple in structure as used by the Indian. The *urdidor* may vary from a huge block of heavy wood (*trascañadera*) in Santiago Atitlán to a low, well polished table with turned legs in San Antonio Aguas Calientes. Either sticks or wooden pegs are set in holes at intervals along the top and are moved according to the length of the warp threads to be used on the loom. On these pegs the cotton is arranged in crosses (*cruces*), and since the number of threads determines the width of the material, they must be very carefully counted.

In Santo Tomás Chichicastenango, Comalapa, and a few other villages, the warping frame is a long board set on sticks a few inches above the ground. The sticks go through the boards and form the eight pegs required for winding the warp threads. In Jacaltenango another kind of warping frame is "a heavy pole about 2 meters long, with a cross-stick 1½ meters in length set through it at one end. A little further down on one side another, shorter stick is set, parallel to the cross-stick. Toward the middle is a row of holes, in one of which a twig or nail is placed, according to the length of warp desired. The thread is wound from one end of the cross-piece and so back and forth. As it is wound, it is crossed over at the small cross-stick, so that the thread which has been on the top of the large cross-stick from then on is underneath and vice-versa; this crossing of the warp strands is maintained when the loom is set up."[9]

As an illustration of the way in which cotton thread is wound on the *urdidor* or warping bar, let us take the manufacture of a *huipil* by a careful weaver in Quezaltenango. Here the cotton is bought in skeins, usually about the thickness of a No. 20 spool thread, often already dyed in the desired color. On the *urdidor*, which here has two rows of three pegs each, the thread is carefully counted and wound. It is not wound around from side to side but

[9] Oliver La Farge and Douglas Byers, *The Year Bearer's People*, 52–54.

crossed along the pegs and at one end turned back in the shape of a large, crossed ∪. The principal crosses or *cruces* are then tied with a very long thread. The cotton is carefully taken off the warping frame, and the two end-sticks of the loom are inserted at top and bottom of the hank. Then the yarn is given a finish of starch and hung out to dry in the sun.

The finish most commonly used is a mixture of ground corn and water (*atol*). Some villages use for this starch (*yuquilla*) the root of the cassava or manioc plant (*Manihot esculenta* Cranz) mixed with water. Others prefer the juice of the root of the *cebollín* plant, called *zayte* by the Indians. (Fuentes y Guzmán[10] refers to the use of this plant also in pottery making.) Starching makes the cotton easy to handle on the loom and, incidentally, gives the textile a peculiar, acrid odor. Cotton is not the only thread so finished prior to weaving. Chichicastenango women apply a very thick solution of water and sugar to the silk they use for decorating their textiles.

The *atolada* changes the color of the cotton according to whether the corn is white, yellow, or dark. In years past there was a decided preference in certain villages for *atoladas* made with yellow corn. It was still in demand in San Lucas Sacatepéquez only a few years ago for use in weaving special ornamental *huipiles*.

As the finished hank is drying, the weaver separates her cotton, thread by thread, counting it carefully as she frees each thread from the rest to keep them from sticking together as they dry. The weaver alternates the cotton, hanging it first from bottom to top on a clothesline and then upside down, so as to get her threads well established between the three crosses. (The third cross has automatically been formed by the other two.) Once the cotton is dry and each thread separated from its neighbor, the hank is ready to go on the loom. These bundles of threads, or *manojos*, are supposed to contain six pairs each (twelve cotton threads) of the kind of yarn used in that village. As the *huipiles* from Quezaltenango are made in three sections, nineteen *manojos* must be used for the middle section; only seventeen for the two side panels.

Nowadays, traditional methods of spinning, starching, and winding yarn are followed by only a few of the best weavers. It is

[10] *Recordación florida*, I, 246.

only the older textiles made of handspun yarns that have tightly twisted thread. It will not be long before this tradition will vanish also, as modern transportation is making it easier to acquire imported yarn already spun and dyed for the loom.

WOOL

In the Peruvian highlands of South America wool from vicuña, llama, alpaca, and guanaco was used for textiles, but apparently no wool of any kind was known to the people of northern Central America before the Spanish Conquest.[11] Sheep were introduced into Guatemala in 1528 by the first royal treasurer, Don Francisco de Castellanos. Merino sheep[12] arrived later, when Don Francisco de Zorilla brought the first flock in 1630, almost half a century before France and earlier than any other European country was allowed to import them. Guatemala is still the wool-producing and market center in Central America.

Today the only Merino sheep whose wool is used commercially are owned by a man who lives near Quezaltenango. Efforts are being made by several progressive governors of departments (*jefes políticos*) of the highland regions to better the breed of sheep raised in their areas, but so far they have not been too successful because the Indians, who are the owners of the largest flocks, do not take proper care of their animals. The sheep are shut up over and over again in the same small, dirty pens and left thus for long periods of time. In fact, both pens and sheep are moved from time to time to provide fertilizer for land on which crops are to be grown.

Sheep of no particular pedigree roam the mountains in the western part of the country. The proportion of black sheep in

[11] In 1940, several llamas from Peru were given to the president of Guatemala, and a pair donated in turn to San Francisco El Alto, where they found the high altitude a suitable habitat. Wool from the resultant herd is already employed for weaving extra-fine textiles.

[12] The Spanish imported their Merino sheep, the product of crossing Tarentine ewes with African rams. The exportation of flocks was prohibited until the fifteenth century, even to neighboring France. Sweden imported its first Merino sheep from Spain in 1725. Spanish Merinos were the property of a certain number of large landholders, who formed a closed company called La Mesta with the right of *cañada* (the right to pasture flocks from lowlands to highlands at will in different seasons of the year) over the greater part of the country.

every flock is large, because their dark, undyed wool is preferred in the highlands for men's clothing.

The Indian shepherd, a picturesque figure in his unique tribal clothing and followed by a faithful dog, patiently tends his flocks and spins their wool while he follows them up and down steep canyon slopes. Using a primitive spindle, he constantly spins from the washed wool carried in a peculiarly shaped basket which he wears suspended from his neck.

In remote highland villages Indians still weave their own woolen textiles on hip-strap or very simple foot looms. They supply the people of the regions of the Tacaná and the Tajumulco volcanoes with homespun yardage or blankets which are never traded outside these areas.

In contrast to the insularity of the highland villages, woolens from such famous wool centers as Momostenango are traded all over Central America. For centuries, however, El Salvador has been the outstanding trading center in Central America for wool as well as other products. It may well be that this association of El Salvador with the wool trade explains the use of the term *jerga de el Salvador* (woolen material from El Salvador) for the short men's coat (*chaqueta*) worn many years ago by the peasant class in Costa Rica. I, myself, have come across Guatemalan Indian acquaintances trading in El Salvador. They and their women folk, who were evidently enjoying this long, arduous trek, had just been to the yearly fair in Santa Ana and were looking forward to the fairs in Vicente and San Miguel. In addition to Momostenango, other well-known wool centers are San Cristóbal Totonicapán and San Francisco el Alto, where on Fridays takes place the most famous wool market in the country.

The wool markets are attractive places. Here are sold all kinds of wool, teasels for carding, parts of the implements used for preparing and weaving the wool, vegetable and mineral dyes, and of course the finished material, either as blankets or as yardgoods in standard lengths of six *varas* (one *vara* is thirty-three inches). It is not possible to match any two lengths, however, for in woolen textiles, as in cotton, the Indian weaver makes no two pieces alike.

Wool tweed made its appearance in 1936 and is very popular

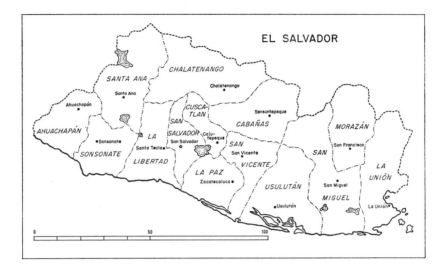

as a trade material. Its introduction is ascribed to the visit of a well-known sportsman from the United States who, when visiting the Guatemalan highlands, wore a natty sport coat of wool tweed. At the market in San Francisco El Alto he bent down to examine some blankets, whereupon two Momostenango Indians quietly stole up behind him and gently fingered his coat to determine the texture and weave. Scarcely a month later the first tweed yardage made its appearance in the wool markets. The Indian weaver, without instruction, is quick to adapt to his own techniques and primitive implements something that catches his eye.

All processing of wool in Guatemala takes place in these wool centers save that which is carried on in a household to produce articles for family use. The men of the highland villages shear their own sheep (generally on June 24, which is considered the most auspicious date for this undertaking), placing the wool to be sold in small nets (*redes*) to await the arrival of the wool trader. The trader buys as many of these small quantities as he can afford, usually gathering enough for one or more larger nets in which it is conveyed to the wool markets.

The processing of the wool is the same the country over, whether at home or in the wool centers. The wool is washed in large baskets in the thermal springs of rivers or lakes with vegetable soap

called *jaboncillo*. When the wool is fairly clean, it is dried in the sun and fluffed with a pair of hand cards—small square pieces of wood with handles and with nails or short pieces of wire set close together on one side. Carding is done by all members of the family.

After the wool is carded it is ready to be spun. Spinning is done by two methods, the most common method employing the primitive wooden spindle, larger and heavier than that used for cotton and with a large, disc-shaped whorl made of wood rather than clay. The right-handed worker spins with his right hand from the wool at his left side. Wool may also be spun on a large spinning wheel (*redil*), apparently little changed in appearance from the time of its introduction by the Spaniards. The wheel is set on a low table.

Wool is dyed in the yarn. After the dyed wool is dry it is wound onto a bamboo frame, from which it is transferred to the *urdidor*, or warping frame. For wool, as for cotton textiles, either the hip-strap or the foot loom may be used. Customarily men are the weavers of wool, and they usually use foot looms, although hip-strap looms are employed on occasion. They are adept at weaving the fundamental patterns, as well as the eccentric ones used currently for mass production, in plain, basket, or twill weaves.

After the textile is woven, it is felted by either thorough washing in a huge vessel (*apaste*, or clay jar) with boiling water, or, as in Momostenango, immersion in the thermal springs that are nearby. During the felting process it is forcefully rubbed and beaten (*aporreado*) on a large stone to make the wool soft and pliable. The result of this process is a well-shrunken and almost waterproof material which is both durable and of excellent quality. (The ancient custom of incorporating rabbit, bat, and other hair during the felting process is no longer followed.) It is then spread on the ground to dry in the sun and finished by fluffing with a teasel.

Silken Fibers

Silken material has long been used in Central America for specific purposes, being found even among prehistoric textiles. The common silkworm (*Bombyx mori*) was unknown, but silky vegetal fibers were used, as well as filaments produced by a variety of spiders and caterpillars. Among the plant products used are the fibers of

31

the *chichicaste* and other related species of the *Urticaceae* (nettle family) and the fine, soft, glossy fiber called *pita floja* from one of the numerous species of agave. For example, a manuscript[13] in Costa Rica shows Costa Rican Indians gathering cocoons in evergreen forests and weaving headbands and loincloths from these silken filaments. Among the insect producers of silklike material is a caterpillar (family *Saturnidae*) known as *gusano del guayabo* (though not the variety of *gusano de guayaba* that frequents the fruit of this tree, *Psidium guajava* L.). I saw it in the vicinity of Antigua and noticed that it spun strong, fine silky threads that might well have been employed instead of true silk.

Various other caterpillars and spiders have been pointed out to me at one time or another as silk-producing insects, but I have not been able to get them classified or even named. All spun short filaments, with the exception of one species of *Hylesia*, a parasite of pine trees. This species spins long filaments which are tough and whitish in color.

After the Conquest the growing of silkworms became a major industry for which certain places, one of them the Isthmus of Tehuantepec, became famous. The weavers there used much silk in their textiles.

During the Colonial period, silkworms were also grown in El Salvador. When this industry became so profitable a business that it competed successfully with the Spanish industry, the monopolists, particularly those of Cádiz and Murcia, saw to it that the Colonial industry was destroyed.

Today silk and rayon thread are imported and sold at all the village markets and fairs. Silk is seldom used for the basic weave, but untwisted silk is much in demand for both brocading and embroidering and is especially used in the *randa*. This silk, called *seda floja*, is Chinese in origin; although scarce, it is still used in the best textiles rather than rayon. All-silk textiles are woven on foot looms for trade pieces for *ladinos*.

Today's Nahualá costume includes silk in both men's and women's clothing. Men's trousers (which they wear under their

[13] José Maria Figueroa (compiler), "Libro verde de documentos históricos." MS in National Library, San José, Costa Rica, n.d.

wool *ponchitos*) are heavily brocaded in silk designs as are the women's *huipiles*, but the silk dye runs at each washing in a most (to our way of thinking) unsatisfactory way, although the Indians seem to take pride in the resulting smear of color.

In El Salvador silk scarves and shawls are beautifully woven on the old-style foot looms and are famous for their wearing qualities, despite the fact that in these tropical countries of extreme heat and humidity even the best materials rot. The silk for weaving these textiles is either imported in the desired colors or dyed with aniline dyes exclusively. An occasional larger thread is included in plain or basket weave in both the warp and weft threads to give the appearance of a cord. *Ladino* women make these scarves—no two ever seem to be alike—in intricate designs and finish the ends with long, hand-knotted fringes. Silk is used as a pattern filler to enhance brocaded textiles in Quezaltenango and San Pedro Sacatepéquez (S.M.), as well as San Martín Jilotepeque, Rabinal, San Pedro Ayampuj, San Miguel Totonicapán, and the Ixil villages. Rayon is also used, and is rapidly supplanting silk for decorating textiles, but only exceptionally are either silk or rayon utilized in both warp and weft threads, one exception being the Sacapulas headband. Rayon is used for the majority of Indian textiles that are woven for trade, or when *seda floja* is unobtainable. Skirt materials often have rayon threads here and there through the warp and weft; headbands, sashes, and belts have silk or rayon used thus to emphasize design or symbols of a particular village.

As a rule, men do not wear material with much silk or rayon content. The designs of their costumes preferably are done in cotton or wool pattern-filler yarns (Cotzal). Ceremonial clothing, however, is very often trimmed with bits of silk, rayon cloth, or embroidery.

IV

*

Dyestuffs and Dyeing

ALTHOUGH A NUMBER OF DYESTUFFS and their resultant colors will be discussed in the following paragraphs, when one considers Indian textiles, one is immediately struck by the predominant use of red and yellow as well as black and white. These four colors have been used in Guatemala since ancient times to represent the four cardinal points of the compass: yellow for south, red for east, white for north, and black for west. They are also associated with the gods once worshiped by these people. Why they were chosen in the first place may be dependent upon something as simple as the availability of natural dyestuffs. Indeed, red, yellow, black, and white are the basic colors of people living under simple cultural conditions all over the world.

Although aniline dyes have in large measure taken the place of the excellent natural dyes available in Guatemala and El Salvador, the latter are still used. Esthetically, the results of dyeing with natural dyestuffs are far more pleasing since the brilliant hues soften rather than fade with time. It is pertinent, therefore, to dis-

cuss the sources of color which are generally used by the Indians.

The oldest histories repeatedly mention that the Indians employed excellent, fast dyes for coloring their textiles at the time when the Spaniards arrived. They are usually referred to by the name of *chuchumites*.[1] Undoubtedly the term *"chuchumite"* applied to the numerous varieties of the American indigo and perhaps also to cochineal red, because it is generally assumed that these two colors together with yellow were favorites at that time. The discovery of aniline dyes by Sir William Henry Perkin in 1857 wrought vast changes in Guatemala and El Salvador as elsewhere in the world. In Guatemala aniline dyes came into general use one-half century later and have rapidly increased in popularity during recent years. At present, however, there is a tendency to go back to the well-known vegetable and animal dyes owing to the scarcity and high price of imported materials.

In the following pages I will describe the colors used by the Indians in their costumes and the natural materials, animal, vegetable, and mineral, from which they are produced. In addition I will give the techniques used by the Indians for dyeing both cotton and wool.

NATURAL DYESTUFFS FOR COTTON

Purple. Cotton dyed with an extract from *Purpura patula* L. and Lam., which produces a soft, rosy purple, has been much in demand for ceremonial garments, though its use is rapidly diminishing. Called *morado criollo* or *morado de carrizo*, the cotton is made up in small hanks of very fine thread and is much more expensive than silk. It has a peculiar, seaweed-like odor and a salty flavor. I have often watched Indians tasting this cotton to make sure it was genuine.

The dye is extracted from a mollusk (*Murex*).[2] Historians mention Costa Rica as the principal place to obtain the dye during the Colonial period. It is said that the finest dye is obtained by gathering the mollusk in the spring when the moon is full. By rubbing one animal against another, the Indians extract a secretion from a thick

[1] Fuentes y Guzmán, *Recordación florida*, I, 266.
[2] See n. 7, Chapter III above.

gland in the gills, the brightest shades coming from a small white sac. The rest of the animal is useless. Thomas Gage in 1648 said, "The textiles of Segovia dyed with this substance are as well liked and famed and high priced as those Roman ones called 'Tyr Purpura.' "[3] Mrs. Nuttall has written the best account of this subject.[4] The virtues of this dye have even found their way into verse: Rafael Landívar, in his *Rusticatio Mexicana* (pp. 42–52), exalts the qualities of the cochineal bug, the *Purpura* mollusk, and the dyes produced from them.

When I was on the coast of Nicaragua in 1936, I found that the inhabitants had completely lost any knowledge of this mollusk. Nevertheless I hunted among the rocks and outer reefs along the shore and finally saw two, the shells, pinkish-white and about three inches in diameter, attached firmly to the underside of stones. I was able to dislodge them and took them home, where I could prove for myself their dyeing qualities.

The Indians of El Salvador use the bark of the *palo amarillo* (*Chlorophora tinctoria* L. [Gaud.]) to obtain a purple dye. In Guatemala a purplish color is also obtained from the juice of the *mora del campo*, or *nance morado* (*Byrsonima cotinifolia* H.B.K.). In addition the peel of the *zapotón* fruit provides a dye verging on violet.

Blue. The plant which is commonly used to obtain a blue dye is indigo (*añil*). The province of San Salvador was the principal center for cultivation of this plant during the Colonial period. Salvadorean *añil* is still considered to be of the highest quality and is often used in admixture with the Guatemalan variety. In Guatemala the center for the cultivation of indigo in Colonial days was Chiquimula. Indigo is commonly known as *jiquilite* or *cuajatinta* in El Salvador, and *sacatinta* in Guatemala. The use of the name is, however, erroneous since *cuajatinta* is a medicinal, not a dye plant. It is not known why this name has come to be applied to indigo in certain sections of El Salvador.

Jiquilite has several subspecies, of which the commonest are

[3] *Nouvelle relation, contenant les voyages de Thomas Gage dans la Nouvelle Espagne.*

[4] *A Curious Survival in Mexico of the Use of the Purpura Shell-Fish for Dyeing.*

Indigofera guatemalensis, with small, straight pods, and *I. suffruti-cosa* Miller, with long, curved pods. In contrast to the Colonial period, when the plant was a source of great wealth as an export to Europe, it is now only sparsely cultivated by the Indians.

Sacatinta (*Fuchsia parviflora* Zucc.) is abundant at high altitudes where it grows about six feet tall. Its dye is inferior to the *jiquilite*. In some areas *sacatinta* is known by the general name of *jiquilite*, and though both are often called *tinta*, the two plants are easily differentiated. Another species also known as *sacatinta* and used for blue coloring matter is *Jacobinia spicigera* (Schlecht.) L. H. Bailey, commonly found in all regions of these countries. It is used as laundry bluing as well as a dyestuff. When acidified, the extract from this plant produces a reddish color.

In El Salvador *irayol* or *guaitil* are the popular names for *Genipa americana* L., another plant commonly used to produce a dark-blue dye for cotton.

In order to extract the dye, the Indians wash the leaves thoroughly and, along with the stalks, crush them on a dry oxhide pegged out on the ground, in a large clay receptacle, or on a *batea*, a flat-bottomed, troughlike wooden wash tray used by washerwomen in these countries to carry wet clothing. The crushed plants, water, and lye are put into a large clay jar or a wooden tub made from half a barrel. If thread is not carefully dried after being dyed with this solution, it retains an unpleasant odor and absorbs moisture easily.

In Santiago Atitlán, a dark-blue, almost black, dye is obtained by mixing five pounds of Salvadorean *jiquilite*, an equal quantity of Guatemalan *sacatinta*, and lye (*lejía*) in solution. The mixture is allowed to ferment for several days in a clay jar and is not touched until a white scum forms on top. The man who does the dyeing then blows on the scum. If it parts to show a green color with a dark undershadow, it is ready (*está de punto*) for the thread, which is then dipped in the solution. The color obtained is as fine a blue as the best that can be bought ready-dyed.

Black. A good black dye is obtained in El Salvador by boiling the mashed fruit of the *nacascolo*[5] tree (*Caesalpinia coriaria* [Jacq.]

[5] The *nacascolo* must not be confused with the *nascacolo*, known in El Sal-

Willd.). After its initial dipping in the dye pot (*tinaco*) and careful drying, the cotton is dipped in a second solution, previously prepared and fermented, of water, black loaf sugar (*tapa de dulce*), a handful of rusty nails, and some overripe *marañón* fruit (*Anacardium occidentale* L.). The cotton is then well rinsed in clear water and hung out in the sun to dry. The shade of black depends on what mineral is added with the fruit. Almonds from a species of tree (*Terminalia catappa* L.) originally brought into El Salvador from India produces a deeper black. The fruit of the bush *espino blanco* (*Acacia cultriformis* Cunn.) contains a large quantity of tannin and makes a successful dye.

In addition to these plant sources, black dye, though not a deep shade, is also obtained from *jugo de jute* (juice of the snail). The snail grows abundantly in the rivers of the department of Jutiapa in southeastern Guatemala and is traded all over the country.

Brown. Natural tawny cotton called *cuyuscate* or *ixcaco* grows abundantly in the lowlands. As it needs no dyeing, it is preferred to all other shades of brown. In villages of the Baja Verapaz mountain regions, the women still use natural brown cotton uniformly for their *huipiles* and other textiles.

When the natural color is not sufficient, it is deepened to a light brown by the skin of the *nance* fruit (*Byrsonima crassifolia* [L.] H.B.K.). A darker shade is produced from the bark of the *aliso* tree (*Alnus acuminata* H.B.K.). The bark of the *quersitron* (*Quercus velutina* Lam.), when added to bichromate of potash, produces a pleasing reddish-brown; when mixed with chloride of zinc, a reddish-brown with a decided violet tint. The crushed stone of the avocado (*aguacate*) mixed with the peel of ripe plantains and added to bichromate of potash yields a tan dye. (It will have been noted that minerals such as sulphate of iron, sulphate of copper, sulphate of zinc, or bichromate of potash are mixed only with such vegetable dyes to produce particular shades.)

Yellow. The most sought-after yellow dye is that made from the bark of the logwood tree, *palo de campeche* (*Haematoxylum campechianum* L., and its related species). Orange is obtained from

vador as *guachimol* (*Pithecolobium pachypus* Pittier), a plant that has been used in past years for ink.

Guatemala

camotillo (*Curcuma tinctoria*). The root of *Curcuma longa* L. gives the best dye. In Santiago Atitlán, yellow is produced by crushing the bark of the *palo de pito* (*Erythrina americana* Miller) in an earthenware jar and mixing it with *palo de león,* also known as *cabello de angel* or *cabello de león* (*Cuscuta americana* L. var. *congesta*). A quantity of lye water is added and the solution left for at least three days, then strained. This dye is popular because it is such a good dye for cotton. Bright yellow may be had by cooking the bark of *palo de pito* (*Erythrina rubrinervia* H.B.K.). For another shade of yellow, *achiote* (*Bixa orellana* L.) is mixed with saffron. Yellow is also obtained from the roots, leaves, and bark of the *chilca* plant (*Senecio salignus* DC.). This small bush grows plentifully along the roads and in the woods all over the country and is easily recognized by its small pointed leaves. After being well washed, it is boiled in water to produce a greenish-yellow coloring matter.

The preparation of dye from dyewoods requires that the bark or the heartwood be first cut up into small logs, sticks, or splinters or reduced to sawdust or powder. In whichever form, the wood is left to ferment for some time in a dark, damp, but well-ventilated place. Then it is immersed in very hot water. The extract is concentrated by evaporation in a vacuum until syrupy (20°–30° C.) or dry. Of course this method is used only where large-scale textile dyeing is carried on, such as the weaving centers where skirt materials and shawls are made. Smaller shops and individual dyers follow more primitive methods for deriving dye for their home-spun yarns.

Green. This color is not produced *de novo* but is made by combining blue and yellow dyes. *Palo amarillo* (*Chlorophora tinctoria* [L.] Gaud.) mixed with indigo is customarily used in El Salvador. In Alta Verapaz, *taray* (*Eysenardtia polystachya* [Ort.] Sarg.) is combined with *palo amarillo* or *campeche* for a yellowish-green shade. The root of the *Curcuma,* a member of the ginger family, gives a yellowish liquid which yields a good green when mixed with indigo. Khaki color is obtained from the bark of the *palo de mora* or mangle (*Avicennia marina* Firsch.), a wood much sought in foreign markets as a source of this dye.

Red. The reddish extract of the *palo de Brasil* is used for both cotton and wool. The species *Haematoxylum brasiletto* Karsten is

39

most popular in Guatemala, *Bocconia arborea* Watson in El Salvador. The latter gives a reddish-orange color and is commonly known as *tiñecanastos* because it is also used for coloring basket materials. There are three other species of *palo de Brasil* and *sangre de chucho*: *Oreopanax xalapense* Dcne. & Planch.; and *Exandra rhodoclada* Standl., which exudes a colorless liquid that turns reddish upon contact with the air.

A very brilliant yellow red is extracted with boiling water from the fruit of the *annatto* or *arnotto* tree, commonly called *achiote* in these countries (*Bixa orellana* L.). *B. orellana* provides the red ingredient, *B. buxina* the yellow. *Achiote* is also a favorite coloring matter for food. The Indians rent trees on large plantations, gather the fruit, and prepare it for sale at markets and fairs. This preparation involves mashing the fruit into a paste, mixing it with grease, and wrapping it in tiny cornhusk parcels.

The nopal cactus or *nopalero* (*Nopalea cochenillifera* [L.] Salm-Dyck) houses the little American cochineal bug that when crushed produces a tiny drop of excellent red dye. Native to Mexico, Central America, and Peru, it was introduced into Spain after the Conquest. The cochineal industry was a major one during the Colonial period but now survives only in Quezaltenango, Amatitlán, and Zacapa.

The cultivation of the insect, of which only the female produces the dye, was described as follows by a couple traveling in Central America toward the end of the nineteenth century. "[In Antigua] the preparation of cochineal was the chief industry, and where coffee trees are now growing there formerly stood rows of nopal cactus on which the cochineal insect lived. This white fluffy-looking creature, which exudes a drop of crimson fluid when crushed, could not survive the wet season without protection, so a framework of rough sticks, divided into many compartments like a plate-rack, was arranged under shelter all along the garden walls, and in each of these compartments one of the flat branches of the nopal cactus was lodged before the rains began, bearing a number of cochineal insects sufficient to repopulate the whole plant as soon as the dry weather came round again."[6]

[6] A. C. Maudslay and A. P. Maudslay, *A Glimpse at Guatemala*, 27.

Antigua and Amatitlán were once (ca. 1840) the center of a thriving industry based on the production of cochineal bugs for commercial use. Nopal cacti were cultivated on large plantations, thus giving employment for many people who nursed the insects through their life cycle as well as harvested the crop during the dry season. On these plantations the cacti were planted in rows much like corn. To each leaf, pinned there by a thorn, was attached a hollow cane inside which the adult insects produced their young. The young cochineal bugs crawled out of the cane and attached themselves to feed on the cactus leaves, where they stayed until they were gathered. The insects were then brushed off the leaves, dried, and exported.

NATURAL DYESTUFFS FOR WOOL

The following dyestuffs are used in Momostenango to color wool.

Blue. Blue is an important color in Indian textiles, and among wool yarns only the white are dyed this color. The wool is first washed in a solution of bichromate of potash, then immersed in a solution of the bark of the *campeche* tree (*Haematoxylum campechianum* L.) and indigo. The color derived is a deep shade of blue.

Green. Green is a color only lately used for the dyeing of wool. Although most green wool is dyed with commercial dyes, the wool may be submerged in a solution of bichromate of potash, then dyed with the bark of the *palo amarillo* (*Chlorophora tinctoria* [L.] Gaud. or *Bocconia frutescens* L.).

Brown. Usually the natural wool is satisfactory without any dye. Sometimes, however, when a dark brown is sought, the wool is cooked over a slow fire in a solution of very strong lime water, then dipped in the liquid extracted from the crushed bark of the *aliso* tree (*Alnus acuminata* H.B.K.).

Red. Cochineal is used for dyeing wool red. It is mordanted with a solution made of limes. Thirty limes must be boiled to produce the mordant for one pound of wool. A very brilliant red is made by the addition of a plant called by the Indians *chinchinegrito* or *cinconegrito* (*Lantana camara* L.). Other shades of red are obtained from the various species of the *palo de Brasil* or *campeche* tree.

41

Black. The almost-black woolen garments of the men are woven from naturally dark wool. When these garments are a dark blue, almost black, color, they have been dyed with the extract of the indigo plant (*añil*). Black is also obtained by adding sulphate of iron to indigo dye.

MORDANTS

A liquid extracted from the well-crushed leaves of *tempate* (*Jatropha curcas* L.) sets colors. The plant grows plentifully everywhere in Guatemala and El Salvador. In El Salvador the skin of the *aguacate* or avocado (*Persea gratissima* Gaertn), well boiled in the dye pot, is said to be excellent for setting colors.

I have seen Indians and *ladinos* who wear black shawls wash them in a solution of well-boiled rosemary, or *romero* (*Rosmarinus officinalis* L.). It is claimed that this herb preserves the dark color and new look for as long as the cloth lasts. The *huipil* of a woman who has just given birth to a child is also washed in rosemary solution. Well dried and warmed by the sun, it is put on her "to give her strength after the ordeal." Sprigs of rosemary are placed in the form of a cross on the fire and allowed to smoulder, while the aromatic fumes waft heavenward to placate the god of the tempest.

WASHING PRODUCTS

A vegetable product rather than soap as such is used by the Indians for washing their textiles. The one most commonly used is *jaboncillo* (*Sapindus saponaria* L.), the outer skin of whose fruit contains 4 per cent saponin. The wash water should be very cold, never hot.

Equally good for dissolving grease and dirt is the root of the *amole*,[7] which contains a large quantity of saponin and lathers well. In the Huehuetenango region, Indians use the *amole* root also as a curative against hydrophobia, and it is known by specific Indian names according to the villages where it is used. This plant (*Agave brachystachys* Cav.), which is commonly found in the

[7] The word *amole* is derived from the Nahuatl *amulle*, signifying the root of any plant that contains saponin. In Guatemala this name is applied to the root of various plants, especially to those of the maguey family.

Guatemalan highlands, is a true agave but in appearance very un-
like the common variety. It is a small plant with a large root and
narrow, thin leaves, soft and without spines, that usually dies down
during the dry season. In Alta Verapaz a most useful plant is the *pac*
or *chupac* (*Polygala floribunda* Benth.). Though *chupac* means "on
the hill where the *amole* grows," this plant is not an *amole*. The
leaves are excellent for polishing silver; the well-crushed and dried
root produces a good lather, and the purple and white flowers are
greatly admired for decoration.

Indians in the region of Quezaltenango keep among their laun-
dry facilities a long, red fruit cluster containing numerous seeds. The
plant is the Indian *uoxit*, the Spanish *mazorquilla*, and the American
pokeweed (*Phytolacca decandra* L.). The fruit is pulverized on a
grinding stone before using. An Indian once remarked to me that the
use of this plant had been discontinued as people were getting "civ-
ilized." When I asked what she meant, she replied that since wash-
ing places, either public or in private houses, had been installed,
the seeds of this fruit obstructed the drains and the Indians had no
other recourse but to use soap.

The leaf of the plant called *lengua larga* (long tongue; *Rumex
obtusifolius* L.) provides a bleach. This plant was probably brought
to America by the Spaniards, since it is native to Europe.

Conventional Uses of Dyes

Certain conventions are observed in respect to the use of dye-
stuffs. These are both regional in nature and related to particular
garments. For example, the preferred color of silk is a purplish-red,
untwisted yarn, *seda española* (Spanish silk). Bright yellow runs a
close second in popularity. I have never seen silk dyed in Guate-
mala nor heard of any that had been dyed by the weavers. It is im-
ported already colored and sold at stores, markets, or fairs.

The dye customarily used in skirts is blue. A good 60 per cent
of the *refajos* and *cortes* are blue with white stripes. The next most
popular colors are red, red and yellow, or combinations of these
colors with dark blue, black, or white stripes with *jaspes*. Least
common are green in combination with other colors and the multi-

colored materials, some of the latter having silk or wool weft yarns.

The Indians who live in sierra villages such as Cotzal, Nebaj, and Chajul prefer textiles of a very vivid red. At the present time, however, the red cotton called crea[8] is scarce and expensive, so that men's coats are being made of brown and white or black and white checked wool, similar to the kilts worn in Sololá. The red coats formerly characteristic of the village costume are now worn only by the *principales* and religious or civil officials.

In Alta Verapaz, where many varieties of the *campeche* tree grow, ceremonial textiles of all kinds were once dyed a pretty shade of yellow or were decorated with designs and symbols in yellow cotton on white or contrasting backgrounds.

Black has not been used for mourning by the Indians at any time in their history. I have seen them use black head ribbons and black and white *huipiles* when mourning a relative, but this is distinctly in imitation of a foreign custom. Yellow was customarily used for this purpose, and in years gone by, widowers are said to have painted their bodies yellow to indicate grief.[9]

In El Salvador dark blue is the predominating color for shawls in such areas of the country as they are still commonly worn by the lower-class people and the Indians. This might be expected in a country which has been a major producer of indigo. The partiality for blue also obtains in Chiquimulilla in Guatemala, a producer of indigo in the later Colonial and early Republican periods.

About a century ago the season for the indigo works to commence was the occasion for a large festival. Crowds gathered to witness the dance called *El Toro y el Caballo* (The Bull and the Horse). To the music of a large drum and a flute, two men hidden under the hides of a horse and a bull danced and performed antics for the amusement of the crowd. Once the dance was over, the villagers proceeded to the river, where the *jiquilite* had been allowed to decompose in large stone vats hewn out of living rock. Everyone worked to extract the *jiquilite* dye, which was then mixed with an equal quantity of *sacatinta* before use.

[8] Crea is a bright-red cotton that has been imported from Manchester, England, for more than a century. It does not fade readily, especially the variety marked *Huevo de Oro* (Golden Egg), and the Indians are very partial to it.

[9] Milla y Vidaurre, *Historia de la América Central*, xliii.

44

Unfortunately, strict color observances are being neglected and gaudy and inartistic mixtures result. Not long ago I was in San Pedro Ayampuj watching a woman weave a textile for herself. When I asked why she was weaving her tribal design in such odd and garish colors when the customary ones of her village were so attractive, she replied, "I attended school and was taught to vary the fundamental colors artistically and told not to follow always a set way." This is what may happen in a few years when the Indians, conscious of the demand for their textiles by outsiders, adopt non-Indian tastes.

Another lapse from conventional colors is due to scarcity of materials such as red cotton and yellow silk. The younger girls in San Pedro Sacatepéquez (S.M.), for example, are making *hui-piles* with a dark-blue background and multicolored designs, using *trasquilado* (the shorn technique), which economizes on the silk or rayon yarns by embroidering them only through the top warp yarns.

METHODS OF DYEING

The two methods with which I am familiar by which the Indians dye their yarns are: (1) dipping the cotton or wool hanks into a dye bath until the desired shade is reached, and (2) tie-dyeing, called *ikat* in Guatemala and El Salvador. A third method, resist-dyeing, is used by the Indians on items other than cloth, although I have been told that this method of adding designs to cloth is followed in Guatemala.

The Ikat Process. In the *ikat* process, where color appears only at given intervals to form the design, the threads are dyed before weaving. This process involves wrapping the hanks of thread very tightly with string at predetermined intervals to keep the yarn enclosed by the string from picking up the dye. The cloth made from such tie-dyed yarns (*jaspe*) is called *jaspeado* by the Indians.

The yarn may be hung from a nail on the wall, stretched between large nails on a long board, or merely held in the hands. It is carefully counted and tied according to the design desired. When dyed and dry, the bound intervals which have retained the original color of the yarn are released. The yarn is then ready to be

45

woven into *jaspeado*, either as warp or as weft threads or as both.

The *ikat* process is usually reserved for cotton yarns, and tie-dyed woolens are uncommon. Only recently have they appeared in the markets. Only the warp yarns are dyed (Momostenango), and the weavers never attempt complicated designs; probably because the *ikat* effects in wool are never so clearcut as in cotton, even though the wool threads are as carefully counted and bound with cotton cord.

Tie-dyeing is known to have been done in the northern countries of South America in pre-Columbian times, and apparently some was also done in Mexico. At present Guatemala is outstanding for the use of this technique for coloring yarns.

Jaspeados or other *ikat* designs are much prized. Any textile woven from these yarns is much more expensive than any of the ordinary materials. Beautiful colors and combinations of designs are achieved by people who specialize in this work. Their skirt lengths and shawls are sought after, not only at markets and fairs in Guatemala but in other parts of Central America and Mexico. The most famous centers are Salcajá, San Cristóbal Totonicapán, Huehuetenango, Antigua, San Miguel Totonicapán, Mazatenango, and some villages around Lake Atitlán; also San Pedro Laguna, Santiago Atitlán, and San Pablo Laguna (the last on string bags), though the San Pedro weavers usually buy their cotton already tie-dyed for their work.

Cortes of the best tie-dyed material are worn by the Quezaltenango Indians and are the one great luxury (*lujo*) they permit themselves. These skirt materials are woven in nearby Salcajá, where the first looms for this work were installed in 1861. The Indians here are distinguished for their exceedingly fine *jaspe* work. Their distinctive design is known as *pescadito* (small fish). The figure, resembling a fish that seemingly floats all around the material, is achieved by tie-dyed warp and weft threads. Other specialties of Salcajá are figures called *liras* (lyres), *muñequitos* (dolls), *jaros* (jars), and *petateados* (matlike designs). *Petateados* and *pescaditos* might well be called the trademarks of this particular village, as they fulfill all the standards of well-made *cortes jaspeados*. These

46

cortes are usually woven in dark background colors: green, dark blue that is almost black, maroon, and brown.

The Totonicapán output is seldom traded outside nearby villages and is never seen in the market centers. The work is of great beauty, very fine, and much in demand for *cortes* for ceremonial use. The distinguishing figure of its *jaspe* is a large flower spray spread horizontally around the material, usually on a green or red background having very fine white lines in the weft threads.

In San Cristóbal Totonicapán, *cortes* in several *jaspeado* patterns are made and are known to the Indians by the following names: *gunda*, *contra* (athwart), *jaspe botado* (horizontal *jaspe*), *rama* (branch), and *cadena* (chain). This town is the only one I know of in the country where two colors are dyed, first one and then the other, on the same strands of cotton. Today the cotton may be dyed with several colors, and the resulting designs are cleverly contrived.

In other villages the coloring technique is much simpler. The Antigua and Huehuetenango products have no beautiful or complicated *jaspe* effects to enhance their value. These *cortes* have *jaspe* stripes only in the weft yarns. The Huehuetenango material is distinguished by a bright red background and *jaspes* in white, yellow, or black stripes, depending on the region where it is to be traded and worn (Santiago Atitlán, Nebaj, Cotzal, or the villages of the Cuchumatanes Mountains). The Indians know at a glance where the *jaspe* materials are woven and if it is correct to wear them according to the tradition in their villages.

Mazatenango is famed for its shawls with *jaspe* decorations. The designs woven here are unsurpassed anywhere in Central America, though Mazatenango vies with Quezaltenango in respect to its reputation for *jaspe* patterns. *Perrajes* (shawls) made in Mazatenango have handsome, wide, hand-knotted fringes at both ends. Wool yarns are incorporated in their weft threads, and they are therefore called *perrajes merinos*.[10]

Though the bright red *cortes* of Santiago Atitlán are imported from Huehuetenango, the Santiago weavers also make *cortes* and

[10] The word "*merino*" has been adopted by the Indians to describe a material which contains any wool at all. When wool is used in combination with any other fibers, it usually appears in the warp.

perrajes for trade as well as cotton material for men's costumes. These materials, woven in the weaver's house on the most ancient type of foot loom, have the *jaspes* only as warp yarns, either in white and black, yellow and black, or blue and black. They are very simple compared to the complicated *ikat* work done in other highland villages.

In Santiago Atitlán I watched a man getting his yarn ready for *ikat* dyeing. He stretched his warp yarns on the loom and placed underneath them on thick paper a very rough sketch of the design. He proceeded to count the yarns and tie them firmly according to this pattern. When all the threads were tied, he took them off the loom and dyed them with the colors he had prepared, dried the yarns, cut the knots, and used this yarn for his weaving.

Men weave *cortes* and shawls from tie-dyed material in all the large centers where this work is a specialty. They also tie and dye the yarn for their work. Women weave the *ikat* textiles only in villages where the *palito* or hip-strap loom is still used, and where the output is simply for their personal use or trade within their own villages.

Tie-dyed textiles were so popular during early Colonial days that they were often used to dress the statues of the Christian saints (San Cristóbal Totonicapán, San Felipe, and Quezaltenango). Imported brocades, however, were used on the statues of the saints in larger churches.

Ikat work in its simplest form is disappearing, but very elaborate designs are being developed in the above-mentioned centers. The tie-dyed cotton yarn from these centers is traded all over the country, and less and less is being dyed elsewhere.

In Concepción Chirquirichapa I have seen a modification of this technique, namely, tie-dyeing yardgoods rather than yarn. It is used for the dark blue coats with white splashes worn by the officials of this town. Whether this represents an old custom or reflects foreign influence, I cannot say. The technique I saw consisted of firmly wrapping, at random, parts of the cloth with cotton thread and dipping it into indigo dye, which would not penetrate into the knots of cloth. I did not see any greasy substance applied to block out the design, as is the case with the true *batik* method practiced

in Indo-China, Siam, and other southern Asiatic countries. It was certainly used here, however, on gourds, pottery, string bags, and other fiber products in the past. Although I have not come across it on textiles in this country, I have been told that the *batik* technique is used. Neither have I seen textiles decorated by impressing color with clay stamps or cylinders as done by primitive peoples in other countries. That this technique was used in the past in Central America is attested by the many clay cylinders and stamps unearthed in archaeological excavations.

V

*

Looms

Tʜᴇʀᴇ ᴀʀᴇ ᴛᴡᴏ ᴅɪsᴛɪɴᴄᴛ ᴛʏᴘᴇs of loom used by the Indians to weave their textiles: the very primitive hip-strap loom, which dates from many centuries before the Spanish Conquest and is called *de palito* (of sticks), and a very simple foot loom similar to that which was introduced by the Spanish along with other textile machinery after the Conquest.

Tʜᴇ Hɪᴘ-Sᴛʀᴀᴘ Lᴏᴏᴍ

The hip-strap loom, from seventeen to twenty inches wide, is composed of two end-sticks between which the warp threads are strung. One end-stick is attached by a rope to a branch of a tree or to the rafters of the porch of the hut. The other stick is attached by ropes to a tumpline (*mecapal*). This, in turn, is passed around the waist or buttocks of the weaver, who thus holds the loom taut. This *mecapal* is a tumpline of hide like the tumplines used by men for carrying burdens (San Antonio Aguas Calientes), a wide strap woven of henequen rope (San Pedro Laguna), or a broad piece of

leather which is well tooled and embroidered with fancy stitches in colored threads (Mixco).

The hip-strap loom is suspended at an angle above the weaver to enable her to best utilize her strength when she pounds back the weft threads with her batten and, at the same time, to allow her to watch the placing of the pattern-filler yarns with which she makes the designs. I have seen this kind of loom hung perpendicularly against the wall of a hut, as are Navaho blanket looms, or from a branch of a tree and weighted with stones or an extra-heavy stick, as in European high-warp tapestry. It is on such looms as these latter that men weave wool blankets in remote mountain villages, where the output is solely for the immediate use of the weaver and his family. Men may also use hip-strap looms when weaving stiff belts, but even so, it is unusual to see a man handling a *palito* loom.

Prior to setting up her loom for a new piece, the weaver offers a prayer and lights candles on the household altar to her patron saint.[1] The weaver sits on a rush mat, a dry oxhide, a piece of cloth, or a small, broad log in front of the loom, either with her feet stretched straight out in front of her (Panchimalco, El Salvador), or with her feet tucked under her body in typical Indian posture (Comalapa, Guatemala).

The principal loom stick is a broad batten (*espada* or *peinador*) of very hard wood which is used to pound back the weft threads.[2]

[1] It is said that Ixchebelyax was the protector and deity of weavers, who rendered homage to her. Her worship originated in Mexico and was brought to Guatemala and El Salvador by some of the prehistoric migrations from the north.

[2] Some Indian names for the various sticks on their looms are given below. (See Lilly de Jongh Osborne, *Guatemala Textiles*, 41–42.)

	Santo Tomás Chichicastenango (Quiché)
large batten	*quemáb*
large stick	*tzuú*
medium stick	*tzulub*
small stick	*quixcal*
small batten	*tzup*
leather tumpline	*ekbequen*

	Rabinal (Quiché)
batten	*quemáb, tejedor*
round stick	*tzuú*
small round stick	*calab*

	Todos Santos (Mam)
spindle	*chup*

This batten, a highly cherished possession, is made by a carpenter, usually from oak or cedar. Whenever I have purchased a loom, I noticed that this particular stick was removed and another, new one substituted, unless I watched very carefully.

Some looms have only five, others as many as ten or twelve, sticks, among them a smaller batten. The heddle stick (*peinador* or *palo peine*) has threads wound around it to fasten it to the warp threads. Often a hollow bamboo cane or reed will do as well and is held in place at either end by a nail. The Indian likes to place dry seeds or pebbles in the hollow cane because she enjoys the pleasing rattle when she is working on the loom. It is also claimed that this rattle tells the husband where and how his wife is employed. A stretcher stick with pointed ends is also used by some weavers to keep the textile of uniform width.

Several small rods wound with colored cottons serve as shuttles. They may be bone (San Antonio Aguas Calientes), a twig, or a long steel instrument that is used as a brocading needle. (Brocading is more often done with the fingers than with a needle, however.) When not in use, the rods are placed upright beside the loom. An extra stick always lies just above the end-stick to hold the finished cloth, which is neatly folded as it is woven and covered to keep it clean.

With the exception of the batten, the loom sticks are usually made of *pinabete* (*Abies religiosa* [H.B.K.] Schl. & Cham.). In villages in the department of San Marcos, the hip-strap and foot looms require sticks of *palo huitzizil* (*Eugenia ateyermarkii* Standl.), a very hard wood from a tree which grows on the coast and is known

cotton thread	*k'im*
to spin	*cholom*
batten	*lacteg*

Other smaller sticks are called *elbad, cojmalson, chup,* and *tzuax.*

<div align="center">San Martín Jilotepeque (Pokomán)</div>

shuttle	*zcox*
smaller shuttle	*cuajchamop*
large round stick	*mut*
small batten	*chocoy*

[3] One of the *Bignoniaceae, matilisguate* is a tall tree, the wood of which is used for furniture (*Tabebuia pentaphylla* [L.] Hemsl.).

as *palo blanco* because the light wood resembles *matilisguate*.[3] The name, *huitzizil*, derives from the word for deer because its strong, flexible wood is used for bows and arrows for hunting deer in that section of the country.

The loom is much prized and is handed down in the family very literally as an heirloom. When not in use, it is wrapped in a clean *tzut* and put away among the rafters of the house. A new loom never seems to satisfy a good weaver as well as the worn sticks of an older one.

Children learn to weave on little looms when they are very young. While a small girl is being taught to weave, she is afraid of the large batten with which her mother or teacher chastises her whenever she makes a mistake in her work. When she becomes proficient, she is given her mother's loom or one of her own.

The narrower looms used for belts and sashes are almost duplicates of those used for wider textiles. The principal batten, however, is quite out of proportion to the size of the loom and the other sticks. It is heavy because the weft threads have to be pounded back forcefully to make a closely woven material.

The principal material used in belts, sashes, and head bands is cotton, with an admixture of silk or wool. The warp threads are always cotton in really good Indian weaving. The Izalco (El Salvador) belts and a few Panchimalco *tzutes* are woven on small hip-strap looms. These are the only places in El Salvador where the primitive hip-strap looms are still used for weaving belts and sashes.

Textiles woven on these simple looms last several years and stand untold washings in lake or river, but they take a long time to make. I have seen cloths that required all of six months to finish. Never will a self-respecting Indian wear a textile which has been hurriedly woven or sloppily finished. Such is reserved for trade.

Hip-strap looms are used for the weaving of *huipiles, tzutes, servilletas,* and other small cloths for personal and household use. Small numbers of *perrajes, cortes,* and men's garments are also woven on these looms in isolated villages.

I have seen another type of hip-strap loom used in San Luis Jilotepeque for the manufacture of the stiff, wide, red belts worn

by *ladinos*. One end-stick of this loom is a smooth stick about a yard and one-half long, which is firmly driven into the ground to hold the warp threads. The woman weaver attaches the other end of these threads fanwise to a horizontal stick about one-half yard long, which in turn is fastened to the tumpline around her waist. She sits at the prescribed length of the belt to be woven and thus holds the warp taut. The belt is rapidly woven in a plain weave without any designs. Instead of having a heddle, this loom has a large, high, wooden comb the width of the loom, which straddles the threads and separates them as the weaver works. This comb is a firm, unpolished piece of wood. It is quite large in comparison to the rest of this very simple loom, which has no other sticks but a batten and a thin shuttle stick wound with the red weft threads.

Still a third type of hip-strap loom is the tiny loom (*paquiote*) used for making the narrow strips that decorate ceremonial *huipiles* in Nabaj. I have seen a woman using one of these looms. For this exquisitely fine work the weaver used small pieces of wire or straightened hairpins for the eight parts of her loom and managed them most expertly.

Skilled weaving is expected of an Indian woman and is second only to skill in cookery as a prerequisite to marriage. Much thought and effort go into teaching a girl the way the textiles in her village are woven and decorated. A girl once told me that because her first attempts at this work did not suit her mother at all, an infusion of *hepazote* or *apazote* (*Chenopodium ambrosioides* L.) was given her for two days in succession, whereupon she became "intelligent" and was able to weave smoothly and expertly in the approved village technique. I was informed by the mother of a San Pedro Sacatepéquez (S.M.) girl, who had been spoken for in the approved village style, that she had not married after over one and one-half year's engagement, despite the wealth that her fiancé boasted in mules and his trade reputation, because the girl had not yet been able to master all the village weaving techniques. She was able to weave the simplest patterns (*trasquilado*), but she was slow in mastering the more complicated brocaded designs which are the pride of the village, so it would probably be another six months before she was ready for marriage.

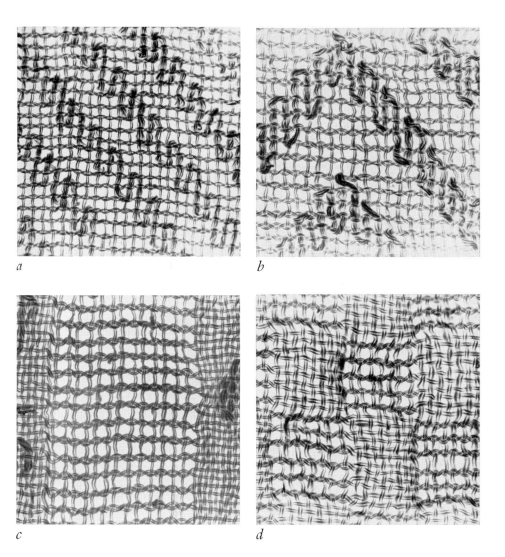

Plate 9. a, b, c, d. Fragments of textiles showing gauze technique from Cobán, Alta Verapaz.

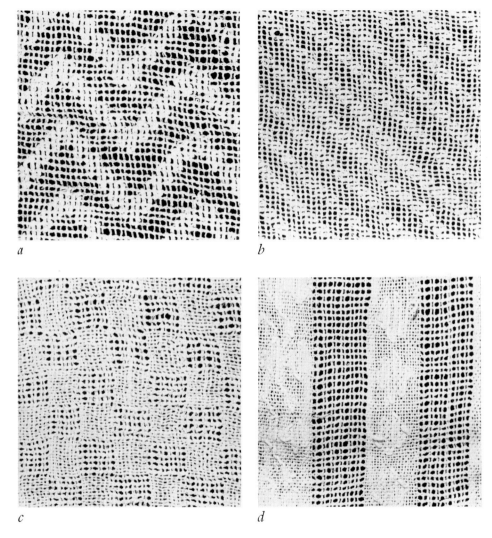

Plate 10. a, b, c, d. Fragments of textiles in leno weave, Cobán, Alta Verapaz.

a

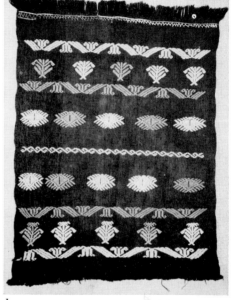

b

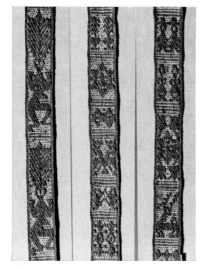

c

Plate 11. a. Huipil from Mixco
woven in lightning symbol. *b. Tzut*
from San Juan Ostuncalco showing
corn plants in rows two and eight.
c. Belt, Mixco, showing dancers, corn
plants, stars, eagle, and deer.

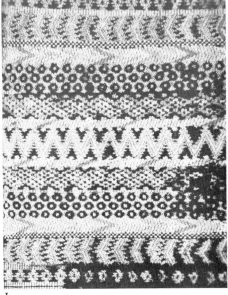

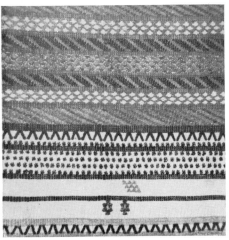

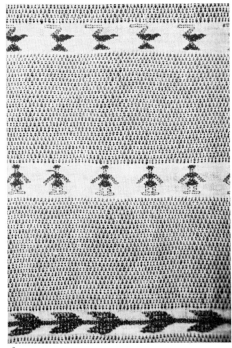

a

b

c

Plate 12. a. Ranciado hupil, Quezal-
tenango. b. Heavy brocaded huipil
San Martín Jilotepeque. c. Huipil
from San Martín Jilotepeque.
d. Huipil in leno weave, Cobán.

d

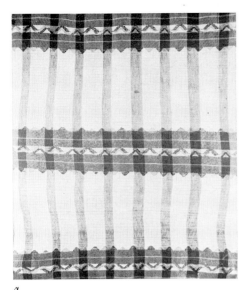

a

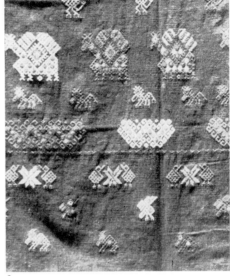

b

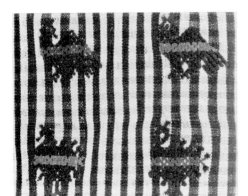

c

d

Plate 13. a. Rabinal textile. *b.* Ceremonial textile, San Pedro Sacatepéquez (G.). *c.* Textile from Santiago Sacatepéquez. *d.* Leno-weave textile from Alta Verapaz.

Plate 14. a. *Manta*, Palín b. Textile with brocaded middle section, Tactic. c. Ceremonial *tzut*, San Pedro Sacatepéquez (G.). d. *Tzut*, San Antonio Aguas Calientes. Note bicycles chasing deer.

b

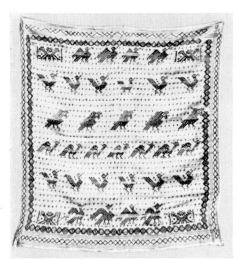

a

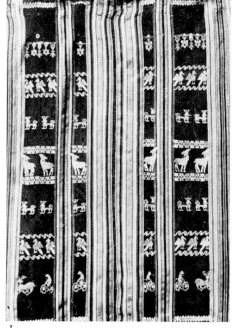

d

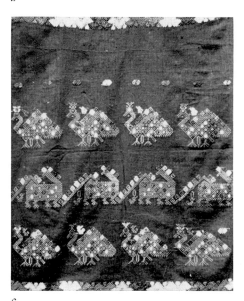

c

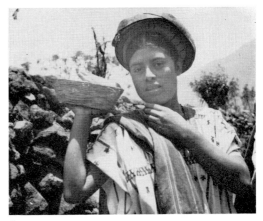

a

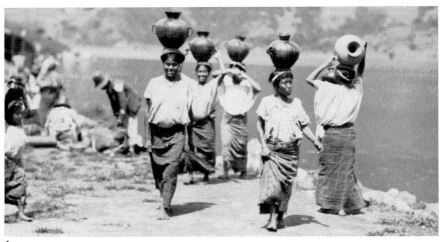

b

Plate 15. a. Woman from Santiago Atitlán wearing white *huipil* with red human figures. Inset around neck is red store-bought material simulating sun symbol. Headdress is a *cinta* many yards long, woven in San Miguel Totonicapán. The *perraje* on the girl's shoulder is of finely woven red cotton with darker red stripes.

b. Santiago Atitlán women carrying water from the lake in *tinajas*.

c. Girl from San Pedro Sacatepéquez (S.M.).

c

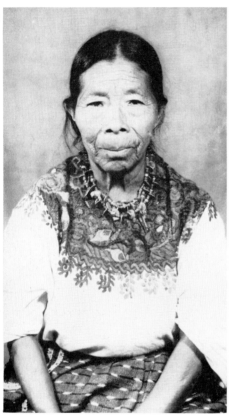

a

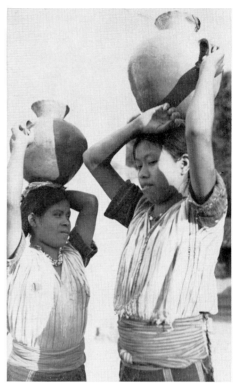

b

Plate 16. a. Woman from San Cristó-
bal Totonicapán wearing *huipil* with
heavily embroidered yoke. Note ap-
plied band of commercial tape on her
refajo. b. Girls from Cerro de Oro
on Lake Atitlán. This picture well
illustrates how garments are repeat-
edly mended. Note set-in sleeves.

The Foot Loom and Other Textile Machinery Introduced by the Spanish

The early Spanish Colonials brought with them as much as they could to make living easier for them so far from home. They could not bring enough clothing to last a lifetime, however, and a trip overseas took so long that the Spaniards imported machinery to expedite the spinning and weaving of textiles for their own use. Thus the foot loom was introduced in the seventeenth century. Although a very primitive machine, it speeded up production and enabled the Spaniards to develop textiles similar to those woven in Europe.

The most prominent men in Guatemala during the Colonial regime took pride in dressing in clothing made from textiles woven on the newly imported foot looms. Fray Domingo Carrascosa, a priest at the village of Cubulco, personally instructed the Indians of that region in weaving in the style, technique, and colors preferred by the Spaniards.

Toward the end of the seventeenth century, Don Antonio Porta y Costas imported a machine that simplified the tedious work of measuring spun cotton for the foot looms. Don Antonio called it a *medidor* (measure). Unfortunately all knowledge of this machine is gone, and I cannot describe it.

A spinning machine was also imported to facilitate textile production. It was introduced under the auspices of Don Martín Barrundia toward the end of the eighteenth century. A master craftsman, Domingo Ponce, was brought to the colony as an instructor in the use of the machine. Worked by both hand and foot and spinning thirty-six threads at one time, it was considered a great innovation. It was so large that no building in the city was big enough to house both the machine and a craft school.

The village of Pinula (now Santa Catarina Pinula, of which San José Pinula, though now larger, is a suburb) on the outskirts of Guatemala City, was the site of the first school of this sort in the kingdom—perhaps even the first in this part of Central America. The school, inaugurated in 1795, was called *El Colegio de Doncellas Hilanderas* (School of the Spinning Maidens). It must have

been much esteemed by the community, as prizes were offered for the best work produced by the girls. The first prize was won by a girl who spun 442 *varas* from one dram, or one-eighth ounce, of raw cotton. This was an occasion for great festivities. The girls took part in a parade from the spinning school to the *Casas Consistoriales* in Guatemala City, where the prizes were distributed. The girls and their companions were driven in coaches drawn by horses in silver trappings. Servants in gay livery carried large, heavy silver trays on which lay the prize-winning cotton. Regiments of soldiers in gala uniforms formed a guard on both sides of the city streets through which the cortege passed. Bands played triumphal music and flags were flown in honor of the occasion.

The old-style foot loom grew very popular. It is stated that the factory of Don Francisco Andorraegui in Antigua was famous for its five workshops where all kinds of materials were woven in great quantities. In good times much cloth of all kinds was exported to Mexico and Peru, which, as colonies, were not as advanced in the textile arts. By 1795 there were one thousand foot looms which produced two thousand yards a year of all kinds of material. Used in these textiles were fifty thousand pounds of spun cotton or eighty thousand pounds of raw cotton, grown on huge tracts of land where many Indian laborers were employed.[4] Fuentes y Guzmán mentions the enthusiasm with which the Indians accepted these foot looms and of how the five workshops in the capital turned out materials of excellent quality, *"panos, palmillas, rajas, jergas y jerguetes,"* materials that served for laborer's clothing.[5] Impressed labor was provided for these shops by assigning vagabonds, fugitive slaves, and thieves to work, and this occupation is said to have helped correct their disorderly inclinations. Fuentes y Guzmán goes on to say that by the end of the century weaving on these looms had degenerated because the government had ceased to offer assistance.

The pre-Jacquard foot loom (the Jacquard foot loom was not used by the Indians), the one so popular today, was brought to Guatemala by the *Sociedad Económica de Amigos de Guatemala* about 1796. The society was founded by Jacobo de Villaurrutia

[4] Batres, *La América Central ante la historia,* II, 118–384.
[5] *Recordación florida,* I, 151.

in 1795 for the purpose of developing the arts and crafts of this country. The society weathered many vicissitudes prior to its dissolution in 1884, and its work was most commendable.

Another Spanish introduction was the machinery for the production of linen cloth. Many interesting details of this machinery are given in one of the early newspapers,[6] together with precise instructions for planting, cultivating, and cleaning and spinning flax so that every part of the plant, residue as well as fiber, should be utilized. Drawings of the machinery were made by the Guatemalan artist, Garci-Aguirre, member of a famous eighteenth-century family of engravers. The Spaniards hoped to produce in Guatemala as good a quality of fiber as was grown in Asia, with which they wanted to compete. Linen textiles were popular and of excellent quality.

The economic depression that afflicted the Spanish colonies, especially the kingdom of Guatemala, at the beginning of the nineteenth century was the prime motivating force for the declaration of independence from Spain. With the depression the cultivation of flax ceased when its growth was banned in the colonies to protect home industries. World conditions in 1940 were responsible for its revival. Large tracts of land were then given over to the planting of flax in the vicinity of Quezaltenango. Now the popularity of flax has waned again, and it is not grown anywhere in Guatemala.

After the Colonial period ended, the *Sociedad Económica* continued to encourage crafts in Guatemala. Aided in its efforts by the government, it offered prizes in 1834 for the best native invention for spinning. The prize was won by Onofre Nájera, who received six ounces of gold for his invention of a complicated spinning machine.[7] The machine was designed to be set on a small bench, and it required the use of both hands and one foot. It may well have been the prototype of the mechanism for fiber spinning in Acatenango, later described.

There have been no further noteworthy mechanical devices introduced into the country as aids to textile production in the past hundred years, with the exception of the sewing machine. Nowadays

[6] *Gazetta de Guatemala,* July 15, 1799.
[7] Archivo Nacional, Guatemala City, B 80.2, *expediente* 22.781, *legajo* 1.075.

such machines, either hand or foot operated, are used by the Indians to make men's shirts and trousers, which are copied from European styles. The machines are also used for sewing hats. Sewing-machine stitches have taken the Indians' fancy and quite often garments made on hip-strap looms are decorated by hand with careful imitations of machine stitches (Sacapulas).

Guatemalan Foot Looms. In Guatemala the foot-power or drawlooms have undergone many modifications of design. In the outskirts of Guatemala City, foot looms are similar to the pre-Jacquard drawloom, well known in other countries. The farther one goes into the country, the more modified these looms become according to the ideas and talents of the individual carpenters. For example, I saw one where all the wooden sections were lashed together with different sizes of rope instead of nails or screws. Two or more logs were laid on the ground as foot treadles, according to the weaving peculiar to that section of the country (Tacaná). The textiles woven on some of these foot looms are artistic, durable, and as distinctive as the hip-strap products.

In Guatemala City, workshops or *talleres* are similar to those in El Salvador. The looms are mainly of the pre-Jacquard type, with hardly any changes, and are worked by *ladino* men. Cotton for these looms is bought already spun and dyed, with the exception of the dark-blue cotton, which is dyed on the premises.

For the foot looms only one cross (*cruz*) of the warp is needed, as compared to the multiple ones necessary for the hip-strap looms. Instead of the Jacquard method of placing designs in the material by punched cards, the workmen follow the finger-weaving method used on materials woven on the hip-strap looms and utilize short pattern-filler yarns in a brocade-like technique. For example, to imitate a Totonicapán *huipil* woven on the hip-strap loom and ornamented with rows of animals and humans throughout the material, the foot-loom weaver starts with ten pounds of cotton to make the two yards of this material which he can complete in a day's work. The figures are put in one by one with the fingers, in exactly the same manner as the women weavers do on the *palito* looms. On the other hand, the man weaving material with colored stripes running through the warp and weft forming squares can

weave as many as twelve to fifteen yards a day. On these looms can be copied even the most complicated *palito*-woven textiles. The majority of *cortes, perrajes, morgas* (skirt lengths of heavy, canvas-like cloth), *mangas* (wool blankets), *ponchos*, and wide textiles for *huipiles* are woven on them.

An interesting small variety of foot loom, lacking a batten, is a table-like affair with a small superstructure, the whole about five feet high. This loom is used for the weaving of the colorful and very intricate tapestry head ribbons. The man who uses this loom beats up the weft with his fingers. The warp threads, always well starched, are either cotton or well-cleaned and twisted fiber. The threads extend beyond the loom the required length for the ribbon and are fastened to a pole driven into the ground. The weft is three-quarters silk or rayon and one-quarter cotton or wool. The finest of these head ribbons are made in San Miguel Totonicapán, where many of these little foot looms can be found.

Weaving schools have been established in some of the larger towns such as Quezaltenango, Chiquimula de la Sierra and San Pedro Sacatepéquez (S.M.), where the pupils are taught to handle both types of loom. The teachers, though conscientious, lack artistic conception and understand nothing of the background of the old textile art. The products of these schools follow neither the traditions nor the artistry of the weaver of old and do not compare favorably with materials woven by individuals in their own villages or in specialized centers such as Totonicapán and Salcajá. In addition, aniline rather than natural dyes are used, and the resulting colors are harsh and garish.

An unusual machine-woven textile is made in the factory of Cantel (Quezaltenango), where the weavers are predominantly women. Known all over the country as *manta de Cantel*, it is a hardy, cream-colored textile that washes a nice, clean white. The white *manta de Cantel* is in enormous demand among the Indians for men's under-trousers and shirts, for women's *huipiles* in the villages where these garments are embroidered and appliquéd on a white background, and where the women no longer weave their own textiles (San Andrés Xecul and Chicalajá). This factory also produces colored material, but it is little used by Indians and so need not be further mentioned

here except to note that occasionally a square may be used to cover a basket or carry a baby (San Francisco El Alto). It is estimated that 50 per cent of the factory's output is sold to Indians, as is also a good part of the white cotton thread spun there.

About half the cotton used in this factory is native grown, coming from the region of Retalhuleu and Mazatenango. The rest is imported. Native cotton staple is three-quarters of an inch long, while that imported from the United States is shorter. The dyes are imported also, formerly exclusively from Europe but now from the United States. The average amount of cotton used is 250–300 bales (averaging 500 pounds each) of cotton a month. The machinery, with 1,500 spindles, is of British manufacture.

Despite the introduction of mechanical aids to spinning and weaving, the Guatemalan Indians continue to do much of their weaving on their narrow hip-strap looms and produce textiles that are far superior to foot-loom materials in technique and color, as well as decoration.

Salvadorean Foot Looms. Foot looms are rapidly replacing hip-strap looms in El Salvador. Only an occasional woman in some remote Indian village may still weave her textiles on a *palito* loom.

Foot looms (*telares*) are worked by *ladino* men (in El Salvador three-quarters Pipil Indian and one-quarter other races). Workshops (*talleres*) often employ several men. An enormous trade is carried on in textiles that are woven on these looms, but the variety is not large, and the color schemes are inferior to the Guatemalan-made materials.

The cotton is bought in strands (*madejas*) and bargained for by the pound. Generally it is already dyed in the colors most in demand; however, some is dyed locally. For two packages (*paquetes*) of white cotton yarn as it is bought in the market, the following quantities of aniline dye are required: three ounces for yellow, four ounces for dark blue, six ounces for bright red and black. In those districts where the cultivation of indigo was once a prominent part of agriculture, an occasional dyer still uses the genuine indigo extract for his basic dark blue.

White cotton receives many poundings (*aporrear*) on the stones at the side of a stream to make it flexible, and all cotton is given a bath

of starch (*enchilatar*). When the textile is to be of a better quality, the starch is finely ground rice flour (*chilate de harina de arroz*); otherwise it is made of wheat flour (*chilate de harina*).

The Salvadorean reel (*debanadera*), similar to those used in all the Indian villages in Guatemala, varies somewhat in design from village to village. From this reel the cotton is wound by a large wooden wheel (*torno*) onto a spindle (*cañón*) which fits into a groove (*malacate*) at the side of the table to which the *torno* is affixed. When the cotton is wound on the *cañón*, it makes a neat, fat bundle. Custom requires ten hanks of cotton for each spindle, so that eighteen spindles weigh ten pounds (this is a fixed trade measure in the textile *talleres*). The spindles are then fitted into a frame (*trascañadera*) large enough to hold several of them. When this frame is full, the cotton is wound on the warping frame (*urdidor*), the colored threads placed according to the desired design of the warp of the material.

Textiles here are not always of the fine quality produced by Guatemalan Indians, who take great care in coloring and weaving cotton. Neither are they decorated with designs of colored pattern-filler yarns laid in with the fingers, as in Guatemala.

Textiles made in El Salvador are not produced for the Indians per se, as few remain who wear tribal dress. Foot-loom products are for clothing worn by the *ladinos* and are made in regular workshops, as in the suburbs of San Salvador, San Rafael, and Suchitoto. In addition to materials for clothing, the *talleres* also produce materials for household "linens." An occasional skirt length is woven for the wide *enagüillas* (skirts) worn in Panchimalco or Nahuizalco. In Izalco and a handful of isolated villages, a few of the Indian women still wear *refajos*, but the material for these skirts has been made in Guatemala and purchased in El Salvador at the yearly fairs or from traders who travel from village to village.

VI

*

Weaving

S EVERAL TYPES OF WEAVE are found in Indian textiles. Each village has its own characteristic weave which is used in all its principal textiles, including those made for trade, and whether woven on hip-strap or foot looms.

The Indians are familiar with the three principles of weaving: (1) *shedding*, or raising the warp threads as needed; (2) *picking*, or throwing across filling threads or yarns; and (3) *battening*, or driving up the filling. They developed on their simple hip-strap looms all the common weaving techniques except double cloth and satin and further enhanced the beauty of their work by incorporating thereon stripes and bands, dots, loops, and figures in a method peculiarly their own called finger-weaving.

The term "finger-weaving" admirably describes a technique which is also called "laid in" or "picked up" by hand (known in Guatemala as *pepenado*, derived from *pepenar*, a Spanish word used as a colloquialism in northern Central America which means "to pick up"). All the fingers are used to insert, lift, or pull out loosely

the pattern-filler yarns of the design. Early historians commented with interest on the process of incorporating the designs in the textiles while the material was being woven.

The weavers of San Antonio Aguas Calientes are expert at incorporating designs by this method. An old *huipil* with its broad designs, each a mosaic of various techniques, was a true work of art. Today these people are no longer able to name the designs they put in these horizontal stripes; no doubt they no longer know.

A brief description of the terms used in commercial weaving will serve to identify Indian textiles, although it must be kept in mind that the Indian technique is not always strictly comparable to the techniques described by these terms as we use them.

Each element of a thread or yarn is called a "ply." These plies may be used singly, or two or more of them may be twisted together to form a plied "yarn." The "warp" threads are the yarns which are strung from the warp beam to the cloth beam of a loom, thus running lengthwise through the fabric. Those yarns which cross the warp threads from selvage to selvage are called the "weft." They are also called "filler yarns." When the weft yarns are used to fill in the designs, they are herein called "pattern-filler" yarns.

The yarn used at the present time for Indian textiles can be classified as homespun, commercial cotton, or spool yarn. Homespun, of either loosely or tightly twisted threads, is composed of one or more plies. Commercial cotton is bought in hanks (imported in colors or plain white) with the plies twisted loosely or not at all and used in groups of two or more to give the appearance of a coarse yarn. Spool yarn (*hilo de carrizo*) has two or more plies.

The older Guatemalan handspun yarns are much more tightly twisted than those made today. This is especially true of *cuyuscate*, the natural brown cotton, whose fibers are getting shorter because this plant has been allowed to degenerate.

Spool yarn was, and still is, preferred for the finest weaving. Years ago, when first imported, it was used for men's ceremonial belts (Quezaltenango). Spool cotton, preferably the coarse or lower numbers, is dyed with the precious *Purpura patula* L. & Lam. (*morado de carrizo*) when homespun cotton (*morado criollo*) is not available.

63

The designs with which the Indians decorate their textiles are made with extra weft yarns inserted by hand using small wooden or bone shuttles or long, thin needle-like metal rods on which the colored yarns are wound.

There are three principal ground cloths made by the Indians: plain, canvas or duck, and basket. Other types of weave, such as rep, twill, and gauze are made by the Indian weavers for specific purposes or garments, but the three foundation weaves are used for basic textiles and are the bases for embroidery and other trimmings. A brief description of the types of cloth woven by the Guatemalan Indians will serve to acquaint the reader with the techniques as the Indians know them.

Plain Cloth. Heavy cotton textiles are made with this basic weave of over one and under one yarn. An excellent example of a very heavy cloth made in plain weave with a coarse, handspun single-ply yarn can be found in the white Chajul *huipiles.* Heavy textiles are preferred for the majority of men's ceremonial garments. In these, from Chajul, both the warp and weft yarns are large and give the appearance of double cloth construction. Of course this is not actually so, for such a technique is not known to Guatemalan weavers.

The manufacture of very heavy, thick material is a survival from pre-Columbian times, probably the reason why it is used for ceremonial clothing. Fuentes y Guzmán states that the women belonging to the Cakchiquel nobility did not weave wide textiles with very fine cotton for both the warp and weft yarns as did the Indians from other sections of the country.[1] These Indians used coarser cotton to give the material a thick, heavy appearance. They decorated their textiles with feathers or designs made in *chuchumite* colors.

Canvas or Duck. In canvas weave the warp yarns are handled in pairs, two up and two down, crossed by a single filler yarn or sometimes by two yarns which are used as one.

Basket. Groups of two or three yarns are used as one in both the warp and the weft in basket weave.

[1] *Recordación florida,* II, 147.

Rep. Rep is the name given a plain weave with either a warp or a weft surface, achieved by the filler being beaten up so close that the warp is entirely covered (weft surface), or the warp yarns placed so close together that they cover the filler yarns (warp surface). Most of the Guatemalan textiles show a warp surface. Many have filler and cord warp surfaces like the commercial reps but are made up of two yarns each way, producing either a filler or warp cord.

The wide red bands of Comalapa *huipiles,* the red stripes on trousers and *huipiles* from Todos Santos, *huipiles* from Acatenango, ceremonial textiles and coats from San Juan Sacatepéquez, and some textiles from Santa María Cauqué are examples of well-defined rep. Sashes and belts from many villages are made in rep weave, the result of close weaving and hard battening. So also are the very fine bands woven in purple untwisted silk for the neck finish of the ceremonial *huipiles* in Nebaj.

Twill. In a twill the filler yarns pass over one and under three warp threads, for example, and on the next row, over two and under three, so that the intersection of warp and weft produces a diagonal rib across the cloth. If the warp and filler yarns are the same number per inch, the twill lines are at an angle of 45 degrees. Satins and sateens are close to twill construction but are patternless. Satins differ from twills in having the warp threads raised or depressed separately but not successively. In satin the bulk of the warp, and in sateen the bulk of the weft, is on the face of the fabric.

Twill and ribbed weaves are almost as common as basket and plain. A good example of twill can be found in the textiles of Concepción Chiquirichapa, which have twill stripes alternating with the embroidered, decorative stripes. The wool *rodilleras* from Sololá and Chichicastenango are made by this technique, as are the stripes on the San Juan Ostuncalco textiles, the wool *ponchitos* often worn instead of a *refajo* by the women in Santiago Sacatepéquez, and a great many of the stripes that separate the thick brocaded lines on most of the *huipil* textiles woven in San Pedro Sacatepéquez (S.M.). Here the twill diagonals vary from 10 to 15 degrees to 4c degrees. Some are all made on the same threading, but the filler yarns, which

are silk and cotton and of a different thickness, make the angle of the diagonal vary. Another example of twill is seen in the purple stripes that cross *huipiles* from San Pedro Sacatepéquez (S.M.).

In Quezaltenango the *huipiles ranciado,* with tie-dyed stripes or bands, now mostly woven on foot looms for trade, are twilled in some of the horizontal bands at a 25-degree angle. The *servilletas* from the village of San Raimundo are twilled in the dark stripes of red or blue with a shot or two of black. The twill is in a 25- or 20-degree angle, filler way. The *refajo* material from San Sebastián, woven on hip-strap looms, is also a twill. The old-style ceremonial *huipiles* from San Pedro Sacatepéquez (S.M.) have a steep twill for the background. Some stripes on the *perrajes* of Patzún are in a twill technique, as are also the black and white woolen textiles from Tacaná. The latter are made on very simple foot looms and have a twill angle of 45 degrees.

Textiles with ribbed surfaces, especially sashes (Jacaltenango), are numerous. The *tzutes* from Cerro de Oro (Colonía de San Andrés) have the ribbing running from selvage to selvage, as do some Colotenango textiles, and might be compared to the wide wale pique or cotton Bedford cloth made commercially which is now made warp way instead of from selvage to selvage. Textiles, mostly trade articles, woven in San Francisco El Alto, are also ribbed like Bedford cloth.

Gauze. In gauze weave an openwork effect is obtained by crossing pairs of warp yarns between each two filler yarns, thus making the fabric exceedingly firm lengthwise. This technique was known in pre-Columbian times, both in Central America and farther south in Peru. *Leno* is the elementary gauze combined with plain weave. *Fancy gauze* includes gauzes combined with other weaves, such as brocade, twill, or satin.

Alta Verapaz (not Cobán, though generally the weaving of this region is attributed to it) is well known for two varieties of gauze. Here single-ply yarns are used to produce fine textiles following techniques known in this region since pre-Columbian times. Most of the gauze and leno techniques, as well as both thin and heavy cotton brocades, are known and made here. Laid-in weave, a technique wherein the design is made back and forth by putting

groups of yarns into the shed with a filler yarn, is to be found in the white "shadow" *huipiles* worn by the older matrons in this region.

In some *huipil* textiles one still sees the very simple openwork technique that looks like mosquito netting. This is not made for coolness in the tropics, as at first I supposed, but rather dates back to the arrival of the Spanish friars in that region. Finding that many of the Indians they had been sent to convert were nude to the waist, the horrified friars promptly cut up some of their precious mosquito netting to make *huipiles* for the women.[2] True netting, as made by the Indian, is not woven on a loom. The loops are cast by hand or with small tools and made in imitation of fine gauze.

Some textiles with highly twisted yarns have a beautiful crepe texture. Old-style ceremonial textiles in Quezaltenango and those spectacular ceremonial trousers once worn in Almolonga are creped in a very marked way. The plain or basket foundation warp and filler yarns are crossed at stated intervals by twisted one-ply or, at the most, two-ply cotton, silk, rayon, or spool-thread filler yarns, heavily battened. The best crepe technique is seen in the very fine textiles woven in San Miguel Chicaj. *Huipiles* from Cerro de Oro are coarser, and the crepe effect is less obvious. San Juan Chimalco textiles also show a definite crepe weave.

Some textiles have a well-finished selvage at both ends as well as on the two warp edges. To achieve this effect, a short end is twisted around the warp thread and turned back into the same shed. Others are finished at both ends but four or five inches from the edge. To achieve this the weaver turns the loom and weaves back. This wide selvage is used as a petticoat extension under the *refajo* or to give strength where it is most needed.

In most Guatemalan weaving, if the pattern yarns are removed, a perfectly formed foundation cloth remains. The pattern yarns are so placed that they form extra fillers for the designs only and in no way affect the basic weave. The majority of designs are brocaded in variations special to each village.

The textiles from Palín illustrate well some of the techniques. The foundation material is elementary; either plain weave with

[2] Ximénez, *Historia de la Provincia de San Vicente*, II, 467.

tightly twisted homespun yarn, giving the older pieces the appearance of cotton crepe, or basket weave made from commercial, tightly twisted yarn. They are smooth and uninteresting, lacking the beautiful texture of the older pieces which is the result of the handspun yarn. Men's ceremonial *tzutes* have a weft surface or rep. Some of the modern textiles are woven with commercial yarn of one or more strands which are grouped rather than twisted together and do not have the appearance of crepe as do the older materials.

Tapestry. In tapestry, the weft threads are packed so closely that the warp does not show. They do not pass from selvage to selvage, but each color is used singly only as far across the warp as it is needed to form the pattern.

Phyllis Ackerman says, "The kindergarten child plaiting a mat is only a little short of weaving tapestry. The Navajo Indian manipulating thick woolen strands into blankets is often already practising the art. For tapestry is but two short steps removed from the simplest and most inevitable type of weaving. When one set of threads, the weft, is woven alternately in and out of another set of threads, the warp, as in darning stitch, the result is cloth. When the wefts are compacted so that they completely cover the warps, the first characteristic of tapestry is produced. When, instead of shooting these weft threads the full width of the loom, each color is passed back and forth only over the area where the pattern requires that color, the technique of tapestry is fully developed."[3]

Not all the Guatemalan textiles that appear so are true tapestry. The threads which form the pattern are not packed so closely as in the real tapestry technique, except in the Totonicapán head ribbons. All the warp threads are not totally covered by the filler design and filler background yarns because the weaving is not close and is not battened up as hard as it should be. Tapestry techniques used by the Indians also include the dovetailed technique, the stepped design, and the slit, whereby open spaces are left by the turning back of the weft yarns at stated intervals in the process of weaving. Some of the finest articles woven in tapestry-like technique are the heavy ceremonial headbands from Totonicapán. Rayon is now often substituted for the untwisted silk formerly used. The designs are

[3] *Tapestry, the Mirror of Civilization*, 303.

separated from the background by slits or open spaces that add to the beauty of these ribbons.

A tapestry technique is to be seen also on the Sacapulas ceremonial *huipiles* and on the very oldest *cofradía huipiles* from Almolonga. In addition the black blankets from Chichicastenango are banded in color at both ends using tapestry technique. Other woolen blankets from the highlands have figures done in what might be classified as a tapestry technique.

Brocade. The foundation for brocade can be practically any of the well-known weaves. The yarns forming the design are either extra warp or pattern-filler yarns. Brocade has the appearance of a simple form of embroidery, and it is sometimes difficult to determine one from the other. Brocading, however, is done while the weaving is on the loom instead of with a needle after the fabric is completed.[4] It resembles overshot weaving. Brocade may be single face or double face. The first is on only one side of the material and is made by picking up two warp yarns and floating over from three to eight to establish the desired pattern. In double-faced brocade, or overshot weaving, the floats (filler way) form the design on the right side, reverse, and appear on the underside. Most textile decoration is done by brocade in Guatemala.

The silk damask in brocatelle weave, used in Spain in the seventeenth century for church draperies, found its way to the colonies but did not influence Indian weaving at all.

The front sections of Tactic and Tamahú *huipiles* are good examples of heavy brocade, wherein the pattern-filler yarns skip from motif to motif on the underside of the cloth. The side pieces of San Pedro Carcha and Tucurú *huipiles* are specimens of thin brocade. Some Jacaltenango *huipiles* have alternating stripes of gauze and basket weaves, the former differing slightly in technique from the gauze made in Alta Verapaz.

San Antonio Aguas Calientes is known for the excellent quality of the weaving produced there. Colors are skillfully combined, and the placement of the pattern-filler yarns is varied on these textiles. They are never simple but have a marvelous brocaded appearance, especially the fine, old *huipiles*. The weavers employ

[4] See Mary Symonds and Louisa Preece, *Needlework Through the Ages,* 108.

more than one heddle and batten the weft firmly. They weave their designs into the cloth while it is on the loom, using a separate thin bone needle for each color and inserting the yarns with their fingers.

A technique similar to that used for velvet is employed for the designs on *huipiles* in Chichicastenango. The pattern-filler yarns are inserted with the fingers in such a way that the surface of the design is raised above the foundation cloth. The loops are left uncut, giving the designs a smooth, thick pile.

As has been mentioned, most designs in Guatemalan textiles are brocaded. Among the most spectacular are those from Quezaltenango, San Pedro Sacatepéquez (G.), and San Pedro Sacatepéquez (S.M.). The many handsome belts made in various parts of the country are also decorated by brocade, particularly the belts worn by the women of Nahualá, where fine brocading is done on all textiles. The foundation cloth of these belts is a warp surface rep of red and white cotton with filler (weft) cords in silk multicolored floss. The extra pattern-filler yarns pass under two top warp yarns (that is, on the right or design side) and over a varying number (from three to eight) of warp yarns sufficiently regular to form a filling rep and a warp cord in a design which is in contrast to the foundation.

The beautiful, heavy Quezaltenango textiles have a foundation cloth either of plain or basket weave with two warp and two weft yarns. The pattern yarns of cotton, silk, or rayon are large, whether the material is woven on hip-strap or foot looms. Finger weaving is supplemented by a stick wound with the colored pattern-filler yarns that are woven from one selvage to the other to form the design. Almolonga textiles have thick brocaded designs, as do also those from Alta Verapaz already mentioned. In Chiché, textiles are brocaded very effectively in rayon or silk against a plain dark background. Some *huipiles* in San Martín Jilotepeque have a handsome design heavily brocaded in many-colored silks that stands out from the dark background.

The lovely brocaded effects in the San Pedro Sacatepéquez (S.M.) *huipiles* can be classified in three groups: (1) The heavy, thick *huipiles*, which are the pride of the village, are a true brocade, with the pattern-filler yarns forming a double-faced design. The brocaded pattern continues in the cloth below the colored figures

in a monotone of white threads or of white and one subdued color. This is characteristic of the best *huipiles* worn by the *principales* of this village. (2) A kind of textile, now almost never seen, which resembles a figured twill called "bird's-eye" might really be classified as either a single- or double-faced brocade. These textiles are known as *acolchonados* (padded-like). (3) The *huipiles* known as *trasquilados* (shorn) have either a white or blue background and either yellow and lavender or multicolored decorations. This is a favorite decoration for present-day *huipiles* since it does not require much silk for the filling threads.

The San José Nacahuil *huipiles* carry designs made by two to four pattern-filler yarns which are grouped and used as one thick yarn. This gives depth to the brocaded figures, so that they stand above the foundation cloth. The animal designs in particular are treated this way. These designs brocaded in low relief may also be seen on the textiles from San Pedro Chuarrancho and San Pedro Ayampuj.

A simple effect achieved by contrasting colors is found on the belts from Totonicapán, San Antonio Sacatepéquez, and San Pedro Sacatepéquez (S.M.). A border of varying width in a solid color is left along the sides. Filler yarns are combined with warp yarns to give a warp and filler figuring used together. The same technique is repeated in a rough, careless way in Izalco (El Salvador) women's belts.

A very startling and effective combination appears on the yoke of Colotenango *huipiles* done with red pattern-filler yarns inserted together with the white filler yarns for a certain space and then left to hang loose. When the weaving is concluded, the loose red yarns are taken up, one by one, and worked into the cloth with a thick needle to complete the design in a simple needlework pattern.

The demands for textiles as well as the appreciation and consciousness of the value of time for other activities (agriculture, trading, household work as maids in the towns) have produced a centralization of the weaving craft. Understandably, villages in which similar weaving techniques were formerly used now buy their materials from one of the weaving centers where like techniques are

utilized. These centers are San Pedro Sacatepéquez (G.), San Pedro Sacatepéquez (S.M.), Quezaltenango, San Martín Jilotepeque, and Tactic.

The expert weavers of the weaving centers follow samplers with the color designs and principal symbols of the villages from which they draw their customers. These samplers are either a short piece of cloth with the design woven in the required technique or a woven cloth with an embroidered design which resembles our European needlework samplers, evidently the result of teaching in mission and other schools. The customer chooses from the sampler (*marcador*) the designs that belong to her community.

Indians of certain centers famed for hip-strap-loom textiles trade their articles far and wide, but the trade textiles are never of first quality. The symbols necessary for textiles woven for village use are incomplete on these trade items. The colors are not identical, the foundation cloth is seldom firm, and the garments may even not be constructed in the same way. For example, Quezaltenango *huipiles*, characteristically made in three sections, when sold to the women of Mixco as trade goods are made of only two pieces of material.

The output from San Pedro Sacatepéquez (G.) has influenced the textiles of neighboring villages such as San Lucas Sacatepéquez, Santiago Sacatepéquez, San José Nacahuil, San Pedro Chuarrancho, and Santo Domingo Xenacoj. The San Pedro Sacatepéquez (S.M.) and Quezaltenango trade pieces are now worn all over the country (San Antonio Sacatepéquez, San Juan Ostuncalco, and Mixco) where weaving has become a lost art or where it is reserved for special ceremonial textiles. The first group are not as often seen as the latter, though they are quite as popular and considered the de luxe textiles by the Indian traders because of their higher prices, due in part to the quantity of silk (today rayon) used in them.

In San Pedro Sacatepéquez (G.) the weaving is close and firm; the yarns are large and the thread count is low (though still above the average for the same kind of homespun material). The foundation weave for these textiles is basket, usually three-over-three yarns. For the earlier ceremonial *huipiles*, large warp and weft yarns were

placed at intervals of one inch to form squares in the foundation cloth. Heavy pattern yarns that give the effect of depth to the design are used for distinctive, brocaded animal figures on these textiles. Handspun and twisted yarn in several plies is still used for these patterns. This is also the place where textiles are still woven with handspun cotton which, intentionally or carelessly, is not spun evenly and is lumpy at intervals along the thread, giving an attractive nubbly appearance to the foundation cloth.

Here are also *chivos* woven (materials with loops from selvage to selvage). The foundation weave is either basket or plain. There are two methods by which the weaver can make the loops. By the first, she finishes the whole cloth and then with a large needle (*capotera*) inserts the colored pattern yarns, looping them up with her fingers at given intervals. By the second, she inserts the colored threads as she weaves, four pattern yarns between each loop and usually eight rows of filler yarns between the colored pattern yarn. For either method she must have a thick, three-inch-long needle for the colored patterns. The large loops may be left uncut, or cut with the double ends twisted around each other. The latter technique is used on ceremonial textiles and gives a much neater appearance to the finished product.

The *huipiles* from San Martín Jilotepeque, Chimaltenango, and Itzapa are interestingly decorated with small dots. The dots are very characteristic of these textiles and make them unique from those of other villages. For example, a San Martín *huipil*, though much coarser, resembles at first glance one from San Antonio Aguas Calientes but is unquestionably distinguished by the dots. The dots are achieved by extra colored pattern yarn being inserted under and over three different filler yarns and then cut off short on the right side of the textile. The dot is thus made by three distinctive shots and forms a tiny cross of the foundation warp yarns, two of these to each arm of the cross with the dot in the center.

Trade modernization was evident in a San Martín Jilotepeque *huipil* that I came across recently. It had all the appearances of a textile from this place, including the dots that in the hip-strap loomed materials are made by short pattern yarns. In this instance,

however, the dots were made by weft yarns running from selvage to selvage, the technique devised for insertion of dots on materials woven on foot looms.

Another example of changes in technique to give the appearance of old-fashioned textiles is to be found in a brocaded textile woven to simulate Quezaltenango *huipiles* sold in Mixco. Since purple yarn is both scarce and expensive, the foot-loom weavers have combined red and blue untwisted pattern-filler yarns to achieve the same effect. The result is not, however, as good as the old Quezaltenango fabrics woven on hip-strap looms.

The foundation weaves, then, of at least 90 per cent of the Guatemalan textiles are simple. What distinguishes them from materials of other countries are the designs and their placement, the cleverness with which colors are combined to give pleasing effects, as well as the quality and texture of the finished products. The Indians excel in the weaving craft. Special villages in the departments of Alta and Baja Verapaz are outstanding for their diversity of techniques: San Juan Chamelco for crepe weave; San Pedro Carchá for leno weave in alternating bands of brocade and gauze or in alternate squares; Tactic for thick brocade in many colors; and Cobán for shadow-gauze *huipiles* with collar and sleeves trimmed with embroidered squares and dots in colored silks or rayons.

Many textiles today, in spite of their lovely appearance, are not woven using traditional techniques. The warp threads are thin, small, and weak, and the filler yarns vary from two to several grouped yarns, making a very poorly balanced cloth. This is also true when grouped, not twisted, yarns are used to give the appearance of the former twisted yarns that appeared at stated intervals to form squares in both warp and weft. In other words, the thread count is not correct. There is, however, no standard number of threads to the square inch which can be used as a criterion of excellence, for individuality is the outstanding feature of Guatemalan textiles.

VII

*

Embroidery and Trimmings

AFTER THE WEAVING IS FINISHED and the material taken off the loom, Indian textiles may receive further embellishment by a variety of means. One of these is embroidery; another, the addition of appliquéd bits of colored cloth or ribbons; a third, the application of black wool braid and other commercially made trimmings; and finally buttons and snaps, used rather as decoration than functionally.

Cotton or silk threads are used in Indian embroidery. The design is usually drawn first on the cloth with a chicken quill dipped in the juice of *sacatinta* (indigo), and the cloth is then sewn into a wooden frame or the top of a round basket.

The only kind of embroidery stitch not commonly used by an Indian embroiderer is the canvas stitch. For example, the four main groups of stitches—flat, looped, chained, and knotted—are represented by satin, buttonhole and chain stitches, and French knots. Composite stitches are used as well as drawn-fabric stitches, insertion stitches, darning, and couching. In addition, the Indian does applied embroidery or appliqué.

Among the beautiful examples of embroidery are the handsome designs made by closely set French knots in San Cristóbal Totonicapán. Embroidery is done on the *huipiles* decorated with a round yoke in San Cristóbal Totonicapán, San Andrés Xecul, Joyabaj, Sumpango, Chicalajá, and one kind of *huipil* from Nebaj. (These villages as well as Olintepeque are the centers for such work.) White *huipiles* from Cobán are trimmed around the sleeve opening and neck with embroidery in colored silk and done in satin stitch.

The Indians of the village of Magdalena, near Antigua, do superb, close, thick embroidery on their *tzutes*. The white store-bought material is completely covered, both back and front, with a mass of fine, daisy-like flowers, predominantly red but also yellow and lavender, executed in satin stitch. Not a fraction of an inch on the whole surface is bare of embroidery, and neither side shows a wrong way of the work. Only older and married women are privileged to wear such *tzutes*, the young girls being restricted to the wearing of a store-bought, flimsy silk *tzut* that they tie cornerwise around their hips. These Magdalenan *tzutes* are by far the most beautiful examples of this work in the whole country.

Equally handsome examples of embroidery are the gorgeous *huipiles* worn in San Miguel Totonicapán. Their surfaces are a mass of bright-colored silk. Among the flowers done in satin stitch are to be found a couple of quetzal birds, while the neck opening is finished by a wide circle with radiating points. In contrast to this elaborate work is the much simpler form of embroidery—the use of straight rows of back stitching to imitate machine stitching. It is used in many villages as a trimming (Cunen), for outlining neck openings (San Pedro Ayampuj), or designs (Chicalajá).

Chain stitch is used functionally as well as decoratively in some localities. In Quezaltenango the three sections of the *huipil* are held together by careful designs in chain stitch, as well as by a wide feather stitch (*plumilla*) which the older women prefer, and which, I was told, was the favorite in olden times. Chain stitch is used decoratively to fill in the textile designs in Santo Tomás Chichicastenango, where men do this work on their own garments as well as on the textiles that the women have woven. Chain stitch is used also

in Quezaltenango to trim the neck openings of *huipiles*. These embroidered areas may be part of the garment where the embroidery is heavy with fascinating floral and animal designs, or they may be separate collars, made for trade in San Pedro Sacatepéquez (S.M.). This round collar is now being made on separate lengths of silk or velvet with the floral design put in by machine or by hand in chain stitch. Such a collar constitutes a trade article, ready to be tacked on the *huipil*, replacing the old-style embroidery done directly on the textile itself. Another example of the decorative use of this stitch may be seen in the intricate floral design on the *refajos* from Izalco, El Salvador.

Various insertion stitches are used distinctively to join the sections of *refajos*, *tzutes*, and *huipiles*. These joins are known as *randas* and are one of the Spanish introductions, being of Moorish origin. Such an insertion stitch as is used in the *randa* is executed as follows.

To make a well-padded, broad *randa* the two pieces of cloth are first hemmed in the desired width of the *randa*. The woman holds the two pieces of cloth together in her left hand, while with her right hand she takes a needle with untwisted silk and passes it under one side of the edge of the hem, drawing it back through the top, through the middle again, where she gives it a backward twist, and under the opposite edge, bringing it out again at the top and drawing it toward the middle. Thus joining the two sides with a neat finish, she continues the whole length of the two edges of cloth.

The old-fashioned colors for the *randa* were red and yellow. The thread preferred is untwisted silk, but many are now made in mercerized or ordinary cotton in all colors of the rainbow. The colors are evenly combined, and when made in alternating, contrasting squares of color as in Quezaltenango, they are called *petatillo* (mat-style).

The placement as well as the width of a *randa* is significant. The latter characteristic is indicative of the village wherein the *randa* is made. Some examples of traditional placement of *randas* are as follows: (1) a cross formed by a vertical *randa* running up the back intersecting one going around the buttocks, (2) one which runs down the middle of the front of the skirt, and (3) a *randa* which encircles the bottom of the skirt just above the hem, as worn by

the Quezaltenango woman. A vertical line in the front joins this *randa* to the waist. The small extra piece in the back, most appropriately called *colita* (small tail), once signified tribal descent.

Narrower *randas* are used to join sections of *tzutes* (Santa María Chiquimula), but the simple insertion stitch described earlier is the one preferred for most of these joins. The existence of the *randa* indicates that the Indian woman has made a functional necessity serve the purpose of decoration.

Among embroideries must be included the work peculiar to the tiny and remote village of Estanzuela. Threads are drawn crosswise and lengthwise to form small openwork squares, which become the background for the design, which is carefully filled in by hand with a needle and rather coarse yarn in a darning stitch. The designs, geometric or floral, stand out from the openwork background and resemble filet drawnwork. Some of the better pieces whereon the design is wrought with finest thread are works of great artistry.

Many years ago, when I first visited that region, this drawnwork was done by *ladino* women to trim the white aprons they wore into town on Sundays, their market day. They carried their carefully folded aprons and shoes in baskets on their heads until they reached the outskirts of town where they donned their finery. They took it off again when leaving town for the long trek home.

I inquired why this work was only to be found in this one village in Guatemala. One of the oldest women replied that a great many years ago a Spanish nun had come to live among them for a while and had taught the women this work to help them support themselves in this arid, isolated spot. The wealthy Spanish colonists in Zacapa and Chiquimula de la Sierra were glad to purchase all that could be made.

Many Spanish orders sent nuns into the colonies in the sixteenth and seventeenth centuries. The preferred route of travel through the colonies was through Izabal and along the mountain trails near this village. Perhaps one of the nuns may have made her way to Estanzuela and while living there taught the women this handicraft she had learned in the convent across the seas. Whatever the source, the work is fine, intricate, and artistic. It is also unique,

inasmuch as this is the only place in Guatemala, and perhaps in Central America, where drawnwork is a major industry of a whole village.

Appliqué work is best represented by the round disks found on Chichicastenango *huipiles*, the red cotton peaks around the neck of the white *huipiles* from Aguacatán, and the rows of colored points forming the large yoke on *huipiles* from villages in the Cuchumatanes Mountains.

Ceremonial garments are decorated with a wealth of embroidery and appliqué. Ceremonial *huipiles* are sometimes finished at neck and sleeves with wide ruffles (*golas*), which have a lacelike edge made by hand with a needle and untwisted silk threads in many colors. The finished edge so resembles the lace made with pins on a cushion that only a person who has watched the Indians at work can tell the difference. *Golas* are also made of store-bought net. They are profusely darned with silk in bold patterns over the entire surface. I have been told that the net was formerly handmade in the old netting technique. Ceremonial trousers from Almolonga, trimmed with embroidery stitches and openwork, are further enhanced with tufted loops of colored threads. Ceremonial garments for men in Quezaltenango are finished off with bright red silk material. Store-bought lace trims ceremonial sashes in Concepción Chiquirichapa.

Wool braid is applied to both men's and women's clothing. Coats are trimmed with black wool braid in Sololá; *refajos* have colored wool braid around the edge in Mixco. Store-bought embroidery that is a favorite for trimming the white cotton trousers worn under ceremonial woolen split trousers in San Juan Sacatepéquez also trims *huipiles* from San Pedro Laguna. *Servilletas* have complicated fringes with knots tied at different angles. Ribbons finish the collars of men's shirts (Almolonga), adorn women's *huipiles* (Tecpán), and trim men's hats (Sololá). Bits of colored ribbon or cloth are also applied with simple embroidery stitches in Aguacatán. Spangles sewn on with colored silks ornament the large *capas* (capes) worn by the *alcaldes* from Mixco. Coins and small snaps trim some garments, the latter used by Indians who are too poor to acquire coins (Santo Tomás Chichicastenango).

79

Buttons are considered the trimming de luxe. They are put on not functionally, as we customarily use them, but decoratively in the most unexpected places; on trousers, shirts, belts, and bags with no other purpose than to be ornamental. Buttonholes are generally used for strings rather than buttons. Men's shirts which are cut to simulate foreign shirts are the only garments on which buttons are used functionally. Whenever I have purchased a bag, belt, or head ribbon, the button decorations were always cut off before I was allowed to handle them.

To be able to tell brocade and embroidery apart, that is to say, whether the design is incorporated during the weaving process or after the textile is off the loom, it is necessary to know the village where the weaving is done as well as the place where the costume is worn. Some of the embroidery designs are so well done that they have all the appearance of brocade, and vice versa. A weaver can usually tell which method of decoration was used by the appearance of the warp yarns on the underside. It is often remarked that most of the modern Indian textile designs are embroidered instead of brocaded by extra pattern-filler yarns, but this is not so. Indians are much more adept at weaving than at embroidering with a needle, and they therefore prefer what is for them an easier method.

VIII

*

Designs and Symbols Used in Textiles

I HAVE ALWAYS FOUND the designs used on Indian textiles pleasing. Whether they are woven into the cloth on the loom or applied after it is finished, they are outstanding for their charm and simplicity. Many of the designs are survivals of ancient symbolism and are still used in accordance with tradition, despite four centuries of foreign influence. These decorative designs are stylized representations of animals of all sorts, plants, insects, ancient gods, and, in addition, symbols which bespeak Spanish influence such as a cross. In addition to these symbolic representations many of the designs have covert meaning usually incomprehensible to the Western mind.

The Indian's values and history are so far removed from ours that what at first glance seems to us only a stylized symbol has a specific meaning for him that we cannot always comprehend. Moreover, no longer strictly limited by the standards of clan and tradition, he may copy anything that suits his fancy. In addition, his designs often take an apparently humorous turn—a barnyard fowl in an amusing attitude or a human figure in a grotesque posi-

tion. The techniques of creating designs on cloth necessitate angular rather than curvilinear outlines. Nevertheless the finished product has expression. Even a five-legged chicken has an element of appeal.

Quiché folklore accounts for the origin of designs in Guatemalan textiles. Two beautiful maidens were sent to tempt three deities, Balam Quitze, Balam Akab, and Mahucutah, who were known to bathe in a certain river. The maidens had been instructed to bring back some sign of their encounter to show the success of their mission. They met the three deities as planned and brought back three capes whereon each had stamped his sign: "the symbols of our being," the deities called them. Balam Quitze painted the figure of a jaguar on his cape, Balam Akab drew an eagle as his symbol, and Mahucutah used as his symbols bumblebees and wasps. The two maidens were given the capes with the words, "Here is proof of your conversation [with us]; take these before the lords. Say to them, 'In truth, Tohil has talked to us; here we bring the proof,' tell them, and have them dress themselves in the clothes which you will give them."[1]

A custom reminiscent of the same legend is observed in the river outside Huehuetenango. Whenever the older and married women bathe, they decorously keep on their *huipiles* and *refajos*. The young and unmarried girls, however, take off their *huipiles*, enacting the legend of the maidens who came to the river to tempt the deities in the beginning of Quiché history.

Post-Columbian influence is evident in textile decoration, first evinced during early Spanish colonization, when great quantities of Indian-made textiles were exported to Spain. As this phase of Colonial trade increased, gradually European-preferred designs were incorporated by the Indians in their weaving. This change was forced upon the Indians by the Spaniards, who sought to have emblems of significance to them used in place of those symbols which they considered pagan and unpleasant. It is characteristic of the Indian, however, that while these motifs meant one thing to the Europeans, they meant quite another to the Indian since he merely adapted his clan symbols to satisfy European tastes. Both sides were

[1] Adrián Recinos (translator), *Popul Vuh: The Sacred Book of the Ancient Quiché Maya*, 198.

pleased with the result: the Indians because their traditions had been maintained, the Spaniards because they felt their efforts had succeeded. A good example of this adaptation is the double-headed eagle, which meant Charles V to the Spaniard but a double-headed deity to the Indian. Another example is the cross, symbol of Christianity, which to the Indian represented the four corners of his corn-patch (*milpa*). Thus to European eyes, pagan symbolism had disappeared in the Indian textiles, but to Indian eyes, quite the contrary.

All textile designs originated as symbols that indicated clan, class, occupation, or status. Every small variation on a given pattern or its placement on a garment was once meaningful, although its former significance may not be known to the present-day weaver. No design is ever used merely for decoration. As far as traditional designs are concerned, there is a primary motif used in every village which is incorporated in every textile woven therein. This custom makes it possible to identify the source of any textile. What is more, the use of the motif is customarily varied according to the socio-economic class of the wearer for whom the garment is woven. One can place not only the village but also the weaver. The weavers of different villages do not use the same motifs, although occasionally we come across similar symbols used in two or more communities. In recent years, in some villages where weaving is done for trade, the weavers have not followed traditional patterns or placement of symbols, and the designs are not carefully incorporated in their textiles. Only textiles made by the older weavers for their own use have the correct number of tribal symbols (*cabal o completo*).

The simplest and perhaps the earliest design motif is the straight line, such as the dashes which the Lacandón Indians still draw on their clothing with the juice of red berries. Interestingly enough, the use of the straight line persists because weaving precludes the use of a curvilinear line. The individual motif may appear rounded, however, because of the close placement of short, straight lines. For example, one can describe a circle with short weft threads.

Individual design motifs are either geometric or representational in character. When representational, they may be forms occurring in nature, such as animals or plants or natural phenomena such as lightning, or they may represent mythical beings, such as the *nahual*

83

(the Indian's alter-ego) or *chacs* (gods of agriculture, wind, and rain). The motifs used in some villages are simple and fairly crude, whereas weavers in other villages produce beautiful and varied designs.

Although the design motifs are traditional in character, they are and have been subject to modification, both in general and in the hands of individual weavers. The two influences which have affected design in general are the modification of designs to satisfy the demands of the Spanish overlords and the latter-day production of materials for trade goods. As I have mentioned before, textiles produced for trade no longer follow traditional design either in respect to motif or the textile as a whole.

In the hands of individual weavers there are again two primary influences which modify design. The first is that of the age-old and widespread superstition that precludes the production of a perfect article; the second is the understandable desire of the artisan to sign his work.

A good example of modification of design to conform to the aforementioned superstition is a beautiful textile which I came across some years ago. Woven in the village of Chiché, its whole surface was covered with closely placed patterns in many well-blended colors of silk. In the midst of the brightest colors was a small area which was worked with white wool. I inquired the reason for this and was informed with great seriousness that no human being was supposed to produce a perfect piece of weaving, this being the privilege only of the gods. Did I not perceive how beautiful this large cloth was turning out? Would not the gods have been wrathful had not the weaver bethought herself in time to mar the surface? Gann and Thompson say, "Certain Oriental peoples have the belief that only the gods make anything perfect, and, therefore, it would be something approaching blasphemy for a human to produce anything without a flaw."[2] The late Mr. Gordon believed that the Maya had the same idea. This is in keeping with a similar explanation I received in respect to an unfinished area at the end of an otherwise perfect and beautifully woven textile. The weaver said she did

[2] Thomas Gann and J. Eric S. Thompson, *The History of the Maya from the Earliest Times to the Present Day,* 224.

84

not dare finish it completely because that would bring her bad luck. Such a superstition is not confined to Guatemalan Indians. "It is common in western American pottery and basketry for the most important structural line of the design to be left incomplete. It is said that this line represents life and that is left unjoined lest the maker end her own life in completing the pattern."[3]

Indian weavers who still use traditional patterns sign their work by means of their own particular modifications of the pattern. Such marks may vary from a couple of colored threads in a specific spot on the textile to the placement of small figures unrelated to the rest of the work.

A *huipil* from Comalapa was lying conspicuously on a chair when an Indian woman whom I know from that village came in to see me. She saw the *huipil* and immediately examined it, saying, "Señora, how did you get this? *Comadre*[4] María López never sells her work." I explained the matter to her satisfaction and inquired how she knew that María López had woven the *huipil*. She pointed to a small animal woven into the corner at the end of the *huipil*, saying that this was the mark which that woman put on every piece she made. The same thing happened when I showed a textile from San Antonio Aguas Calientes to a native of that village. She did not hesitate a moment before informing me, correctly, that *Comadre* Chón was the weaver of the piece.

The placement of design varies according to the village wherein the textile is made. On some textiles a few motifs are scattered at wide intervals, while other textiles will be covered with a mass of design. Trade goods, for example, are apt to be so covered with designs that it is hard to find a clan symbol. Textiles made for Indian use, however, tend to maintain traditional placement and design motifs. It is the pleasing traditional design of the motif or symbol and the textile as a whole which makes Guatemalan textiles so much in demand.

Designs are worked in silk, cotton and silk, rayon, and often

[3] Bunzel, in Franz Boaz (ed.), *General Anthropology*, 584.

[4] "*Comadre*" means godmother. When two matrons are very friendly, they often call each other "*comadre*" without necessarily being the godmother of the other's child by either baptism or the marriage ceremony. It is a term of familiar respect.

wool, on cotton backgrounds. Fuentes y Guzmán,[5] however, mentions a way of applying designs that has now entirely gone out of use but might well have been the original of appliqué work. Leaves of trees were carefully cut and placed on a pattern of perhaps a human figure, jaguar, or bird. The leaves were then sewed on the cloth with fiber, which outlined the figures and held them firmly. This trimming was used to decorate cloaks and other clothing of high-ranking dignitaries. The designs were carried out in different colors, and great pains were taken to select leaves that matched the natural tones of the figure. This ornamentation is said to have lasted for as long as two years, after which the fiber threads became worn and loosened.

Although hereinafter I describe one by one the symbols which appear on Indian textiles, several designs may appear on one garment. As an example of the numerous figures which may be included in one piece, let me describe the old belts from Totonicapán which have a multitude of little figures along their entire length.

Figures of Spanish soldiers, guns, and horsemen are juxtaposed to lightning (Hurakán), Indian temple mounds, a large hand, a deer (Mazat), two symbols representing light and darkness, a mat design (Pop), and others which I will not attempt to interpret. The large hand is surrounded by four small human figures and four dots, possibly indicating a numerical count.[6] Curiously, these belts resemble those worn by women on the Isthmus of Tehuantepec, Mexico. Similar belts from Totonicapán, though with fewer symbols, now appear in many other villages. Upon inquiry in some distant villages I was told that they were not the original village costume belts but that a weaver from Totonicapán had settled among them and taught them this technique (Tejutla).

Another old type of belt found in Mixco is shown in the illustration section. It is red on white, made with a technique whereby the patterns are achieved by the use of heavy versus light warps.

[5] Fuentes y Guzmán, *Recordación florida*, I, 240.

[6] The Mayan system of counting was based upon a unit of 20. Numbers from one to nine were written with a bar-and-dot notation, the dots standing for one, the bars for five. *Una mano*, a hand, represents five and is currently used as a unit of trade for small staples and fruit. Half a conventionalized flower is also used to indicate an open hand.

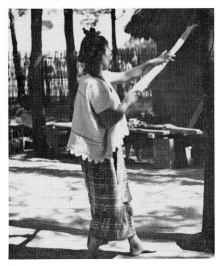

a

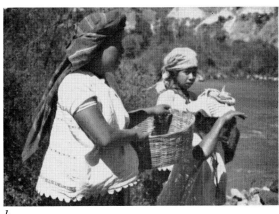

b

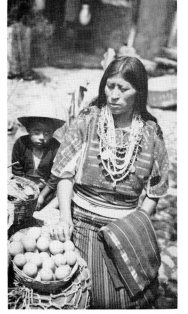

c

Plate 17. a. A Sacapulas woman makes candy.
b. Sacapulas women, whose *huipiles* are deco-
rated with needle stitching only on the back,
although the bottom edge is scalloped all the
way around. *c.* Market vendor from Santo
Tomás Chichicastenango wearing many
strings of *chachales*. Her basket of lemons
rests on a string *red*.

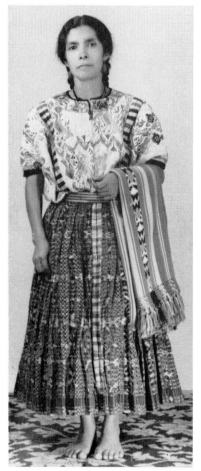

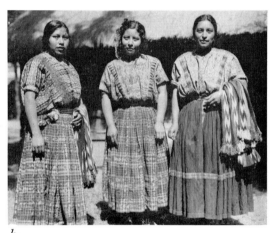

Plate 18. a, b. Indian women from Quezaltenango. Two styles of *refajo* are illustrated. Note broad *randas* on *huipiles*. *c.* Parade of Santa Cruz del Quiché maidens on occasion of presidential visit.

a

b

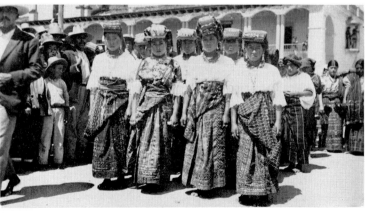

c

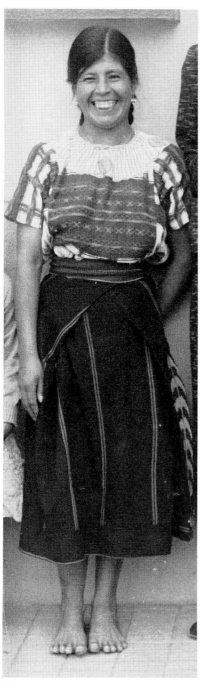

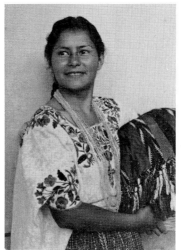

b

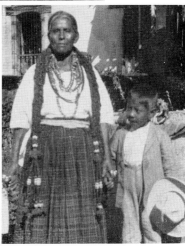

c

Plate 19. a. A Mam woman from Todos Santos (Cuchumatán). *b.* Young woman from Cobán whose shadow-weave textile is hand embroidered around neck and sleeves. She wears many silver chains. Her pleated *corte* is dark blue with white stripes. *c.* A matron from Cobán wears her hair in the red wool *tupui* (coral serpent) style, now out of fashion.

a

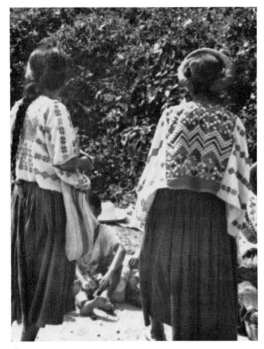

a

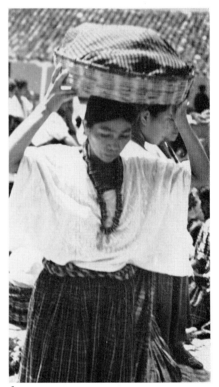

Plate 20. a. Women of Tucurú. *b.* An
Indian of Cobán wearing a shadow-
weave *huipil.*

b

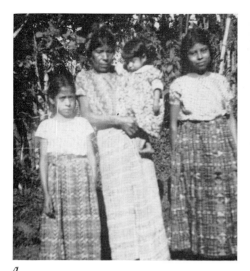

a

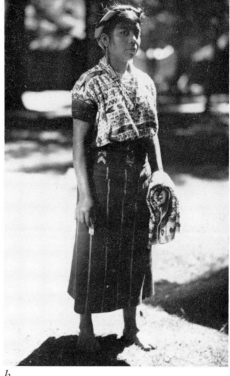

b

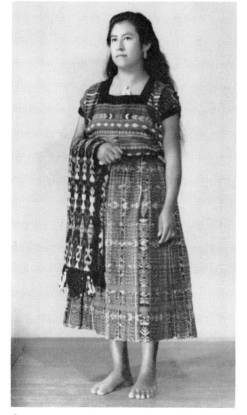

c

Plate 21. a. An example of costume transition in Rabinal. Older woman *(middle)* wears traditional village dress. Young woman *(right)* wears typical *huipil* but pleated skirt. The little girl *(left)* wears a *huipil* made from store-bought material; the baby a dress. *b.* A Palín woman wears earrings and necklaces. *c.* An Indian living in Guatemala City suburbs wears a San Martín Jilotepeque *huipil* and a Salcajá *refajo*. She carries a *perraje* made in tie-dyed technique from Mazatenango.

Plate 22. a. Men of Sololá keeping busy though seated. *b.* Women from Patzicía. Woman on left wears a *refajo* with a tie-dyed design. The little boy is dressed in the typical Cakchiquel wool *ponchito* worn only by males. *c.* Mixco girl wearing very wide wedding *huipil* from San Martín Jilotepeque. Note the fine weaving that can be done with tie-dyed thread in her *refajo*.

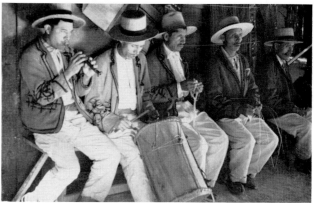

a

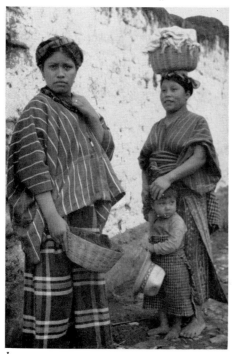

b

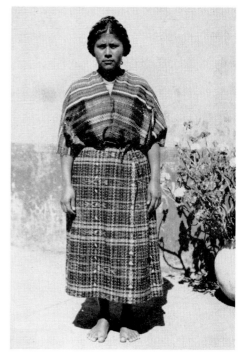

c

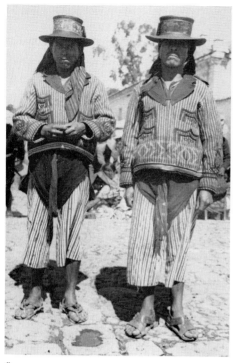

a

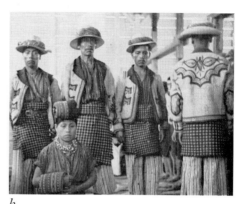

b

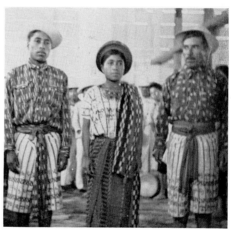

c

Plate 23. a. High-caste men from So-
lolá. Corn-plant symbol is woven into
lower edge of wool coat, and bat
(now called butterfly) on the pockets
is repeated on the back of the coat.
b. Men from Sololá wearing *pon-
chitos* instead of simulated loincloth,
as in *a. c.* Santiago Atitlán people,
the men wearing tie-dyed shirts.

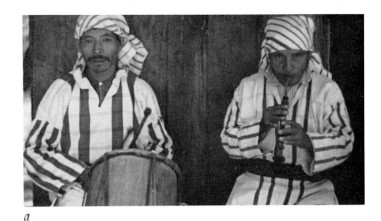

a

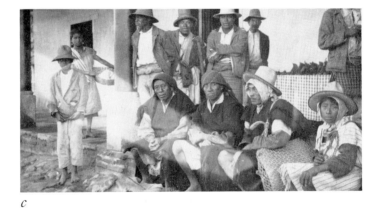

b

c

Plate 24. a. Chirimía players, Zunil. *b.* Men and woman
from Almolonga, Quezaltenango. *c.* Traders from San
Martín Sacatepéquez (Chile Verde).

Purpura-dyed threads are used along the margins. These belts were made in the town of Yalalag, Oaxaca, southeastern Mexico, and brought over the mountains to Guatemala yearly by traders.

The symbols which appear on this belt are both ancient and modern. The largest, shown in the left panel, are two figures dressed for the Feather Dance, a dance very popular in Yalalag but not known as such in Guatemala. The headpiece is a large, light frame of wood, trimmed with quetzal and cotinga feathers, the latter a soft blue. At the top of the middle panel two corn plants appear. Just below the corn is a six-pointed star, a symbol dating from the Colonial period and found now in Antigua on furnishings of that era. The fourth figure on the center panel is the double-headed eagle, here the ancient dual symbol, one side looking for good, the other, evil. At the top of the right panel are two dancers, conveying both ancient and Christian religious ideas. The fourth symbol from the top is a deer, representing the Great Deer Lord of ancient times. A Deer Dance is still performed in Yalalag at the beginning of the deer-hunting season.

In the following paragraphs the major design motifs used on Indian textiles and their placement are described. When it is known, the origin of these motifs is given.

The Plumed Serpent. Perhaps the most conspicuous and most frequently used symbol on Indian textiles made for personal use is the plumed serpent. It may be much embellished with scrolls and feathers; or as is more commonly used now, it may be a recurring inverted and horizontal S. However represented, the motif is obviously a representation of the esteemed and worshiped plumed serpent, the god Gucumatz.[7] The creator of the world out of darkness and silence, he was the most important Mayan deity and accordingly the deity most often represented in Mayan art.

[7] Gucumatz, Quetzalcóatl, or Kukulcán are the names by which the deity, the feathered serpent with the plumes of the quetzal bird, was known to the Maya, Aztec, and Quiché Indians. Quetzalcóatl was also said to have been a mythical half-deity, half-human chief who appeared to pre-Columbian people bringing them wisdom and the arts. The people did not benefit from his teachings, and he left them, promising to return. When the Spaniards arrived, the Indians, thinking their leader had come back to them, mistook Alvarado for their former chief, who had been as fair and light-skinned as Alvarado. The plumed serpent was a revered symbol also among the ancient tribes of Mexico. One of the prettiest legends in that country attributes to the plumed serpent a duality represented by the morning and evening stars.

87

This undulating symbol of the feathered serpent is prominent on belts from San José Nacahuil and the women's belts from Magdalena. Quezaltenango *huipiles* have two rows of the serpent design, banded above and below by rows of small birds resembling eagles or falcons and, in addition, two large bands of a recurring inverted and horizontal S. The large double S (one of which is reversed) on my *huipil* from San José Nacahuil forms a cartouche enclosing a pine tree. On Santo Domingo Xenacoj *huipiles* there are several of these symbols joined together in a wavy line over the shoulder (*serpenteado*). Ceremonial *ponchitos* and those worn by the upper-class, older men in most of the villages of the Cakchiquel area have a conventionalized serpent outlined in the openwork border.

The Scepter of the Plumed Serpent. The scepter of the plumed serpent, reminiscent of the Mayan period, is often incorporated on *cofradía* tablecloths in San Pedro Sacatepéquez (G.). It resembles the scepter held by the main figure on Stela 8 in the ruins of Naranjo and on various monuments in Palenque.

Gumatz. Similar in shape to the serpent symbol, though much smaller, is the figure of Gumatz, a caterpillar. Brought to my attention by a Quiché-speaking woman who called it *choconoy* (black worm), it is called *gusano* in Spanish. It is woven into textiles near the edge, indicating the textile's humble rank, as in the *huipiles* of San Pedro Sacatepéquez (G.).

The Sun. The sun symbol is of greatest importance, for it represents the dispenser of light and heat. It is interpreted also as "man." This life-giving symbol is conspicuously placed on both the men's and women's costumes, often in combination with a round disk representing the moon, indicative of the power of the sun over the phases of the moon.[8]

The sun symbol is used in some form on 80 per cent of the women's *huipiles*. The round hole for the neck represents the sun,

[8] In Chichicastenango the sun cult and the sun totem are still important to the Indians. There existed, until a few years ago, a group of men belonging to the highest caste who called themselves Priests of the Sun. I know that two generations ago in Quezaltenango the sun cult was firmly entrenched and its appropriate ceremonies were still conducted at corn-planting time. The Pipil Indians in Izalco (El Salvador) also refer to sun worship in their myths.

its rays made with colored stitches or bits of appliquéd material (Santa Eulalia and San Mateo Ixtatán). The appliqués of the latter village are further enhanced by being filled in with bright yellow thread. *Huipiles* from Nebaj, Chichicastenango, Patzún, and many other villages bear representations of the sun and moon disks in either their woven surface or the appliquéd trimmings.

The sun also appears prominently on the clothing of people from Chichicastenango. There is a round disk on the front of a costume of a Mayan dignitary on Stela 8 at Naranjo. In Mayan times a gold or jade plaque, the symbol is now outlined in colored silk or black ribbon on the men's coats and emphasized by a button or snap in the center. It appears as well on trouser flaps as a mark of age. The women of this town also display this symbol, outlined in embroidery on their *huipiles*. The sun symbol was outlined on a *huipil* which I saw in Tamahú in a manner reminiscent of ancient figures carved on stone. Its exact duplicate was shown on the front ends of a sash or *maxtli* (breechclout) depicted on a clay idol unearthed in a prehistoric site in this same region and now in the archaeological museum in Guatemala City. Other variations of the sun figure occur on textiles, one of which is the Maya glyph, Kin, the first of the series of heiroglyphs for the nine Mayan time periods.

The sun is also placed on *tzutes* and *servilletas* (San Mateo Ixtatán). *Cofradía* textiles have the round sun disk indicated by a face and decorations of flowers and birds, signifying the sun's power to bestow fertility. It is perhaps more than just coincidence that not far from this village are the ruins of Quen Santo,[9] where a large stone disk carved with a similar face was found in the mound called the House of the Sun. In Comalapa the sun symbol appears prominently on ceremonial textiles, its importance understandable when one knows that these people depend upon agriculture for their livelihood.

Chacs. Fruitfulness of race and soil are represented by many symbols and designs. Rows of small figures to be found on textiles are undoubtedly representations of some form of the numerous

[9] Quen Santo, situated in the department of Huehuetenango in the northern part of Guatemala, is the site of ruins dating from A.D. 840 to 889 (Morley, *Inscriptions at Copán*, 40).

chacs or deities who occupied a prominent place in the Maya pantheon. (Certain religious officials were also called *chacs*.) As gods of agriculture, winds and rain, the *chacs* guarded the fertility of the earth. These figures are best seen on the old-style *huipiles* from Mixco and Totonicapán. Small *chac* images made of clay or wood are set along the ridgepoles of houses in a few villages such as San Andrés Sajcabajá, Rabinal, Nebaj, Chajul, and Tactic.

Nahuales. Other small figures may be interpreted as representations of personal *nahuales*. The *nahual* is an animal that the Indian believes is part of his own personality and his invisible companion. It lives the same life, suffers the same illnesses and accidents, and enjoys the same pleasures as the man who, if necessary, is able to convert himself at will into his *nahual* counterpart. When the man dies, the *nahual* is his protecting spirit. It is distinct from the *chacs* or collective deities who oversee the general good of a village. When I wanted to purchase a San Juan Sacatepéquez baby cap, the mother indignantly backed away, saying, "The cap has the figure of the child's *nahual!* It is impossible to sell it, as it is a part of my child and cannot be separated from him!"

Giants. One of the symbols appearing on Maxeño *tzutes* from Chichicastenango is a red figure of a giant with uplifted hands and the sign *Uo*, a large X, repeated several times. The giant represents some form of the numerous *chacs*,[10] possibly the god of agriculture, of which he is said to have been the discoverer.[11]

I am intrigued by the fact that the most utilitarian of modern

[10] *Chac* is also the name for the color red, and the giants on the old *tzutes* are always woven in red cotton.

A Quiché folktale tells of a giant people called Quinametzin who populated the earth during the second era of earth history. They were destroyed by the earthquakes which put an end to this era, the Sun of the Earth (Batres, *La América Central ante la historia*, I, 431). From the book of Chilam Balam of Chumayel we find that Ah Uoh Pucil were giants rather than gods (Antonio Mediz Bolio, *Chilam Balam de Chumayel*, 20). *Uoh* is a sign in phonetic writing. The Mayan glyph for the second of eighteen months is *Uo*. The sign *Uoh* may be connected with the red *chac* with uplifted hands. It may, too, be associated with the conventionalized glyph, *Uo*, which probably has undergone evolution (as have the rest of the Mayan glyphs) and lost its original cartouche. It may be, however, that modern weavers, having no idea of the significance of these two signs, have woven the Kin (Sun) glyph into this form by crossing the lines.

[11] Diego Lopez Cogolludo (translated by Ethel-Jane Bunting), "Ancient History of Yucatán," *Maya Society Quarterly*, Vol. I (1932), 21.

fastenings, the common safety pin, is used to fabricate the symbol *Uo* by the simple expedient of pinning two safety pins across each other at right angles. Women use them on their *cofradía huipiles;* men display them prominently on the backs of their red wedding coats in San Juan Sacatepéquez. I was told that they were placed that way as a symbol "that brings us good luck."

Some of the present-day *tsibal kaperraj* (*cofradía* ritual table-cloth) of Chichicastenango have figures of women with large triangular skirts and arms akimbo, which are explained as the *ixtán* or female domestic servants of royalty. These cloths, now reserved for the tables of the *cofradía* for the ritual meal, perhaps were once used in the homes of the nobility before the Conquest.[12] My *tsibal kaperraj*, a very old one, has no domestic animals but has all the above described signs.

Cross. The cross on textiles has pagan as well as Christian connotations. As crops are of prime importance to the Indians, many symbols signify weather conditions, good or bad. One of them is a highly stylized cross. In Indian tradition the cross signifies the four winds or directions of the heavens, and, by extension, the four sides of the *milpa* (corn patch), the four directions whence come the life-giving elements that make the crops grow.

Ceremonial *huipiles* from San Juan Sacatepéquez have four large red patterned areas, two covering the back and front forming a yoke and one over each arm. When the *huipil* is laid out flat, the red areas form a cross, each arm of the cross being the same length. This design appears also on the heavy *huipiles* of Colotenango. The Cotzal *cofradía huipil* has red crosses woven into the material. In a San Lucas Sacatepéquez textile I saw an almost solid black design woven in such a manner that tiny white crosses were formed at regular intervals over the whole surface.

Foliated Cross. A foliated cross topped with a pheasant and, in most cases, rooted in some sort of vessel is a design which is used frequently on textiles. Such a design is to be found at the ruins of Palenque, Mexico, where it is carved in a most artistic manner on stone. The Spanish priests, following on the heels of the *Conquis-*

[12] N. Flavio Rodas and L. F. Hawkins, *Chichicastenango: The Kiché Indians, their History and Culture, Sacred Symbols of their Dress and Textiles,* 135.

tadores, decided that it represented the Holy Ghost, *Espíritu Santo,* complete with its bird on top.

A very common figure on textiles looks like a tall plant or tree with leaves up its trunk. It probably represents a survival of the innumerable tree crosses found in Maya traditions, called the "Tree of Life," the "Deity of all Trees," "Spirit of the Trees," or "Sacred Tree." It is interesting to find many of the *cofradía* and ceremonial textiles worn for Christian services bearing this pagan symbol.

The design is very prominent on Quezaltenango ceremonial textiles, particularly on the white *huipil* worn by women over their heads and faces as a sort of veil for important religious occasions. In this instance it looks like a plant with a bird poised at the top. It occurs also in the very precious *cuyuscate* ceremonial headbands worn by the women (of old Mam stock[13]) from Concepción Chiquirichapa. I have found the same figure on trade pieces from Totonicapán, and was told that it was preferred in olden times by women of high caste in the tribe. I believe, therefore, that it is an ancient Mam symbol, worn only by those high in the organization of tribal life, for Quezaltenango and Totonicapán had Mam inhabitants, and Concepción is a Mam colony.

Lightning. Another very obvious weather symbol is the lightning design displayed on many textiles. This is the personification of Hurakán, the rain maker. This design is outstanding on the dark-background *refajos,* where the *jaspes* form the lightning design. It is discernible also on *huipiles* from Mixco, San Lucas Tolimán, and Magdalena and is particularly prominent and pretty on the old-style San Andrés Semetabaj *huipiles.*

Ollin. The Ollin (movement) sign of the Aztec *tonalámatl* is frequently repeated on textiles from Santiago Sacatepéquez. This symbol must have been introduced from Mexico either in prehistoric or post-Columbian times.

Red and white striped *huipiles* from Colotenango have many small fascinating symbols in irregular rows, among which this Ollin

13 The Mam Indians are descendants of one of the oldest tribes. The center of their ancient kingdom was at the fortress city of Zaculeu. At present they are to be found in the departments of San Marcos and Huehuetenango, and a few remain in Quezaltenango and Totonicapán, where they still maintain their tribal traditions and speak their own language.

symbol can be found. Although the other symbols have been so modified that their significance is now lost, a *huipil* from this village has the superficial appearance of a page from an early codex.

The Double-Headed Eagle. The double-headed eagle, either realistic or very much conventionalized, is found repeatedly on Indian textiles. An Indian from San Juan Sacatepéquez told me that the *kablicok*, as he called the large double-headed eagle that decorated the textile I showed him, was used by those of noble rank in his village and represented the Great God who had two faces, "one to look forward and the other to look backward, the one looking for good, the other for evil."[14] When I showed this man a textile woven for trade that had many double-headed eagles all over it, he laughed and said, "No, that is not our double-headed eagle, *kablicok*, but a bird that has come from other lands," which I interpreted to mean the double-headed eagle of Charles V commonly used on belongings of the Spaniards just after the Conquest and still found on church doors, convent walls, and other public places.

A similar interpretation of this symbol was given me when I asked for its meaning on a wedding *huipil* in San Juan Sacatepéquez. "In the past," my informant said, "it was only the married women who were allowed to wear this bird symbol with two heads on their *huipiles*. It was a symbol of the bird that came from overseas. It was a reminder to the woman not to conceive while this bird was around, as it was a bad bird and carried children to its lair, to inflict punishment on the Indian race." It will be remembered that because of their mistreatment during the Colonial regime, the Indians refused to bear children in order to leave no descendants to suffer similar wrongs.

Women from Chichicastenango use this figure customarily on their *huipiles* but call it by the Quiché word *kot* (eagle). They explain it as "one head looking upward toward heaven and the other down toward earth."[15] Although today in this village other symbols

[14] The idea of duality of good and evil is widespread. On my asking a woman from Quezaltenango why she repeatedly wore her skirt inside out, she replied, "It is because everything has two sides—a bad side and a good side. To placate the spirit of the bad side, I wear my *refajo* indiscriminately either way so as to wear out both sides at the same time."

[15] Rodas and Hawkins, *Chichicastenango*, 121.

may have many interpretations, the interpretation of this symbol of the double-headed eagle is consistent. Now much conventionalized with a round disk in the middle of its body, and now drawn in satin ribbon though formerly in silver, its interpretation has probably remained the same since Mayan times.

The Tree. Another common and easily identified symbol is the tree. Two trees are represented; one the ceiba found in the region of Guatemala City, the other the pine tree of the highlands.

The ceiba (*Eriodendrum vesculifolium* H.B.K.) is still a sacred tree and is preserved whenever possible when the forests are cleared. To the Indian it symbolizes life. The ceiba represented the center of the twelve cardinal points, which together made thirteen, the sacred number among the Maya. This tree was believed to have its roots in the earth, its trunk above the horizon, and the top in the sky. It was called the "tree of council." Under its branches the village councils were held, for the wise men of the tribe claimed to derive inspiration from its roots. Indian dignitaries were elected under it. It was also believed that from the roots descended the Indian race. Even now, on special occasions, the roots are decorated with rose petals and *pom*[16] is burned near them. The ceiba symbol may be seen on the *huipiles* of San Pedro Sacatepéquez (G.).

The pine tree is equally sacred to the people of Maya descent who came from "the land of the pine tree." On clothing, it is a symbol of longevity. A woman of noble birth from Quezaltenango, in discussing with me certain matters concerning her tribe, lamented the effects of modern civilization upon her people. Hurry and hustle and outside influences did not permit time to properly instruct the children in respect to traditional beliefs and customs, among which was the wearing of appropriate symbols of their own class on their clothing. She and her family, she said, had always worn *huipiles* of one kind quite distinct from those used by the lower-class women, who were not entitled to wear the pine-tree symbol.

[16] *Pom* (Maya; *copal*, Aztec), a resinous tree gum, is the Indian incense burned at all ceremonies, whether Christian or pagan. The darkest kind, wrapped in two pieces of pumpkin shell (*tol*), is now used only in Momostenango for the most sacred rites. The second variety, wrapped in cornhusks, serves for other ceremonies. The kind sold currently in small gray pebbles in all the markets is used extensively in Indian huts as a disinfectant or insecticide and as an incense before the household altars. Poor people burn it in church.

94

She mentioned that her wedding *refajo* had had a pine tree embroidered near the hem. She deeply regretted the modern indiscriminate use of such symbols. The next time I came across another elderly Quezaltecan who appeared to be a likely source of information, I inquired of her also concerning the use of the pine-tree symbol. She said she would like to please me but could not, as she belonged to a lower-class family which knew nothing at all about the designs and their significance. She and her people were quite satisfied to wear the designs taught them as children without inquiry into their meaning.

Birds, Animals, Insects. Although today domestic animals are frequently represented on textiles, the traditional animals, birds and insects associated with Indian mythology are still favorite motifs. Among them are the two animals and two birds which brought the news of the existence of corn to mankind and were accordingly considered sacred. They are the skunk (*zorillo*, in Guatemala called *zorro*), the coyote, the parrot (*cotorra*), and the crow (*cuervo*). These animals are frequently used on textiles from San Pedro Sacatepéquez (G.), San Antonio Aguas Calientes, San Pedro Chuarrancho, and Cotzal. Other favorites are those which were depicted on the first textiles sent by the deities to the people, such as jaguars (Chuarrancho), eagles (Chichicastenango), and wasps and gadflies (those slender insects found on textiles in the Lake Atitlán region). Highly prized are the symbols representing the animals and birds mentioned in the legends which account for the Indians' existence: the wild boar (*jabalí*), a species of grouse (*chocoyo*), a gallinaceous bird, *azacuán* (*Buteo swainsoni*) that used to be sacrificed to the idols, and the mountain cat (*gato de monte*). They appear frequently on the majority of all true Indian textiles. In addition, highland textiles often show the raccoon[17] (*taltuza* or *mapache*).

In Comalapa figures of birds are used especially to decorate ceremonial textiles. The bird depicted is similar to the one kept as a sacred relic in the *cofradía* house in the village of San Juan Bau-

[17] According to legend, raccoons were once men who escaped the floods by turning into raccoons and burrowing underground. Their love of corn is a latent human trait.

tista. When I inquired into the significance of the bird, I was informed finally that "when St. John the Baptist came to teach us a different religion, that of Christ our Lord, he had nothing with which to write down the laws of the church so we could learn them. Then a bird came to help him—'a bird of our land' and 'of our forefathers' race'—and offered his feathers so that St. John could write with them. The saint ruled that our bird should be worshiped with him. Therefore we keep the bird effigy together with the saint's figure." This explains the amazing sight which greets the visitor to *cofradías* of this village—food, water, and flowers placed with devotion before a clay or wooden bird on the altar. This also explains the significance of the birds on the front of *cofradía huipiles* in this and other villages with the name of San Juan Bautista.

Another bird which is used on textiles is the crane, which in legend was a messenger of the gods and which represents long life. Currently it is placed near a pine tree, another longevity symbol.

Ducks. At corn-planting time in Alta Verapaz the rivers and lagoons are crowded with wild ducks, and it is hardly surprising that ducks appear on *huipiles* here. The duck symbol may have originated with *azacuán*, the bird which appears flying north when the rains are to commence (the season for corn planting) and returns at harvest time, flying south. Wild ducks appear also on Lake Atitlán and therefore occur on the textiles of this region. Rows of plump ducks make very distinctive decorations on San Andrés Sajcabajá *huipiles*.

Peacock or Turkey. The peacock design occurs on ceremonial textiles of Quezaltenango, on the *tzut* worn by a bridegroom around his neck, and on a large *tzut* (now store-bought) worn on very special occasions around the shoulders of high-caste women. This peacock I interpret to be a turkey (*pavo*), the symbol of Tláloc, god of fertility and god of rain and life, or *El Pavo*, bird of the gods of rain. It might very well be a Mam symbol since even to this day Mam *brujos* go to Lake Chicabal to celebrate rites at which a turkey is sacrificed. The Quezaltenango Mam preceded the present Quiché inhabitants; thus this may be a very ancient Mam symbol which has survived on ceremonial regalia, though now conventionalized into a peacock. A turkey is also figured on textiles from San Pedro

Sacatepéquez (S.M.). Indians who live in distant forests sacrifice a turkey, spilling its blood in the four directions of the heavens at the time for planting corn. A symbolic ceremony also takes place on St. Mark's Day (April 25) in San Pedro Sacatepéquez (S.M.). At this time a cock's blood is spilled on the ground, lighted candles are placed around it in the four directions of the heavens, and the Indians pray for rain and sunshine for their crops.

The Quetzal. The quetzal (*Pharomacrus mocino* L.), that lovely bird of many colors which lives in distant forests, is now the national bird of Guatemala and so appears on all national emblems. Once nearly extinct, it is now protected by law from being killed or exported. Its appearance on textiles is an innovation, for when the bird was the symbol of the great god Quetzalcóatl, only its feathers, not its body, were depicted. The quetzal, therefore, is embroidered, not woven, on the textiles, demonstrating its new departure from ancient symbolism. An example of this may be found in the *huipiles* of Totonicapán on whose dark background are embroidered large quetzal birds with their colorful feathers and long tails. Very occasionally a quetzal is woven into a textile, but this is a distinctly modern practice (Santo Domingo Xenacoj).

The Bat. The woolen coats worn by men in Sololá, especially those worn for civil and religious ceremonies, are trimmed on the back with black woolen braid to form a stylized bat. This has erroneously been interpreted as a butterfly. The bat is the symbol of the Royal House of Xahilá (House of the Bat), whose prince was the leader of the Cakchiquel nation during its long legendary journey in search of a permanent home. Formerly a distinction of the high born, this design now appears indiscriminately on most of the wool coats from this village, and has been adopted by *ladinos* for their sportcoats.

Tapir and Horse. The tapir (*danta*) had great symbolic significance in pre-Columbian days and was closely connected with Mayan mythology. Its figure, frequently found sculptured on the stones of old ruined cities, appears on a stone tablet in Palenque richly caparisoned and taking part in an initiation ceremony.[18] Its Indian name, *tzimin*, was transferred to the horse when that creature arrived with the Spanish conquerors.

[18] Mediz Bolio, *Chilam Balam de Chumayel*, 52.

The horse quickly found a place of its own in Indian symbolism. From the time of its arrival with the Spaniards[19] it was considered supernatural. For its association with gunfire, it became to the Indians a manifestation of the god of fire; for its swiftness, an attribute of the monkey who had formerly held this place, it was given the monkey's duties as messenger between gods and men. This concept is represented by a model of a horse with a rider, carried in one of the imposing processions during the annual feast of Santo Tomás in Chichicastenango, December 18–21. The little wooden figure, Tsiholah or Tzijolah, is one of the main attractions of the festivities. Nahualá, Santa Catarina Ixtahuacán, San Juan Sacatepéquez, and Comalapa textiles have well-designed figures of horses.

The Monkey and the Deer. The monkey and the deer, once closely connected with ancient Quiché tradition, still appear in ritual dances[20] and are outlined on some textiles (San Pedro Sacatepéquez [G.]). I have a ceremonial *huipil* from this town which has rows of monkeys prancing across the front as the yoke trimming and a *tzut* from Palín with a monkey border. Textiles from Nebaj show the howler monkey (*zarahuate*), an animal often encountered in the rain forests of the mountains above this village.

The deer appears prominently on textiles from San Antonio Aguas Calientes and Comalapa, either alone or bearing the cross of St. Hubert. The deer in conjunction with the cross is a post-Columbian adaptation. Here the Christian cross has been cleverly camouflaged by the addition of signs to make it resemble the Indian cross, whose four arms are of the same length.

The Jaguar. The jaguar, mythical lord of the Maya month

[19] The Indians' initial experience with the care of a horse was in 1524, when Hernan Cortés, in his journey across El Petén, left his horse in the care of the Indian chief, Canek, on the island of Tayasal. Despite the attentive care given it, the horse died. The chief and his Indians were terrified and set up an effigy of it to be worshiped in their main temple, which the Spanish priests later recognized as a sacrilege.

[20] Corpus Christi, one of the greatest festivities in the Roman Catholic church, is celebrated in Guatemala and El Salvador by the sale of fruit decorated with tiny monkeys and birds. No child, *ladino* or Indian, is content to go home without such a pear, peach, or quince. Larger realistic monkey figures are sold also. The decoration of the fruit and monkey figures are pagan survivals. An interpretation of the birds was given me by an Indian who showed me the bird on her fruit and said it was the bird *azacuán* which heralded the rainy season.

Pop, is often depicted on textiles. It can be seen very distinctly on the old-style textiles from San José Nacahuil, where it forms a spectacular design in combination with a much-conventionalized serpent. The skin of a jaguar, serving as a cloak for dignitaries and dancers in pre-Conquest days, is clearly shown on paintings and sculptures of that time. Frescoes at the Mayan site of Bonampak show a stupendous array of costumes worn by dignitaries, among them, prominent because of their spotted surface, cloaks of jaguar skins. Jaguar masks are still used for dance rituals.

The Scorpion. With but one exception, textiles in El Salvador have no symbolism in the figures that decorate them. This exception occurs on the *refajos* of the upper-class Izalco women. Large floral designs are embroidered around and up one side of the skirt and the figure of a scorpion is placed near the waist. According to the mythology of these Indians, the scorpion is a symbol of life-giving power and therefore of fertility.[21]

Flowers. When used in connection with the scorpion, flowers are fertility symbols. If the sole trimming on a textile, they again signify fertility, as on Chichicastenango women's belts, Quezaltenango *huipiles*, Magdalena *tzutes*, one of the Totonicapán *huipiles*, Chicalajá *huipiles*, and San Francisco El Alto ruffles. Flowers are also to be found on the ribbons on women's ceremonial *huipiles* in many villages and the hatbands on men's ceremonial hats in Solá. (These ribbons, an import from Czechoslovakia, were once commonly used in many villages for trimming hats and garments.)

Corn. Still the staple of Indian diet, corn was the basis about which evolved the high culture of the Mayas, and around it grew almost fanatical devotion and special rites. Its special deity, Yum Kaax, lord of the harvest, was represented as a youth with a leafy headdress. The Kan sign of the Mayas, a grain of maize, is always associated with him.[22] Interesting primitive rituals are observed at the start of the corn-planting season everywhere that Indians still live.

The long pointed leaves of the corn plant are to be found outlined on the ceremonial headribbons from Totonicapán close to

[21] Leonhard Jean Schultze, *Mythen in der muttersprache der Pipil von Izalco in El Salvador,* 31.

[22] Herbert J. Spinden, *Ancient Civilizations of Mexico and Central America,* 103.

woven figures of rabbits and two small human beings. The whole depicts the legend of the rabbits who stole the corn and the culture-hero brothers who discovered them. Corn-leaf designs adorn the best quality old-style woolen blankets, Nebaj *tzutes* (tie-dyed), and the border of ceremonial wool coats from Sololá.

The Bundle. Designs or symbols on textiles similar to those on monuments and codices are significant, though many have become so transformed that their meaning is vague. Some, however, have become amplified, with innumerable added lines and curlicues, preserving just enough outline to enable one to distinguish their original forms. Women's sashes and ordinary blue *huipiles* from San Juan Sacatepéquez, textiles from San Pedro Ayampuj, and some Tecpán textiles bear a design resembling the glyph called the "Year Bundle."[23] On the other hand, the placement of this figure on some of the textiles is also very reminiscent of the ancient symbol for zero, the rosette well outlined in colors, which was described to me as meaning "the rose of our ancestors." Whether these two symbols were ever used on textiles as a mark of rank or official position, I have not been able to ascertain. Now they are used indiscriminately as elements of design on clothing.

Frets. Frets are used to outline designs or form horizontal bands on textiles. They recall designs on Mayan monuments and codices, especially the carved figure on the back of Stela I, Quiriguá, on which the beautiful fretwork is identical with that used on the textiles of San Antonio Aguas Calientes, San Pedro Chuarrancho, and San Martín Jilotepeque.

Banners. A very clear design on many textiles is a pair of crossed flags or banners, either simulating the wings of a bird or as a symbol in itself. When forming part of a bird's plumage, one element is always held erect and is very evidently a flag or banner. I have found no explanation for these banners, but there might be some connection with the units of twenty (the total of one's fingers and toes) represented by flags in the Indian system of numbers. The banners are clearly shown on textiles from San Pedro Sacatepéquez (G.) and Quezaltenango.

[23] Hermann Beyer, "The Position of the Affixes in Maya Writing," *Maya Research*, Vol. III (1936), 102.

The Eye. A design often found on textiles in various parts of the country resembles a large eye with a frame around it. A favorite position for this symbol is the shoulder piece (*mano*) or between the two undulating lines of the plumed serpent (Quezaltenango). When it appears on the *mano* (San Pedro Sacatepéquez [S.M.]), it is described as "the hand and eye of our Lord, who gives us everything." In Quezaltenango it was explained as "the eye of our great God who watches over our own people."

The majority of symbols to be found on textiles may be seen to relate to fertility, the most important concern of all primitive peoples. The next largest group depict omens for good and evil. The ancient symbols connected with the genesis of the race are nowadays losing their significance and taking on modernized forms. Sometimes they become garbled, incomprehensible combinations of the very old and the new, adopted by modern Indians who neither know nor care about their ancient background.

The Indian weaver of today is quick to copy modern ideas of decoration. He is no longer confined to old tradition, especially in working upon those pieces which are designed for trade with the world outside Guatemala. He has discovered what modern tastes prefer and embellishes his textiles with so many figures that the old symbols are being crowded out. Despite this awareness of present-day interests, those textiles which are made for home use are still carefully woven with traditional symbols. These people have developed and maintained this technical skill to a high degree.

IX

*

Women's Clothing and Accessories

STYLES OF CLOTHING AMONG THE INDIANS have not reflected passing vogues until very recently. For centuries unalterable rules of dress have prevailed in each Indian village which no imagination on the part of the wearer could change in the slightest detail. The Indian weaver wove and ornamented a straight piece of cloth, and with a twist or a stitch here and there, converted it into a garment. With ever increasing pressure, however, the influences of the outside world are making themselves felt, and the Indians no longer maintain so strictly their traditions of dress. Laxities have occurred in color and placement of traditional village designs, and additions to the costumes have been made with store-bought items such as blouses or commercially made ribbons and lace. The old women shake their heads over what has happened to the village life of yesteryear and lament that their granddaughters have neither the time nor interest to learn the finer, more intricate techniques of weaving or embroidery.

It is the costumes of the grandmothers rather than those of the

granddaughters which more nearly represent traditional Indian attire. The Indian women wear a wrap-around skirt and a loose overgarment which is akin to, although not strictly, a blouse. Either over or under the blouse, they wear a belt or sash. They dress their hair in styles which vary from locality to locality, employing ribbons or colored wool strands. They wear kerchiefs in various ways. Occasionally they protect their feet with sandals, although ordinarily they go barefoot. As with all peoples, they love color and self-adornment, adding jewelry to their costumes when possible. Since each item of the Indian costume varies in style from village to village and in manufacture and method of wearing, it would be well to discuss them item by item.

Huipil. The word itself is derived from the Aztec *huipili,* or according to Sahagún, *uipil* or *juipil,* meaning "covering." It may also be called *tapado*[1] or *pot* in many of the Guatemalan villages, though the word *huipil* is far more common. In El Salvador the Spanish words *camisa* or *camiseta* are generally used to indicate a blouse.

The *huipil* forms the blouse part of the costume, although it is not strictly a blouse. It is worn in many lengths and many ways. The very short variety reaches only part way to the waistline, showing an expanse of bare torso (Palín). A longer style falls to below the knees and looks like a chemise as it hangs loosely over the skirt (Jacaltenango).[2] Others are very long and massive, the lower part being tucked into the skirt under the belt and forming a sort of underskirt (Quezaltenango). Between the extremes of very short and very long, *huipiles* vary greatly. Some are just long enough to tuck under the belt (Santa Apolonía); others hang loosely over the skirt, showing the belt in front (*cobán*); still others are firmly and neatly tucked into a stiff belt, giving the wearer a slim and well-groomed appearance (San Antonio Aguas Calientes). A few of those which are tucked in are worn bloused over the belt (Santa María Chiquimula).

Huipiles vary also in their width and may be constructed of one, two, or three parts, according to the traditional style in each locality. One-piece *huipiles* are scarce. The most beautiful ones are

[1] *Huipiles* and shawls, as well as other garments, are called *mi tapado.*
[2] Jacaltenango and Aguacatán are two villages where the Indians cannot be classified with their Mam neighbors, but are Jacaltecos and Aguacatecos, distinctly different groups.

those made in San Pedro Sacatepéquez (S.M.). Three-piece *huipiles* are not for ordinary wear but rather for ceremonial occasions, although some are worn in such villages as Cotzal, Nebaj, Olintepeque. Quezaltenango, San Antonio Palopó, and Santa Catarina Palopó.

Ordinarily, *huipiles* do not have sleeves. The parts of the *huipil* which hang over the arms are left unfastened in most villages, although in some instances they are gathered into a ribbon or other band (modern style in Totonicapán). The closest thing to a sleeve is found in the Lake Atitlán region (Sololá).

Huipiles are most frequently made of cotton and decorated with silk, cotton, or wool. Very seldom are they made entirely of wool as are the old-style Comalapa *huipiles*. I have never seen a true Indian *huipil* made entirely of silk. Half the decorated *huipiles* have designs on both front and back; of the rest, some have decoration only on the back (Sacapulas); others only around the neck (San Andrés Xecul) or over the shoulders (one kind in San Juan Sacatepéquez). In San Juan Ixcoy, long, wide, white chemise-like *huipiles* are worn over a tight red skirt. They are undecorated, their starkness emphasizing their cumbersome appearance.

Various techniques are used in the construction of *huipiles*. The sections are sewn together with a *randa* by the *medianos* of Quezaltenango; with a gaily-colored chain stitch in a flowered design (*principales*, Quezaltenango); or with loose stitches of ordinary sewing cotton (Palín). The most common *huipil* is made in two sections sewn together with such fine stitches that the seam is hardly discernible. A hole is cut for the head to pass through, and the edge of the neckline is then finished with a buttonhole stitch (San Raimundo). The sections may also be joined by a tiny satin *randa* and the neck opening finished off with store-bought ribbon (San Pedro Ayampuj); or by a sort of herringbone stitch and the neckline finished with inserts of bits of ribbon or cloth (Patzún). Often the opening for the head is not cut out but is formed merely by leaving part of the seam unsewn (Comitancillo). Sometimes a strip of material which may be silk and elaborately decorated is applied to the neckline.

Many *huipiles* have a strip across the shoulders decorated in a closer pattern than the rest. This may be called *mano* (hand) or

culebreado (snakelike), depending upon the design. The *mano* may be the only decoration on the garment (work *huipiles* from San Juan Sacatepéquez), or it may be part of the elaborate all-over design of the *huipil* (San Pedro Sacatepéquez [S.M.]).

The sides of the *huipiles* may be sewn together from hem to armhole (Comalapa), or left open and the two sides crossed and tucked under the belt to hold the *huipil* firmly in place under the arms (San Antonio Las Flores). When the *huipil* is wide, the surplus is held up from the arms by a woolen cord called *tocoyal*, which passes around the neck and under the cloth at the arms, pulling it back to the shoulder. It is fastened around the neck with a knot at the back (Mixco). This use of the *tocoyal* is rapidly disappearing, as is also the fashion of wearing a large, well-woven band (*cinta*) for the same purpose (*principales* in Quezaltenango). On festive occasions in former years the *huipil* was held by this gay band, which was tied on the right shoulder with the ends thrown over the shoulder, the silver and silk tassels hanging down the back and giving a most elegant appearance to the costume.

In general only one *huipil* is worn next to the skin, but nowadays an extra *huipil* has been added to serve as an undershirt. Sometimes the under-*huipil* is invisible, although in Magdalena, women wear a white *huipil* with store-bought embroidery under a regular hand-woven one displaying the tribal emblems. The latter is worn in such a manner as to allow the sleeves and neck of the undergarment to show. In other villages the women wear two hand-woven *huipils*, one for extra warmth in cold weather (Patzún), or as in San Martín Jilotepeque, simply to add color. The top *huipil* serves as a protection against the sun when turned up over the head like a hood. An extra *huipil* may be worn as a shawl, folded neatly and worn over one shoulder or on the head for ceremonial occasions, or it may be worn over the ordinary *huipil* for a special church function (San Antonio Sacatepéquez, Nebaj). Another style of *huipil* worn in San Mateo Ixtatán is enormously wide and full. The eight yards of cloth which sometimes go into the making of one of them are used as an extra lining across the lower half of the garment, making it clumsy and heavy.

Some *huipiles* have a solid color for the middle section (Santa

Catarina Palopó). Formerly, all-white *hupiiles* of fine texture were customary for self-respecting matrons in Cobán, but now many *huipiles* with colored middle sections have been introduced, and often the all-white ones have colored trimmings around the neck and sleeve openings. Plain, white, coarse cotton or fiber *huipiles*, long and narrow like bags, are worn loose over the short, tight *refajo*, or skirt, by the Lacandón women.

As with all integral parts of the Indian costume, the individuality of the *huipil* distinguishes the residents of one village from those of another. The color and mode of wearing may be very similar, but some detail will mark the difference. For example, the women in Comitancillo and Concepción Tutuapa both wear bright red *huipiles* with horizontal yellow bands, but attached to the *huipil* of the latter is an extra piece at the end of the part hanging over the arms, on which are four or five inches of vertical inserts brocaded in thick yellow thread.

Class and marital status also are distinguishable from the *huipiles*. In some communities the length has special meaning, according to the age and station of the woman who wears it. In Panajachel the married woman is entitled to wear designs in the much esteemed *seda española* (reddish-purple untwisted silk), whereas the single girl is allowed only scant red cotton trimmings. Different socio-economic status may be identified by weaving and design (Totonica-pán). In Quezaltenango this distinction is still very apparent. The *huipil* known as *pishquin*, bearing pine trees and birds in red, purple, and yellow silk and usually made on hip-strap looms in San Pedro Sacatepéquez (S.M.) is deemed suitable for high-caste Indians. The *ranciado sencillo* worn by the lower classes has no embroidery at the neck and scanty *jaspes*, and is now often woven on foot looms. The *ranciado de palito*, woven on hip-strap looms and worn by the middle class, has silk threads throughout the fundamental design.

Ceremonial *huipiles* have special shapes and special names depending on how or where they are worn (*Huipil de misa*, church *huipil*; *huipil de cofradía*, fraternity *huipil*; *zuquel*, or *huipil de casamiento*, wedding *huipil*; *huipil de muerto*, burial *huipil*). They are worn as an extra garment over a huge headdress or over the regular *huipil*.

In general, ceremonial *huipiles* are made in three sections, even if the ordinary one worn in that village is in only one or two sections. In Rabinal, where the long, rather narrow ceremonial *huipil* is thrown over the head like a shawl, the two ends are draped around the arms with the closed baglike part fitting over the elbows. When the women return home from town and church on Sundays, they carry small purchases in these end-bags.

In Jocopilas the *huipil de misa* (made of gauze with silk embroidery) is called *reshpatán*. The long, lower part of ceremonial *huipiles* must extend over the skirt when worn by the women of Totonicapán who belong to the church organizations (*chuchuxeles*). A special decoration is often a distinguishing item of the lower part of the long ceremonial *huipiles* and shows off splendidly as it is worn hanging loose over the skirt (the kind called *acolchonado* in San Pedro Sacatepéquez [S.M.]).

The *zuqueles* worn in Cotzal are very handsome. Most of them are made from white gauzelike material or lace (Nebaj), decorated in ornate designs with colored silks and trimmed around the edges with lace or embroidery. The *nimpot* (Comalapa) is an example of this type of *huipil*.

The burial *huipil* is a much-prized garment and is held in readiness for the journey into eternity. In some places (San Juan Sacatepéquez) it is woven in a special technique. In Quezaltenango it is called by the apt name of *huipil de salir* (*huipil* for departing). Women are usually buried in their ceremonial clothing, particularly if they are members of a *cofradía* (San Lucas Sacatepéquez); but a person of a lower socio-economic level or one who has no ceremonial garment is clothed with a lace or gauze *tzut* finished with ruffles which frame her face. She must also have a silk handkerchief in her hand, preferably one that has served near a sacred figure in a shrine or church (San Martín Jilotepeque).

White blouses having small puffed sleeves with lace or embroidery at sleeve and neck are also called *huipiles*. Despite their foreign origin, these blouses are worn with tribal skirt and belt (San Pedro Laguna). Sometimes they have hand-embroidered ruffles around the neck (San Francisco El Alto). When such blouses are used for gala occasions, the ruffles are made of net and richly embroidered with colored silk and gay spangles.

A spare *huipil* serves as a coat in cold weather or as a head covering when going to church. It is folded neatly and carried over the arm, head, or in a basket until required. It is often different from the everyday village *huipil,* though distinctly recognizable as of the village type (San Pedro Sacatepéquez [G.]).

When doing strenuous work in the fields or at home, women often turn their *huipiles* inside out to preserve the outside of the garment. This does not account for the fashion in vogue during the last few years, however, among Indian women who come thus dressed to market. As the *huipil* is considered part of the woman, she hides the good side to preserve it from evil spirits and the covetous eyes of foreigners.

When the costume is otherwise wholly Indian, a store-bought cotton *huipil* usually denotes the efforts of civil and ecclesiastical authorities to make these people cover the upper part of the body (San Sebastián and San Pedro Pinula in Guatemala; Izalco and Panchimalco in El Salvador).

In El Salvador the hand-woven and embroidered *huipil* is no longer used, if, indeed, it ever was. Indian women wear plain cotton blouses with ruffles edging the neck and puffed sleeves. These blouses are trimmed with store-bought lace or embroidery, and frequently have tucks or shirring to simulate a yoke. They are always in the brightest of colors: blue, pink, or yellow, with self-colored trimmings (Izalco and Panchimalco). In other parts of El Salvador, long, chemise-like white cotton garments without decoration of any kind are worn over the skirt.

Refajo (Skirt). It would seem almost impossible that a plain piece of cloth simply wrapped around a woman's body could be worn in so many styles, but this is just what happens with the *refajo.* *Refajos* are either *envueltos* (wrapped skirts) in lengths of five or five and one-half yards or *plegados* (pleated skirts) of eight or eleven yards. They are never sold by the yard but in standard lengths called *cortes.* No Indian trader will cut off even an inch from the *corte,* whether it is a *plegado* or an *envuelto.* When the *cortes* are very thick and heavy, more like a thick canvas sailcloth, they are known by the specific name of *morgas* (Tecpán, San Pedro Sacatepéquez, and Patzún).

Refajos envueltos are always tightly wrapped around the hips; sometimes so tightly that it seems a physical impossibility for the wearer to sit or walk. They are worn long enough to touch the ground (San Pedro Leguna), short to above the knees (Zunil), or halfway down the calf of the leg (Palín).

The length of the *refajo* is determined by the custom observed in each village. The knee-length version is popular among women who live in some mountainous sections of the country (Zunil). In some villages where tribal laws still are observed, the length is an indication of marital status. When the *refajo* is worn above the knee, the girl is a virgin; when worn just to the knee, the young woman is young and married; but when the *refajo* extends to the middle of the calf, the woman is past childbearing (Chichicastenango).

Some *refajos envueltos* have pleats taken at the sides which make them a little wider looking (San Pablo Laguna). Others, and usually those not held by a belt, are twisted and rolled around the waist (Nahualá and San Pedro Leguna), or have ends which overlap the belt to form an extra pleat or a large half-overskirt (Todos Santos Cuchumatán). When no belt is used, it would seem as if the *refajo* were defying the law of gravity. It manages to stay in place despite the strenuous exercise the woman takes, though nothing but the way it is deftly twisted around the body holds it up.

The ends of the *refajos envueltos* are variously finished on the overlapping side. This style may constitute a difference between neighboring villages, which may also be expressed in the width, or placement of the stripes of the material, even though the coloring may be the same (Cotzal and Nebaj). The way the ends of a *refajo envuelto* are placed in some villages proclaims the marital status of the women. The married woman brings the end of the material toward the right hip; the single girl doubles it so that the end falls on the left hip (Nebaj).

Colotenango is the only place that I know of in Guatemala where the *refajos* carry hand-embroidered designs. The very narrow sections are sewn together to make this semiskirt, and tiny designs in silk or cotton are incorporated in the textile. Some *refajos* have

rows of cotton, wool, or velvet braid or silk ribbon sewn around them at a given distance above the hem (Mixco).

The *refajos plegados* often have a hem on both edges, so that either edge may be gathered and used alternately at the waistline to evenly distribute wear (Quezaltenango). Some of them have a cotton tape binding the hemline to protect it (Mixco). The *refajos plegados* are always worn long and extremely full. More often they are merely designated as *cortes*. When not in use, they are put away carefully by pulling them together with the gathering string and then twisting them over and over into a long, sausage-like roll that is coiled into a circle resembling a large snail, the gathering string (either a wool or cotton tape) being then tightly wound around the coil. A fine, accordion-pleated effect is thus achieved and much admired by the Indians, who never iron their clothing. I have seen a very wealthy modern Indian who had a large wardrobe, complete with pier glass and hangers on rods, keep her *refajos* neatly disposed in coils along the shelves.

Refajos of both varieties may be sewn together with fagoting in an insertion stitch (*randa*) in various widths resembling satin stitch in appearance, or with a herringbone stitch. The different widths and directions of the *randas* are endless.

The amount of silk or rayon thread may serve to distinguish the *refajos* of one village from those of another (San Pedro from San Antonio Sacatepéquez [S.M.]), or the amount and placement of *ikat* design (Quezaltenango and Totonicapán). Color, too, is significant. In places where red and yellow are generally used, a self-respecting widow who has not remarried and has remained faithful otherwise to the memory of her dead husband wears a blue and white striped *refajo,* a striking contrast to the traditional red and yellow (Nebaj).

In villages where more than one kind is used, *refajos* and *cortes* are known by distinct names and are classified according to the designs on the materials. For instance, a dark-blue background with narrow white vertical stripes is called *variado;* those with *ikat* designs are *jaspeados;* and the ordinary dark blue with white horizontal bands, worn daily by women of the lower class are called *cortes sencillos* (Quezaltenango).

In the village of Panchimalco, El Salvador, an enormously wide skirt which literally drags on the ground is finished off at the bottom with a narrow ruffle giving the effect of even greater width to the *enagüilla*. It is woven of cotton material on a foot loom in a tiny dark-blue and red check. The top is gathered into a band of shirring to form a yoke on which are a few embroidered stitches which look like smocking. The ruffles are decorated with colored cross-stitch. These Indians achieve a striking effect by tucking one edge of the *enagüilla* into the waist, allowing a wide white petticoat to show beneath it.

The *refajos* from the villages of Izalco and Nahuizalco in El Salvador are of the tightly wrapped variety. Those from Izalco have a special wide band of embroidery around the lower edge and up the left side, chain stitched in cotton or silk thread.

Belt (faja, ceñidor). The design and wearing of belts also are subject to tradition. Custom, not the fancy of the wearer, dictates that the ends be worn loose, fastened, or tucked into the belt, and that the belt be worn under or over other clothing. They are made primarily in black and white stripes of varying width. A large proportion of the belt is wool, and all-wool belts are worn in some places (Momostenango). In many areas the weft threads are now silk, the warp being either heavy cotton yarn or fiber.

Belts may be woven as narrow, stiff lengths and wound many times around the woman's waist, as in Quezaltenango, or as wide sashes encompassing the entire midsection of the trunk, as in San Juan Sacatepéquez. The very wide ones may be heavily decorated for the entire length (San Juan Sacatepéquez), while the narrow ones may be ornamented only in the middle section with, for example, flowers and lines. Such a girdle signifies a woman's fertility and is worn over or just below the stomach (Chichicastenango). Some have fringes tucked under the belt, holding both belt and *refajo* securely (Almolonga near Quezaltenango). Others have tassels in bright colors at both ends which hang loose over the side of the *refajo* like a fringe (San José Nacahuil). One type distinctive and unique to Nebaj has a beautiful raised silk middle section.

Sometimes a belt may signify rank and descent (Izalco, El Sal-

vador). Such belts are the only hand-woven ones worn by any Salvadorean Indians. But, more practically, this part of the costume fulfills the need for pockets. In Pueblo Nuevo, women tuck money or pieces of candles into their wide, red wool belts when they come into town on market day. In Patzicía the belt holds the baby upright over his mother's back.

In early Colonial times children were hidden to prevent their being baptized into the Christian church.[3] Matters are handled otherwise today; for example, in San Juan Sacatepéquez, Guatemala, when a baby boy is taken to church to be baptized, his mother hides a small bow and arrow (*arcos*) in the baby's belt to ward off possible evil from this ceremony and to appease the deities of his forefathers. The priests, aware of this custom, search diligently through the baby's clothing before commencing the baptismal rites.

In several villages women wear a maternity belt under their clothing. Such girdles are made of white cotton with the tribal design executed in color. They are wide and stiff and make a good support for the body. There is a superstition in San Juan Sacatepéquez that when two women who are *enceinte* meet, one's baby passes to the other. To prevent this exchange, the mothers sew two obsidian points to the sides of the maternity belt. Obsidian points are mentioned by Sahagún[4] in connection with the Mexican goddess Cihuacóatl or Tonantzín, the earth goddess. This goddess is said to have carried a cradle on her back as a woman carries her child. She mingled with the other women in the market and, suddenly disappearing, left her cradle behind. When the women noticed the forgotten cradle, they looked into it and found a piece of flint shaped like a lance point.

Shawl (*perraje, tapado*). The use of *perrajes* is a post-Conquest custom. These are generally woven of cotton, *merino* (cotton and wool), or silk. Those made of silk are for trade and in most instances are woven in villages other than where they are worn. For example, Nebaj *tapados* for church wear are woven in Rabinal technique and bought from that village. Quezaltenango *perrajes* are woven in Totonicapán, while very ornate ones are made in Mazatenango.

[3] Diego de Landa, *Relación de las cosas de Yucatán*, 343.
[4] Sahagún, *A History of Ancient Mexico*, I, 27.

The styles of the *perrajes* vary. Some come in two lengths, sewn along the middle and without fringe (San Cristóbal Totonicapán); some are three yards long, all in one piece, and adorned with many *jaspes* and a wide, knotted fringe (Mazatenango).

A *perraje* sometimes takes the place of an extra *huipil*, once customarily worn in many villages. When folded neatly and thrown over the left shoulder, it is a sign that the woman is unmarried; when thrown over the right shoulder it indicates that she is married (Santa Cruz del Quiché and Tajumulco). *Perrajes* may also be folded many times and carried about on the head until needed (Cobán).

The style of wearing *perrajes* varies from village to village. Sometimes the middle part crosses the chest and the ends are thrown back over the shoulders (Santa Cruz del Quiché); or conversely, the center section covers the back while the ends come forward and the left end is thrown back over the right shoulder (Mazatenango). In Nebaj the shawl falls at full width from shoulder to skirt hem across the front.

Large, square, white cotton *tapados*, with a few tucks along the four sides and an embellishment of white store-bought embroidery are worn by the Mixco *nodrizas* (wet nurses). These *tapados* are folded corner to corner and worn over the shoulders, the apex almost reaching the hem of the *refajo* in back.

Other long, white cotton *tapados* made of hand-woven gauze-like material and trimmed at both ends with store-bought lace or embroidery are wrapped around the head, the ends then crossed in front with one very long end allowed to float out at the back (Quezaltepeque, San Luis Jilotepeque). To this variety of gauze *perraje* belong the many kinds of ceremonial covering other than *huipiles* or *tzutes*. These *tapados* are always long and trimmed with store-bought lace. Sometimes they are made of curtain material embroidered all over with symbolic figures (San Sebastián) or decorated with crosses woven into the textile (Nebaj).

In the very hot low coastlands (Zacapa) *perrajes*, called *rebozos* by the *ladino* women who wear them, are tightly wrapped around the head as a protection against the sun. These lightweight *rebozos* are woven on foot looms in very fine cotton. They have little or no fringe and are quite plain and uninteresting.

Perrajes serve other purposes than protection against heat and cold. In Quezaltenango those called *chucubal*, which are made of two long pieces of plain, unfringed material sewn together in the middle by a narrow *randa*, help carry babies on their mothers' backs. Chichicastenango women tie their babies to their backs with a cotton cloth called *kaperraj*. In cold weather they let it extend in front down to the edge of the skirt and tie it around the neck at the back. When a woman enters church she folds the *kaperraj* and places it neatly on her head. It is also worn in this fashion as a protection against the sun.

In El Salvador the Indians wear shawls woven on foot looms. The *ladinos* wear shawls which have a beautiful knotted fringe at both ends. Cotton and cotton-and-silk combinations are customary and are woven in exquisitely blended color combinations.

Headdress (*tocoyal, tupui, cinta*). Indian women arrange their hair in traditional ways, employing ribbons, bands, cords, and cloth strips of silk, cotton, and wool to enhance the final effect. The most elaborate headdresses are worn by older women for ceremonial purposes, while young, unmarried girls wear a simple headdress or none at all.

There are, in general, three styles of headdress, each with local variations. There is the *tocoyal*, a headdress employing colored strands of wool cord. The *tupui* (coral serpent), also employing colored woolen cords, is now reserved for high-caste women, though it was used ceremonially in ancient times. The *cinta*, or hair ribbon, is woven of fine cotton, wool, or silk, again twisted or braided into the hair to complete the headdress. These headdresses all necessitate that the Indian woman's hair be long, either all over the head or only in the back.

Tocoyal. Woolen strands of various colors (black, red, and purple) are braided into the hair or braided together and worn as a kind of coronet. I have seen at least seven different colored wool strands in addition to a magenta wool braid wound around the hair to form a large roll on the head (Santiago Sacatepéquez). In San Antonio Las Flores the ends of the wool strands are permitted to float free, giving an untidy appearance to the headdress as they stick

out all over the head. Some women arrange the *tocoyal* so that it falls toward one side of the face (matrons from San Juan Sacatepéquez), while others let the braid hang down the back with the *tocoyal* extending some distance below the end of the braid (San Pedro Sacatepéquez [G.]). For ceremonial purposes *tocoyales* are used to form enormous head rolls. Matrons belonging to the *cofradías* wear dozens of them in various lengths, twisted through the hair and wound around the head to form a huge mound (San Pedro Ayampuj). Such headdresses contribute to the blaze of color created by any religious procession in which these Cakchiquel Indians participate. Women belonging to the Mixco *cofradías* combine quantities of *tocoyales* in black, mauve, and magenta into a huge headdress, a very important part of their ceremonial costume.

Black *tocoyales* are twisted into a very thick braid, one end of which has enormous black woolen tassels composed of many tiny and incredibly fine braids. It is twisted around the head with the tassel hanging at the side of the face. This headdress, worn by the Santa María Chiquimula women, becomes a receptacle for all the hair which falls out, for it is considered bad luck to throw away even a few hairs. This large band may also serve as a bank. The women of this village hide their money in their hair to prevent their husbands from taking the few cents they make on market day.

Tupui (coral serpent). Woolen cords also make up those rare headdresses worn by the older, high-caste married women in Cobán. This head decoration is from three to four yards long and is made of small cords, each wound smoothly around a white cotton cord to give it body. The final product is almost the thickness of one's wrist. The ends are ornamented with blue, yellow, and red wools woven into a delicate design and finished off with intricate tassels and openwork fringes, which add at least another quarter of a yard to the *tupui*. The *tupui* is twisted into the hair, which is worn in a tight red wool casing down the back. The middle part of the *tupui* is knotted into the hair at the nape of the neck and hangs down to the edge of the full skirt.

Women of lower socio-economic level are entitled to wear another variety of *tupui* made of bright-red, rather thick woolen cord.

A much simpler ornament, it is tightly wound around the braid of hair to make a tight casing and falls stiffly halfway down the back. The ends are neither twisted nor allowed to hang loose.

In years past the ceremonial *tupui* was a much-prized possession. It was made with infinite patience from wool brought down from the highlands, kept with much care, and handed down from mother to daughter. Young girls, even if belonging to the family of a *cacique* (chief) were not permitted to wear it. At present this *tupui* has almost completely disappeared. A few of the older matrons still cling to this fashion, but none of the younger generation wear even the ordinary *tupui* of their forebears.[5] The Indian explanation is that the heavy wool causes the hair to fall out.[6]

Cintas. Cintas, or head ribbons, are woven in every color of the rainbow of fine cotton, wool, or silk. They are made in certain well-known localities. When narrow, they are braided into the hair or wound into the hair when it is plaited around the head, the well-knotted and twisted ends worn in front (San Cristóbal Totonicapán). Very long ribbons are worn wound around the head many times to form a sort of flat halo in Santiago Atitlán. Some head ribbons are short and have just a few threads to finish the end (Rabinal). Elaborately knotted fringe finishes off wide bands worn by women at Sacapulas. Of the same length are bands from Aguacatán, but these have intricate designs along the whole length. To the eyes of foreigners the San Juan Chamelco women have an untidy appearance, as the hair is cut short over the ears to form what the Indians call *aladaras,* or forelocks. The braids of Chichicastenango women are encased in cord or wool bindings and fall stiffly down the back. In this village, hair cut across the forehead in bangs proclaims to the world that the wearer is a woman of bad reputation.

The age of the wearer is often distinguished by the color of

[5] It is believed that when the first Spanish friars arrived in what is now the department of Alta Verapaz they strongly objected to the Indians' worshiping a large gold effigy of a four-legged animal placed on a hill. As the priests preached against the way the Indians burned incense and lighted candles to worship this idol, to the astonishment of the Indians the gold effigy slowly sank out of sight into the hill! Nowadays the women of Cobán, Alta Verapaz, wear the *tupui* in memory of the animal's tail, and the women in Chamelco, Alta Verapaz, wear their hair cut to fall over their ears in memory of the animal's ears.

[6] Lilly de Jongh Osborne, "Tupui or Coral Serpent Black Spots on Indian Children," *Maya Research,* Vol. II (1935), 179–83.

her headdress. Older women wear narrow mauve *cintas;* the young-er girls wind bands of red and black wool or colored *cintas* in their hair (Cotzal and Santa María de Jesús). Other matrons may bind their hair with narrow silk *cintas,* and the young girls wear their hair loose down their backs, tied at the neck with an unpretentious *cinta.*

Ceremonial head ribbons give the wearer full scope to satisfy her fancy. Usually very wide and long, they have enormous hard silk tassels from which hang silver loops with silk ends (San Miguel Totonicapán). Other ceremonial ribbons are as much as twenty yards long. Over them the ceremonial *huipil* is worn like a veil (San Sebastián), or part of the *huipil* may fall over the face from a roll that looks like a large hat made of *cintas* (Quezaltenango). Some of the older women, especially those belonging to the *cofradías,* wear their hair on top of the head in a tall, handle-like arrange-ment intertwined with a woven band and a wool *tocoyal* (San Juan Sacatepéquez). Further elaboration is sometimes achieved by *cintas* from which small coins, usually the old-style silver *cuartillos,* dangle at the side of the face.

In Rabinal a wide *cinta* is woven into the hair and arranged around the head. Huge, very stiff ends are worn on the right side. They are made of varicolored silk wound over a cardboard with the silk ends sticking out around the two boards.

Cloth may also lend itself to head decoration in the form of narrow lengths of a yellow and red textile wound into the hair and carefully tufted at intervals to give the effect of enormous beads. When a woman so attired carries loads on her head over difficult trails, she lowers this headdress and wears it as a gigantic necklace (Nebaj). Perhaps the most spectacular headdress is the one worn by the women from Tamahú and Tucurú. It is composed of bright-red cotton-cloth strips coiled around two strands of hair which are turned up at the back in a peculiar manner and wound around the head to form a huge, crownless turban which stands out from the head like an automobile tire. In San Miguel Ixtahuacán, a plain red cotton band is worn around the head over the coiled hair and tied over the forehead. It looks tidy and rather modern.

Kerchief and Utility Cloth (servilleta and tzut). These handy cloths made of cotton or wool are used by both men and women,

though certain ones are reserved for one or the other sex. *Servilletas* are called by various names according to the use they serve. They, as well as the *tzutes*, have different tribal designs for each specific use; as part of the man's costume, as a head or hat decoration, or as a simple cloth to carry food or other small traveling necessities. Whether *tzutes* or *servilletas*, they are much valued and often are the only Indian relic of an otherwise drab costume that has become distinctly *ladino*. *Servilletas* usually have a white background and fringe, whereas *tzutes* are in colors according to village tradition.

Indians are very careful to keep their food from contact with anything that might not be clean. *Servilletas*, therefore, are used to wrap the food carried on a journey. They are also used to cover baskets and serve as napkins and tablecloths on special occasions.

Servilletas are folded and carried on the head, suggestive of the way they are worn by peasants in Italy. San Raimundo *servilletas* are famous for their good quality and heavy knotted fringe. Enormously thick *tzutes*, called *cochaj*, are tied around the neck as a protection to the back when the women carry their loads of produce to market (Almolonga). The Santa María de Jesús women use large, nicely embroidered *tzutes* for the same purpose but at the same time convert them into glorified kerchiefs by pulling one end toward the face. Men of Sololá wind *tzutes* around the crowns of their straw hats (Santa Catarina Ixtahuacán). In Chichicastenango the men wrap their heads in *tzutes* tasseled at the corners. Here the men affect various kinds of *tzutes*, among them the precious *pizbal-cotzil* in which offerings for the deities are placed or in which the prayer bundle is wrapped. A plain red *tzut* is chosen to wrap the fire rockets for religious festivities, as when pilgrims, returning from their long journey to the shrine of the Black Christ at Esquipulas, announce to friend and foe their safe return.

A *servilleta* known as *chivo* (goat) is a specialty of the village of San Pedro Sacatepéquez (G.). It is used by all Indians in this section of the country and is specifically made to keep tortillas hot. Good *chivos*, woven of native brown cotton (*cuyuscate*), also come from the village of Tajumulco.

Large white *servilletas*, in this case called *tzutes*, serve as a sling to hold a baby on its mother's back. A medium-sized cloth is put in

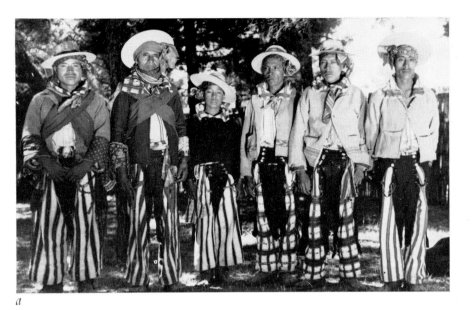

a

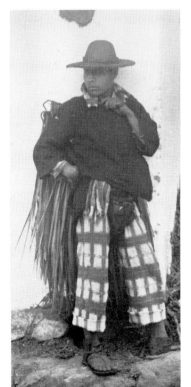

b

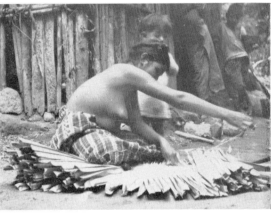

c

Plate 25. a. Men from Todos Santos (Cu-
chumatán). *b.* Young man from Todos
Santos (Cuchumatán) using a *zuyacal.*
c. Woman sewing palm leaves into a
zuyacal, San Sebastián (San Cebolla).

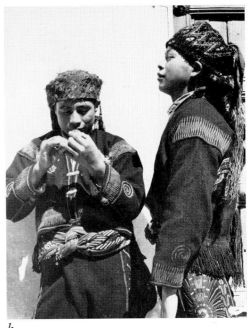

b

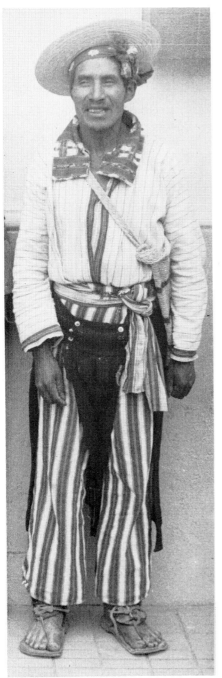

Plate 26. a. Mam man in tribal costume, Todos Santos (Cuchumatán). Note sandals which have heel cups. *b.* Young men from Chichicastenango. The men weave their own head cloths and do their own textile decorating by hand.

a

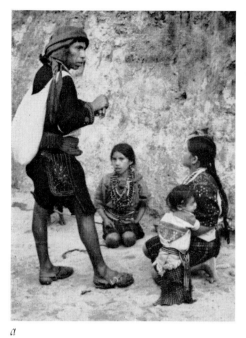

a

b

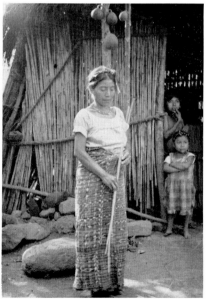

Plate 27. a. Family group from Santo Tomás Chichicastenango resting on the trail. *b.* Section of child's cap (*montera*) showing variations in weaving technique of the dark-blue background. *c.* Woman from Nahuizalco, El Salvador. Her tie-dyed *refajo* is wrapped and tucked in at the waist.

c

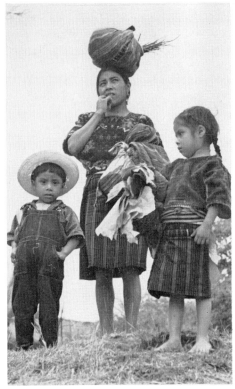

a

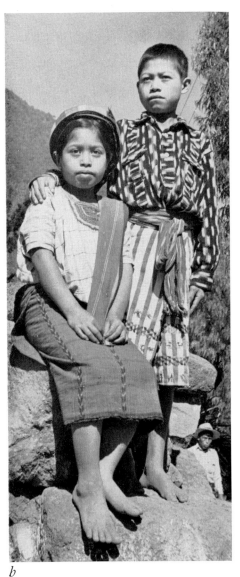

b

Plate 28. a. Woman and two children from Chichicastenango. The little girl is dressed traditionally, but the boy is clad in overalls. He carries his own small wool bag. b. Two children from Santiago Atitlán dressed like their elders in traditional village clothing.

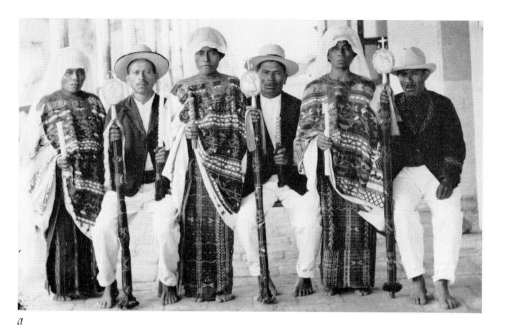

a

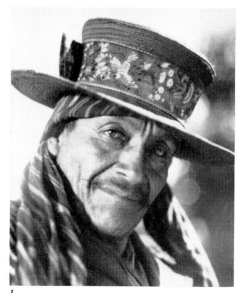

b

c

Plate 29. a. Cofradía members in ceremonial costume, Nebaj. The men hold silver icons; the women, candles. *b.* A ceremonial hat from Sololá with embroidered band. *c.* A *cofrade* displaying an icon, Comalapa. Small bells lend musical accompaniment to the processions.

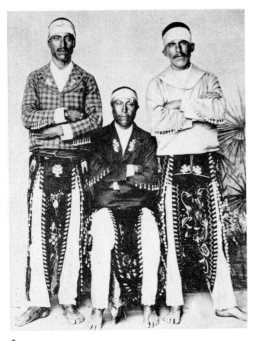

a

b

Plate 30. a. *Mortomes* in ceremonial costume, San Miguel Totonicapán. b. Man from San Martín Sacate-péquez (Chile Verde) dressed in woolen official *capixaij* worn over village costume, an old-style ensemble seldom seen now. c. *Cofradía* members from San Martín Jilotepeque. These men are announcing the *misa de agua* (Rain Mass) held in May to bless seed corn and animals.

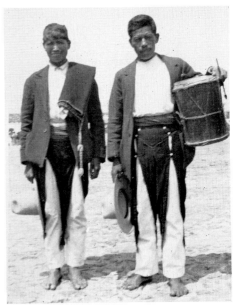

c

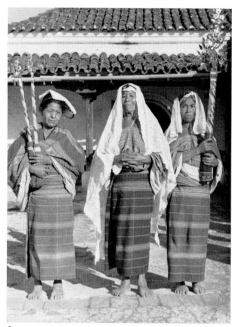

b

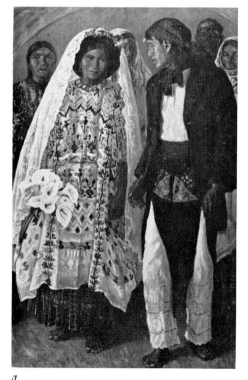

a

Plate 31. a. Wedding group from Quezaltenango. Painting by Humberto Garavito. *b. Cofradía* members (*texeles*) from Comalapa.

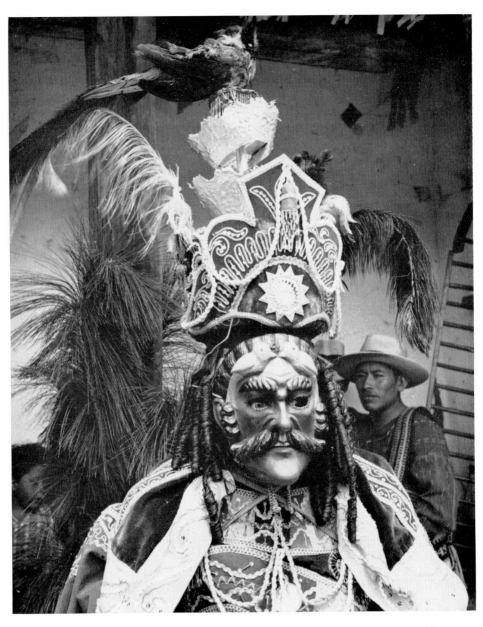

Plate 32. An ornate dance mask representing Tecum Uman, chief of the Quiché nation, who fought Pedro de Alvarado. Fiber curls frame the face. Quantities of trimmings embellish this rented costume.

a basket with one end hanging over the edge to form a sort of handle by which the woman balances a basket on her head while she trots along the road or trail. A small *tzut* is often thrown over the right shoulder, ready for immediate use as a man's handkerchief (San Pedro Laguna). *Tzutes* fastened cornerwise around a man's neck add a gay note to an otherwise somber costume in Nahualá. In villages where men and women are nude from the waist up, a large *tzut* may hang around the neck, swinging from side to side as the Indian walks along the trails in the hot lowlands where he needs protection from the sun.

The one-yard-square white cotton *tzut* that holds church candles or the ceremonial bottle of *aguardiente* that accompanies a request for a girl in marriage has stripes and designs in yellow and purple stars and birds and is known by the name of *subalchij* (Quezaltenango). Another small *tzut* woven in San Pedro Sacatepéquez (S.M.) of heavy material and decorated with silk or cotton trimmings around the edges is especially made for a young girl's wedding day to hold the dish of festive food—usually turkey—which she ceremoniously offers to her new mother-in-law.

In some villages women wear the *tzutes* draped cornerwise over one hip (Magdalena). Small *tzutes* are used as purses to keep money securely tucked in the belt or sash on market day (San Lucas Sacatepéquez). In Zacualpa[7] women tie red *tzutes* around their heads. These two-part kerchiefs, joined by a narrow *randa* and finished at the ends by small ball tassels, give the wearers the appearance of European gypsies. Here the *tzut* is cut as a triangle, and money may be hidden in the middle corner. Large ones have tassels at the three corners. A large, extra *tzut* often takes the place of the extra *huipil* as a head covering when a woman enters church. A *tzut*, well woven in red crea and ornamented with the village designs in varicolored silk, contains the ground corn paste for tortillas, the Indian staff of life (Nebaj).

[7] The name Zacualpa or Azacualpa must be reminiscent of a Spanish gypsy settlement during the Colonial period. Nowadays, several villages in Guatemala that bear this name have a tradition about gypsies having settled or passed that way (e.g., Azacualpa in the department of Santa Rosa, where gypsies settled about two centuries ago). These people are of a distinctly different physical type than those of the neighboring villages.

Tzutes are important adjuncts to all ceremonies, whether religious or civil. Men wrap their staffs of office, when not in use, in red cotton *tzutes*. Specially made *tzutes* with beautiful decorations have a hole near the middle, through which passes the stick that supports the church figures when these are taken out in processions (Mixco). The men belonging to *cofradías* use a special color for their *cofradía tzut*. For instance, in San Juan Sacatepéquez, the *cofradía* color is *cuyuscate;* the ordinary one, white with colored stripes. These cloths are usually made of cotton or cotton with silk designs. The only large all-wool ones I have seen are the black ceremonial *tzutes* worn by the San Martín Jilotepeque men who belong to the sodality. These, decorated with stitches of colored wool and small tassels at the corners, are worn like a cowl collar with the two points of the hypotenuse in front. Small wool *tzutes* are wound around the head in bands by the *cofradía* men in Nebaj.

As with other hand-woven textiles for Indian clothing, the *tzutes* are being replaced by store-bought kerchiefs in bright colors and printed designs that have no tribal significance. Color, in contrast to the use of symbols, continues to be important, however. For example, men and married women of Tonimchun wear a sedate mauve kerchief around their heads; the girls, bright yellow ones. This is the only individual survival of the Indian costume in that region. Thus it can be seen that the *tzut* is an indispensable part of the costume of the Guatemalan Indian.

Footwear (zapatos, caites, sandalias). On the rare occasions when Indians wear shoes, they prefer the high-buttoned style. Ordinarily women wear sandals but less frequently than do the men. The sole is a plain piece of leather held on by thongs which pass around the ankle and between the toes. Sandals with a heel-cup are worn by the Indians in many villages of the Cuchumatanes Mountains (Todos Santos).

Sandals are of two kinds: those for everyday wear, *caites,* and the *sandalias,* which are reserved for festive wear. The latter, worn only by men and enclosing the foot anteriorly, boast numerous decorations of leather, silk stitches, and colored strands of wool forming designs in the intricate vamp, which is finished off with numerous small buckles.

In the village of San Pedro Nonualco, El Salvador, the women wear a low, velvet slipper without heel or heel strap. It sometimes has a bit of embroidery. At least it serves to keep the feet off the very hot ground of these tropical latitudes.

Jewelry (alhajas). Indian women wear necklaces, earrings, and rings (*chachales, aritos,* and *anillos*) just as do white women but with different significance. The amount of jewelry worn indicates the woman's marital status. The single woman wears quantities of *chachales* and other pieces; the married woman converts her jewelry into chains, rings, and so forth for her children (San Juan Sacatepéquez). The women of Santa Cruz del Quiché wear the most ornate and tasteful jewelry of coral and silver filigree, short earrings, chains, and rings. Patzicía women wear necklaces made of jet.

Necklaces (chachales). Coin necklaces (*chachales*) are much prized by the Indian woman, who will almost starve before she will part with them, for they are usually heirlooms. The long necklace is composed of many silver coins separated by small colored beads and has a large silver cross pendant from it (Momostenango). Among the silver coins predominate the *macacos* or *cortados* (pieces of eight). These coins, irregular in contour, were in circulation until late in the nineteenth century and were minted in Central America during the Colonial period. Whenever worn, the *macaco* must be a gift, for one that has been bought does not assure the good luck that these pieces of eight are claimed to bring the owner.

Shorter strands carry smaller coins and coral beads, or the entire necklace may be made of coral (San Juan Sacatepéquez, Santiago Sacatepéquez). From others dangle tiny silver figures (*pixcoy*) representing animals, human beings, and household utensils. These figures, though minute, are complete in every detail. Occasionally the human figures are in grotesque or humorous attitudes. Some old *chachales* have small silver coins set at intervals along the chain (Cobán). Most of them are so heavy that it is a miracle that the wearer is able to go about her daily work. Nowadays the women of Chichicastenango wear many strings of glass beads instead of the old silver-bead *chachales*.

In Sacapulas the women wear large silver plaques suspended on either a narrow black velvet ribbon or a silver chain. The plaque

has for a center piece a Peruvian *sol*, which is surrounded by leaves worked in silver from which hang tiny silver quetzals and jaguars. For ceremonial wear a *macaco* may be used instead of a *sol* in the center of the plaque.

In villages where outside customs now prevail, the *chachal* is giving way to a string of brightly colored beads or a chain with a silver plaque representing a holy figure (Quezaltenango). The modern *chachales* worn in Alta Verapaz (Cobán) are beautiful, long silver chains with silver filigree balls hung on them at intervals. The clever silversmiths of this region are kept busy meeting the demand for these necklaces.

Chachales de brujo are chains worn by witch doctors or medicine men. They may consist of small jadeite stones of all shapes, with a large silver cross at one end and a jadeite figure of an idol at the other; or, composed of enormous silver coins, they may extend below the wearer's waist, almost to his knees.

Other types of *chachales de brujo* have two small silver hands, one closed, the other open—the hand that receives and the hand that gives. When a lay woman wears a hand on her *chachal*, it may have special significance, especially if she is a trader and lives in the region of Sololá. There the hand symbol was one which was used sixty years ago to indicate a hand of salt or that amount which filled to the level an open palm, and was said to be worth "20," or about twenty pieces of some small commodity like fruit or vegetables. Formerly an open hand symbolized zero. A *mano* (hand), signifying the number five, is the standard unit for selling fruit at the present time in Guatemala instead of the usual dozen.

Salvadorean *chachales*, called by the Spanish name of *rosario*, are distinguished from those of Guatemala by being shorter and having many colored, thick, untwisted silk rosettes placed between the beads and coins. The little figures are cut out of flat pieces of silver and resemble paper dolls. The heads are usually seeds and may be those of the palm. The crosses are large, very heavy, and rounded in comparison with the flat Guatemalan ones.

Another, still shorter, *rosario* is made of dried palm seeds or the seeds of the *caulote* tree (*Guazuma ulmifolia* Lam.) strung on heavy red or green silk thread. On the end hangs a small scapular which

represents *el corazón de Jesús* (the heart of Jesus) and is embroidered on cloth. The *rosario* is worn over the *huipil* or *camisa* and is prominently displayed in front (Panchimalco).

Earrings (*aritos*). Earrings are very popular with Indian women, and long ones are preferred. Some are so long they touch the shoulder (Quezaltenango). They may be made of silver or gold filigree, or from a flat piece of silver or gold cut into a simple ornament (San Antonio Aguas Calientas). An uncommon decoration of the ear lobe is in vogue in some Ixil villages (Cotzal and Chajul). Thin, colored *tocoyales* are passed through the ear lobe and then knotted to form tassels, or tied through small silver coins. Sometimes this novel earring is twisted around the ear and allowed to hang over the top like a fringe (Chajul). This mode may be a survival from very ancient times.

Nowadays peddlers go from village to village selling earrings and rings set with cheap stones. Only the wealthiest Indians still use the genuine antique pieces.

Rings (*anillos*). Several rings are worn on one hand. They are made of a broad silver band decorated with a dove, an emblem of two joined hands, or any kind of cheap stone.

The major part of the marriage ceremony in Sacapulas depends upon the use of rings. After the girl is dressed in her bridal costume, the presiding official places around her neck a ribbon or chain on which are strung all the silver and brass rings she owns in addition to the ones the bridegroom has been able to afford as a wedding present. The necklace ends in a large plaque, as described previously. The old plaques always had a skunk (*zorro*), a coyote, a parrot (*cotorra*), and a crow (*cuervo*) as pendants. These are the four sacred animals who at the beginning of time brought to mankind the news of the corn that grew on top of the pyramidal mounds and who therefore are the symbols of plenty. Fertility is also symbolized on the girl's marriage *huipil* by the sun and moon. The ceremony continues, according to tradition, until such time as the godmother takes the chain or ribbon from the girl in the nuptial chamber and brings it to the waiting guests. There, after a prayer, the chain is placed over the bridegroom's head as the sign of possession, and he goes into the room to meet his bride. When she is pronounced

clean and chaste, she regains her chain with the rings, which henceforth becomes an invariable part of her costume.

Wide silver rings are worn on all the fingers of both hands by the older married women in several villages (San Pedro Sacatepéquez [S.M.] and Santa Cruz del Quiché). In Olintepeque the older women wear numerous brass rings of different widths on the middle finger. *Cofradía* matrons take pride in loading their fingers to capacity to outshine their lesser sisters on festive occasions.

To one appreciative of tradition and handsome attire, it is sad to see Indian costume both Westernized and commercialized. Unfortunately the adoption of European dress means the replacement of articles of worth and beauty by the cheap and gaudy.

X

*

Men's Clothing and Accessories

THE INDIAN MAN'S CLOTHING is just as colorful and picturesque as that of his wife. In most Indian villages the men wear clothes copied from those of the Spanish *conquistadores* of the sixteenth and seventeenth centuries. They also wear modern adaptations with Indian touches added to conform to what they believe is *comme il faut*. Thus when trousers and coat are cut on modern lines, the coat is shorter than usual, giving the suit an exotic appearance.

Coat (cotón, saco, chaqueta). The Guatemalan man's coat is usually woven of thick, hard wool from highland sheep, although some are made of colored cotton. They are very short and very stiff. In colder altitudes they are lined with inexpensive, store-bought material. Coats made of homespun cotton are red and lined. Those from Chajul have gay little animals in colored cotton or silk on back and front. Men from Cotzal, Nebaj, and San Juan Sacatepéquez wear coats which are striped in very bright red and black and decorated with heavy black braid. The greater the number of pockets,

the higher the price of a coat from Sololá, where the pockets are ornamented with braid. A coat without an opening down the front (*cotón*) is an adaptation of the old-style, one-piece garment and is now worn only by the older men. In some villages the lower classes are not permitted to wear a coat; in others they are probably too poor to avail themselves of this privilege.

Both official position and marital status are indicated by the amount of black braid on a man's coat. Many curlicues at top and bottom of the back of the coat and on the sleeves indicate that the wearer is married, while much simpler coats with scant braid are worn by single men. The officials or *principales* of the village who retain class distinction wear coats with blue-black wool cuffs and collar (Nebaj). Coats from Cotzal are much like those of Nebaj but have many more pockets, although the higher price of red cotton is rapidly changing these habits.

Trousers (*pantalones*). Trousers, cut in two styles, are made from commercially woven materials (such as flour sacks), homespun cotton, or wool. The most common are cut in European fashion but are greatly adapted to suit Indian tastes. They are worn ankle-length, and the waist is secured by a belt. A popular material is a flour bag, the better liked if it has trademarks on it. I have seen Indians in the markets closely examining flour bags before buying, selecting those with as many as possible of the red or blue stamped patterns. The trousers of white homespun cotton, which are sometimes rolled above the knee, are a sort of uniform adopted for work or worn by traders who substitute them for their village costumes when on the road. Dark woolen trousers match the black, blue, or brown coats which are also worn rather widely at present.

The *pantalón rejado*, trousers split on the sides as far as the thigh, are somewhat less frequently worn. They may be short, reaching to just above the knee, or may fall to the ankle. The short ones are either decorated with a great deal of silk or cotton around the opening, or are undecorated and worn over white cotton trousers trimmed with lace or store-bought embroidery. Those which reach to the ankle are split all the way up to show the white cotton undertrousers. The long, woolen overtrousers worn by men in Todos Santos (Cuchumatán) hang loose at the back of the legs, giving the

appearance of a loincloth. Some long trousers have buttons, fringe, or embroidery on the split side.

Some trousers are fashioned from two straight pieces, with or without a small V-shaped inset in the crotch. The top part, too long and full, is rolled into a large twist around the waist above the belt so the trouser legs reach only to the knee (San Lucas Tolimán and other Lake Atitlán villages). Other short trousers are cut with four seams which form a cross on the seat of the trousers. In San Martín Sacatepéquez (Chile Verde) the trousers resemble two bags joined with a small V-shaped inset on the front side of the crotch. Some Indians wear shorts, profusely decorated with silk embroidery around the edge, and so abbreviated under the woolen *ponchitos* as to give the men the appearance of wearing a kilt and no trousers at all (Nahualá, Santa Catarina Ixtahuacán).

Trousers and coat to be worn for ceremonial purposes are usually made of wool and heavily trimmed with store-bought silk, preferably red and yellow. They are decorated with spangles and embroidered with designs in colored silks, the turned-over ends of bright-colored silk being placed exactly in front to simulate pockets (Sumpango). Years ago in Almolonga ceremonial trousers of white cotton were preferred, trimmed around the legs with wide drawn-work and red needlework and intersected by cotton threads forming loops and rosettes. Nowadays the trend is toward split and decorated short trousers for ceremonial use. These unusual styles combine the fashions of antiquity with Colonial and modern adaptations.

People from Quezaltenango and its vicinity are known as *chivos* (goats) because in years gone by the men wore woolen clothing made from the sheep in this region. When this material got wet from rain or from perspiration when the men were working in the hot lowlands, it emitted a strong animal odor; hence the nickname.

Many years ago the Indians of El Salvador favored short, white cotton trousers which reached only to the knee and were completely hidden by a long, loose white shirt. Now they wear the usual, long, white cotton trousers rolled up only when the men are traveling on long journeys.

Blanket (poncho, ponchito, manga, frazada, or rodillera). A rectangular woven article which we would ordinarily call a blanket

or rug is used variously by the Indian as a pad under a load, a sign of office, an article of clothing, a covering, or a mat to kneel on. According to the way in which it is used, it may be called *poncho*, *ponchito*, *manga*, *frazada* or *rodillera*.

The *ponchito* is a rectangular cloth which is worn as an apron or a kilt, depending on local tradition. It is woven of thick, coarse wool in various colors and patterns (again dependent upon local tradition), and finished in various ways. Apparently *ponchitos* are first put on at puberty and worn short, about two-thirds of the length of the thigh. (I have been unable to learn whether any puberty initiation ceremonies take place with the change of dress as in the old Maya culture.) When a man marries, he dons a knee-length *ponchito*, whereas older men wear them of a length sufficient to cover the knee, and often reaching to the ankle when they are members of some religious or civil organization.

The *ponchito* is worn as a double apron in nearly all the Cakchiquel villages, except for San Antonio Aguas Calientes and Parramos where it is replaced by a *capixaij*, and in Sololá where it is worn as a kilt. It is woven in dark-blue and white checks in Comalapa and San Martín Jilotepeque; in dark-brown or black and white checks in other villages. The ends are finished by a fringe of twisted warp yarns. The *ponchito* worn by the upper classes has a white border and fringe, with or without an openwork design resembling a snake.

The technique of making the snake design is worthy of comment. After the checked part is finished, the black warp threads are cut and the ends carefully inserted and worked back under the last few weft yarns. White warp yarns are inserted to replace the black ones, and all the warp yarns are then twisted in pairs and replaced on the loom. The upper portion of the white border is then woven in plain weave with white weft yarns. Certain warp yarns are again loosened, twisted in pairs, crossed over other warp yarns, and once more attached to the loom. Weaving is resumed below the space for the snake design. The warp is finally loosened from the loom, cut the desired length for the fringe, and the warp yarns tightly twisted in threes. The under warp yarns are cut away carefully, leaving an openwork snake design along the white border of the *ponchito*.

Evidently the *ponchito* evolved as an apron for the front of the costume after the Sacatepéquez tribe separated from the Cakchiqueles about two centuries before the Spanish Conquest, since it is not seen in the Sacatepéquez area (roughly the departments of Sacatepéquez and northern Guatemala). A few men wearing *ponchitos* of the Cakchiquel type have been seen in the vicinity of San Pedro Jocopilas. These Indians may be a recent Cakchiquel immigration.

In the Nahualá valley, west of Sololá, a much heavier black-and-white checked *ponchito* is worn as a kilt. It completely envelops the body below the waist and covers the white cotton shorts with their borders of red figures. The two fringed ends are open at the back. In Sololá the lighter-weight brown-and-white checked *ponchitos* are wrapped around the hips, extending to the knee over the striped cotton trousers which reach to the middle of the calf.

Kiltlike or wrapped *ponchitos* are worn in widely separated sections of the country and by as widely separated Indian groups. Trade may be one explanation for the diverse occurrence of this form of dress.

Ponchitos worn by the Mam groups, who live at altitudes well over eight thousand feet in the department of San Marcos (Tajumulco, Tacaná, Chivinal, Comitancillo, San Miguel Ixtahuacán, Concepción Tutuapa, and Ixchiguán) are made of white wool with a black pin stripe and, reaching to above the knee, are wound very tightly around the hips. The older men in Concepción Tutuapa, especially those who hold official posts, exchange their *ponchitos* for a garment resembling a loincloth. The open trouser legs are doubled upward to form a square piece in front which is tucked into the red sash. The side pieces are fixed in such a way that with the two triangular front pieces they form pockets wherein the men keep their hands warm in these cold altitudes. They are known by the name of *mantilla* (diaper) and are worn over long white cotton trousers (the latter also being worn by the younger men). The way they wrap their *ponchitos* distinguishes these mountain men from the *ponchito*-wearing Indians of Nahualá, Sololá, and Santa Catarina Ixtahuacán.

Shirt (*camisa*). Shirts have only recently become a part of the

Indian wardrobe. Fashioned after those worn by other peoples, they have been modified to meet the Indian taste. Many buttons dot the front, some for use, others for ornament, those of colored glass being particularly admired. Silk decorations are done in geometrical designs, figures of animals or flowers (Santa María de Jesús and Almolonga). Shirts of white homespun cotton have profuse decorations on the front in red machine stitching (San Miguel Ixtahuacán).

In addition to armholes, the body of some shirts has simply a round opening for the neck, with tucks across the front (Santa Cruz del Quiché). Others have no collar. The neckline will be finished off by a band with well-twisted cotton ends which are allowed to hang loose. The same decoration is often applied to the cuffs (Sololá). The sleeves are almost always rolled to above the elbow.

As a rule, shirts are tucked into the trousers, though in El Salvador they are often full and allowed to hang from the yoke straight and loose for about half a yard over the trousers. This style of wearing the shirt loose is an old custom. In Chajul the older men and those belonging to church organizations prefer this distinctive style. In that village the shirts are picturesque, being made of thick red cotton with black pin stripes and decorated with small human and animal figures in colored cotton or wool. These closed shirts resemble the closed coats, also dating from antiquity, which are worn elsewhere in the country.

This garment quaintly serves other than the ordinary purpose. The San Juan La Laguna shirt, red with white stripes and red cuffs and collar, has large points in front incorporating pockets, one side for matches, the other for money.

Unusual adaptations of the shirt are utilized for religious ceremonies. A long, voluminous white cotton shirt with very long sleeves hangs loose over the village costume, covering it completely. Except for its embroidered decorations, it is almost the counterpart of a woman's *cofradía huipil* (Cotzal). Long shirts covering the trousers are worn in San Martín Sacatepéquez (Chile Verde) under the woolen overdress.

Coats are occasionally worn over shirts, but this was not and is not now the prevailing fashion. In Chichicastenango it is only in recent years that a shirt has been worn at all. Formerly the costume

prescribed no shirt, for the coat was joined in front in such a way as to form a pronounced angle, thus exposing the chest. Cut much on this style are the heavy white shirts worn elsewhere. Men of Suacite wear these shirts alone or beneath a woolen overgarment.

Cape (*capixaij;* from *capa y saya*, cape and skirt; *gabán*). The cape is a most fascinating garment. An Indian adaptation of the cossacks worn by the priests of the earliest Colonial period, it is now being replaced by a more modern style of coat. Although sometimes made of thick white cotton, it is usually woolen, either the natural black brown or a dyed blue black. It is a long rectangle with a hole in the center for the head. The ends, fringed on one or both sides, hang to the knee, or just short of it, as in San Miguel Acatán. A long cape is fastened at the waist with a colored sash. This garment resembles an apron rather than a cape. There may be cuffs to secure the garment at the wrists, as in San Antonio Aguas Calientes where the *capixaij* is called *codiarte*, or it may hang loose over the arms as in Todos Santos (Cuchumatán). An extremely long *capixaij* that drags on the ground is worn by the men from San Martín Sacatepéquez (Chile Verde) who leave it at home when they go to the coast to work. This is exceptional, for other Indians who wear the *capixaij* continue to use it in hot climates. Usually a pair of white cotton trousers is worn under the *capixaij*.

As an official garment the cape may take on strange forms. Enormous sleeves, all of ten feet long with fringe at the ends, hang loose when the wearer performs official duties. The *capixaij* is also draped over the shoulders like an ungainly cape, the two seamless sleeves crossed in front and allowed to fall over the back. The length of the *capixaij* designates the religious or civil posts which the individual may hold. I have seen an *alguacil* from Santiago Atitlán throw an extra *capixaij* over his shoulder as a badge of authority every time he went outdoors, even if only for a few steps.

The *capixaij* is never trimmed, save for the aforementioned fringe, and the variations in shape and significance are many in various sections of the country.

A woman seldom wears a *capixaij*. When she does don one as a protection against the intense cold of the highlands, it is always short, made exactly like the men's and worn as an outer garment (Ilom).

Another garment called a *capixaij* and made of two large howler monkey skins is worn by Todos Santos (Cuchumatán) men working at high altitudes outside their village. In addition to being a protection against cold, it also keeps their clothing clean. Sheepskins serve this purpose for shepherds in the high pastures of the bleak Cuchumatanes Mountains, while Indian *mozos* often protect their clothing with rough leather or burlap aprons.

Sash or Belt (*cincho, banda, cinturón*). Belts and sashes are often the only remnant of native costume worn by the Indian (Mixco). They range from the humble liana (*bejuco*) which precariously holds up the man's trousers (Lanquín) to the sashes which are much decorated with varicolored designs (Almolonga).

The old-fashioned sashes of red cotton with wool embroidery in different colors and long, knotted fringes were worn by high-ranking men in Cotzal. When worn as an insigne of position or rank, they are very wide and heavily trimmed. Sashes for ceremonial wear are decorated with tribal designs, and the ends are finished with wide pieces of lace which hang down in either the front or the back (Concepión Chiquirichapa). Of the two kinds of sashes worn in Rabinal, the ceremonial ones must be made of netted weave, called *pax*.

Some sashes are wound around the waist, and the ends are allowed to hang down in front as far as the knees (San Pedro Laguna). In other villages the ends are brought forward, given a twist, and doubled over (Almolonga). Brightly decorated sashes are often the only colorful part of an otherwise drab and uninteresting adaptation of modern clothing (Aguacatán).

The Indians of Almolonga insist that the sash be knotted exactly in the center of the waistline in front. Others allow the ends to fall straight down in back and front, in the style of the primitive *maxtli*. As a rule, Indians on the trail and at work wear wide red cotton sashes with the ends hanging down in front, the whole firmly held in place by a leather belt. This everyday sash can also be fastened back and front like a loincloth, as ceremonial sashes were once worn in Almolonga. The ordinary wide sashes are very long and are wound firmly many times around the body.

Leather belts are gradually taking the place of the old picturesque sashes. Either homemade or bought in town, they are deco-

rated with a few additional stitches of colored silk or cotton. Small leather belts are used occasionally to decorate hats. Sometimes both belt and sash are worn, the former purely as an ornament.

Hat (*sombrero*). Men wear hats more often than women. When a woman does wear a hat she chooses one made of straw or palm leaf. Men's hats are made of straw, palm leaf, *junco* (rush), hide, or felted wool. The last material is stretched over a form of black beeswax and molded into shapes which differ somewhat from those customarily worn by Europeans, as in Nahualá. Some hats from this village have a flat brim that curls at the edge and sport a gay colored ribbon which hangs down the back. Such a hat is worn perched on top of a large red cotton *tzut* wound around the head.

I have seen an affluent Indian wear two or more felt hats, one on top of another, as proof that he can afford city-bought articles. I have also seen an Indian wearing a couple of felt hats in addition to a high-peaked straw hat, creating a headgear suggestive of a pagoda.

In Santa María de Jesús, ceremonial activities call for a top hat like that worn by European statesmen on formal occasions, but the Indian version has gay ribbons around the crown that hang over the brim. The very highest officials in some villages are entitled to wear straw hats dyed a deep black and trimmed with colored ribbons (Sololá), or with a colored *tzut* wound around the crown.

Additional information on Indian hats will be found in the chapter so entitled.

Bag (*guangocha, morral, bolsa, matate, red*). An indispensable adjunct to an Indian man's costume is his bag, which will vary in size from the tiny well-woven bag for the medicine man's precious kit (Nahualá) to the large, open-mesh *red* that carries anything from charcoal to pine needles, wool or vegetables (San Antonio las Flores). Other items carried for personal use in bags are *servilletas* containing food, *tzutes* holding money, or the little tin tubes which contain the precious papers that prove the owner's compliance with required military and civil obligations.

In bags, as in everything else, each village has its own particular size and shape. Bags from Sololá are knitted of heavy, cream-colored wool while Zacualpa bags, which resemble those of Sololá,

are knitted of a thicker material and are seamless. Bags from Santa Catarina Ixtahuacán are further differentiated from these by the addition of pretty black and white figures. The Chichicastenango bags, differing from those of Nahualá in size and technique of manufacture, are woven of thick white cotton thread or, when destined for ordinary use, of fiber. Nahualá bags have corners protected by leather; others made of wool or cotton are finished with a thin solution of beeswax. Where the bag is worn over the shoulder or slung across the back, a *ponchito* is neatly draped over it.

Women seldom use men's bags, except in the more remote sections of the country. In El Salvador the men frequently prefer saddlebags (*arganas*) made of fiber, string, or leather.

Raincoat-umbrella (*zuyacal*). The Indian's umbrella or raincoat is made of palm leaves sewn together. A most useful garment, it is a capelike affair, which, when not in use, is tightly rolled and fastened to the carryall (*cacaxte*).

The Guatemalan *zuyacal* has been declared to be very unique and peculiar to Guatemala and Mexico. Every Indian on the trail from May to November (the rainy season) carries a *zuyacal* ready for instant use. This article is worn in different ways again according to the village of the man's origin. As a cape worn about the shoulders with the ends of the palm leaf split to form a fringe, it covers the man completely to mid-calf. Placed over the head and shoulders, the *zuyacal* sheds the rain in streams, back and front.

As with all other articles of costume, the rapid adaptation to modern dress has now resulted in the wearing of large plastic squares in the brightest colors available to take the place of the *zuyacal*. Even Indian laborers use them and resemble gigantic brilliant mushrooms as they go about their work in the fields.

Hardly ever have I seen women using *zuyacales*. I have observed women along the roads near Retalhuleu when caught in a heavy rainstorm calmly take off their only garments (*refajos*), fold them into their baskets, and cut a huge plantain leaf to protect each basket, the women themselves remaining naked until the storm is over. Men will also employ large leaves as a raincoat if caught in a storm.

Tumpline (*mecapal*). The tumpline is a man's prized posses-

sion. The frontal piece is preferably made of oxhide and fastened to the load with a fiber rope. The hairy side is worn next to the forehead, to which it becomes shaped in time. Occasionally the frontal piece is made of leather without hair, decorated with a few stitches of colored cotton.

Just as it is the exception for men to carry loads in a basket, so does a woman rarely use a *mecapal* except to hold her loom around her waist or hips. One of the rare exceptions is in San Juan Chamelco, where women living in the hills carry their burdens by means of a *mecapal*, and another is the women of Chinautla, who use a *mecapal* to carry their huge loads of pottery into town to market.

Stick (bastón). Another item of accoutrement is the wooden staff that helps Indian traders and carriers (*mozos*) over bad roads. Wooden wands of office (*varitas*), the badge of all high officials, bear silver knobs and long, silk tassels. When in the presence of higher officials, the Indian places his stick across the table in front of him. A stick called *bordón* may also be carried, particularly by the old men of Rabinal.

Carryall (cacaxte). A wooden stand or crate called *cacaxte* is always part of an Indian trader's belongings. It is a carryall, between three and four feet high, carried on the back and secured by a tumpline in precisely the same manner as depicted in the Indian codices of prehistoric times. It accommodates merchandise, small animals, vegetables, fruit, and even human beings. When the latter are carried thus, as for example, patients being conveyed to hospitals or travelers to distant estates, their heads are protected by an awning (*toldo*).

The traveling Indian carries with him those items which he feels he needs to ensure his creature comforts. On his back, protected by one of the famous Maxeño *rodilleras* (black with red and white borders), he carries his *cacaxte* in a large *red* (string bag), a small bundle of *ocote* wood (resinous firewood), a little bunch of onions and garlic, a tin pot for boiling coffee, a box of matches, and in the rainy season, a rolled *zuyacal* suspended from the top. He may also include an extra *poncho* or woolen *manga* if he expects to encounter cold weather.

Indians on a journey will stop at hot springs or wait until their

small fires have heated water to satisfy their thirst, for they will never willingly drink cold water.

The countryside takes on a gay color when a crowd of Indian men, dressed in their tribal garments of many hues and as many fashions, passes along the road. It is unfortunate that this striking raiment is being replaced, for there is nothing more dull or stereotyped than the dress of the Western European man.

XI

*

Miscellaneous Textiles

Children's garments, in general, are small replicas of those of their parents. Little boys are put into long trousers as soon as they are able to walk, although in the hot coastlands children run about naked until they are six or seven years old. In some villages the symbols on boys' trousers and the length of girls' *refajos* indicate their age and maturity.

An Indian mother puts a cap (*montera* or *gorra*) on her newborn baby to cover his head and eyes. Beautifully decorated in the tribal designs, these caps are kept on the babies for at least the first three months of life to ward off the "evil eye" or to protect them from the glance of a curious foreigner. The cap also prevents the ears from standing out too much, a feature about which the Indians are very particular.

Dolls (*muñecas*). Dolls, much loved by their little owners, are dressed in duplicates of their costumes, which of course conform strictly to tribal and village design. The dolls may be of one solid piece of wood or have movable limbs. Both kinds are very crudely

fashioned, though sometimes one comes across finely modeled and artistically carved faces (Totonicapán).

Ladino Clothing. Among the *ladinos,* skirts are called *enaguas* and the blouses, *blusas.* Both are made of cheap, commercially woven materials. The *blusa,* trimmed with lace and embroidery on the sleeves and yoke, is tucked into the very wide pleated *enagua,* which is adorned with a few ruffles around the bottom. The *enagua* is worn over a petticoat (*fustán*) and may be held up around the waist by a stiff silk belt woven by the Indians. A cotton shawl (*rebozo*) covers the shoulders, though in years gone by, colored silk kerchiefs were folded to form a triangle, the apex at the back, the ends crossed in front and held by a nice gold brooch. This class of women (*mengalas*) prided themselves on their jewelry and still have many beautiful pieces, usually made in filigree with added pearls and gems. They often wear a number of necklaces of colored beads. The women wear their hair hanging down the back in one or two braids tied with a brightly colored ribbon. *Ladino* men wear modern clothing made of wool or cotton. They wear shoes, as a rule without socks or stockings, although occasionally they succumb to store-bought socks manufactured from coarse cotton.

Nowadays the picture of both men and women of *ladino* status is far from attractive. In El Salvador these people wear clothing which is a mixture of modern styles and their own adaptations. In regions where *ladinos* are largely of the lower class, the degree of Westernization of their clothing is less marked, and some of the colorful tribal dress is still worn.

Religious Textiles. In addition to the textiles described so far, there are others which must be included in this discussion. These are the textiles which are used by the Indians for their religious ceremonies. They are always woven of the finest yarn and in the best techniques of the village weavers. Great care is taken of them, and they are handled carefully. Nine times out of ten their use refers back to pagan rather than Christian religious custom.

Such textiles encase the poles or sticks on which the church emblems are borne in processionals (Nebaj). The cloths or *tzutes* used by both men and women members of a *cofradía* who are privi-

leged to carry the sacred figures in the processions protect the figures from contact with the human body (Chajul). Other cloths, adorning the stands whereon the images rest, are tied firmly to a pole with a cloth band. A cloth strip of solid color lies under the candlesticks. The candles or the bottles of ceremonial liquor used in the *cofradías* or on pilgrimages are wrapped in special *tzutes*. In some villages the sacred figures are dressed in Indian textiles woven from the best homespun cotton and dyed with vegetable dyes. The preferred color is lavender. It is among these religious textiles that some of the loveliest old-style weaving is still to be seen.

Tablecloths and *tzutes* that serve in the *cofradía* houses are also considered religious textiles. Special care is taken in their weaving and in their decoration with tribal symbols and fringe (Tactic, Quezaltenango). Square white cloths bearing Christian symbols hand-embroidered in color are reserved for Holy Week ceremonies. Many of the textiles, whether *tzut*, tablecloth, or clothing for the sacred figures, bear Spanish words and Roman Catholic symbols embroidered throughout the cloth. The significance of these symbols to the Indian is that their appearance pleases the village priest.

Blankets. Until recently, all good woolen blankets were woven in stripes of black, brown, or dark blue and white. The two ends were finished with fringe, openwork, or both. Sometimes, a few yellow, red, or green designs simulating corn leaves or zigzag lightning patterns were placed between the stripes. Present-day blankets are made in all colors of the rainbow, and the designs appearing on them are what the merchants think are wanted by the tourist trade. These designs, which are woven in tapestry technique, are either figures copied from prehistoric stones or animals or humans in grotesque attitudes.

The older blankets which were woven on hip-strap and foot looms were never wide. Thus only very modern blankets, particularly those woven on foot looms, are without a seam through the middle.

The famous ruglike blankets (*rodilleras* or *ponchitos*) woven in Chichicastenango are of black wool with two red, white, and blue end stripes done in tapestry technique. The *ponchitos* in blue,

black, or brown are primarily part of a man's costume (San Antonio Palopó, Santa Catarina Palopó, Nahualá, Chimaltenango and others). They are well made and of unquestionable wearing quality.

Rugs. Interesting wool rugs known as *pellones* are woven in the region of San Pedro Solomá. They are made two yards long by one yard wide, in undyed black and white wool, and look like a large French poodle. In some, the twisted wool strands are at least six inches long. The technique is much like that of the cotton *chivos* woven in San Pedro Sacatepéquez (G.), which is also the center for the textile *coladores* (strainers).

XII

✢

The Relation of Costume to Custom

Costumes

I<small>N</small> <small>GENERAL</small>, costumes can no longer be grouped according to any affiliation (tribal, regional, or social), for in the eastern and northern lowlands and the southeastern part of Guatemala the Indians have become *ladinos* and have largely discontinued wearing their tribal clothing. In western Guatemala, particularly in the highlands, however, the Indians do retain individuality in their costumes, though when they go to the hot lowlands, especially along the Pacific Coast, they discard many items of costume that are considered obligatory in their home villages.

A good example of this loyalty to native dress is exemplified by an Indian couple of my acquaintance. Some years ago a young Indian man belonging to a high-class San Cristóbal family went to Guatemala City to study law. He graduated with honors and set up his practice in the city, where he married a *ladino* girl. Circumstances forced him to return to live in his native village, where he immediately changed his fashionable *ladino* clothing for the dress of San Cristóbal. His wife donned the thick, white *huipil*, the pretty green

and blue *refajo,* and the heavily decorated headribbon. She eventually was elected, as was her prerogative, to be head of the *cofradía,* and wore the enormously long, white ceremonial garments with grace.

If Indians deign to notice the costumes worn in neighboring villages, they usually express contempt for them; they are not as well woven, they have fewer symbols, or the widths or lengths are not to their taste. An Indian from Quezaltenango told me that the women from San Pedro Sacatepéquez (S.M.) did not have as nice *huipiles* as her people wore, despite the fact that she had just bought before my eyes a *huipil* woven in San Pedro Sacatepéquez for her own use. She had to add at least one-half yard of white material to the bottom of the garment so it would conform to the customary length worn in her village.

Clothing is not divided into "everyday" and "best" as with us. The ordinary Indian citizen has but one full set of clothing, made according to tribal prescription, unless the individual is very wealthy indeed (in which case the person may be considered as belonging to the *nouveaux riches* and looked down on). Times have changed, but for the general class of Indians, one costume is still the rule, with special ceremonial clothing for the privileged groups.

Two social groups wear clothing which sets them apart: *brujos* (now mostly called *ajitz*), *maestros, shamans,* and *zahoris* (witch doctors, wise men, sorcerers, and medicine men), and the officials belonging to church organizations and the civil government of the villages. Of the two kinds of *brujos* (those who predict evil and those who predict good), the former are greatly feared. The *principales,* on the other hand, are much respected, and to them the traditions of the clan are entrusted (*hombres de confianza,* trusted men).

Rank is emphasized by an extra garment such as a coat, *capixaij, tzut,* cape with colored lining, extra *manga,*[1] or by larger *huipiles,* better *chachales,* or special head covering for the women. Civil *alcaldes* and *regidores* wear large *tzutes* like turbans. It is not good policy for any outsider wearing spurs to enter an Indian courtroom

[1]*Manga* (sleeve). In this case the extra, or only, long sleeve is made as part of the black wool overdress. It is open and gathered into a narrow cuff.

(*juzgado*), for spurs remind the Indian of the old Spanish dominance and oppression, with which he is naturally ready to quarrel. In the *juzgados*, Indian justice is dispensed strictly according to Indian tradition.

The best time to see ceremonial costumes is during religious festivities (especially when the Indians are celebrating the patron saint's feast day), during Holy Week, and, in the larger villages, during the yearly fairs.

Opportunity to view tribal dress is offered when a group of Indian officials from a municipality comes into Guatemala City to confer with the president, a cabinet minister, the governor, or the archbishop about village affairs. The majority of such visits are concerned with claims concerning communal lands that are either being taken away by *ladinos*, or encroached upon by Indian neighbors. These Indian officials are correctly dressed according to village rank and station. For instance, the officials from Mixco will carry a large cape (*capa española*) made of black wool lined with red silk and surfaced with silk embroidery and many spangles. Hats worn as part of this ceremonial costume used to be trimmed with gay bands, the flowers and other figures emphasized with spangles. The men unfold the cape about their shoulders when in the presence of the officials whom they have come to consult. They walk into the office of the official, one by one deposit on the table in front of him their wands of office, and then stand with folded arms awaiting his command to speak. Formerly the Indians would kneel and kiss the floor in front of the official, but this was discontinued several years ago.

Clothing, always well washed before any fiesta day, lasts a long time. In some places I have seen *huipiles* with more patches than original cloth, but until a garment is really worn out the making of a replacement is not even considered. This is very true today when the demand for textiles is great. The Indians have quickly learned that they bring good prices and sell their output as fast as they can get it made.

When a girl marries a man from another village, she adopts the style of clothing worn by his people. In most villages, however, the Indians would rather not marry outside. If a man falls in love with a girl of another tribe, the pair will preferably live together unmar-

ried rather than offend their own people. An exception seems to be the village of San Miguel Uspantán and its nearby hamlets, with whose men Santa María Chiquimula women have intermarried since about 1874.[2] For many years the Santa María Chiquimula people have been roaming these mountainsides, pasturing their sheep and planting their corn far from their own village. They travel far and wide trading their wool and corn at the Ixil village markets. They are an austere nomad group which refuses to mix with other tribes. The anomaly of their marrying into a completely different tribe might be explained by the fact that the famous inhabitants of San Miguel Uspantán who resisted the *conquistadores* so courageously have been largely replaced by immigrations of Santa María Chiquimula Indians. In the village itself it is stated that the present occupants are outsiders and not the original settlers.

As I have said previously, the garments of different classes or castes in each village are made of cloth which is distinctive in both color and pattern. Sometimes details of costumes indicate the ages of the wearers. Then again, some communities lay special stress on the fecundity of the individual, whose costume proclaims it to all who care to notice. When describing costumes, I have specified first those worn by members of the nobility or *principales;* second those worn by the middle class of *medianos;* and finally those of the lower class or *plebeyos,* as differentiated earlier.

Variations in climate as well as cut and style have influenced the material used in costumes, such as the heavy woolen garments worn by men in some of the highland villages. The former geographic isolation of communities may well have led to the development of distinctive costumes. The preservation of these climatic, geographic, and class differences in dress dating from pre-Columbian times reflects the conservatism of the Indian and is a tribute to his self-respect.

The Indian is markedly village-conscious. For example, while I was chatting with an Indian man, he brought up the fact that he had heard that my village, Guatemala City, was at war (1942) and wanted to know if our men were fighting valiantly for their corn

[2] Franz Termer, *Zur Etnologie und Etnographie des nördlichen Mittelamerika,* 340; Otto Stoll, *Etnografía de la república de Guatemala,* 142.

patches. When I tried to impress him with the fact that his village, San Miguel Ixtahuacán, was also at war; in fact the whole country of Guatemala, he looked perturbed and shook his head, saying it was only my village and not his, as his did not belong to the same Guatemala that mine did!

A factor to be considered when trying to classify costumes in Guatemala is the yearly mass migration from the highlands to the lowlands, where the men go to work on the coffee estates during the growing season. Whole villages take up their goods and chattels, including their pigs and dogs, and set out on the long trek to the lowlands. If these highland Indians remain as *colonos* (permanent workmen who live the year round on the estate), they tend to maintain their highland costumes. This accounts for the strange sight of a highland costume in the warm coastal plains, which is a puzzle to the unwary ethnologist.

Among the many mass migrations I have encountered, I still have a vivid mental image of one which I recall with pleasure. San Juan Ixcoy Indians were coming from the Cuchumatanes Mountains on their way to the Pacific Coast, a walk of twenty days. The men's backs were heavily laden with large packs, and the women's with their infants and toddlers. Pigs and dogs ran about helter-skelter underfoot, tripping the weary-faced and lagging children. This group had stopped to rest near the village of San Sebastián, near Retalhuleu. The women's tight red skirts, long loose white *huipiles,* and queer yellow headcloths floating down their backs made a bright spot amidst the comings and goings of the men in their short dark wool *capixaij* and white trousers browned by the dust of travel. The sharp contrast between the clothing of the travelers and that of the residents of the village nearby stands out vividly in my mind as the most striking picture I have seen of the great diversity and contrast in Indian native dress.

For the last century the Indian population has so increased that the original land grants ceded to their forefathers are no longer sufficient to support them. Accordingly, remote and sparsely populated areas have been granted to the Indians, who although they may move far from their home villages, have preserved their costumes as they wore them there. Thus some well-known village costumes

are found in out-of-the-way places, where supposedly they have no right to be. For example, Momostenango Indians were granted lands by Justo Rufino Barrios (president of Guatemala, 1873–85) in the hamlet of Chehul situated on top of the sierra summit. Ever since they moved into this region, they have had disputes with their neighbors over territorial boundaries, but nevertheless, Momostenango costumes are seen within and without the limits of their recent grant. Such a situation might be a reasonable explanation for the Santa María Chiquimula costumes found in and around Uspantán.

Costumes show the influence of the Spaniards of early Colonial days (the Quezaltenango *refajo* and Cotzal men's coats) just as they are modified by modern non-Indian dress (Cobán). In addition to these two modifying influences there has been intertribal influence in the remote past. When the early friars gathered together Indians from scattered tribes and nomad groups living deep in the forest to establish communities, frequently ten or more tribes would be represented in one village population and brought with them traditions of costume. They brought, too, symbols which hitherto had served as a distinction of socio-economic status. The Indians preserved the predominant colors and symbols of costumes represented in such a community and its satellite villages scattered in the hills nearby (*del monte*, as these people living outside the villages but belonging to them are called). In these outlying areas interesting textiles are sometimes found which are woven in the ancient technique with old, well-defined symbols. I have been told that the reason for some villages having six or more variations in the designs and color worn therein was because their forefathers did not belong to the same tribe, and thus the individual was obliged to differentiate his descent (San Juan Sacatepéquez). Although they have lived within these villages for a matter of centuries, individual family groups carefully preserve costume characteristics of the areas native to them.

Distinctive and much-decorated Indian costumes were traditional long before the white conquerors arrived, but there is no mention in the histories of a reason for the diversity. It is said that in Peru the variety is attributed to the first chief of the Incas, who ordered each group of Indians to be clothed in a different style in order that

the subjects of his vast dominions might be distinguished. Though this sounds plausible and might be paralleled in Guatemala, I have found only one such reference[3] wherein are mentioned the colors of the headbands used as a special device for distinguishing the region native to the wearer. The distinction in dress probably lies in the fact that the peoples who inhabited Guatemala and El Salvador prior to Spanish Conquest were distinct tribal groups, frequently warring with one another. There was no such unity here as was found in the Inca kingdom farther south.

Perhaps religious costumes may have contributed to the distinction of dress. Special textiles (*mantas* and *vestidos*) are known to have been worn on the feast days of certain deities.[4] These special costume adjuncts were no doubt preserved as the tribes were scattered or absorbed by succeeding waves of peoples. Later when Christian saints became the patrons of individual villages, Christian religious symbolism was added to the pagan, while distinctive ceremonies were maintained. Nowadays, whenever *huipiles* that are trade pieces are worn, especially those from San Pedro Sacatepéquez (S.M.), Quezaltenango, and San Martín Jilotepeque, it is an indication that that village was founded by Indians from other parts of the country who have lost much of their costume tradition (San Lucas Sacatepéquez, Mixco).

Modern authors have repeatedly stated that the priests were responsible for all the costume diversity among the Indians, saying that the religious orders caused the clothing of their flocks to be different styles and colors so as to distinguish the groups under their guidance. But the priests could never have devised so many costumes or created such diversity of decoration of the textiles. Furthermore, the Indians have been relatively slow to adopt items of European material culture and have always adapted them to suit their sense of the fitness of things. I like better an explanation once given me by an Indian from a remote village when I asked him if he knew why his neighbors dressed so differently from his own people. "It is done that way," he said, "so that *Tatita Díos* (our Little Father

[3] Fuentes y Guzmán, *Recordación florida*, II, 146.

[4] *Codex Magliabecchiano*, XIII–3, Manuscrit Mexicain Post-Columbien de la Bibliotheque Nationale de Florence.

God) may know the different villages we come from and not get us mixed up, as would be the case if we all dressed alike. This way it is a great help to Him, as we are so many." It is as good an explanation as any I can think of for the costume diversity in Guatemala.

There is one garment, however, that I have mentioned as reminiscent of the friars' influence, but even this has been markedly modified by the Indian. This is the *capixaij*, which is ordinarily made of some dark-colored thick wool and is suggestive of the monks' habit. The dark-blue, dark-brown, and even grayish *capixaij* with fine white and black stripes are suggestive of the Franciscan habit. The first Franciscan missionaries found it impossible to obtain the shade of brown used in the habits of their particular order and so were allowed by their superiors to wear cassocks of dark blue. Accordingly, permission was received to have the Indians weave new cassocks of blue, indigo dye being readily available. The white cotton *capixaij* is suggestive of the Dominicans' white habit. In some villages the Indian has substituted a large, bright red *tzut* for the black cowl of the religious order. Although the village of Parramos belonged to the Franciscan order in other days, the white *capixaij* is found there also. This may be because the village is so near Antigua, where all the orders, especially the Dominican, were once extremely active.

The nuns' habits also influenced the costumes of the Indian women. Wide skirts with doubled ends falling over the waistband which are worn in some villages are suggestive of the nuns' costume. On the other hand, the very wide skirts and style of wearing them in Quezaltenango are distinctly copied from the Spanish lay women of the sixteenth and seventeenth centuries.

San Miguel Totonicapán is a good place in which to study costumes because more than one tribe of Indians is represented there. The early settlers were of the Mam tribe, later superseded by the Quiché. These Quiché settlers were of the upper class; in fact, the last king of the Quiché was crowned here less than a century ago, though his crown was promptly taken away by the authorities of the republic of Guatemala. Three distinct Quiché classes are still preserved in Totonicapán, and have not mingled with the descend-

ants of other tribes such as the Tlaxcalan and other Mexican follow-
ers of Pedro de Alvarado who settled here.

Quiché clothing has retained its distinctive appearance. Quiché
women of the upper class wear white *huipiles* with beautifully deco-
rated bands of tiny figures (*muñequitos*). The *huipiles* are tucked
into a *refajo merino* colored dark green and blue with complicated
white *jaspe* designs. A stiff belt completes this trim costume which
complements the proud carriage of these women. Their costume is
further adorned by *chachales,* many rings, and long earrings. It is
from this class that the women are chosen for the *cofradías.*[5] They
wear an extra large, white over-*huipil* embroidered in many colors
with long sleeves woven in white shadow designs. Their head ribbons
are certainly the most ornate and finest in the entire country.

The second-class women wear *huipiles* with *muñequitos,* but
the overall pattern is much simpler and has no silk. The *refajos* have
more blue and hardly any *jaspes.* The third-class women wear white
cotton *huipiles* with blue bands across the surface and an occasional
very small figure of a deerlike animal. Their *refajos* have no *jaspes*
at all.

The *perrajes* also are very distinctive. The higher the class,
the more wool used in them and the brighter the colors, though
none have fringe or netted finish.

Upper-class women said to be of Mexican-Indian descent
wear *huipiles* made from *cuyuscate* cotton, with applied embroid-
ery worked in beautiful colors with thick silk. The design usually is
composed of flowers with a prominently displayed quetzal, a late
addition. With these *huipiles* are worn *refajos* of the red and black
variety known as *zambos* (a *zambo* is a person of mixed Indian and
Negro descent). The second-class Tlaxcalan and Mexican women
wear coarse white or *cuyuscate huipiles* with weft yarns of many
colors used alternately. All women of Mexican descent wear *perrajes*
with warp yarns of very fine cotton and weft yarns of alternating
multicolored wool and cotton. They are woven on foot looms and
closely resemble the true Mexican *perraje.*

Men of all classes wear modern clothing. The two upper classes

[5] Rodas and Hawkins, *Chichicastenango,* 109–10.

wear suits of thick, blue wool; the lower class wears the usual white cotton trousers and shirt, adding a woolen *capixaij* when the weather turns cold. Although their clothing does not differ, the men are careful to observe those social amenities considered appropriate to the preservation of class distinction.

Men who belonged to the *cofradías* in Totonicapán in former years were called *mortomes*. They still wear the most elaborate clothing, similar to that worn by the so-called *Alcaldes de la Iglesia*. The long, dark woolen trousers are split to the thigh and adorned with much silk and silver thread embroidery. The short, bolero-like coat is decorated with rows of small silver tassels. Under this woolen suit is worn a white shirt and a long pair of white cotton trousers trimmed with lace. A wide headband which resembles a tumpline more than a *tzut* is tied around the head. A very wide red sash completes this striking costume, which is always buried with the man when he dies.

In the midst of its many Cakchiquel neighbors, the village of Santa María de Jesús is a settlement of Quiché whose ancestors came from Quezaltenango. As late as the beginning of the nineteenth century, the Santa María de Jesús Indians still wore loincloths decorated with red cotton figures. For many years they have supplied the Guatemalan market, bringing their vegetable produce into Antigua. In addition to their brightly decorated loincloths, officials wore large, black top hats set at a rakish angle and set off with a brightly colored ribbon around the crown, the ends hanging loose and fluttering in the wind. With this they wore black woolen coats and carried large staffs of office with enormous silver knobs and many colored tassels. This costume was startling as well as unique. After 1890, the official set gradually changed the style of its clothing, but until a very few years ago, their ceremonial garments were still impressive: a pair of black woolen trousers and a short coat literally in rags, a red cotton shirt with many figures executed in silks, a wide red cotton sash with ends hanging to the knees, a large *tzut* tightly tied around the head under the tall top hat, and lastly, an extra, much-decorated *tzut* tied like a cape around the neck. In this village the Indians affect a small mustache and occasionally a scant beard.

Another very distinctive costume is that of the *cofrades* of

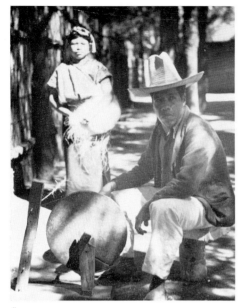

a

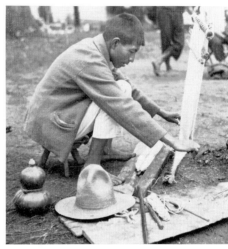

c

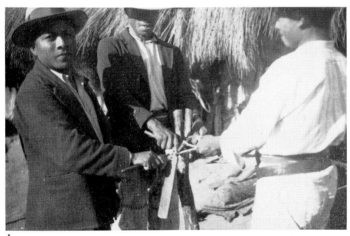

b

Plate 33. a. Spinning and twisting fiber into string, Acatenango. *b.* Ropemaking, San Pablo La Laguna. *c.* Weaving fiber saddlebag, Guatemala. Note gourd water bottle.

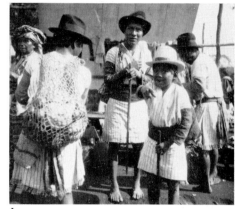

b

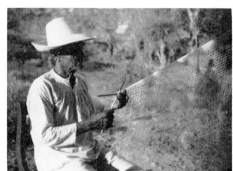

c

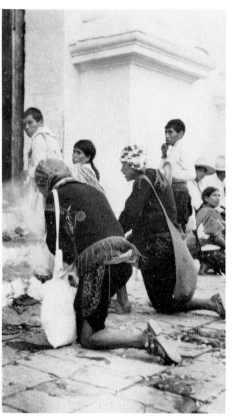

a

Plate 34. a. Chichicastenango men kneeling on church steps. Their bags are called *chim*. Man on left swings incense burner. Fringe on their coats represents rain. *b.* Boys from San Martín Sacatepéquez trading on the coast, their wares carried in *redes* (mesh bags). *c.* Making a fish net, Lake Ilopango, El Salvador.

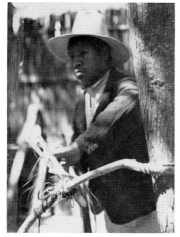

Plate 35. *a*. Man uses *parenquima* to cut maguey leaf, Acatenango. *b*. Bleaching and drying fiber for hatmaking, El Quiché. *c*. Stitching and finishing hats, El Quiché.

a

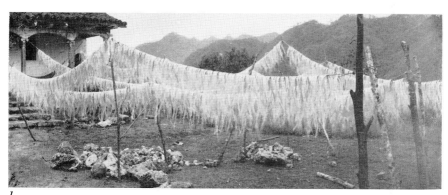

b

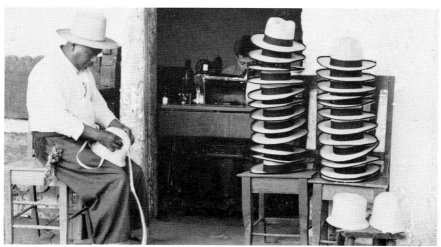

c

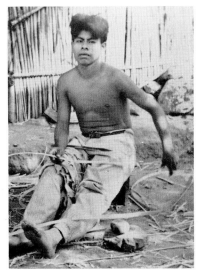

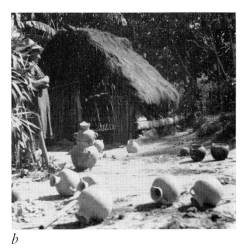

b

a

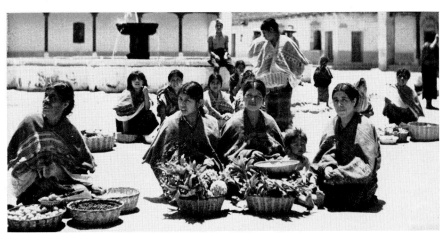

c

Plate 36. *a*. Man making a *tumbilla*, Nahuizalco, El Salvador. *b*. Pottery center, Chinautla. *c*. Market scene at Comalapa; wares displayed in baskets.

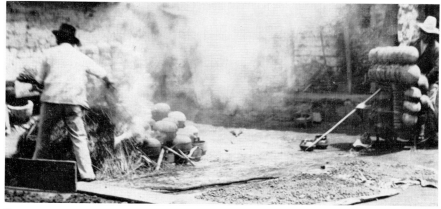

a

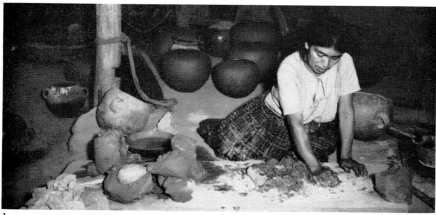

b

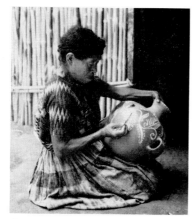

c

Plate 37. a. Firing pottery, San Cristó-
bal Totonicapán. Coffee beans dry on
hide on ground. *b, c.* Pottery making
in Chinautla: *b.* working the clay; *c.*
painting the design on the jar.

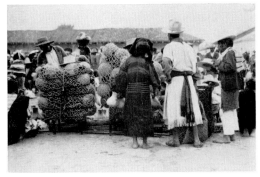

a

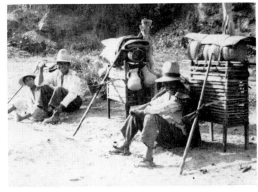

c

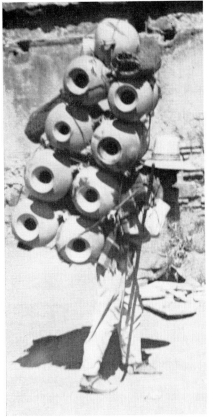

b

Plate 38. a. Pottery market, San Juan Ostuncalco. Man and woman from San Martín Sacatepéquez (Chile Verde) inspect the wares transported in mesh bags. *b, c.* Other methods of transporting pottery to market include *b*, by tumpline, and *c*, by carryall. Note *pichachas* (sieves) on carryall to right.

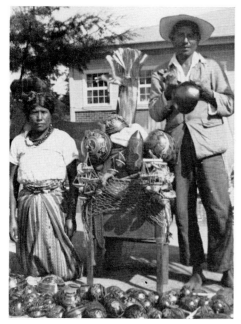

a

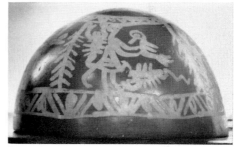

b

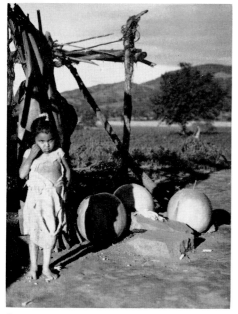

c

Plate 39. a. Rabinal Indians displaying
their carved gourds at yearly fair,
Guatemala City. Small baskets hang-
ing from corner of carryall are used
to measure small quantities of food
staples. *b.* Negative-painted gourd
with scorpion, duck, and female fig-
ures, Izalco, El Salvador. *c.* Fruit from
the taro vine ready to be converted
into containers (*toles*), El Salvador.

a

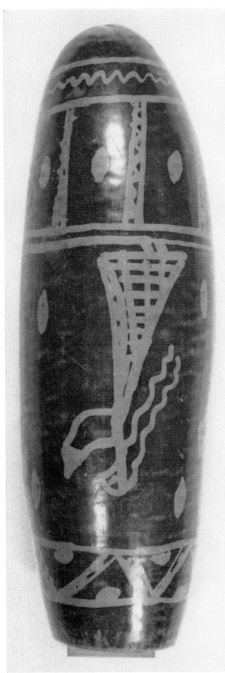

c

Plate 40. a. Black and white gourd in negative technique from Izalco, El Salvador, a form of gourd decoration not used any more. b. Old black and white *jícara* probably from Izalco, El Salvador. c. Very rare Colonial carved and silver embossed *jícara* from Antigua.

b

Tecpán. These men wear long woolen trouserlegs which are left to flap in the wind while the top part is tucked between the legs as a loincloth. The latter is adorned with innumerable buttons serving a purely ornamental purpose. Shirts are of white cotton as are the long undertrousers, finished with wide white lace or embroidery. The black and white wool coats with many pockets are worn to show a wide expanse of shirt. A long, white *tzut* is tightly drawn over the head and crossed at the back of the neck. The ends are brought forward and tied in a knot under the chin, from whence they hang over the coat down to the knees. Enormously long *chachales* with dozens of coins are worn around the neck. To complete the costume, another huge red *tzut* is thrown like a cloak across the back, with the ends knotted in front. You can imagine how well-stuffed and plump the well-dressed *cofrade* looks when he attends a church ceremony.

Perhaps the most startlingly beautiful men's costumes are those worn by the handsome, dignified Maxeño men (Chichicastenango). Here the old tribal traditions are almost intact under a very thin veneer of Christianity and European influence. Their costumes signify the age and office of the wearer by the placement and style of weaving of the symbols; for the women these are indicated by the length of their *refajos*.[6] The men wear very thick, heavy wool costumes, the trousers short to the knee and split to the thighs with side flaps shaped like the fins of a fish and decorated profusely in colored silks, the prominent symbol being the sun. The small boy from the age of seven wears a sun above a cross, showing that he is still under paternal protection. When twelve years old, he is permitted to wear two suns on his flaps, indicating that the youth is attaining his powers of manhood, though still under the aegis of paternal authority. At the age of twenty-one he is entitled to wear a most beautiful, single sun embroidered amidst floral decoration, indicative of his stature as a man capable of self-guidance. The man who is sterile is not entitled to these symbols. The costume is further enhanced by a coat with a V-opening at the neck, once exposing the chest, though modern custom now demands a shirt and a long,

[6] Once called *chuchuxeles* in Totonicapán, women members of the *cofradías* are now universally called *capitanas*.

wide sash of red cotton wound around the waist, its free-hanging ends finished with fringe. Worn also is a red or white *tzut*, depending upon the office the man holds, profusely embroidered with silk or cotton and embellished with large tassels. Sandals and knitted bag finish this spectacular costume, which is reminiscent of several Spanish peasant garbs.

One of the most spectacular women's costumes in this area, and perhaps in the country, is that of the Jahuiches (Pokonchí), as they are commonly called. These people are rapidly dying out. The principal village is Tamahú, though a few live in Tucurú and on nearby coffee estates. The costume consists of a three-piece, dark-blue *huipil* which falls over a very wide, red pleated skirt. The *huipil*, heavily brocaded in red, yellow, and green, has a center section of vertical zigzag designs. What sets these women apart is their distinctive headdress. They add heavy strips of red cloth to their hair and wind the whole about the head to form a unique turban.

In the Alta Verapaz region are worn very wide, rather short, full *refajos* with *huipiles* hanging over them. The women, who here alone still wear the unique *tupui*, wear a great deal of silver jewelry.

In the high Cuchumatanes Mountains the women in the majority of the villages wear a very long, wide white cotton *huipil* that hangs loose over the tightly wrapped skirt, both innocent of any decoration. The sandals for both men and women in this area have heel cups. In most of the villages the men wear some form of *capixaij*, probably for warmth.

In the Ixil Mountain villages (Cotzal, Nebaj, and Chajul) the costumes for men and women are of a special red cotton. The men's red jackets are worn with a red sash and white cotton trousers. Topped by a square straw hat, the costume is certainly one of the most colorful ensembles in the country.

Nowadays the larger towns that are surrounded by villages where Indians wear scant clothing require them by law to wear more clothing when they come into town. The women from San Sebastián bring a *huipil* of store-bought material and put it on just before entering Retalhuleu, taking it off after they leave. So also dress the women from Samayac, whose very bright *huipiles* of store-bought cloth contrast sharply with their hand-woven wrap-around

refajos. Men do likewise with their shirts, which they do not wear in their own villages.

Costumes and textiles of El Salvador retain very faint traces of the Indians' tribal background, as shown in the costume worn by the women from the village of Izalco. The tightly wrapped, long *refajo* is held up by a wide belt with blurred designs, woven in a special way that recalls those belts worn in the highlands of Guatemala (as, for example, Totonicapán). This belt is taboo to the women of neighboring Nahuizalco, though both villages are supposedly of the same Nahua descent. This very slender link might authenticate the tradition that when the Nahua Indians came to settle the villages on the steep slopes of the Izalco volcano, they were led by chieftains and captains belonging to the Mayas. It would naturally establish their relationship with the highland Indians of Guatemala. The link is strengthened by the fact that the Izalco women buy their *cortes* from the Guatemalan highland traders instead of weaving their own or buying them locally, as do the Nahuizalco women and the lower-class Izalco women who work in the fields and at crafts. Names of some of the best people in this village are more reminiscent of Mayan than of Nahua roots. Though I have not found any documentation for it, the Maya-Nahua tradition has been repeatedly told to me by people from that village.

At the beginning of the Colonial period in El Salvador, *alcaldes* wore costumes consisting of heavy woolen coats, white cotton trousers, and black straw hats with bright-red hand-woven bands. The younger men wore woolen aprons in black and white, such as may now be seen in the highlands of Guatemala.

However the different costumes originated and however they are worn at the present time, they are not only handsome and colorful but are important to the Indian's identity as an individual and as a member of his tribe. The Indian considers his costume to have a soul like his own to be cherished, spoken to kindly, and amused as if one of the family. When I asked a woman in the market the meaning of the gay red and yellow chickens, rabbits, comb, and tiny figures of jars that decorated her *huipil*, she said that they had been placed on it so that the textile might have something to amuse it, have water to quench its thirst during the long hours she was in

the market, and a comb to comb its threads into place when they became unruly.

Once a couple came to my door to sell the women's *huipil.* When I had paid for it, the man promptly appropriated the cash and, with his stick, gave the *huipil* a thorough beating to prevent the spirit of his wife from being sold and carried away with the textile. I have seen this happen repeatedly when buying textiles that have been used. I bought from an old woman a much-worn, beautiful old *tzut.* After much persuasion and promises on my part to take care of it, she gave it up reluctantly, first beating it and shedding copious tears over it, moaning and whispering to the textile how great her need for money and hence the necessity for parting with it, hoping that the textile would not hold it against her.

Recently in Huehuetenango an Indian from the village of Todos Santos, resplendent in his queer tribal costume, was seen peddling three costumes of his village. When asked the reason for this unusual occurrence (these people are very loath to mix with outsiders and not at all amenable to outside influence on their village customs), he replied, "I want to sell these costumes, as surely such valuable textiles will be enough to take me to visit the country wherein lives the *gringa* professor who tarried in my village, studying our ways. I want to see her again, as she was kind to me and cured my family when ill, and admired our costumes, and said they were good." (The name *gringo* is generally applied to foreigners of Saxon descent. In El Salvador they are called *cheles.*)

Customs

If costume is the "style of dress typical of a community" and customs those "social conventions carried on by tradition and enforced by social disapproval of any violation."[7] then in Guatemala both costume and custom acquire a far more picturesque significance. *Costumbre* (custom) once ingrained in a person or village, grows until it becomes part and parcel of that person's or village's costume. The costume gradually becomes a custom which influences the whole village. When Indians are questioned about why certain costumes are worn in such and such a manner, they give the same

[7] *Webster's New World Dictionary.*

answer, no matter where they are from. *"Es costumbre."* (It is the custom.) That ends the matter as far as they are concerned. A more sophisticated explanation may be found in the history of each village responsible not only for the native costume but also for the fact that it has become a matter of custom.

It is difficult to distinguish costumes and customs of the past from those of the present which incorporate changes effected by the influence of the outside world. For example, it is customary for the prescribed everyday costume of a Todos Santos man to be a red-and-white striped outfit with an oversuit of thick black wool, a red *tzut* on his head, a very flat-crowned straw hat trimmed with feathers perched squarely on top, belts and woolen odds and ends about his waist, and his feet shod in sandals with high heel-cups. When these mountain people travel, custom requires that the unmarried women of the family walk in front of the men, while the married ones follow meekly behind. Thus there is pattern of travel plus pattern of color provided by their distinctive costumes.

Another illustration of the items of costume decreed by custom is to be found in the procedures followed in an engagement of a young couple in Quezaltenango. The costume of the young man includes a red mesh sash. When his girl accepts his offer of marriage, it is customary for him to give her this sash as a token (*en prenda*). The girl shows the sash to her father without uttering a word. When the formal proceedings of asking for her hand are started, the *tertulero*, or go-between, arrives at the fashionable hour of two o'clock on Sunday morning. At two o'clock on Sunday afternoon, the young couple see each other face to face, supposedly for the first time, according to old custom, and present themselves for the parental blessing. Then and there the marriage price and details of the wedding are arranged; for example, the way the feast is to be conducted for the prescribed two days at the young man's house and for one day at the girl's.

The girl's wedding costume must also follow the dictates of the village. Her hair is arranged in two long braids tied with long, wide ribbons, bows falling almost to the hem of her skirt. Her *refajo* is very full and usually has been worn by her mother on her wedding day. There is a great deal of red in its texture, and a pine tree

is embroidered near the hem. The white shadow-work over-*huipil*, similar to our wedding veil, is heavily embroidered in a band of floral design around the opening through which the bride's face shows.[8] It is worn over her huge headdress, which is made of twenty yards of silk hand-woven *cinta*. The wedding *chachal*, here called *rosario* because it resembles a Christian rosary, is gold filigree with pearls, loaned for the occasion by the bride's grandmother.

After she has been spoken for, a girl must go to stay at her god-mother's on probation, to demonstrate that she is proficient in all the household arts before she marries. If she proves her worth, she has the privilege of wearing a bang of curls across her forehead, but if she does not come up to standard, she returns home with her hair neatly brushed back from her forehead and tightly braided. No wedding bells will ring for her in the near future.

More modern influences are felt by the Indians who live in the cities than by those who spend the major part of their lives in their own villages. The costume of Indian girls who work in the cities includes modern aprons. These must always be washed before they come in contact with the rest of their costume because non-Indian hands have made them. In some villages (Santa Cruz del Quiché, for instance) the apron has been adapted to become part of the Indian woman's costume. It is always made of Indian-style skirt materials, has many pockets, and is enhanced with braid, tape, or other non-Indian trimmings.

How closely textiles are associated with customs appears in the very interesting Holy Week *costumbres* of the village of Santiago Atitlán.[9] The costume worn by a figure called Maximón or Ma Shimón, supposedly representing Judas but really derived from the Indian's past, must be woven by virgins and washed far out in the waters of Lake Atitlán. When the girls come back to shore with the clothing, they are received with much rejoicing and a fiesta which includes chocolate, *atole*, and skyrockets. These maidens dress Maximón behind closed doors in the *cofradía* house dedicated

[8] Today this *huipil* is woven in Totonicapán in a technique differing from that used in Alta Verapaz, although they appear to be similar.

[9] In this village it is a bad omen for a man if a woman steps over him or his tools. Similarly, men must not sell or linger in the market place, an area which is solely the women's.

to his cult. Before they dress the idol, however, they must drop his costume from the loft (*tapanco*) to demonstrate that the "spirits send down this costume" (*los espíritus mandan esta ropa*). The costume of Maximón must not be touched or seen by outsiders until he has been completely dressed.

Fecundity is very important, even to the present-day Indian, who has lost many of his old beliefs. The concern with human fertility is clearly demonstrated in village customs and proclaimed on the woman's costume (though usually lost from men's garments), either by symbols or by the way the clothing is worn. In the village of Comalapa a young girl wears her hair down her back, caught at at the nape of the neck with a beautiful colored, narrow, woven ribbon. The woman who has had children discards this ribbon and winds her hair around her head several times to form a large knot over her forehead.

In Chajul the people still retain their Indian costumes. The women wear red or white loose *huipiles* over their tightly wrapped red *refajos;* the men wear red shirts and vivid red coats with numerous birds and beasts embroidered irregularly over the surface, both set off by white trousers. It is customary for a young man so dressed who has been accepted by a girl's family as a prospective husband to bite the girl on her right cheek. Once married, the bride is confined to the hut—not even allowed to go out for the customary jar of water which her husband provides before he leaves for his work—for the first nine months of wedded life. If by the end of that period she shows no sign of pregnancy, the husband has the right to throw her out, for she has shown her unfitness to be a member of his family by not fulfilling her sacred duties of family continuity.

When a maiden of the village of Olintepeque is ready to marry, she changes her everyday white-and-red striped three-piece *huipil* for a beautiful dark-blue *huipil* with horizontal magenta silk stripes. She also wears a dark-blue-and-white-striped, tightly wrapped *refajo*. This costume shows off to advantage her youthful figure as she walks down the village street. It is not long before a young gallant with thoughts of marriage in his head saunters casually up to the girl and drops a silver coin down the front of her *huipil*. If the girl

is receptive to his attentions, she permits him to remove the coin, thus indicating to all who witness this custom that she considers herself engaged.

It is a *costumbre* for a girl of San Pedro Sacatepéquez (S. M.) to be proficient in the various and difficult weaving techniques of her village; otherwise she may be beaten by her husband and her future in-laws, if not actually returned home to her parents for not complying with all the requirements of a well-educated girl. With her weaving she must be able to make enough money to buy a first-class wedding costume for her fiancé, a costume which is store-bought and quite according to modern fashions. On the other hand, her future husband must send her a complete costume a couple of days before the wedding. This includes a *huipil* with lavender cotton and yellow silk in the much-prized *acolchonado* technique at both ends, a bright gold and red *refajo*, a belt, and so forth, as well as a *huipil de cocina* (kitchen *huipil*). This ordinary *huipil* must always be made on the hip-strap loom in the traditional village colors of red, lavender, and yellow. The girl puts on her finery and, accompanied by her whole family, goes forth on her wedding day to the young man's house where the wedding feast is to be celebrated. At five in the afternoon, after all the festive food has been consumed, the mother and her father bid the girl a tearful good-bye and hand her over to her husband. The marimba plays melancholy tunes, and the parents and all their elderly friends weep copiously and leave the young people alone. Meanwhile, sundry rockets are fired to inform the world that the girl now belongs to her husband.

My informant from San Pedro Sacatepéquez (S.M.) said that the *costumbre* for the neighboring village of San Antonio Sacatepéquez was very uncivilized compared to theirs. The young man who fancies a girl casually goes to her father and offers money, liquor, and promises in exchange for the girl. If the father accepts, the girl must change into her best costume, which is somewhat similar to that of San Pedro Sacatepéquez (S.M.), though not as elaborate, and forthwith departs with the young man without wedding celebrations, music, food, or any other token for the rest of the family—"exactly like buying a pig and taking it home; very different from the civilized customs prevalent in our village."

As we have seen earlier, some of the most striking costumes in the country are those worn by the men and women from Santo Tomás Chichicastenango. A change in costume is part of the tribal rituals which are still observed in this village. For example, when a *cofrade* is nominated by the *Alcalde de los Naturales* and elected by the rest of the *cofrades* in secret conclave, he may not wish the office, but he has no choice whatsoever in the matter, as they bring him by force to the *juzgado* and put on him the special jacket which is the sign of his office. Once vested, he must serve a year or so in the organization without protest.

One of the very few traditional customs still practiced in El Salvador can be found in the village of Cacaopera—that of the election of the village *alcalde*.[10] The customs connected with this election again involve a matter of costume. The Indian candidates are made to stand in a row opposite an equal number of men with bows and arrows[11] with strings drawn so that the points can penetrate no farther than a pin prick into the candidate's chest. The blood that comes from the wound is tasted by all the judges, who decide which candidate has the purest blood of their tribe and is therefore the one elected to the coveted post. (I cannot guarantee whether they know anything about the difference in the quality of the blood!) The candidates wear a very clean pair of white trousers and a white cotton shirt (removed for the ceremony) hanging squarely and loosely from a yoke. A broad palm-leaf hat completes the costume.

In the village of Senahú, where immigrants from San Pedro Carcha settled years ago, the women's costumes are very picturesque. They wear a three-piece *huipil* with a brightly colored center section, and a very full, pleated skirt. This costume is typical of the Alta Verapaz area, where the Indians are more tribal than village conscious.

A reversal of the usual engagement custom is to be found in this village. Here the father of the girl asks for the hand of the young man for his daughter. On his first visit he takes with him one *quetzal;* on his second, he brings two *quetzales* to show the earnest purpose

[10] The *alcalde* of El Salvador and Guatemala is the mayor of the town. He is no longer called *intendente*.

[11] Bows and arrows are decorated in this region with designs made of the seeds of the plant called *Lagrimas de San Pedro (Coix lacrima)*.

of his visits. If on the third visit, when the matter is talked over quite openly, his petition is not accepted, his money is returned.

The women from the village of Mixco make a pretty sight in their ceremonial costumes. The skirt is wide, with stripes and *jaspes* in many bright colors, a hem bound with black braid, and black and colored ribbons above the hem on the skirt. The *huipil*, nowadays bought from Quezaltenango traders, is worn over the *refajo*, as all proper *cofradía huipiles* must be worn. Filmy, curtain-like material is worn on the head when entering church or walking in religious processions. The headdress is an enormous mound of woolen *tocoyales* in reddish purple, black, green, and red wound into the hair. The belt that holds up the skirt is woven in white weft threads with red, green, and orange cotton or purple and magenta wool in a traditional design. Much jewelry is worn by these women with their ceremonial costumes. The belt and makings of the headdress are always bought from traders who come during the dry season (once a year) from distant Oaxaca, Mexico. The Mixqueñas will wait all year for these traders to acquire a new belt, despite the fact that they weave other textiles in their own village. A Mixco woman, years ago, would not consider wearing any other kind and was careful to see that the one she bought had woven into it designs of small double-headed doves and human figures holding a bunch of feathers.

Morgandanes states that "in San Juan Yalalag, a little village northeast of Oaxaca City . . . women wear similar headdress and belts identical to those worn by Mixco women. Both items . . . are imported from Oaxaca into Mixco."[12] This identical habit suggests a probable historical relationship between the mixed Pokomanes now dwelling in Mixco and the Indian population of San Juan Yalalag. These Pokomanes are descended from the population moved by Alvarado to modern Mixco from Mixco El Viejo when he destroyed the latter stronghold. The Pokomanes inhabiting Mixco El Viejo in Alvarado's time apparently migrated there from Cuscatlán and probably represented an admixture of Pokomán and Mexican Pipil.

[12] Dolores Morgandanes, "Similarity between the Mixco (Guatemala) and the Yalalag (Oaxaca, Mexico) Costumes," *American Anthropologist*, NS, Vol. 42 (1940), 361.

Thus does some current detail of costume such as a belts worn by the women of two communities in different modern nations reflect migrations and tribal admixtures long past.

Another example of how such a detail of modern dress may reflect past tribal history is afforded by the *huipil* worn by these Mixco women on ceremonial occasions such as marriage or death. This *huipil* is identical with one affected by the Cakchiquel women in San Martín Jilotepeque. The latter community is situated just west of the Mixco El Viejo ruins. Thus the *huipil* common to Mixco Pokomanes and San Martín Jilotepeque Cakchiqueles suggests a long admixture of feminine taste, if not blood, in those pre-Conquest days when the ladies' ancestors lived in communities not far distant from one another.

In Cobán a discreet woman does not appear in public without pulling her *huipil* to the front and securing it with her right hand, her left arm folded demurely across her waist. A gay young person—today practically all the younger generation—walks along debonairly with arms swinging at the sides, totally disregarding the earlier custom.

The Indian who has become *aladinado* has discontinued his costume and perhaps, more important to his way of life, his village customs. Having given up his native mores and customs and not yet assimilated those of European culture, he goes through a transitional period wherein he has no guideposts whereby he may satisfactorily gauge his own conduct. Lost to him are both his native customs and costume—the outward symbol of his most important cultural traditions—and his sense of belonging and sense of security.

Dances

Dances, largely mimetic in character, are customarily performed as part of Indian ritual rather than for recreation. Such performances are always planned for some feast day or other special commemorative occasion. Very special costumes are needed, as the dancers assume the roles of animals, warriors or Spanish soldiers, Christian saints, and pagan gods. It is costume rather than song or choreography which identifies the role played by the dancer. Since the dances are matters of grave importance, months are necessary

for their planning. Because these dances are based on Indian rituals modified to meet the requirements of Christian religious festivals, it is next to impossible for a casual observer to understand them. I am aware of only one exception to this custom of ritual dance, and that is *El Son*, a secular dance of which there are several variations. The costumes and customs of the dance rituals are endless; hence I will cite only a few of the less well-known and most unusual ones.

Ritual dances fall primarily into two categories; those of pre-Spanish origin, requiring simple costumes, and those dating from post-Conquest times, with very complicated, ornate costumes. The most popular of the latter are those which represent the Spanish Conquest and include dances known as *La Conquista, Los Moros, Los Toritos, La Historia,* and *El Tunco de Monte.* For all of them the costume display is stupendous.

Dance costumes exemplify the Indian love of color and express the Indian concept of the roles portrayed. Within this concept, dance costume is realistic to a degree. For example, the costumes for all the later dances emphasize imported materials, props, and styles that were not known before the Spanish Conquest. The costumes are stylized and conventional and not subject to alteration of any detail by the individual dancer. They are usually rented for the performance.

Indians will travel many miles over difficult trails to San Cristóbal or San Miguel Totonicapán to hire the costumes. The most famous source of supply is the Totonicapán store of the late Miguel Chuj (El Moreno), which he inherited from his father and grandfather. The store is crammed full of all sorts of dance paraphernalia, including masks and costumes of every description. The costumes rent for from one to one hundred dollars for a complete outfit, depending on whether they are simple or ornate and whether the cast is large or small. The men who are sent to hire these costumes very seldom pay the whole rental in advance, but they always seem to be trustworthy and faithfully return the entire outfit, settling the bill in full at that time. They transport the more delicate parts of the costumes in tribal *tzutes.* Less fragile parts are carried in large bundles or saddlebags.

In addition to San Cristóbal and Totonicapán, costume sup-

pliers are now to be found in the larger villages such as Santo To-más Chichicastenango, San Pedro Carchá, and Comalapa. The store of Miguel Chuj, however, remains the pre-eminent source of supply. I have known men to come from as far away as southern Mexico to rent costumes from him for village festivities.

All kinds of strange and seemingly unrelated articles are part of the costume of the dance character. Occasionally a folded towel is carried over one arm; an umbrella is hooked over the arm and unfurled during the dance; or perhaps a large handkerchief in gay colors is waved back and forth as the dance proceeds. Many ribbons, coins, bells, shells, and beads hang from mask, hat, sleeves, and other parts of the costume and jingle pleasantly as the man dances. Swords, round tin plates, gourds, rattles (*chinchines*), sticks, whips, and lances similar to those used during Colonial days are a few of the many adjuncts of the costumes. In El Salvador the lances are still called *partesanas* with the old Spanish meaning of halberd.

Whereas the Indian choreography is as realistic as possible, it has had to give way in recent times to practical considerations. For example, in Santa María Chiquimula the Dance of the Conquest was performed with horses, but this practice was discontinued in 1940. Similarly, toys are now carried in dances where small animals were formerly used; now the jester carries a toy monkey during his performance.

The clothing used by the jester (*gracejo*) in both countries is a conglomeration of ragged and tattered odds and ends of everyday dress; or he may be dressed as an unesteemed animal, perhaps a rat. The jester, a figure shown in paintings and carvings of the Mayan period, is always greeted by the spectators with rejoicing. He performs antics and carries in his hand a rattle, whip, or toy monkey animated by means of a string. With these he makes gestures, sometimes ribald, to entertain the audience during the otherwise monotonous performance of the interminable ritual dances.

A mask is an important part of the dance costume. Old-style masks were made of wood, carved and painted artistically to represent the desired expressions of the various characters. Some have movable horns and eyelids. In certain dances in El Salvador I noticed that the Spanish conquerors were distinguished by red masks,

while the Indians, as such, wore blue. One explanation given was that the masks distinguished the Christian (red) from the pagan (blue) characters. I was also told that the masks with a roll or stick across the upper lip signified Toltec warriors while the masks of Aztec warriors bore rings with colored stones—mostly green, representing jade or emerald—between their half-opened lips.[13] Poorer people who cannot afford such wooden masks fashion their own from the bark of palm trees, cutting slits for eyes, nose, and mouth (*aculhuaca*), or make them of wire screen (Caribs). Other substitutes are made of the fruit of the morro tree, and cheap, imported masks made of papier-mâché are used as well.

Another customary part of the dance costume is a wig. These may be made of cotton, wool, henequen, or other fibers. Those furnished as part of the most expensive costumes are made of dyed human hair.

In El Salvador the dance costumes are much simpler than those in Guatemala. The rich velvets and satins of the Spanish characters are here replaced by cotton prints and calicos, resulting in a less colorful effect. This substitution of cheap for expensive fabrics may be related to the rapid disappearance of Indian costumes and customs in that country.

For the pre-Spanish dances, which are generally derived from some ancient form of fertility rite, the costumes are often simple cotton shirts and trousers. In these dances the principal characters represent animals and wear either the skin of the animal, cotton trousers and shirt painted to represent the skin, or a representative mask. Such is the dance called *Tilux* performed in San Juan Ixcoy, in which the participants wear animal skins. The implication of the dance is that animals are the rightful owners of the forests. Another dance in which animal skins are used as costumes is called *La Copa de Barro* (*samchosh*, clay vessel).

The monkey is the animal most frequently portrayed. This

[13] The Mayas inlaid the teeth with turquoise and inserted a jade stone in the mouth of their dead (F. Blom, S. S. Grosjean, and H. Cummins, *A Maya Skull from the Uloa Valley, Republic of Honduras*, 11, 13; José Milla, *Historia de la América Central*, I, 42). I have seen teeth encrusted with jadeite in burials of the Mayan period from the collection of Sr. Vitalino Robles in Quezaltenango. It is also mentioned in the book of Eduardo Cáceres, *Historia de la odontología en Guatemala*.

character calls to mind the legend of the Popol Vuh,[14] in which the two culture heroes turned into monkeys to amuse their mother. The dancer, dressed in a black woolen suit with a long tail and a realistic mask, performs amusing antics as he capers about.

Another favorite dance character is the snake, either a live one used in the dance (Snake Dance in Chicalaja) or an enormous representation made of papier-mâché (Comalapa). In a dance performed in the region of San Miguel, El Salvador, the principal character covers himself almost completely with the skin of a large snake, letting the tail drag on the ground. With his toenail, which he has carefully cultivated for months in anticipation of his part in the dance, he scratches the ground in imitation of the sound (*cascabel*) of a rattlesnake. His mask has the cold empty expression of a real snake.

Sometimes early and late dances appear to have been combined, if one may judge by the costumes. In such dances one performer may appear in simple cotton garb, while another is dressed in a modern frock coat striped in yellow and black and knee breeches or perhaps long trousers made of black or colored satin. Similarly, Spanish costume and pagan custom may be combined in such dances, especially in one called *Torito* or *Toro* (the Bull) in Guatemala. The man who kills the bull carries a long knife. Before starting his work, he makes a dramatic gesture in front of the altar on which rests the figure of the Christian saint, or perhaps points to the four corners of the earth. Then he pretends to stab himself in the chest, a gesture that was made by the ancient priests in the temples before sacrificing their victims to the pagan deities.

Another such dance, *La Invitación á la Fiesta*, is probably derived from a fertility rite, although the Indians do not appear to be cognizant of such an origin. It is performed in the village of San Pedro Nonualco as a curtain raiser, so to speak, to the popular *La Historia*, the Dance of the Conquest. In this dance the female character is portrayed by means of hanging a skirt of many colors from a long pole topped by a silver disk, the symbol of the sun and hence fertility. The pole with the skirt is taken first to the priest for blessing and then to the center of the village where the *alcalde* and

14 Recinos (translator), *Popol Vuh,* 144–45.

regidores kiss it in turn before commencing the main part of *La Historia*. As it is believed that the chief dancer will be married within a year, this part is much sought by men who have been unfortunate in their love affairs.

In the aforementioned *La Historia* the costumes of the *conquistadores* as well as most of the Indian chiefs are made of red, blue, or green velvet combined with satin and profusely trimmed with metal braid, embroidery, fringes, bits of looking glass, spangles, coins, ribbons, and feathers. These costumes are cut in the style of sixteenth and seventeenth century Spanish dress. The Indian chiefs not only wear long trousers with military stripes but also small aprons back and front, suggestive of the loincloth. His gorgeous costume set off by a wig with long reddish curls implies that Alvarado, conqueror of Guatemala in 1524, was the son of the sun (Tonatiuh). Alvarado's aides, too, are dressed in the epitome of elegance.

The costumes representing the Spaniards are surmounted by three-cornered hats with elegant plumes, ribbons, buckles, and braid, or by round caps with bunches of flowers. In contrast, the Indians wear huge headdresses topped with zoomorphic figures. The principal characters wear long hose of bright pink or white cotton and high-buttoned red or black boots. The rest of the performers wear ordinary shoes. Leggings are often worn and are usually made of canvas and trimmed with braid and even spangles. The rented shoes are always too large for the small-footed Indians and torture the wearers during the continual dancing which goes on for days on end, but they will gladly suffer this discomfort in return for the honor of participating in these festive occasions. Neither is the head covering particularly comfortable, since it includes not only headdress and mask but also a cloth wrapped around the head to cover any gap between them. This cloth, as penitence and offering to the saint whose special day is being celebrated, is not removed for the entire period of the ritual.

The participation of women in ritual dances is prohibited; neither may women go near the costumes for the dances. Sexual abstinence is maintained by the dancers during the period of the performance. Female characters are personified by men in feminine dress. Several dances in both these countries include a couple that

represent "Old Man" and "Old Woman." Why, nine times out of ten, the woman's costume should be a floor-length and drab old Mother Hubbard made of cheap commercially woven material and a rather worse-for-wear straw hat trimmed with artificial flowers I cannot fathom, but that is the preferred costume for this role.

Dancers representing saints are also clothed in costumes of Spanish Colonial style, and they, too, wear a small satin apron tied around the waist. I once saw a costume for St. Sebastian (Paleca, El Salvador) in brightly colored blue and pink with silver and gold paper fringes and white lace. The dancer's cape was a square silk tablecloth profusely embroidered with flowers. His face was covered with a red mask which had black trimmings (eyes, nose, mouth, and moustache). He wore a black wig on which sat a tall crown of silver paper, and his feet were shod in large black shoes. St. Sebastian was closely followed in his every move by a small boy dressed in a fashionable, much-ruffled blue organdy costume, his head swathed in a turban of pink satin with silver and colored flowers. On his feet were white man-sized tennis shoes, which he appeared to find uncomfortable. Every now and then, when no one was looking, he slipped off a shoe and wriggled his toes. Other dancers were dressed in much the same manner as the saint, himself, though their long trousers had wide stripes and their faces were covered either by a white cloth or by masks representing a human being and topped with a weird figure of an animal (snake, tiger, etc.). The animal may have been the Indian's *nahual*.

Quite out of the ordinary and not according to the ritual-dance traditions is a performance given in San Pedro Sacatepéquez (S.M.). Called *Danza de la Pach* (Dance of the Corncob) and danced by women, it is dedicated to the deities that preside over the weather and make the corn grow. This dance is further unusual in that several girls take part. Their participation suggests old rites wherein virgins were chosen for service in the temples. They are young, good looking, unmarried, and exquisite dancers. They wear beautiful bright yellow and red *refajos* and *huipiles* in yellow silk and purple cotton and the best *chachales* and rings they own or can borrow. In addition, they wear modern-style aprons with two pockets in which they keep their hands while they dance with their eyes fixed

discreetly on the ground. In turn, each girl takes from the altar a figure made of corncobs and husks with hair of corn silk which is dressed in a replica of the woman's costume of this village. The girl dances, reciting to the deities that control the weather, while a male dancer circles around her as she moves with slow steps up and down to the tune of the marimba. The corn from the cobs which form these effigies is used as seed for the next planting.

Another excellent example of the marriage of Spanish concepts and Indian ritual is to be found in the El Salvador Dance of the Mountain Pig. The chief character is dressed in a huge pigskin. After several hours of monotonous recitation and dancing along the village streets, the procession comes to a halt, the pig is symbolically killed and quartered, and the pieces are figuratively given away to the populace by the killer, who is dressed in Colonial Spanish costume. The various parts of the pig are distributed with hilarious and lewd remarks about well-known village persons and neighbors and are received with great clamor. I have heard words recited during this performance that distinctly belonged to pagan tradition, such as supplications to the deities for good weather for the crops and thanks for the abundant crops of the last year. The speakers appear to relate such recitations to Christian rather than pagan ritual. The sacrifice of the pig suggests an offering to the ancient deities, especially to Tláloc, god of rain. This dance is terminated by offering the best piece of the pig to a statue of the Christ Child which reposes on an altar carried on a litter at the head of the procession.

The *Jeu-Jeu*, performed in Izalco, is a typical seasonal dance. When I saw it in 1933, the principal characters were dressed to represent savages, or *jicaques*, a term used in both Guatemala and El Salvador to designate wild men who wear little clothing and live in the jungles in northern Guatemala and the unexplored territories of Honduras. Their costume consisted of a short full skirt made of grasses and palm leaves, a gilt crown trimmed with large feathers, gilt bracelets, belts, and leg ornaments, and they carried bows and arrows. (A Guatemalan costume for these roles consists of skirts of wheat grass [Comalapa] and rough, untidy henequen wigs.) Twelve dancers encircled a thirteenth, who slowly threw corn on the ground while repeating invocations to the weather deities. Periodically the

dancers stopped and shrilly called, "*Jeu-Jeu! Vengan las aguas, vengan las aguas!*" (Let the rains come, let the rains come!) The echo from the distant hills and dense vegetation came back as "*así sea, así sea*" (this shall be done, this shall be done).

These thirteen dancers were finally joined by another group who performed *La Ofrenda de las Mazorcas* (the Offering of the Corncobs). The newcomers carried long poles of the stripped and cleaned wood of the *guarracho* tree (*Quararibea funebris* [Llave] Standl.). These poles had short branches on which were stuck ears of red, yellow, black, and white corn. Some of the poles were twenty feet high and were daubed with red and blue—indigo and cochineal. They had been stored in the *cofradía* house prior to the performance, and if a woman had even come near them there, it would have been interpreted as an omen for bad crops for that year. The corn from these cobs was used for seed at the main planting in that section of the country.[15] I was told that years ago this whole performance, including the offering of corn, had special reference to the *tzolkin*.[16] The principal members of the cast had then recited, each in turn, thirteen verses to the music played on the *teponaztli*.[17] Each verse had special reference to one of the thirteen months of the *tzolkin* calendar and always ended with the cry, "*Jeu-jeu.*"

The gaudiness and extreme richness of the dance costumes is in keeping with Indian tradition rather than Spanish influence as suggested by their fabrics and cuts. Centuries ago the ancestors of these Indians performed dances whose costumes were most spectacular and whose themes continue to be expressed in modern dances, whether or not these themes are known or understood by the Indian of today.

[15] In El Salvador there are many sections where the lush soil produces three crops of corn a year: the *tunamil*, or corn planted in the month of September when the rainy season is about to end (*miaz de sol*, sun corn); *supanmil*, planted when the rains are about to commence, either in April or May (*maiz de invierno*, winter corn); and *apanmil*, planted about the end of December (needing irrigation to make it grow; *de regadillo o humedad*).

[16] The *tzolkin* was the sacred year of 260 days observed by the pre-Columbian Mayas. In highland Guatemala it still serves as a basis on which to calculate dates for the performance of rites and ceremonies, but in El Salvador, so far as is known, it is no longer in use.

[17] The *teponaztli* is a musical instrument of Mexican origin, now almost extinct. Made of a hollow log with sealed ends and two rectangular slits on one side of the cylinder, it is played with rubber-tipped sticks.

PART II

* * *

Other Crafts

XIII

*

Miscellaneous Fiber Products

TEXTILE WEAVING is now the most important craft of the Guatemalan Indians. Besides textiles, many other items of their material culture are handcrafted of fibers. These adjuncts to daily living are largely made of vegetal fibers other than cotton and include such items as bags,[1] rope, hammocks, saddlebags, fish nets, fire fans, and the like. The processing of fibers for the manufacture of these articles is an important Indian occupation. In El Salvador the fiber craft is well developed and forms one of the principal industries of that country. String bags, pack-animal accessories, rope, and the famous hammocks are the principal products.

The Processing of Fibers. Plant sources of fibers used in Indian crafts include the *corozo* palm (*Attalea cohune* Mart.). The banana plant used in the fiber craft, erroneously called Manila hemp

[1] I wish to recall to the reader the knitted wool bags described earlier such as are carried by men of Sololá, Zacualpa, Nahualá, Santa Catarina Palopó, and Joyabaj. They are usually black and white, handknitted by the men as they walk along the trails. The needles used are two small wooden sticks, or perhaps metal umbrella ribs. Lately modern knitting needles are preferred

and useful only for its fiber, should not be confused with the edible banana (*Musa sapientum*). The fibers of *abaca* (*Musa textilis*) and *tizote* (*Yucca elephantipes* Regal) are also utilized. Many kinds of plants of the genus *Agave* are used. The principal fibers of the *Agave* are variously known as henequen or sisal, *mezcal, mezcalito, pitón,* and *pita floja,* and are used for hammocks, bags, horsegear, ropes, cables, twine, fine cord, and other articles. Whereas in Guatemala henequen fiber is used only for Indian crafts, it is one of the chief crops in El Salvador—mainly in the San Miguel sector—and is extensively cultivated for exportation, although it is also processed locally for the manufacture of coffee bags and for craftwork.

The Indian method of processing henequen is of interest. After the green henequen leaves are cut, they are beaten with a hardwood club or mallet (*pilón*) to separate the fibers. Though quantities of prehistoric grooved stone bark beaters, mostly oblong, have been unearthed in different sections of these countries, I have not seen any similar modern ones used at the present time. Well-worn river stones are used instead. The pulp is then separated from the fibers with a large forklike wooden tool. The remaining fiber is well washed in river or lake and hung on a tree or spread on the ground to dry. Finally, it is combed several times to separate the fibers, which are tied into skeins ready for sale or immediate use.

Aniline dyes are used to color these fibers. These colored fibers are employed for the manufacture of such articles as hammocks, saddlebags, horsegear, and bags. One method of decorating bags is by painting on the designs after the bag is completed. The results are extremely crude. By another method, the string is dyed before the bag is woven. It is stretched between small stakes, then rubbed with color for predetermined lengths so that a pattern will appear automatically as the bag is woven. Sometimes the dyeing is done so as to achieve parallel lines of alternating colors, sometimes to suggest tie-dyeing.[2] The latter is very typical of the San Pablo La Laguna craft, although it is not the true and careful *ikat* (*jaspes*) of the textile craft.

Maguey fibers are used in the region of Acatenango. In this

[2] Samuel K. Lothrop, *The Henequen Industry of San Pablo, Guatemala.*

area the maguey plant takes six years to reach maturity. Young plants used in its propagation are known as *hijos,* or it may be propagated by means of cuttings taken from the short, tender inner leaves (*tiernos*). Every year the outer leaves are cut in a slanting direction so that in the rainy season the water will not collect in and rot the plant. From one *quintal* of leaves five pounds of fiber are extracted. It takes one *mozo* four hours to extract the fiber from one *quintal* of green maguey leaves.

The best quality of *pita floja* grows in Acatenango, though it is abundant in the hot lands along the coasts. One variety of this fiber is so soft and pliable that it resembles silk when well cleaned, twisted, and woven. Acatenango-grown leaves are cut, thoroughly washed, and passed through a *parenquima.*[3] The *parenquima* consists of a sapling firmly inserted in the ground or tied to two posts and doubled over to form an arch, to which are attached close together two small, rough, upright sticks. The maguey leaves are forced between these sticks and deftly manipulated back and forth until all the bagasse (*bagazo*) or pulp has been extracted, leaving the clean, white fiber. Another kind of *parenquima* is made of two small, rough, unfinished boards between which the leaves are passed back and forth so that the fiber is well separated from the pulp.

Once this process is concluded, the fibers are washed and dried in the sun and are then ready to be sold or twisted into string or rope. The Indians of Acatenango claim that their product is superior to that of the San Pablo La Laguna Indians because of the way in which the fiber is separated from the pulp. The latter Indians, it is claimed, allow the leaves to putrify, which is said to weaken the fibers.

A number of these plant fibers lend themselves nicely to weaving. Upright looms are used for weaving Guatemalan pack-animal accessories (*cinchas* and *enjalmas*), slings for casting stones woven by the Lenca Indians of El Salvador, and saddlebags and some hammocks in both countries. For the saddlebags, the Lenca use looms one and one-half yards long by one-half yard wide. Pack-animal ac-

[3] *Parenquima* is a Spanish word adopted by the Indians for the soft part of the leaf, as well as for the device which separates fiber from pulp. Parenchyma is the fundamental tissue which makes up the bulk of fruit pulp or pith of stems.

cessories and slings are woven of untwisted fiber known as *pitón,* a much coarser fiber than is ordinarily used in the rest of the fiber craft.

Bags. One of the most important products made of fibers not customarily used for the manufacture of textiles is the bag. In Guatemala some kind of bag is indispensable to a man's costume and the variety of fiber bags is enormous. Equally varied are the techniques by which they are woven. The smaller ones are slung over the shoulder by a long, handle-like band with a slipknot to shorten or lengthen it according to the wearer's choice. The biggest (*redes*) are used for carrying large quantities of such things as wool, charcoal, or vegetables. Cotzal and Nebaj are centers for the bag industry, as well as string and rope. Every street and every hut has its own workshop. Long fiber twine is twisted from one side of the village street to the other.

Matates, morrales, and other small bags made by San José Poagil Indians are of maguey fiber. A three-inch needle is used for their manufacture. It is made of bone from the foreleg of a sheep and rubbed until smooth as old ivory. A small hole is drilled through the top to serve as an eye.

The bag called *chim* by the Maxeño Indians is made in a standard technique and adheres strictly to traditional design. The everyday, ordinary *morral* is woven of *pita,* and henequen fiber, while ceremonial bags are woven of very coarse cotton yarn on upright looms.

Cotzal *redes* are open-mesh fiber bags used to carry charcoal, vegetables and other bulky articles. A pad of straw or leaves is placed under the bags to protect the carrier's back from the heavy load. Men and boys weave these *redes* at odd times, perhaps while waiting for an official to attend to their business or while exchanging the day's news with one another as they wait in the corridor of the *Intendencia* (*Alcaldia,* town hall).

The Nebaj bags are smaller than the Cotzal *redes,* though they are made by the same technique. *Morrales* and smaller bags are also woven in this open-mesh technique, but the mesh is finer. For the latter the loops are cast over small-gauge rods or sticks, whereas for the large bags or *redes* only the fingers are used to cast the loops.

Bags are also woven with a tiny wooden stick which has a small slit instead of an eye for the string. The weaver begins his bag down at his ankles and, working around his body, continues upward until the top edge of the bag is reached near his waist. He then steps out of the finished bag and inserts strings in the loops at top and bottom to close the ends.

Rope Production. The production of rope, twine, or string is an important Indian handicraft. A wheel much like a spinning wheel is used for spinning the fiber. It is mounted on a small upright frame on the ground beside which a man sits and works the wheel by turning a small iron handle. His wife helps him by walking back and forth holding an armful of fibers which twist through a little bamboo cane at the side of the wheel, and are spun into a long thread. The Indian woman makes cording from the spun fiber thread by the use of a small wheel attached to a board held in her hand.

Ropemaking is generally the work of women who employ for the purpose a small wooden implement (*taravilla*) that is rapidly twirled around an axle by one woman while another feeds to it the two-ply fiber strands. In many places, however, men make string or twine by the age-old method of twisting the fiber across their bare thighs, passing their hands rhythmically back and forth to make a two-ply string. This technique is a very old one and is generally believed to be the method by which spinning was done before the invention of the spindle. The rough fiber irritates the skin and often causes profuse bleeding.

Very famous for their fiber production and rope-making industry are the regions of Alta and Baja Verapaz, particularly San Cristóbal. The rope is made into *manojos* (handfuls) containing two *lazos* (ropes of six yards each), by which measure they are sold for a few cents apiece. Olopa is also known for its fiber crafts, wherein henequen, *mezcal*, and cimarron fibers are used.

The process for preparing henequen in El Salvador is identical with that of Guatemala. In El Salvador both men and women use the *taravilla* for twisting the twine and string. Rope is twisted on a ten-foot-high wooden wheel worked by a man who turns the handle of the wheel rapidly as he winds string into two- or three-ply rope. The same method is used for the preparation of twine for

the upright looms and cotton for textile looms; namely, the *urdidor* or warping bar which has a number of sticks on which the fiber is placed. A more primitive method utilizes two sticks set in the ground according to the length of the loom required.

In El Salvador medium-thick rope is sold by *brazadas* (one dozen strands, each six yards long). Very fine string is made from well-twisted two-ply *coco* fiber (*Cocos nucifera* L.) and also from the fiber of the banana (the many species of *Musa*). The fiber of the *escobilla* (*Sida rhombifolia* L.) is frequently used for ropemaking as well as weaving bags. It is estimated that a rope of this fiber measuring 12.5 millimeters in circumference can sustain a weight of four hundred pounds. The plant grows everywhere in El Salvador. San Miguel, Suchitoto, and Chirilagua, famous centers for this craft, are regions where *escobilla* grows abundantly.

Hammocks. Hammocks are commonly used in both countries, and those of El Salvador enjoy some renown. The upright frames used for weaving hammocks are made by driving two long, heavy poles into the ground. The technique varies a little between the countries and also between the villages where this craft is carried on. In Guatemala, most of the hammocks and smaller bags are woven in a loose plain over-and-under technique. In El Salvador the finest hammocks require a hardwood needle made of *guachipilin* wood (*Pithecolobium albicans* [Kunth] Benth.). The finer the needle, the finer grained the wood must be. These hammocks require twenty-three yards of *mezcalito* cord. It is wound around the needle, which has a *lengueta* (tongue) slit on one side to hold the cord or twine firmly while the man weaves.

In this latter country a few hammocks are woven by stretching the warp fibers on a large horizontal frame (in this instance serving as a loom) which is slightly raised above the ground. A man throws the shuttle with the weft string across the frame and through the warp yarns to his wife on the other side of the frame. Small hammocks are woven by placing two sticks in the ground in the desired size for the hammock. The man or boy who makes it uses his fingers to cast loops from one row to another, very deftly judging the spacing of the loops in order to make the mesh even.

This netting technique is the same as that used for small bags and nets.

Saddlebags. Since pack animals are still in common use in these countries, saddlebags are in demand. The finest saddlebags come from the town of Zacatecoluca. The top of the loom used for making them is fastened with a rope to a branch of a tree; the bottom is weighted with stones or a heavy end-stick to keep the loom hanging taut vertically. The weaver, customarily a man, sits on the ground, a stone, or a stool. The firm battening of the fiber weft threads makes a peculiar noise and gives these looms their name, *chillote* (noisy). In Chalatenango, however, two upright poles serve as a loom and are driven into the ground at the required distance apart. On them the saddlebags are woven with *mezcalito* fiber. These vertical upright looms formed by two long poles are used also in the Guatemalan villages of Jocotán and Camotán. (Jocotán is also well known for its excellent violins. It is claimed that the tone, because of the quality of the wood, is the best of all those made in Guatemala.) Saddlebags (as well as other small bags) are also woven on hip-strap looms in a plain technique and with firm battening of the weft fibers (Ixchiguán).

Saddlebags are finished by doubling over the two long end pieces upon themselves and sewing the sides with a large needle threaded with fiber. The middle is braided for a handle, and the loose ends are inserted into each other from side to side. These middle warp threads may be left loose, without any crossed weft threads during the weaving process, and later firmly wound with colored fibers in separate units to make a strong handle.

Nets. A very special craft product of both Guatemala and El Salvador is fish nets. Made of cotton yarn or henequen fiber, they are manufactured in a specialized technique by men living near lakes, large rivers, and the sea. With one end of the net fastened to a tree or post, the loops are cast by hand and knotted, one by one, into the preceding top line, perhaps using a small bone or wooden implement instead of the fingers to produce very fine fiber nets. The work is done rapidly and is amazingly even. The nets are weighted with stones, clay beads, or other readily available small heavy ob-

jects. Very good nets are a specialty of the villages on the Pacific Coast as well as Quezaltepeque, where fine, well-finished nets are woven in this old technique. I was told that some clay beads and jadeite stones which were being used for weighting the nets in this village had been unearthed in pre-Conquest sites.

The discovery of the netting technique is attributed to a Mexican deity, Opuchtli, one of the gods who preside over weather conditions and agriculture. That the technique was much used by the Mayas is clear from the costumes depicted on stone and pottery. Nets are also frequently mentioned in histories dealing with pre-Conquest times: ". . . the invention of fishing nets. . . . a very rich looking blanket fashioned like a net. . . . a blanket of cotton very thin like net."[4]

Fire Fans. Fire fans (*sopladores*) are a common trade article. The heart of a rush (*Cyperus canus* Presl.), after the glossy outer strands of this plant have been stripped for mat weaving, is used in Guatemala and El Salvador for making fire fans as well as handbags and saddle blankets (*sudaderas*). In El Salvador this flexible and porous material is called *tule* or *sontul;* in Guatemala, *cibaque. Cibaque*, cut when the moon is full, is woven in more or less the same over-and-under technique as the mats made of this fiber. The filler strands are held with the big toe while the weaver (man) works the other strands with both hands. Other fans are made of *tule*, but the rushes are shorter than those used for the mats and usually not glossy. The fire fans are finished with a small, stout handle made of reeds. They are sold at ridiculously low prices, considering the time and patience required to make them. They are indispensable to the Indian for his fires, whether he is on the trail, in a rest hut on the top of a mountain, or in his own village home.

The finer the weaving or twisting of fiber or threads, the more adept is the Indian craftsman. It would almost seem as if the finer and more intricate the technique, the harder and more deftly he works at it. This is an outstanding feature of all the miscellaneous weaving and twisting of fibers I have mentioned. The craftsman expends much patience, diligence, and time on even the smallest detail of

[4] Sahagún, *A History of Ancient Mexico,* 39, 83, 101.

the most ordinary article that he sells for a pittance, considering it all well spent—if he considers the matter at all—if the finished article conforms to his ideas of beauty and appropriateness according to tradition.

XIV

*

Mats

IT MAY WELL BE that one of the earliest forms of weaving in Central America was mat-making. The importance of mats to the Indian mènage is supported by quantities of archaeological evidence. Today mats serve as walls for the Indian huts, as beds, and as tables. They play an important role on ceremonial occasions when they are placed under the sacred figures or used by the shamans for their rites. *Petates tule* of Guatemala and *acapetates* of El Salvador were used early in the sixteenth century by Spanish priests as doors for their first crudely constructed living quarters.[1] They are an almost indispensable household furnishing from the time an Indian is born on a mat till the time he dies and it becomes his shroud.

The mat was a symbol of power among ancient tribes, especially among the Mayas. Their calendar was painted on a mat. The first month of the Mayan year was called *Pop* (mat). Among the Quiché there is a tradition about a king of this nation who was

[1] Francisco Vázquez, *Crónica de la provincia del Santísimo Nombre de Jesús de Guatemala*, I, 115.

called Ahau Apop (king of the mats). Whenever he appeared in public on ceremonial occasions, his litter was covered with rich new matting. Mats are still used during Holy Week to cover the litter for the figure of Christ in San Pedro Laguna. Prehistoric graves in Kaminaljuyú and Uaxactún show the imprint of mats which were used as shrouds for dignitaries. Ceramics of this period have mat designs on vessels and jars. In the burial mounds of Uaxactún (Burials 40 and 43 from Structure A–V) are distinct mat impressions on the dry mud.[2] These mats were evidently made in a technique identical with that of today which is used all over the country, namely, the *petate tule* technique which is most commonly used for household mats.

EL SALVADOR

Several villages in El Salvador have become famous for the excellent quality of their mats, the outstanding ones being Nahuizalco and San Juan Yayantique, where they are woven of maguey fiber, and San Isidro and Lolotiquillo, where they are woven of palm leaves. The tedious journey to Nahuizalco is well worth the effort when one is in search of knowledge of mat-weaving. Rushes here are called *tule* or *tul*.[3] Planted when the moon is new, they must be cut when it is full. It is believed that if they are planted at any other time they will grow without roots, or if cut at a time when the moon is in any other phase, they will produce a material of poor quality by which the village will lose its reputation.

The tending and cutting of the rushes is the work of men, while the women weave the mats (*trabajo de mozas*). The plants grow on the slopes and hollows of the ravines where rich bottom lands are formed by the refuse of the village dumps (*tierra de joyas*). These bottom lands are always moist, even during the driest period

[2] A. Ledyard Smith, "Report on the Excavations at Uaxactún During 1935," 17, 18, 21, 22.

[3] In El Salvador *petates tule* are woven from *tule silvestre* (*Cyperus canus* Presl.), said to be indigenous to Mexico and Central America. Other species of this plant also called *tule* by the Indians are *C. alternifolius* L., *C. articulatus* L. (widely used for soothing toothache), *C. meyerianus* Kunth. (or *tule montes*), *C. panamensis* (Clarke) Britton (called *coyolito*), and *C. surinamensis* Rottb. (which grows in the dry sandy river beds called *arenales*). Also used by the Indians for its fiber is *Typha angustifolia* L., which grows abundantly in the swamps near the village of Ateos.

of the year. Here the rushes attain a height of six or seven feet, though the species called *tule de culebra* grows only to a height of four feet. The latter is always carefully cut by the Indians with a knife (*corvo* or *machete*),[4] whereas the common variety is simply torn up by the roots.

After being cut, the rushes are left to dry in the sun which in this part of the world is hot indeed. It takes four days for them to dry out and reach the proper state for slitting, each stalk yielding three pieces. The triangular stalks are held firmly by the large toe of the right foot and slit with a sharp knifelike instrument made of wood of the *huiscoyol* tree (*Bactris subglobosa* Wendl.). This little cutting tool (called *rajador*) is about sixteen inches long and one inch thick, with a small piece of leather attached to its middle to protect the fingers from the sharp rushes. One end is very well sharpened to permit it to slip easily under the outer layer of the rush.

Some of the slit pieces may be colored; others are left in their natural state. Those not dyed have a yellow-green tint. They must be left on the ground for several nights so that the heavy dew of this region may saturate them, making them pliable for weaving. The pieces to be colored are gathered into round bundles or circlets and firmly tied together. Between each circlet there is a thick padding of the dry red leaves of the *mashaste* or *majaste* plant. (*Arrabidaea chica* [H. & B.] Verl.), which gives three colors: when boiled once, a bright reddish yellow; when boiled and cooled several times, a chocolate brown, and when boiled with a large helping of mud, black. When a dozen of these circlets have been sandwiched together, they are firmly tied with a strand or twine made of the heart of the *tule* plant. The bundles are placed in a large clay vessel containing clear water and *mashaste* leaves. A fire is lit under the vessel and the contents boiled until the rushes have achieved the desired shade. The process is called *capear con mashaste*.

In addition to the *mashaste* colors, a black dye is used which is obtained by mixing the *mashaste* leaves with a quantity of very finely ground, almost black, roasted coffee. To absorb the black

4 This large knife is indispensable to the laborers in these countries and serves alike to peel fruit, trim the nails, murder a foe, kill a reptile, cut down a tree, or open a hole in the ground to plant corn. In Guatemala the shape is straight, long, and narrow, while in El Salvador it is curved and called *corvo*.

dye, the strands must be first left out in the rain and dew until slightly rotten, then boiled in the *mashaste* and coffee mixture. For green or blue, aniline dyes are used exclusively. A mordant is obtained by mashing the leaves of the *tempate*.

After the strands have been thus prepared by the men, women customarily take over the work of weaving the mats. When women mat-weavers buy their materials, they purchase the rush strands in hanks of eighteen pairs. The finest mat (about two by one and one-quarter yards) requires from seventy to seventy-five pairs, depending on the length of the strands. A clean mat is spread on the ground on which the strands are held with stones. The weaving, done with the bare hands, is started at one corner of the new mat. The strands are woven over and under diagonally according to the pattern desired. As more strands are required, they are added with a needle-like instrument with one split end wherein the *tule* strand is firmly inserted to continue the weaving. This process is called *agujerearlos con aguja de huiscoyol* (piercing with a *huiscoyol* needle.) The needle is about eight inches long and by constant use acquires a fine dark polish. The woman mat-weaver seemingly prizes it as highly as does the textile weaver the batten of her loom.

In Nahuizalco mats are made of long, even strands and are considered to have the best wearing qualities, especially those called *tashón* woven from *tule de culebra* and with wide colored stripes throughout. The ordinary mats (*añadidos*) are one and one-half yards long by one yard wide with either no decoration or just an occasional, reddish meandering strand. They are woven from shorter lengths of *tule*, added to as required in order to obtain the full length of the mat. Mats known by the name of *fondo* have a predominating white background with irregular diagonal stripes of various colors. Those called *labor* have a few well-placed geometric designs. On both the ordinary and the *culebra* mats, the ends of the strands are neatly doubled over at the edges and deftly inserted on the underside of the mat.

Once the mats have been finished, the men are busy again stacking them in bundles and tying them firmly with henequen ropes to their tumplines, by which means they tote them down the steep slopes of the hills to the trading centers.

The mats from San Pedro Perulapán are considered to be of good quality, especially the kind called *añadidos*. They can be sold on the San Salvador market for a lower price because of the proximity of that town to the capital. The Nahuizalco mats, however, are most in demand. Mats from Santa Catarina Masahuat compare favorably in quality with those from Nahuizalco and Chirilagua.

Very famous are the mats called *acapetates* woven by Nahuizalco men and boys. They serve many purposes; among them walls, roof coverings, capes, and umbrellas. These mats, made in standard sizes of six feet or eight feet square, are woven from the *vara de carrizo* or *vara de cohete* (*Arundo donax* L.), a strong, glossy grass. The reeds are cut and divided into sections with a *corvo* and well mashed with a stone to flatten them out. At night they are left out in the dew to become flexible. While the worker is weaving, the strands are moved back and forth in a snakelike movement to make them pliable (*para que truene*, so they may snap). The mat is finished by trimming the four edges rather than by working the ends of the strands back into the underside of the mat.

Also woven in Nahuizalco were the famous *petates de sala* which were used years ago in great quantities to cover red-brick floors in the aristocratic homes of Guatemala City. They were traded over the frontier in the dry season of the year. They were very large (twelve by six yards or fourteen by eight yards) to fit the floors of the colonial houses. The earthquake of 1917–18 necessitated a change in the architecture of the city houses, and since the demand for these large mats ceased, they are not obtainable now.

GUATEMALA

In Guatemala mats are woven everywhere in techniques similar to those of El Salvador. As might be expected, in areas where rushes and reeds grow profusely, mat-making is a major industry. Peculiar to Guatemalan technique is the male weaver's frequent use of his big toe to manipulate the rushes during the weaving process in order to keep his hands free to weave the mat rapidly. Also characteristic of technique in this country is the fact that a wooden needle is not often used.

Ordinary mats in Guatemala are woven from *Cyperus canus*

186

L. and are of excellent quality when they are made in the villages of San Pedro Yepocapa (in the region of Yepocapa there is one yearly crop of reeds instead of two), San Andrés Semetabaj, San Raimundo, Jalapa, or other villages where the plants used for mats grow in the rich soil of swamps or rivers nearby. *Cyperus canus* L., used for weaving mats in El Salvador, is known in Guatemala as *cibaque*, whereas the mat known in the latter country as *petate tule* is woven from *Typha angustifolia* L., *T. latifolia* L., and *T. pentagularis*.

Mats are also woven in Guatemala from the leaves of the *palma Chiapaneca* (*Calyptrogyne ghiesbrechtiana* Wendl.). The Rabinal Indians have assured me that their mat, *petate Chiapaneco*, is the only genuine mat of that kind, so called because the weave originated in the state of Chiapas, Mexico. On investigation, I found that the plant from which they are woven is called *palma Chiapaneca*. The leaves used are taken from the center of the cluster (*cogollo*). These tender green shoots are cut with a particularly sharp knife and divided by a steel pin, needle, or nail into the required length and width (about two yards long by one-quarter inch wide). They are left outdoors overnight, usually on the roofs of the huts, and when flexible enough are woven into mats in the usual over-and-under technique and finished off with a fringe. These mats are notable for their splendid wearing qualities and distinctive colored designs (the strands are colored with aniline dyes). For transport to market, they are doubled over into a flat parcel instead of being rolled as in El Salvador.

Mats traded from the village of Zapaluta, Mexico (now called Villa Trinitarias) are also fringed and folded but are yellow green, lustrous, and of fine texture. The *petates zapaluta* are the finest mats made. Unlike those woven in Rabinal, Cubulco, and nearby vicinity, which are sold in all the larger towns and villages in this country, these mats are seldom traded outside such centers as Antigua, Guatemala City, and Quezaltenango.

The reeds for the Guatemalan *petate tule* are cut and flattened with a heavy wooden mallet and well dried in the sun. This wide reed is woven in a simple over-and-under pattern with the edges coiled into a twist resembling a cord. This coiled edge makes a firm

mat which is usually two yards square. The best-known *petates tule* come from San Antonio Aguas Calientes. Other towns where the *tule* craft is a specialty are Santiago Atitlán and Cerro de Oro, situated on Lake Atitlán, along whose shallow edges the rushes grow abundantly. The men go out in their dugouts[5] when the moon is full and pull the rushes up with their hands. The women mash them on the ground with a wooden mallet (*mazo*) and dry them for a couple of days in the hot sun before using them for weaving the new mat in a simple over-one-and-under-one technique. In Cerro de Oro, two kinds of *petate tule* are woven: one from the short *tule* of the thickest, glossiest variety; the other from *tule* which has no gloss and using the entire length of the long rushes. In this village the trade product is a small prayer mat called *de dar gracias a Díos* (to give thanks to God). It is used in church on ceremonial occasions and to kneel on during processions. It is less than one yard square and well finished around the four edges.

Two kinds of *tule* mats are made in the Lake Amatitlán region. The first, *petates de agua fría* (cold-water mats), are made of rushes growing in the cold waters of the lake; the other, *petates de agua caliente* (hot-water mats), of rushes growing in the thermal springs which occur sporadically along the borders of the lake.

Tule mats are woven also in San Pedro Laguna. In this community, men not only cut but also prepare the rush and weave the mats, holding down the strands with a stone. When they weave the edges, they use the big toe to hold the rushes. The ends, after being turned on the underside, are neatly cut.

In addition to reeds, mats are woven in Guatemala of grass and fern. Attractive round mats are braided from tall grass (*jayatz*) in the village of Ixchiguán. When sewn up, the mats resemble New England braided rugs. In some places, as in the region of Huehuetenango, mats are woven from a kind of giant fern (*petates o esteras de helecho*). At best, they are not to be compared to those woven of reeds and rushes.

All kinds of mats are brought into the town markets for sale during the dry season of the year (January, February, and March).

[5] Unique dugouts ply this lake. Made of cedar or *aguacate* wood, the boats have raised sides and square stern.

The most sought after are the *petates tule* in Guatemala and the *acapetates* in El Salvador. Small stores in the vicinity of the central markets in the larger towns and in Guatemala City where mats, baskets, and fiber articles are sold are known as *tiendas de jarcia*.

XV

*

Hats

GUATEMALA

IT HAS LONG BEEN AN INDIAN CUSTOM for men and women alike to wear a more or less ornate headdress, either as protection from heat or cold or perhaps to exhibit rank or position in the community. Hats have become popular among men and are worn fairly generally, but seldom will an Indian woman in full tribal costume wear a hat. Some exceptions are the women from Todos Santos (Cuchumatán) and San Miguel Acatán, whose hats are of straw.

In Guatemala the most desirable and expensive so-called straw hats are those woven in San Pedro Pinula, El Jicaro, and several villages in the departments of Quiché, Petén, and Baja Verapaz. Other centers for the hatmaking industry are Chajul, Nebaj, Cotzal and Cobán. In villages where a hat of special shape is favored, the raw material is purchased from traders who bring it from the lowlands or other places where it grows in abundance.

In every Indian village where traditional clothing is worn the hat follows the dictates of the costume. Most often it is worn over

a *tzut* or headcloth which is the Indian's real headdress and part of the tribal outfit.

In Todos Santos (Cuchumatán) men and women wear distinctive, square-crowned, thick straw hats. The women trim theirs with two bands, one (*toquilla*) of woven palm leaf and the other a blue silk ribbon. The men's hats are distinguished by the use of two or three bands according to the wealth of the owner. One is usually made of leather, one of finely woven horsehair in black and white, and a third is of brightly colored wool wound around a few strands of palm leaf. Men who are privileged dancers wear a large bunch of feathers on one side of their hats.

While riding on muleback in the mountains some years ago, I came upon a busy Todos Santos man. Dressed in full tribal costume complete with black wool overdress and a red *tzut* on his head topped by a heavy straw hat, he was sitting in front of his thatched hut industriously plying an elderly, much-the-worse-for-wear sewing machine to make a new hat. What a marked contrast between the old and the new, particularly in such a remote mountain valley!

Hats from Santa Isabel Huehuetenango and neighboring villages in the Cuchumatanes Mountains customarily have a high-peaked crown and a brim jauntily rolled a bit on both sides. The crown is trimmed with a black cotton band (*toquilla negra*). In San Juan Atitlán of the same region the heavy white straw hat with shallow crown and wide brim looks like a large saucer and gives the wearer a rather rakish appearance as it balances on top of his straight black hair. The most stylish hats from this village, worn by the officials, are made of hide and are similar to those worn by some of the highland Indians of Peru. Such similarity to Peruvian costume may be noted in various details of the costume in villages in the Quiché region.

In Huehuetenango the straw hat with tall peaked crown is decorated with a wide horsehair band with little tasseled ends. The highland Santa Eulalia men, on the other hand, prefer a hat that has a disproportionately tall, narrow, round crown, the narrow brim causing it to resemble a small candlestick with a tall candle. The

men from San Juan Ixcoy wear high peaked hats, well starched and very white, woven in the style of a coarse Panama hat.

Wide brims and tall peaked crowns are characteristic of the hats of the Rabinal men. In several villages of the Baja Verapaz region, they weave palm-leaf hats of excellent quality. Those for ceremonial and official wear in Sololá are made of straw varnished black. The shape is that of a small, narrow sailor trimmed with a red or green ribbon band carrying flowers and bird designs. The two small ends of this ribbon fall over the brim of the hat.

In some villages hats are trimmed with a red *tzut* rolled around the crown giving the wearer a top-heavy appearance. When the hat is worn perched on top of a *tzut*, it suggests the man has a perennial headache.

Hats from the notable hatmaking villages of Chajul, Cotzal and Nebaj are of peculiar shape and very solidly made of double strands of palm leaf. In the regions where the hats are heavy I was informed that they were thus made to prevent them from blowing off easily in the high winds of this bleak climate. The Chajul hats are made by braiding palm leaves imported from coastal areas. A one-quarter-inch-wide strand is carefully pleated and doubled into fine points resembling rickrack braid, each row overlapping the last to form a very heavy brim and square crown which are stitched into shape by a sewing machine. When the hat is completed and starched with corn paste (*yuquilla*), a wide black ribbon is wound around the crown. For special costumes, this ribbon has birds and beasts embroidered on it in red and yellow. When walking long distances, men occupy their hands by weaving the material for their hats.

For the Nebaj and Cotzal hats the men place palm-leaf strands row upon row without the fancy peaks of their Chajul neighbors' hats, though they also use a sewing machine for joining the strands. For ceremonial wear, the edges of these hats are finished off with black ribbon or braid. The palms for the hats in this region are brought from San Miguel Uspantán, where also hats and mats are woven. Chichicastenango straw hats are not woven locally but are traded from Rabinal and Cobán. Palm-leaf hats are sewn together with a strong henequen fiber in the village of San Miguel Ixtahuacán.

Hats woven in the village of Chivinal are very heavy with a

solid, square crown. They are woven from *arpón*, a name given to the heart of vines and roots of hardy plants growing on the hot coastal plain. The material is dark brown, and although very difficult to work, it is not only fashioned into hats but also into fancy baskets.

Pilgrims, both men and women, bound for the yearly fair and pilgrimage to Esquipulas wear straw hats with very wide brims for protection from the hot sun during their many days' journey. When returning, the pilgrims trim their hats with wreaths of Florida moss (*Tillandsia usneoides* L.) and also small, yellow, gourdlike fruit called *chichitas* to show that they have fulfilled their vow to visit the shrine of the Black Christ.

San Pedro Pinula hats are manufactured from *palma real* (royal palm). The young, tender leaves or shoots in the center of the palm are removed, bleached in the hot sun, braided, and then sewn together with a sewing machine.

Specialization in handicraft is characteristic of the Chorti Indians living in the department of Chichimula, each such worker specializing in an individual craft. The people of the village of El Tesoro weave good hats of *palma real* which have gained fame all over this region and are traded into the neighboring countries.

Hats imitating the Mexican shapes (*sombreros*) and trimmed with all kinds of fancy bands and colored wool stitches are, of course, made only for *ladino* or tourist trade. Enormous sun hats, too, are made for this purpose. They are woven in gaily colored strands, some with brims more than one yard in diameter and tall, narrow peaked crowns of almost the same height. These hats are also woven in the port of La Unión and several neighboring villages in El Salvador. The well-made hats from Retalhuleu, Guatemala, are distinctive inasmuch as the leaves are woven directly into the shape of the hat without first being cut into strands or braided.

In the northeastern lowlands of Guatemala grow numerous varieties of palm which are used by the inhabitants for their hat-weaving. The palm most commonly used is the *palmilla* (*Carludovica palmata* Ruiz & Pav.), from which only the unopened inner leaves are selected. The *palmilla* requires very fertile, damp, sandy soil. The plant grows about six feet high, and those shoots which

are used are about three feet long. The leaves must be carefully cut with a very sharp knife or *machete* so the rest of the plant is not injured. A large *palmilla* hat of the finest quality requires forty palm-leaf strands. Fewer strands are used for cheaper hats.

In the department of El Petén there are many hamlets where very wide-brimmed hats are woven from the coarse leaf of a variety of palm which grows wild in that region, as well as from local coarse grasses.

Hats are woven from the *palma de coyol* (*Acrocomia vinifera* Gerst.), which grows in the lowlands, as well as from the *palma de petate* or *palma Chiapaneca* (*Calyptrogyne cohune* Mart.) and rushes such as *Cyperus canus* Presl. and *Typha angustifolia* L. They are known as *sombreros de palma, de junco,* and *de petate,* according to the material used in their manufacture.

All palm leaves to be used for hats are cut during the three days before full moon to insure good quality. The palm strands are separated by a knife or other sharp implement into the necessary widths which should be as uniform as possible. For a woven hat, the worker continually wets the strands with cloths saturated in clean water. The work is started at the center of the crown. The more strands woven into it, the better the quality of the hat. When it is necessary to add strands during the process of weaving, a tiny replica of the *huiscoyol* needle employed for matmaking is used.

The palm strands are colored before they are woven. Bright colors are always achieved with aniline dyes. A light black much in vogue for designs is obtained by burying the strands in the ground until they are thoroughly discolored by the soil. The *mashaste* plant is used when a dark brown is desired.

In general, the hatweaving industry in Guatemala is being taken over by *ladinos* or *mestizos* in the northeastern section where the palm grows in abundance, as the villages of El Jicaro and San Pedro Pinula.

El Salvador

Salvadorean hats are widely known for their wearing qualities. The techniques of hatmaking are very similar to those described for Guatemala. The hats of the braided variety are here made of riper

palm leaves known as *plazón* or *palmatostad*. For the woven hat and especially for children's hats, the soft-textured *palma de montana* (forest palm) is preferred. To stain the palm leaves reddish brown, the Indians of El Salvador bury them with *mashaste* leaves, and, as my informant expressed it, "they must be taken out of the earth before the time is up" (*antes de tiempo*). To blacken them, the Indians leave them in the ground until they are well rotted (*tiempo entero*). The shapes are not as varied as those of the Guatemalan hats. All are worn with an attempt at modern style. As hats are essential for outdoor work in this hot climate, the most desirable are the light-weight ones with a very wide brim and medium-peaked crown. In both countries woven hats which are to be used as trade articles are bleached and stiffened with a solution of oxalic acid, sulphur, and starch before they are blocked.

San Antonio Masahuat was a flourishing hatweaving center as early as 1561. The Indians, impressed with the advantages of the Spanish hat, adopted this article for their own use, first as a distinction for their religious and civil officials and later for general use. Once they discovered how practical were hats, they substituted hats for their more cumbersome headdresses (such as those worn by Mayan officials prior to the Conquest). A thriving hatmaking industry was already in existence only seventy years after Columbus first touched these shores.

Some of the famous modern hat centers in El Salvador are Zacatecoluca, Cojutepeque, San Antonio Masahuat, Tenancingo, Chirilagua, Olocuilta, San Pedro Puxtla, Izalco, Chilanga, Suchitoto, and Sensuntepeque. The latter community is famed for its fine palm-leaf hats with colored designs. The Izalco hats are made by emigrants from other hatweaving villages who have settled here. They use a tiny *huiscoyol* needle and do exquisite work.

The inverted *coles* (square baskets with fitted covers), especially those large ones of San José Nejapa and nearby villages, make an elegant and unique headgear for women. The women wear them to market, fill them with vegetables and fruit, and carry them home on their heads in the heat of the day.

When an Indian man must shop for a hat because he lives in a village where they are not made, he needs the advice of at least

three or more of his village cronies. He usually buys his hat before his village celebrates its patron saint's day. Time and patience on the part of both shopkeeper and friends are required before the question can be settled to the entire satisfaction of all concerned. Usually the buyer proudly goes forth with not one but several hats, one on top of the other, for the men of his entire family or, if he is a merchant, for trade in his own village.

Indian hats are made in seemingly innumerable shapes. Every village has its own style. They may be stiff or soft, high or low crowned, have rolled or flat brims, be heavy or light weight, and ornamented with plain or embroidered ribbons of silk, cotton, or horsehair, or with wool or leather bands. All are worn with great dignity.

XVI

＊

Basketry

I T HAS BEEN SAID that "the basket is perhaps the first device cre-
ated by human ingenuity that may be called a luxury."[1] The basket
craft is of such importance in Guatemala that in Chajul one of the
early dances (Dance of the Baskets, performed once a year) cele-
brates this craft. The principal dancers wear baskets woven in that
village as ceremonial headgear. Basketry is an ancient handicraft
in Guatemala; many pieces of pottery of prehistoric manufacture
have been found which were decorated with basketry designs.

Baskets of all shapes and sizes are necessary to the daily life
of Indian and *ladino* alike from the time he is laid in a basket cradle
at birth until his death, when small baskets of food are laid beside
him to provide him with nourishment on his long journey into the
afterlife. Keen interest, knowledge, and great care are exercised
in acquiring any basket—a person does not shop casually for such a
purchase. Baskets commonly used come in families; *canastas* should

[1] Morris Decamp Crawford, *The Heritage of Cotton, the Fiber of Two Worlds
and Many Ages*, 19.

not be confused with *canastos*, though only a handle stands between them. The feminine variety boasts a handle, large or small, while the masculine counterpart has no handle and is always more or less shallow.

The *canasto panadero* (baker's basket) is large and wide, with strong sides capable of holding the large variety of breads which are one of the Guatemalan breakfast specialties. The next smaller size is the *cajero*, calculated to contain a *caja* of vegetables or small fruit or its equivalent of twenty-five pounds of vegetables such as string beans. Next is the *cuartillero*. It is made to contain one *cuartilla* of black beans or corn, those absolutely essential staples of all Central American diet. Next smaller is the *cafetero*, not because coffee is prepared in it as the name implies, but because it is used by the women who come to the coffee estates to gather the crop. A slight variation, *medio canasto* (half a basket), contains the average crop from one small coffee tree. A decidedly smaller *canasto* is woven more closely than any of the former and is called *colero* (sieve). It is used to sift cooked corn for making dough for tamales. This basket is reputed to be so well made for this purpose that when the corn is strained through it, only the eye (*ojo*) of the corn kernel remains. The *colero* is a specialty of that industrious Indian village, Rabinal.

Baskets found in the Guatemala City market come from the nearby villages of San Juan Sacatepéquez and San Raimundo. The materials for the baskets made in these two communities are imported from Estancia Granda, Estancia Chiquita, and other places. These baskets are distinguished as *finos* (fine) and *ordinarios* (ordinary). As far as I can see, the distinction lies in the materials from which they are made. The first are made of a woody vine (*bejuco de cajeta*), which is flattened for the purpose of weaving, while the splints for the other are wicker.

Antigua is the distribution center for baskets of a particularly good quality made in nearby villages such as Parramos, Itzapa, Comalapa, and San Martín Jilotepeque. These *canastos* are held in high regard because of their strong reinforced edges. Tecpán is another trading center, especially during March and April, when baskets from all around this region are brought in to town for sale. All sizes

and shapes are displayed temptingly for the buyer's inspection. Those from Santa Apolonía appear to wear better than others, because the Indians of that village cut their *caña de Castilla* in February and March so that it will not rot as it does when cut in other months.

Canastas with handles are not very popular with the Indians, handles being a European rather than an Indian characteristic of basketry. Gaily colored small *canastas* are made in Tecpán and in Aguacatán. These pretty baskets, notwithstanding their long journey into the Guatemala City market, sell for a ridiculously small sum. Though *canastas* are made by Indians, they are preferred by the *ladinos* who do not care to carry *canastos* on their heads in the Indian manner.

The baskets known as *coles*, ranging from two inches to one-half yard square, are made in the region around Patzún. The various sizes are nested within one another, and each has its own snug lid. They are perhaps the finest baskets made in Guatemala. The smaller size, when woven of wheat straw in a mat design, is called *col de seda*. The price is well worth this very beautiful, soft, well-woven article. Larger *coles* are woven of rushes in much the same manner as ordinary mats, though the strands are cut wider than those used for matmaking.

Unique, large, square baskets with a close-fitting lid, woven in the same technique as mats, are used to hold crude salt in the Sacapulas saltworks.[2] Palm-frond baskets are a specialty of villages south of San Juan Hermita. In the hamlet of Niño Perdido the Indians weave baskets from *zacatón*, a tall, thick grass. The finished articles have a nice gloss, and the edge is usually reinforced with a tough fiber from some vine which is also used for the splints. Shepherds in the Ixil region wear a peculiar, elongated basket hung around their necks to carry stray bits of wool for spinning while they tend their sheep.

Many other places are centers for basketweaving, and the craftsmen use the materials which nature has conveniently placed near their homes. In Sololá, *carricillo* (*Bambusa aurea*) and in other

[2] The Indians of this village gather salt deposited by the nearby river. There are community privileges, and each man owns a square of land near the river which he works in the most primitive manner. This salt is reputed to be a curative for eye trouble.

places woody *capulín* (*Calabura tiliaceae*) are used to reinforce the baskets during the coffee harvest when they are subject to constant wear and strain.

The fishermen of the village of Santa Catarina Palopó on Lake Atitlán use an interesting basketry fish trap (called *garlito* or *xucubil*). It is made of twigs laced together with dry lianas to form a cornucopia which is attached to a twelve- to fifteen-foot bamboo pole. The bait is held by two twigs fastened to the basket with two crossed bands of vine. Stones on the bottom hold the basket upright in the shallow waters near the shore. The fishermen paddle out in their dugouts to gather their catch (small crabs, snails, and *muni*— a small fish resembling perch) which they carry in to trade in the Sololá market.

Very special, fine baskets are woven from *carrizo fino*. Small flat baskets resembling a plate from three to ten inches in diameter are currently used for measuring vegetables or fruit in the markets. Some baskets about the size of the usual large *canasto* are woven in Chiquibul (Siquibul) from reeds. The warp strands are of a woody vine which is doubled back on itself about four inches from the edge and inserted into the weft strands. The double weft strands are twined around each other to form a very thick, well-finished, four-inch edge. This distinctive border identifies these baskets as having been made in this village.

Another kind of basket called *ruguma* is used by the Caribs who live along the Atlantic Coast. It is woven in a matlike technique from a long, tough, flexible vine which grows abundantly around Lake Izabal (*bejuco de bayal* or *palma de bayal*). The material is a climbing palm, a species of *Desmoncus*, with sharp thorns on the tips of the leaves. These baskets are used to prepare cassava flour,[3] the Carib's staple food. Cassava roots are ground into a paste which is stuffed into the basket. The basket is then suspended from the rafters of the hut to form a swing on which the whole family sits as long as there is any juice dripping from the basket. As Cassava juice is poisonous, the lengthy sitting is necessary to extract only

[3] Two types of cassava or manioc are cultivated: the bitter (*Manihot utilissima* Pohl) and the sweet (*Manihot aipi* Pohl). The roots contain starch and hydrocyanic (prussic) acid. It is necessary to remove the latter highly poisonous product before the available starch can be made into bread—hence the squeezing basket.

the fine dry paste which can be utilized for food. Those long round baskets resemble a large thick cable and are very elastic. By the time the paste is well dried, the basket has shrunk to its smallest capacity thereby closing the open end. The woven handle on one end of the basket is reinforced by a wooden lining; the open end has a couple of bowknots of the same mat material as the basket—an artistic gesture on the part of the weaver.

EL SALVADOR

Like mats, Salvadorean baskets are of very superior quality. Whereas in Guatemala large baskets and baskets with handles are currently used, in El Salvador they are seldom made or used either by Indian or *ladino*. The ordinary market basket of whatever size is very shallow. It is strong enough to be used for carrying large quantities of vegetables, fruit, chickens, and other produce. The best of these shallow baskets, distinguished by the brownish color of the reeds used in their manufacture, are called *viroleños*, the nickname for the Indians who live in the village of Zacatecoluca where they are made. Another dark basket used in El Salvador is not of local make but is imported from Honduras during December. It is an ordinary, large, strong, round basket called *guache*, primarily intended for the use of coffee pickers. A variation of this basket has reinforced edges dyed with the red extract of the *mashaste* leaves.

The most popular and useful Salvadorean baskets are the rectangular *tumbillas* (called *petacas* in Guatemala), which have tightly fitting shallow lids. These are made in sizes from ten inches long by five inches wide and deep to about one and one-half yards long by one-half yard wide and deep. Rarely do they have colored decoration.

Tumbillas are of a better quality when the reeds are cut during the dry season and at full moon, as otherwise they disintegrate easily. The Nahuizalco people, renowned for their matweaving, are expert at making *tumbillas*, for which purpose they use the same *vara de carrizo* as for *acapetates*. The technique employed for weaving *tumbillas* in El Salvador and *petacas* in Guatemala is the same as that used for the *acapetates*. They are woven of broad, glossy strands, the sides having very closely set warp splints. The reeds

are cut with a steel knife when still young. After being split, they are left out in the dew for a couple of nights and then worked by the men. A skilled craftsman can make three of the larger *tumbillas* in one day. *Tumbillas* have taken the place of suitcases and traveling bags because of their lightness and elasticity, especially for air freight. Rats and mice can not gnaw through the strong, sharp reeds. *Tumbillas* without lids, as well as ordinary deep baskets, are made only in San Pedro Perulapán.

Cestillos, cheap, strong baskets made in Cojutepeque, are made from a vine called *cestillo*, a species of morning glory with a brownish flower which is everlasting. These baskets must be distinguished from *cestillas*, baskets which come from the region of Mejicanos on the outskirts of San Salvador and from San Miguelito. The latter have reinforced handles with edges well wrapped with palm-leaf strands, and one or more encircling bands of color made with aniline dyes.

Baskets woven from *caña de Castilla* are from the department of Sonsonate. The young center fibers of the coconut palm are also fashioned into delicate, pretty baskets in Apaneca. Baskets made of bamboo are easily distinguished because of their gloss, but are generally considered to be not very durable.

Several other villages also have basketweaving specialties: Tenancingo, where the *palma de sombrero* (*Carludovica palmata* Ruiz & Pav.) is used; Chilanga where the baskets are multicolored; San Juan Nonualco and Santa Catarina Masahuat, towns where the famed *petaquillas* or baskets of almost white rushes are made; and Olocuiltla, whence come plain but very serviceable baskets.

Esquipulas, a small village just over the border from El Salvador and a well-known Guatemalan place of pilgrimage, is a large trading center for Salvadorean baskets. Devout pilgrims returning from Esquipulas bring them to the markets of Guatemala and Honduras during January and February.

None of the baskets in Guatemala or El Salvador are woven in a complicated technique. The majority are built up by crossing from six to ten splints of the material at the center of the basket and weaving a pair of weft reeds in and out of the main splints (dif-

ferent from European and North American Indian techniques). At the edge of the basket the splints are doubled over and inserted again into the weft reeds. In the better-made baskets, the doubled-under splints are woven until the flat bottom is reached. The top or the rim is finished according to the particular techniques used in the regions where the baskets are made. Some have no extra finish at all, the warp strands being held down firmly by the doubled-under splints. Others have two or more wide strands of woody vine or the dried, long leaves of the same plants as the splints twisted around each other and inserted in the last two splints to reinforce the edge. This technique is also used in the many varieties of Guatemalan and Salvadorean *canastos* and *canastas*. The handle of one of the latter baskets is firmly made of a number of splints wrapped with the same material. In fashioning *canastas*, the main splints of the basket are not doubled over at the edge but crossed from side to side to form the handle, which is never very high. The material which smoothly wraps the handle is tucked under itself for a fairly firm finish.

The more complicated basketry techniques, by which entwined warp strands and coils are made into attractive designs, are usually the work of city craftsmen or those Indians who have learned foreign techniques. *Ladino* craftsmen in Guatemala City and San Salvador weave beautiful baskets from palm leaves and other materials with artistic colored designs, but they should not be included in a discussion of Indian craft because the shapes and decorations show a decided foreign influence. Strangely enough, these baskets slightly resemble those beautiful baskets made by the Pima Indians of the North American Southwest.

The colored strands for baskets in Guatemala and El Salvador are dyed with aniline dyes, with the exception of a brownish-red dye used in El Salvador which is produced from the *mashaste* leaf as in matweaving, and the *tiñecanastos* (see Dyes and Dyestuffs).

In addition to the materials already mentioned, members of the wicker and sedge families are employed in basketmaking in both these countries: *carrizo montes* (*Olyra latifolia* L.), *caña de cohete* (*Arundo donax* L.), and *vara de Castilla* or *caña brava* (*Gynerium sagittatum* Beauv.), and the different kinds of lianas (*arpón*), roots, and vines from the forests that are never far distant from the Indian villages or hamlets.

XVII

*

Ceramics

For purposes of this discussion I have divided ceramics in these two Central American countries into three periods. Into the first period I have put all the pottery that was made by the Indians prior to the Spanish Conquest. Albeit archaeologists have further subdivided this grouping by when and where the pottery was made and the design, shape, or color of the pieces, such a subdivision is not pertinent to the work at hand. My second period corresponds with the historic Colonial period and includes pottery made after the introduction of the potter's wheel by the Spaniards. Present-day pottery, which I have watched being made, comprises my third period.

Although there is a great wealth of such material from archaeologic sites, I shall only briefly mention the pre-Columbian ceramics in order to provide the reader with a historic background for modern Indian pottery. Ancient Guatemalan pottery varied from the simplest hand-molded forms to the truly superb examples of Mayan pottery. The study of these specimens has contributed notably to the knowledge of the development of prehistoric civilization in

these countries. Though outside the scope of this work, Mayan ceramics are unique and form one of the most brilliant chapters in the history of this craft.

Outstanding examples of Mayan ceramics in Guatemala are the *Vas de Chama,* found near the village of that name and now in the University of Pennsylvania Museum in Philadelphia; the exquisite collections from the ruins of Kaminaljuyú (near Guatemala City), Piedras Negras, Alta Verapaz, and Uaxactún; the collections in the National Museum of Guatemala City; and the discoveries at Tikal, preserved in the museum there. There are several splendid collections in Guatemala: one at the Jefatura Politica of San Marcos, where the Tajumulco collection is housed; and the Rossvach Collection in Chichicastenango, including Quiché and other specimens from the highland region and a magnificent collection containing some of the best ceramic and jadeite specimens found in the country which belonged to the late Don Vitalino Robles of Quezaltenango.

Pre-Columbian pottery from El Salvador is of great diversity because of the number of different peoples of distinctive cultures who occupied this area. Owing to the volcanic nature of the country, stratification has been disturbed; consequently archaic pottery is found side by side with the most beautiful polychrome and high and low relief ware of the early cultures. To this first period also belongs the unique pseudo-vitreous plumbate ware found from Panama to Mexico. The center for manufacture and distribution for this ware appears to have been Guatemala and El Salvador. Outstanding examples are preserved in private collections such as that of Dr. Oscar Emeterio Salazar, Mr. Herbert de Sola, and the San Andrés Collection owned by Don Francisco Duenas. To show how frequent and how mixed are the periods in the different sites in this country, I need only to mention a magnificent polychrome jar in high relief having exquisite Mayan designs which was found side by side with much cruder specimens in La Rabida, just on the outskirts of San Salvador. Many interesting items are on exhibit in this nation's National Museum.

In the Colonial period, Indian manufacture of pottery was modified by European techniques. The outstanding change came with the introduction of the potter's wheel at the end of the seven-

teenth century. This the Indians adapted to meet their own needs, and the adaptation is now generally known as the Indian wheel. The use of tin and lead glazes was also introduced by the Spaniards, who in turn had learned the process from the Moors and Arabs in the twelfth century. The Indians, however, made little attempt to copy the wide variety of ceramics brought into the colonies by the Spaniards. One exception was the manufacture of tiles.

Tiles, known as *azulejos*, were predominantly of Moorish origin and were imported from Spain where they had been made for centuries. In Central America they were made by Indian craftsmen working under the direction of foreign artisans. Tilemaking was learned by the Indians because tiles were desired by the Spaniards. Beautiful tiles of this period can now be seen in the National Museum of Fine Arts in Antigua. They formed part of the fountain of the first cathedral in Ciudad Vieja (1534). Once blue and white, the *azulejos* are now without designs.

With but few such exceptions, Indian ceramics were not noticeably influenced by imported wares, and the natives continued to produce those simple types with which they were already familiar. Historical accounts state that during the Colonial period the best pottery was made in the province of San Salvador.

The third period brings us to the present day and the wares made by modern Indians. Ceramics are made either by hand using the most primitive methods (work usually done by women) or by the potter's wheel and earth oven (the work of men). Hand-modeled pottery is ordinarily produced as a home industry in the Indian village. Wheel-made pottery on the other hand, is usually the work of *ladinos* and is customarily produced in town or village workshops. The clays used are in most instances locally found. Large deposits occur near Salamá, Cobán, Amatitlán and Jalapa in Guatemala.

As with other Indian crafts, the products of each ceramic center are distinctive and renowned for their respective distinction. Some of the ancient ceramic centers are still prominent today and continue to produce the same types of ware which they have made for centuries. Such centers are Salamá, San Pedro Carchá, Santa Apolonía, Jalapa, Chinautla,[1] and several villages in the department

[1] In addition to utility wares, Chinautla is also famous for its quaint figurines—

of El Quiché, especially San Pedro Jocopilas. Mixco, however, mentioned as a famous center for ceramics in the eighteenth century, retains but a vestige of its past prestige,[2] making only a few articles for home use. For these, the clay is repeatedly refined on a grinding stone, the last polish before firing being given by a chamois or other pliable leather remnant. Antigua and Totonicapán are famous for their incense burners (*incensarios*). No religious event is complete without them, and some are really works of art.

Pottery shapes are regional; for example, the ordinary water jars made in one village differ from those made in others. The three-handled water jar is easily recognized as a product of El Salvador and adjacent Guatemalan villages and also of a few villages near the Mexican border. In the rest of Guatemala water jars have only two handles. Small water jars with two spouts, called *pichingas* in El Salvador and *porrones* in Guatemala, are seemingly copies of prehistoric shapes from Peru and Ecuador. *Porrón* in Guatemala is a general name for a water jar with only one spout.

El Salvador

The manufacture of handmade pottery in Paleca, a small village near San Salvador, is typical of this craft in that country. The women of this village specialize in three articles for which this place has become famous: good-sized water jars (*cantaros*), large, open-mouth cooking pots (*ollas*), and flat, round platelike dishes that are used to roast tortillas over an open fire (*comales*). A good worker can made from fifteen to twenty jars a day. The clay is brought from deposits near Aculhuaca, mixed well with river sand and water, and then left to settle in an earthenware jar for a couple of days. This mixture is strained several times from one jar to another with a gourd sieve (*pascón*) until all undesirable matter has been removed. More water is added, and the mixture is set aside for another day or so. When the clay has settled, it is removed and spread on the ground to dry. The proportion of sand used for tem-

red with white markings or vice versa. The last famous potter of the highest caste whose knowledge of her craft had been handed down for generations has recently died. Ceramic candlesticks which she had made for the occasion were properly placed around her bier.

[2] Fuentes y Guzmán, *Recordación florida*, I, 290.

per does not seem to conform to any standard measure save the hand and eye of the potter, who invariably adds the right amount. The clay is then molded carefully with very wet hands over a dish or pot, often an archaeological specimen without neck or handle. (Small articles, however, are made without molds.) With infinite patience the woman pats the clay over the up-turned mold to get a uniform thickness for the walls of the new vessel.

After it has been thoroughly dried by the sun, the pot is carefully removed from the mold. On the second day it is skilfully finished by shaping the simple opening and adding handles if these are desired. An assistant then rubs the surface, both inside and out, with a whitish stone (celt) to give a smooth, polished appearance. This celt, *piedra del rayo* (lightning stone), is a valued implement. When I asked where this prehistoric stone had been found, I was told that it had been found lodged in the deep cavity of a tree which had been struck by lightning. This solidified the sap, according to my informant, and formed this stone for the craftsmen to use in their work. It was alluded to as "sent from Heaven."

If the vessel is to be decorated, a fine red clay, *tahuite*,[3] is dissolved in water and the liquid brushed on with a cornhusk. A gourdful of *tahuite* is enough to color a fairly large water jar. *Tahuite* is found in different grades in eastern Guatemala and in San Vicente, El Salvador.

The vessels to be fired are placed on large stones on the ground and covered with dry straw from wild rice mixed with leaves and small twigs. The fire is closely attended for an hour and three-quarters to two hours to see that it burns evenly and briskly. After firing and while still hot the vessels are sprinkled by hand or with a cornhusk dipped in a liquid made from the fruit of the *capulin montes* (*Saurauia pauciserrata* Hemsl.) or the fruit of the *nance* (*Byrsonima crassifolia* [L.] DC) to provide a decoration consisting of black irregular dots and dashes formed by the droplets.

The Paleca potter's manufacture of the useful *comales*[4] differs

[3] *Tahuite*, a confusing word because it refers to two different things, is used in this chapter to indicate a fine red clay for decorating ceramics. The round tablets of the same name sold by dealers in the markets of both these countries are composed of a mineral clay deposit. They are dissolved in water to cure digestive troubles of children.

from the foregoing technique. A large hunk of prepared and kneaded clay is spread on the ground and deftly twirled to shape a flat dish with shallow sides. The woman pats the rapidly twirling clay into place with a wet cloth, forms a rim, and scrapes and bakes it.

This is the method of molding pottery by hand employed in all small villages in El Salvador where the primitive craft is of primary importance to the economic life of the inhabitants. Variations in the ware so produced result from the proportion of sand to clay, the quality of the clay, the shapes of the vessels, and, above all, the volcanic nature of the various soils in El Salvador. The material used for firing varies from village to village, too: twigs, leaves, straw, dung, or reeds—i.e., whatever is nearest at hand and will produce a hot fire.

Wheel-made pottery is produced in small manufacturing plants. Such a plant consists of a somewhat open yard on one side of which a long shed houses the potter's wheel and the brick or mud tanks for preparing the slip. On the other side is the kiln adjacent to the rooms where the finished articles are stored.

The clay is brought to the plant by oxcart. After being cleaned of all foreign matter, it is mixed with sand in almost equal proportions, slightly more clay than sand being used to prevent the vessel from being brittle. Water is added, and the mixture is passed several times through a large, fine-meshed wire strainer. When the consistency suits the potter's special formula, the mixture is left to settle in the tank. It is then removed, combined with ordinary mud, and spread on the ground, where the men mix it thoroughly with their bare feet.

When it is fairly well kneaded, the clay is ready for the wheel. The potter's wheel now used is essentially that introduced from Spain at the end of the seventeenth century. It consists of a large horizontal governor wheel worked with the bare feet of the craftsman who sits before it on a high bench. A shaft through the center of the wheel is topped by a smaller wheel on which the potter manipulates the lump of clay. Everything about the wheel is of wood except the central supporting shaft.

[4] *Comales* are a necessity of the kitchen menage in these countries. I have even seen the coastal Caribs use them for roasting the large, fat ants known as *zampopo*, considered a delicacy by these people.

The potter cuts the molded vessel off the wheel with a strong, fine string. He cleans out the inside and molds the edges with a bamboo stick or a piece of broken pottery. The finished article is dried in the sun for about seven hours, then polished with sandpaper or a small stone and fired in a kiln. If it is to be decorated, the few simple designs are drawn freehand before glazing or baking. They are applied with a small brush, chicken feather, or cornhusk dipped in sulphate of antimony. The antimony is prepared in small kilns dug in the side of a hill. Liquid lead is the usual glaze and is prepared in a small earth oven. The vessels are fired in kilns that range from small, square brick or earth ovens to fairly modern kilns where the articles are carefully stowed with wedges. Hardwoods are used to insure even heat throughout the firing. There seems to be no attempt made to entirely cover the biscuit with glaze, and the percentage of cracking and breakage is very high. Seldom are any of the pieces perfect.

The finished articles are carefully packed with straw in large nets or baskets and taken to market either by oxcart or on the heads or shoulders of men or women. The pottery is very gay and attractive as well as useful in Indian or *ladino* households. It is so inexpensive that its breakage is of little moment because new pieces can be bought from the constant supply available in all town and village markets.

San Juan Nonualco, Cojutepeque, Apopa, Chalatenango, Ilobasco, Panchimalco, and some villages near San Salvador are keen rivals for the quality of their products, whether made by hand or wheel. It is generally accepted that Quezaltepeque produces the most artistic articles made on a potter's wheel. Also famous for their ceramics are Ahuachapán, Guatajiagua, and Concepción Quezaltepeque, though pottery is, of course, made in almost every village.

There are two types of ceramics made in El Salvador which are unique and accordingly worthy of comment: the figurines of Ilobasco and the Apopa water jars. The townspeople of Ilobasco make very nice and well modeled figurines. The tiny figures have a great deal of expression and animation. (The attractive little dishes also made here are well molded and colored.) Splendid clay deposits

are readily available to this community, and the potters take great pride in their individual and secret methods of manufacture. A few of the older craftsmen told me that they added to their clay the resinous extract of the *escobillo* plant (*Sida rhombifolia*), which they believe improves the malleability of the clay.[5]

The very tiny figurines are molded by hand, whereas the larger pieces are fashioned in wooden molds. By either method the results are pleasing. A family by the name of Castillo had the reputation of being master craftsmen in this field, and they maintained their standing by making only the very best. The articles are baked either on stones on the ground or in simple kilns, depending on the quality and quantity of the output. The figurines are painted with one or more coats of gold and enamel, preferably *sapolin*.

Ilobasco ware is made during the entire year but traded only in the Christmas season. It is carefully packed in baskets or boxes and transported to the larger trading centers, especially San Salvador where the dealers or craftsmen set up their stands and display their wares on the streets adjacent to the central market. It is a joy to shop for these tiny figurines. Although the sale lasts several days, the supply is limited, and the first-comer gets the best.

The craftsmen of Apopa make a well-known red water jar. It has a few well-placed decorations made after firing by careful scraping and polishing with a stone. The design stands out from the body of the vessel, which is only barely scraped for a finish. The effect is that of a self-colored shadow decoration. The design is further enhanced by applications of *tahuite*.

The Apopa jars are molded in modern shapes. Some have stoppers, often fashioned in the form of a human or monkey face. Vessels with such a stopper are further decorated with hands modeled or painted as if resting on the body of the jar. I have a similar jar found in an archaeologic site in El Petén, Guatemala. This shape seems to have been developed, with slight differences, in widely separated

[5] This custom of using a vegetal temper is very old. It is stated that in the early Colonial period craftsmen kneaded their clay repeatedly to refine it and ground it further on the grinding stone or *metate* as is done today by older craftsmen. They then combined it with the juice of the root of the *cebollín* (a wild lily-like plant, fibrous and thorny, with a root containing a sticky substance) to make it malleable. *Cebollín* is also used to cure rheumatism.

geographic areas. For example, a jar of this description found in the Missouri Valley is now at Dartmouth College Museum.

GUATEMALA

Ceramics made on the potter's wheel in Guatemala are of good quality and artistry. A variety of glazes cover the biscuit evenly, and the whole vessel has a well-polished appearance without flaws. In this glazed ware there is now a great variety of shapes, decorations, sizes, and colors. The better grade of this ware is no longer a product of the original Indian craft but manufactured for trade purposes. Very modern household utensils as well as favorite Indian articles such as *batidores* (medium-sized jugs), *escudillas* (small round dishes), and *sartenas* (properly *sartenes* or round dishes with two handles used as frying pans) have been copied.

The principal colors of this pottery are various shades of blue obtained from cobalt oxide which the potters get from old blue enamel ware; green and crimson from oxide of copper obtained from old copper kettles and candlesticks; yellow from antimony, and a drab green or shades of red and yellow from scrap iron, the color depending upon the degree of oxidation. Indians travel great distances to obtain lead for glaze. The largest deposits of lead are to be found in the vicinity of Chinautla.

The principal towns where this ware is made (as well as some of the simpler glazed pottery) are San Cristóbal Totonicapán, Antigua, and San Miguel Totonicapán. The last is perhaps the best known such center. In the first two, whistles, vessels shaped like owls, and small toys are made also as specialties for the large yearly fairs in different regions of the country. Many of these special articles are now painted rather than glazed.

Until a few years ago Antigua was known as well for its beautiful, tiny, clay figurines similar to those from Ilobasco, El Salvador. In Antigua, however, the clay was mixed with the greasy substance called *nij*. Antigua and Sololá are especially known for glazed incense burners, so much in demand for religious processions. As the Antiguan ceramics are so well known and the place so accessible, I will describe the manufacture of wheel-made pottery there.

The source of the clay used for Antiguan pottery is near San

Lorenzo El Tejar. The clay is pulverized by grinding it between a huge stone and a round, brick, table-like mortar. The wheel of this mortar is turned by a large wooden handle. After being ground, the clay is strained through a fine wire sieve. It is then placed in a tank, mixed with water, and combined with plain mud in proportions according to the potter's private formula. The mix is kneaded with the bare feet and worked on the potter's wheel in the same manner as described for El Salvador. The vessels are dried in the sun and then fired in large ovens which are much more modern than the Salvadorean ones. Finally, the vessels are decorated and lacquered.

The gray glaze[6] so popular in Antigua is composed of lead, some sand, and tin and is prepared in a small kiln dug in the ground. The glaze is mixed with a given quantity of water and placed in a small, round tanklike receptacle about three feet high. In this tank rest three enormous blocks of stone, each weighing at least two hundred pounds. These stones are fastened to an upright pole and are worked by a horizontal handle. A man turns this apparatus all day until the glaze is well mixed and of the right consistency. A chicken feather or a cloth dipped in the glaze serves to draw simple designs on the vessel before it is fired in a kiln.

In the shadowy room where the potter sits at his wheel are a table and Christian altar. Lighted candles and flowers arranged in well-made clay vases decorate the altar. This quiet, dimly lit room presents quite a contrast to modern industrial mass production of pottery.

The hand-molding of pottery, too, is an important Guatemalan craft. The shaping of vessels is done in various ways: molding over an inverted old clay utensil, molding on a saucer or shallow dish on which sand is sprinkled beforehand, building up without the aid of any mold, or carefully holding the shape with straw while the worker manipulates the clay. Coil-made pottery is seldom made in these countries, although the technique was used in pre-Columbian times.[7]

[6] A black glaze derived from pine pitch (*brea*) is used on jars of a peculiar shape from the mountain regions of Huehuetenango and San Marcos.

[7] Some years ago I came across an old Mayan technique in Yucatán, that of using a wooden cylinder for a mold. The mold was placed on a board and spun by the potter by rolling it between the soles of his feet. Shaping by hand achieved the desired form. This process was called *K-abal* and the potter claimed to have learned it from his father and uncles, who were well-known potters.

Once or twice I have come across a survival of the primitive method of molding the clay over the dry fruit (*guacal*) of the morro tree (*Crescentia* spp.). The *guacal* or gourd burns away as the vessel is fired, leaving the vessel in the shape of the gourd. This process is well described by Thomas Belt. "In making their earthenware vessels, the Indians up to this day follow this natural form [of the gourd fruit]. . . . The gourd forms of bowls possibly originated from the clay being moulded over gourds which were burnt in the baking process. It is said that in the Southern States the kilns in which the ancient pottery was baked have been found, and in some the half-baked ware remained, retaining the rinds of the gourds over which they had been moulded. Afterwards, when the potter learned to make bowls without the aid of gourds, he still retained the shape of his ancient pattern."[8]

Designs used to decorate hand-molded pottery are always simple. A few geometric patterns or lines, human and animal figures, or flowers in rough outline are applied with a few brush strokes. White or red clay is used for some of the brush designs and smoke of the *ocote* pine for black designs.

Before such clay utensils are put into use it is necessary to "cure" them. For articles that are to be used over the fire, the highland people pour a mixture of water and corn paste into a new vessel which has been well heated. When the pot is cold and dry, the corn is brushed out by hand, and the vessel is then ready for use. The potters of the lowlands rub the outside of a new vessel with the black native soap called *jabon de coche* (soap from pigs), as well as thoroughly sudsing the inside before setting the vessel out in the sun to dry. Both processes make the vessel waterproof. Ordinary water jars used to keep water cool are merely smeared on the outside with a banana or plantain skin, lard, or a heavy solution of water and lime and afterwards submerged in water for some time.

Centers of the ceramic craft which make wares of particular interest include Chinautla, near Guatemala City, which produces excellent handmade pottery. The best are the water jars (*tinajas*)

[8] *The Naturalist in Nicaragua*, 47.

and the well-shaped, big red jars (*tinajeras*) about five feet high and flecked with mica and auriferous particles. They are decorated with such designs as a large sun made by two imprints of the five fingers of the craftsman's hand. The handles of these jars are decorated with tiny faces.

The principal pottery of this village is distinguished by its whitish appearance and numerous red brush designs. The whitish clay brought from near Mixco is claimed to be the best for articles to be used over a fire as they stand the heat better than the red ones (which are considered to be better for holding water). Well-shaped river stones, a bamboo stick, pieces of broken pottery, or a prehistoric celt are used in this village for polishing the clay. Here as in El Salvador the celt is described as being "Heaven sent."

Large water jars, flat round plates, and large, open-mouthed pots with two handles (*apastes*) sold on the Chimaltenango market hail from Santa Apolonía, famous for its splendid red clay ceramics of all sizes and shapes. Here, also, is used a whitish clay brought from a great distance.

Large round pots (*apastes*) with a brownish tinge are much in demand for cooking tamales and appear in the markets around Christmas time. These cooking pots, perhaps the finest in the country, have a very rough exterior in sharp contrast to the smooth inside surfaced by clay much refined on a grinding stone.

Large, very red water jars and *apastes* come from San Pedro Jocopilas, a center for this ware for the whole Quiché region. In San Marcos the large pots for cooking tamales are well glazed and boast four handles. In this region glazed ware is made in great quantities in Tejutla and Malacatán.

Jalapa is famous for its very dark red, well-polished ware decorated with simple black human and animal figures. The shapes are characteristic of this region and easily recognized. Momostenango's specialty is the large pot for distilling native liquor (*aguardiente*).

In Salamá and its vicinity (Rabinal, Purulha, and San Miguel Chicaj) the ceramics have a unique luster, giving a pearly appearance to the red-clay vessels. It is obtained from a mineral (*cascahuil*) found in the hills near San Sebastian (near Rabinal) in caves known

to the inhabitants of a nearby hamlet. This mineral is ground repeatedly on a *metate*,[9] mixed with water, and applied to the clay. The red or black brush designs that also distinguish this ware are applied before baking.

Clay articles other than such vessels which are of importance to the Indian include long, round beads which are made to serve as weights for fishing nets in Alta Verapaz and small figures which are set along the ridges of houses in several villages. Clay whorls in Tonimchun are still made in the same shape as they were centuries ago. The Lacandón Indians make clay whistles either in the shape of an animal or decorated with an animal figure. These whistles are carried by hunters to reproduce the call of the animal represented by the whistle.

Another such article is the *pichacha*, a clay jar-shaped sieve with a pierced base. Its major use is for washing corn for tortillas (San Sebastián, Retalhuleu). *Pichachas* are also used by witch doctors or *zahorines* in the performance of their rites. A few embers are put in the bottom of a *pichacha* with a tablet of copal which burns slowly. Fine ashes and smoke ooze out of the small holes while the shaman performs his rituals. The *pichacha* is used by the shaman either in a village hut or in the woods where he consults the occult powers (Huehuetenango).

Pichachas are used also in the marriage ceremony of the Indians of Quezaltenango. In keeping with most wedding festivities, the ceremonies include much feasting and drinking. After the guests have left the young couple is obliged by tribal custom to eat as much as they can of the remaining food. What they cannot consume is then placed in a new *pichacha* and the bride and groom must not eat anything else until all the food in the *pichacha* is gone. It is considered a bad omen for the future happiness of the young couple if the food in the *pichacha* spoils before they can finish it.

Clay vessels play a part in an important festivity called Guajxaquip Báts celebrated once a year in Momostenango on the out-

[9] *Metate*, or *piedra de moler*, is the rough stone used by the Indians to grind corn for the major element of their daily meal, tortillas. In addition to the preparation of foodstuffs, the Indians also use the *metate* for grinding craft materials. These grinding stones are the specialty of the village of Nahualá, where on market day they are sold in every size required.

skirts of the town. Numerous altars of bits of broken pottery which has been offered to the ancient deities mark the spot that in time becomes a solid mass of debris.[10] The date for this festivity is calculated according to the *tzolkin* calendar. Thousands of Indians gather for this celebration, all laden with red clay vessels to be sacrificially broken and used as offerings. This ancient ceremony, lasting for several days, is conducted strictly according to time-honored ritual.

Handmade pottery is being rapidly replaced by the products of the potter's wheel. As with every other craft, quality is now neglected in favor of quantity and speed of production. Artistry is a less important consideration than monetary return, even though the latter is minute when one considers the time and effort involved in the manufacture of clay utensils and objects of art.

[10] Antonio Carrera Goubaud, *The Guajxaquip Báts: An Indian Ceremony of Guatemala.*

XVIII

*

Gourds

THE FRUITS OF THE MORRO TREE, the cucurbits and other plants
bearing fruits with hard, woody skins, collectively called gourds,
form natural containers which need little processing. The peoples
native to Central America learned long ago to use the dried shells
of these fruits, halved for bowls, quartered for eating implements,
and whole (or nearly so) as cups or for water jars. Readily avail-
able and easily replaced when split or broken, the domestic utensils
made from these fruits became indispensable. Their production con-
stituted a lively industry in the areas where the gourd-producing
plants grew naturally.

As in respect to every other article in common use, the Indian
ultimately applied decoration to the gourds. Such gourd containers
were some of the most prized items in the pre-Conquest tribute lists.[1]
Many pictures and carvings of that time show deities and officials
holding carved gourds supposedly filled with chocolate, "the drink
of the gods."

[1] Clark, *Codex Mendoza.*

218

Particular artisans became well-known for their skill in this craft. Landa mentions the round fruit of the "calabash tree" from which the Indians made drinking vessels, decorating them with paint and rich ornaments.[2] Certain villages specialized in carving and decorating gourds in different ways. A brisk trade was carried on in pre-Columbian and Colonial days between the Indians of Alta Verapaz in Guatemala and those of Sonsonate in El Salvador, the Cobán Indians exchanging dyewood for Sonsonate's cacao beans. Such trade, or the migrations between 1544 and 1574, may have been responsible for the introduction to El Salvador of Guatemalan skill in gourd decoration from centers of this craft famous to this day. There are today several villages in Central America where the natives are recognized masters of gourd decoration.

During the Colonial period the Spaniards were enchanted with the Indians' decorative work on gourds and coconut shells and engendered a lively trade between the Indian centers and the principal Colonial cities for the production of gourd utensils. Such utensils were decorated by the Indians for Spanish use, traded to the capital of the kingdom of Guatemala and used in many aristocratic households of *La Muy Noble y Muy Leal Ciudad de Santiago de los Caballeros* during the sixteenth, seventeenth, and eighteenth centuries. The aristocrats added a touch of their own by having the silversmiths of their households decorate such articles with silver trimmings. Coats of arms of the noblemen and prettily fashioned feet of hand-hammered silver set off splendidly the highly polished dark surface of the *jícaras* and *guacales*. Those *jícaras* which were small and lozenge shaped were cut in half lengthwise, incised with designs, polished, and trimmed with silver along the edge. At one end of the spoon-shaped cup a silver chain and ring were appended to permit attachment to a saddle. The Spanish horseman was thus assured of a drinking vessel when riding through the countryside. These *jícaras* are no longer to be found.

The idea of ornamenting gourds with silver was of Spanish origin during the sixteenth century. Coconut cups trimmed with silver in the same manner as those later used in the Spanish colonies were made in England, Germany, and Holland from decorated fruit

[2] Landa, *Relación de las cosas de Yucatán*, 240.

imported from their colonies. In Holland a leather cup was used which was almost identical in shape to the gourds and coconuts of the Spanish colonies. A coconut cup trimmed with silver attributed to the skill of William Busfield of England in about 1680 is almost the duplicate of one I once owned which had been carved in Nicaragua at about the same time. Today these cups trimmed with silver are a collector's item.

It was the fashion among the Colonial Spanish elite to offer hot chocolate or *atole* in the pretty cup-shaped receptacles during evening social gatherings (*tertulias*). Many a choice bit of gossip was exchanged, political events were discussed, and more than one governor-general's reputation was made or broken on a cold drizzly night while the guests refilled their *jícaras* with the delicious steaming liquid served in vessels quite unknown to them in their far-off homeland.

As noted previously, there are several fruits whose husks or shells are used as containers. These are the fruit of the morro tree, various species of the cucurbits, and the coconut (*Cocos nucifera* L.). Dictionaries, books, and labels on museum exhibits are confusing because they attribute the gourd entirely to the calabash or the cucurbit family, and, when speaking of *Crescentia cujete* L., call it, "calabash tree." All through Central America, C. *cujete* and C. *alata* H.B.K. are called *morro* or *jícaro*, and the products made from the dried fruit are called *guacales* and *jícaras*. The fruits of all species of cucurbits are also called gourds, but these are seldom found in museums as they are not ordinarily decorated.

The *morro* (C. *alta* H.B.K.) is a tree of medium height with a flattened top and small leaves. The large bell-shaped flowers that grow on the branches and trunk produce the fruit generally known throughout Central America as *morro*, *jícara*, or *güira*. In certain districts where the dry and rainy seasons are sharply defined there are large tracts of land entirely covered by *morro* trees. These lands, known as *morrales*, turn into veritable swamps during the rainy season while during the dry months the ground is so baked by the intense heat that there is hardly any other growth.

There are two different kinds of *morro* fruit. From the spherical variety (C. *alata*) bowl-shaped containers are made which are

known as *guacal* or *huacal*, while the ellipsoid fruit (*C. cujete*), called *jícara* or *xícara*, is used for cups.

Containers made from the dried fruit of the different species of cucurbits and commonly called *calabaza*, although quite as useful, are not nearly as popular as the *morro*. The calabash utensils are seldom decorated, but when they are, they are painted. The kind most commonly used, also called *guacal*, is the fruit of *Feiulla cordifolia*. The fruit of *Lagenaria depressa* and *L. gourda* are often used as water containers, especially by Indians who travel or work in the fields.

Another Central American plant which yields fruit suitable for containers is the *tol* or *tarro* vine (*Lagenaria leucantha* [Lam.] Rusby). When ripe, the huge fruit is cut in half, the seeds and pulp removed, and the shell dried in the sun until it is hard. These receptacles are either decorated in the same manner as the black and white gourds or painted with ordinary paint in very bright colors. The decorated and painted varieties are tourist trade pieces, whereas the undecorated ones, called *tol* or *guacal de tol*, are used at home for strainers for clay slip, containers for vegetables and fruit, babies' bathtubs, and many other purposes.

This fruit attains enormous size in the warm climates of both countries. In El Salvador there is a belief that if a pregnant woman walks through a field where *tol* vines are in flower, the fruit will be stunted and the woman will have a difficult labor or the baby will be born deformed. Women in that condition, therefore, will make long detours in order to avoid such a field. The large, lacquered gourds traded throughout Central America are the Mexican *jicapextle*, the fruit of the *tol*.

Plain, unadorned gourds are used widely and are common items of trade in the village markets. They cost little or nothing. Accordingly, when they become discolored or split they are thrown away, and new ones are either bought or made from the handiest source in the vicinity.

Decorated gourds are used by the Indians for many purposes: household utensils, children's rattles, pretty receptacles for small articles and buttons, toys, masks for ceremonial dances, and rattles with which to beat on the empty carapace of a turtle for one type of

music at special celebrations around Christmas time. The masks are so well cut into grotesque expressions that they are rapidly taking the place of the old beloved but cumbersome wooden masks. Oddly shaped gourds are fashioned into delightful animal figures by the addition of four legs of wood.

GUATEMALA

In Guatemala the village of Rabinal (inhabited by Quiché Indians) is presently famous for its artistically finished engraved gourds. Many other villages in this republic are known for this industry, but in no other town is the work as well done as in Rabinal. In El Salvador the village of Izalco is at present the center for engraved gourds.

Gourd decoration in Rabinal is so renowned that about 1890 a man by the name of José Yol was sent over to Izalco at the request of the authorities there to teach the Rabinal techniques to the villagers. His teaching had no lasting effect, however, for I have not noticed the influence of the Rabinal style on the Izalco products.

Guatemalan Indians decorate most of their gourd utensils. The most popular are the black and dark-colored varieties with white decorations in high or low relief. Another kind, known in this country as *pintado* (painted), has a red or yellow background with designs in black, yellow, red, and white painted on the smooth surface. Gourds with other bright colors applied with aniline dyes are modern trade pieces made for the *ladinos*. There are three styles of decoration used on gourds in Rabinal, where the Indians call the *guacal*, *tzima*, and the *jícara*, *cocal*.

Black Engraved Gourds. One of these decorative styles is the engraved decoration of a gourd previously stained black. The green fruit is cleaned of all its pulp, cut into the required shapes, and dried in the sun. The rough outer skin is then removed by rubbing with the leaf of the evergreen oak tree (*Quercus ilex* L.), known here as *chaparro*. Its rough surfaced leaves are commonly used as an abrasive. Once the vessel is smooth, it is dyed with lampblack obtained from the smoke of pitch pine (*ocote*) mixed with grease. When the color is set, the artist proceeds to decorate the gourd according to his fancy, using a crude knife which he calls *buril* (burin) and

with which he manages to engrave the most exquisite designs. The gourd is then carefully polished with the waxy substance called *nij*.

Nij, *nije*, or *ajin* is the Indian name given the waxy material extracted from a louselike insect (*Coccus nige* or *Coccius axuua*) which lives on resinous trees in the regions of Rabinal, Cubulco, San Pedro Carcha, Cahabón, Amatitlán, and Barberena. The female insect is larger than the male and of a reddish color; the male resembles mother-of-pearl. The trees on which the insect lives are the *jocote* (*Anacardiaceae*), the piñon (*Jatropha curcas* L.), the *guayabo* (*Psidium guajava* L.), and the *marañon* (*Anacardium occidentale* L.). The insect was first named by Pablo de la Llave, of Mexico, who called it *ajin*.

The usual procedure for extracting the wax is to put the insects in boiling water and squeeze the wax from them. The wax then floats to the surface of the water. The bodies of the insects are pulverized in a mortar and well mixed with the wax. This mixture is washed and the red pigment dissolved in alcohol, for if it is present it will injure the lacquer made with the wax. Generally the pigment is not well extracted, and the *nij* has a decidedly reddish-yellow tinge. The *nij* is composed of a greasy wax with two distinct parts which can be separated by warm alcohol: the yellow wax, or *labeina*, and the white, *nigeina*. Alcohol will dissove the *nigeina* and leave the *labeina* adhering to the vessel. The *nigeina*, pure and dissolved, floats to the top. *Labeina* is soluble in ether or gasoline. For industrial purposes, however, it is found cheaper to use the whole wax rather than go to the expense of buying alcohol and gasoline.

Before applying it to a gourd vessel, the artist mixes *nij* with linseed oil and thickens it with lampblack until it is soft enough to give a good polish. As the *nij* is being applied to the gourd it is repeatedly rubbed with the palm of the hand, hot wax being gradually added until a high gloss is achieved. Most Indians do not take the trouble either to prepare the wax properly or to use linseed oil but apply only the very hot wax. A second and even a third coat of *nij* may be applied to bring out the design on an especially fine gourd.

The Rabinal craftsmen come in to the annual Guatemala City fair with great quantities of decorated and undecorated gourds. The

undecorated gourds have been especially prepared with black dye and polished with *nij* but are not further worked. While the fair is going on, the artist engraves these gourds in a marvelously quick and efficient manner with his ordinary knife or burin while the buyer waits. The most intricate work is as nothing to such a man. He will engrave names and mottoes without any mistake, even though he knows nothing of the alphabet.

Monochrome Engraved Gourds. Dark-brown or yellow gourds with designs engraved on them are handsome but not as popular as the black and white variety. The engraving is done before any color is applied. Red is obtained from a mixture of grease combined with the powdered seeds of the fruit of the *achiote* tree (*Bixa orellana* L.). The grease is combined with finely powdered mahogany sawdust when brown is desired.

Painted gourds. Painted gourds are prepared as are black engraved gourds, except that the polishing, while not high, is more carefully done so the surface will take the dye evenly. Once the basic color is dry, the artist decorates the gourd inside and out with symbolic figures of humans and animals in graceful postures. These figures are very similar to those found on prehistoric pottery and stone. It is the painted gourds that are used by the Indians during the performance of traditional rites.

This style of decoration is also used for the *tecomate*, a peculiar, long, bottle-shaped fruit from the calabash vine (*Lagenaria siceraria* [Molina] Standl.). When the fruit is dry, the seeds and pulp are removed through a small hole at the narrow end, small clay pellets and stones inserted, and the hole closed by a cornhusk. A couple of *tecomates* are used as a rattle to accompany the music for ritual dances.

A red dye, seldom used now, was once made with a preparation of animal blood and lye and was much sought after for painting ceremonial gourds. More rarely, indigo was mixed with lemon for black, very much in vogue a few years ago. A good yellow dye for coloring gourds is made from the bark of the *palo amarillo* (*Chlorophora tinctoria* [L.] Gaud.), which grows abundantly in the forests about Alta Verapaz.

224

In the years gone by, the Kekchi Indians of the village of Cahabón excelled in decorating gourds of all kinds. The men of one family acquired fame for their splendid workmanship and prided themselves on being descendants of master craftsmen in this industry. Their trademark seems to have been the armadillo (*Dasypus*), which was incorporated among the decorations on the gourds. The gourds done by this family were in great demand for use in religious rites and for the households of the higher-caste Indians. Only one member still lived there in 1930; the rest had emigrated to live among the Mopán Indians in the more remote areas of the department of Petén.

Outsiders have taken the place of these Kekchi gourd decorators. These newcomers in Cahabón naturally are not as expert as those who went before them. I have been told that the Kekchi craftsmen also knew the negative process of gourd decorating which may well be true for prehistoric specimens of the negative or lost-color process on pottery have been found in that region.

Some of the *jícaras* used for ceremonial events in *cofradía* houses, especially in the highlands, are decorated by the negative process. Those I have come across are of two kinds, both distinctly ancient in technique. The first has designs similar to the prehistoric, geometric pottery designs in the lost-color technique, which, I was told, originated in the region of Alta Verapaz. They might well have been made by some ancestor of the Cahabón craftsmen. The second kind is decorated by this same process but in designs exactly like those which occur repeatedly on the gourds from Izalco, El Salvador.

Large gourds decorated in the lost-color technique bearing those designs which are much prized in San Juan Sacatepéquez were said to have come from the south. The Quezaltenango *jícaras* for very special occasions were also said to have come from the same southern region, and were obviously an Izalco product.

Gourds and *jícaras* are closely associated with religious observances. The tall *jícaras* called *de brujo* (gourds used by medicine men and witch doctors) bear symbolic figures painted in black, white, and red on a yellow surface. They may contain hair, bits of cloth, buttons, seeds, or trinkets belonging to the person who

has asked intercession in bringing good or evil to someone, or who wishes to have his fortune told. These belongings, however, do not necessarily have to be the property of the person who pays for the *brujo's* services. For instance, a young man wishing to marry takes odds and ends of the girl's hair and personal apparel to the *brujo*, who carries them in a *jícara* to his place of mystery in the woods, usually under a ceiba tree. The following day the *brujo* returns with his report which enlightens the young man about whether it is advantageous to press his suit. If the *brujo* reports that the girl's health is poor, the youth goes no further, as it can only cause expense to marry a frail girl. The youth then seeks for a wife whose health is approved by the *brujo*.

Weddings, christenings, funerals, and other ceremonies, whether Christian or pagan, are occasions for the consumption of much food and drink. For such affairs, gourds are used to serve the ceremonial food and drink. On the first and second days of November, gourds of all sizes are filled with special food, the prescribed tidbits consisting of *fiambre* (rather like Russian salad), *jocote en dulce* (a plumlike fruit cooked in brown sugar), and well-seasoned pumpkin and sweet potatoes in syrupy brown sugar. Following the lighting of candles, offering of prayers, and placing of yellow flowers (*Calendula officinalis* L.) on the graves, this food (called *cabecera*, headpiece) is placed at the heads of the graves. (These yellow flowers, called *flor de muerto*, present another association of yellow with mourning.) The mourners believe that the spirits of the dead return at midnight to partake of the food. Next day the Indians return for their gourds and take it to be a good omen if the food has disappeared. If the food is still there, however, it is a sign of the spirit's displeasure and will bring bad luck to those who brought the offering.

Ordinary bottle-shaped gourds, *tecomates*, are used to regain affections that have strayed or to turn back thoughts to the person who calls—*llamar en un tecomate* (to call into a gourd). A person who leaves his home and does not send back word of his progress or a client who changes to another merchant gives just cause for the offended person to call into an empty gourd the name of the person who has strayed. The name having been called repeatedly and in-

sistently, it is not long before the matter is settled, the loved one returns, the traveler writes, or the client comes back to the fold. In some regions a large clay jar is used for this purpose instead of an empty gourd. The echo produced in the empty vessel supposedly engenders clairvoyance.

Another traditional manner of using gourds is the placing of *tzutes* over and under bread and a *jícara* containing *chilate*[3] for guests. Custom requires that the gourd cup be red and yellow and also that the *tzutes* be decorated with red and yellow figures.

El Salvador

The Indians of El Salvador also use gourds, and the village of Izalco has gained a reputation for its decorated *morro* products; *guacales* (*cascos de anfisarcas de guacal*) and *jícaras* (*anfisarcas de jícaro*), both of which are elaborately decorated by various methods.

Other villages prepare plain, unadorned *guacales* and *jícaras* for their own use and call them *cheles* (a name applied in El Salvador to fair-haired people, especially foreigners). The preparation of *cheles* involves cutting the fruit in halves or quarters, removing the pulp and seeds, and boiling the hard shells in a heavy lime-water solution before drying them in the sun. This process gives the gourd a smooth, clean, yellowish surface inside and out.

Black Engraved Gourds. Black engraved gourds are made in El Salvador as well as Guatemala. A fruit is divided according to the shape required. After it is well cleaned of all pulpy material, the shell is rubbed with the leaves of the *guarumo* tree (*Cecropia peltata* Flores) to obtain a smooth surface and remove the outer thin layer of skin. The dye (*tinta*) is prepared by mixing fermented corn with oxidized nails and water in a large earthenware jar. In another jar is prepared a mixture of the well-mashed and boiled fruit of the *nacascolo* (also called *nacascolotl* or *nacascolote*) (*Caesalpinia coriaria* [Jacq.] Willd.). The gourd is dipped in the *tinta* and dried in the sun, then in the *nacascolo* solution and dried again. This process is repeated several times a day until the required shade of black is

[3] *Chilate* is a drink made from dark-purple corn mixed with chocolate. Corn may also be boiled in lime water and ground to make *totoposte*, the diet of troops on the march. Yellow corn is fed to game cocks in the belief that it gives them stamina and valor. The leaves of young corn are polished and used as cigarette paper.

obtained. Between every complete round of dipping the gourd is well polished with the palm of the hand. Occasionally, for special gourds, a varnish made of finely powdered charcoal mixed with lemon juice is applied by a woman who continuously rubs the surface of the gourd while exposing it to the hot sun.

When the gourd has been so dyed and polished, the craftsman decorates it with any sharp instrument at hand. I have seen a man use the rib of an umbrella for the purpose with great success. The engraved figures appear in white beneath the black-dyed background. These gourds are generally decorated with one or, at the most, two animal figures, the favorites being rabbits and fish. These animals were especially prominent in many of the old beliefs of the Izalco Indians. The Izalco gourds are easily distinguished from others of El Salvador by their dull gloss.

Painted Gourds. Another variety of black gourd with white decorations is called *pintado* (painted), but it has nothing in common with the painted gourds from Guatemala. The *pintado* gourd is scarce nowadays. The method of preparing it had almost died out in the last decade, though it was the *pintado* gourd which made Izalco famous as a center of gourd decoration.

After the gourd has been cleaned, dried, and rubbed with *guarumo* leaves, the artist carefully lays on the design with warm grease. Currently he uses beeswax instead of *nij*. Should any of the lines become too thick or the design be not carefully etched, the artist carefully goes over the outline of the figures with a sharp implement to cut away any surplus wax. The gourd is then left to cool, and the next day it is dyed black with *tinta* and *nacascolo*. After it is dry the artist holds the gourd over a fire and with a cloth wet with hot water cleans off the melting wax or grease that covered the design. The design in sharp white outline is thus exposed on the black background.

These negative-process gourds resemble the more common gourds decorated in low-relief; however, at close range the techniques can be distinguished. The designs on the negative-process gourds are very primitive and in most cases represent some clan symbol. There seems to be a tendency to draw the same figure from one decade to another. I have repeatedly come across a female fig-

ure in graceful attitudes with either a birdlike or a monkey head and flowing wavy hair down her back. This figure is accompanied by animal figures, usually a scorpion and a bird. I have one of the gourds showing the so-called dance of *el alacrán y la mona* (the scorpion and the monkey) which a modern Izalco Indian interpreted for me: "The female figure represented by the monkey is pursued by a scorpion (*alacrán*). As she runs away from it, they meet a duck who sings so sweetly that the scorpion dances away without harming the monkey."

Such figures probably date from prehistoric times and are associated with important fertility rites and ancient myths of the Pipil Indians from whom the Indians in Izalco and Nahuizalco are descended. In these myths the scorpion represented the male. The bird is undoubtedly the *charra* or sekset considered to be one of the discoverers of corn. The female figure with flowing hair is the representation of water—rain and the sea with its tides and waves. In the older myths of this region the sea is feminine, being similarly influenced by the periodicity of the moon. It is the moon upon which the *tonalámatl* (the ancient Nahua calendar which corresponds to the Mayan *tzolkin*) is based and by which are calculated the dates for planting corn. Rain and water fertilize the earth and are represented by the wavy hair of the female figure. The face of the female figure is that of either bird, monkey, or human representing the beginning of mankind and of legendary animal lore.

Unadorned and unpolished gourds of the calabash vine are used everywhere in El Salvador in the same ways as in Guatemala. Large, plain white gourds come from the region of San Miguel, where the gourd tree is called *cutuco*. It is a larger species whose leaves and fruit are bigger than those of the morro. Port Cutuco in the department of La Union, El Salvador, is named for this tree which grows abundantly all over this region.

Gourds are put to every possible use in El Salvador. The Indians even use small gourds on their arrows as a protection for their hands. A large inverted gourd closes the smoke hole at the apex of the high, sloping roof of the thatched Indian huts. A large dry *jícara* is carefully punched full of holes and is used as a strainer

for clay slip (*pascón*). The best-known musical instrument, the marimba, has a sounding board made from *jícaras* of graded sizes. Another instrument in this country is the *caramba* which has an inverted half-gourd called *cumbo* placed halfway along the reed arch which holds the strings. A large half-gourd attached to a long stick makes an excellent skimming ladle and is so used in the sugar mills. Two dried and well-cleaned half-gourds form the two plates at the end of a weighing scale: they are hung by strings of henequen from a horizontal stick which, in turn, is carefully balanced by a small loop of string at its center. One of the gourds holds the weighing stones which have been checked in the Office of Standard Weights. These are but a few of the uses for gourds in this country.

The art of decorating gourds has degenerated in the last few years, and a flamboyant style has resulted from mass production. *Ladino* artists have at various times and with great success tried their skill at gourd decoration. The finished product is well proportioned and artistic but is not as appealing as those decorated by more primitive techniques.

XIX

*

Conclusions

THE FOREGOING DESCRIPTION of the handicrafts native to the Indians of Guatemala[1] and El Salvador was undertaken in the knowledge that these crafts are fast becoming a thing of the past. Special emphasis was placed on textiles not alone for their variety and frequent beauty. Their production represents the most diversified of Indian skills which have survived Europeanization.

Among the Indian handicrafts which are so rapidly giving way to industrialization and commercialization, the production of textiles is outstanding. The use of machine-made metal thread and pre-dyed and aniline-dyed yarns to produce foreign and abstract designs which have no traditional Indian meaning have taken the place of homespun and home-dyed yarns used to develop the interesting traditional figures and symbols which alone once decorated Indian textiles. Increasing demand of the foreign market place for pseudo-In-

[1] The reader familiar with the geography of Guatemala will realize that I have omitted discussion of the handicrafts of the northeastern part of this country. They have been well described by Charles Wisdom in his book entitled *The Chortis of Guatemala.*

dian fabrics and designs is being met, and quite understandably. If his income is tied to the production of textiles which suit foreign taste, the Indian weaver may be expected to produce them.

Ladinos have seized the opportunity presented by the export trade by establishing factories and workshops and introducing machinery not only for the production of textiles but also ceramics and basketry. As agrarian culture gives way to industrialization, per force of necessity, the village weavers flock to these factories and workshops. Their former skills in handicrafts suffer from disuse.

The factory is not alone in enticing the Indian village weaver from his or her loom. The wages of a servant girl are far more attractive than the small profits gained from long hours of back-breaking toil over a hip-strap loom. The Indian miss is no longer interested in learning pottery-making, weaving the traditional village designs, or the finer techniques of decorating gourds. When her grandmother dies, these skills frequently die with her. The *morro* tree is no longer carefully tended, and its fruit are small. The lost-color technique of gourd decoration is well named—few remain who know it. The end of an era is at hand.

Custom changes with the times. Today's baskets are often fine imitations of foreign ones, particularly those with stout handles. Foot-treadle sewing machines have been carried high into the mountains to speed up the manufacture of clothing and hats. The remaining village weavers, with an eye for a rich *gringo* buyer, incorporate American cross-stitch embroidery designs in their textiles. Sheets of brilliant plastic have replaced the palm-leaf rain capes once worn by *mestizos* working in the fields.

At the present time, however, there are still distinctive and lovely costumes to be seen in Guatemala, although native dress is disappearing. There are about two hundred villages in this country wherein either men or women or both still wear tribal dress. Within these villages, the younger people are now leaning more toward Westernized dress, and the lovely old costumes are usually worn only by the older people on ceremonial occasions such as a church festival, birth, marriage, or death.

In addition to these villages, native dress tends to persist in the

fincas (coffee estates, as distinct from the *haciendas* or cattle ranches). Here Indian laborers, settled as *colonos*, appear to have preserved their village costumes though far from home. Such a community is Pampujilla near the village of San Lucas Tolimán. Whether costume worn here is an amalgam of several elements or the residents' native village dress, I cannot say. It is rapidly disappearing in favor of the white shirt and trousers worn almost universally in this area by such workers.

In sharp contrast to Guatemala, El Salvador has only five or six villages where distinctive costumes still appear. The three wherein more Indians wear native dress than not are Panchimalco, Izalco, and Nahuizalco.

The Indian men, in particular, are discarding their native dress except for ceremonial occasions. The change most widely effected is to wear a Western-style shirt or a sweater (for example, those worn by Maxeños) under the typical village costume, while overalls grow daily in popularity for men and small boys. The women tend to preserve their native costume in greater number, owing no doubt to their less frequent contact with the world outside their own villages. Those women—usually the younger generation—who come into the city to work, in their common human wish to become "one of the crowd," have adapted their dress to more closely parallel that of the Westernized world into which they have moved.

Despite the trend toward Westernization which is evident in the present everyday garb of most Indians, ceremonial costumes continue to maintain their basic Indian characteristics. This is true even for villages where the Indians wear almost none of the traditional costumes for everyday clothing.

Crafts other than the textile one have been highly developed in particular geographic areas within these two countries and the products spread countrywide by the Indian traders. As the excellent quality of particular items became known, the Indians preferred to wait for the trader from Rabinal with his mule-load of gourd vessels or mats, and the one from Chinautla with his water jars, or perhaps the Indian would leave his village and travel to Guatemala City or Antigua to search for a particular type of basket in the big

markets of these cities. The Antigua market, in particular, has baskets from three nearby towns (San Martín Jilotepeque, Itzapa, and Parramos, which are reputedly well made.

Rope and rope products are still made in lowland villages where maguey and henequen are readily available. The Indian knows that if he needs rope other than what his wife and children can provide for him he will be able to find what he wants in San Miguel, San Sebastián (Huehuetenango), or San Cristóbal (Alta Verapaz).

Like all youth, today's trend-conscious young Indian is anxious to be as "up to the minute" as possible. His reply to the often-put question, "Why do you change?" is always *"Es la moda"* (It is the fashion). What a shame that so many of the beautiful examples of Indian handicrafts I have described in these pages are rapidly being put aside in favor of more modish trade and store-bought goods; how sad that the old native skills are vanishing, for once the individual is caught up in the whirl of today's rapid pace of living, he will never again return to the old, the traditional culture patterns and influences. Who is to say which is best?

COLOR PLATES

In this section are shown some of the traditional Indian costumes of Guatemala. The first eight plates are from photographs by Joya Hairs. The other color plates are from original water colors by Sra. Julia Ayau de Lopez Escobar.

Plate 41. Todos Santos: man and woman, note feather in man's hat indicating that he was a dancer during festivities.

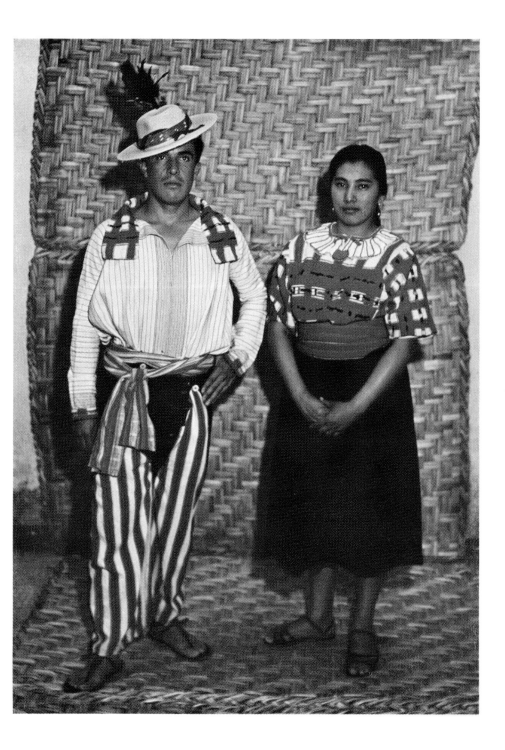

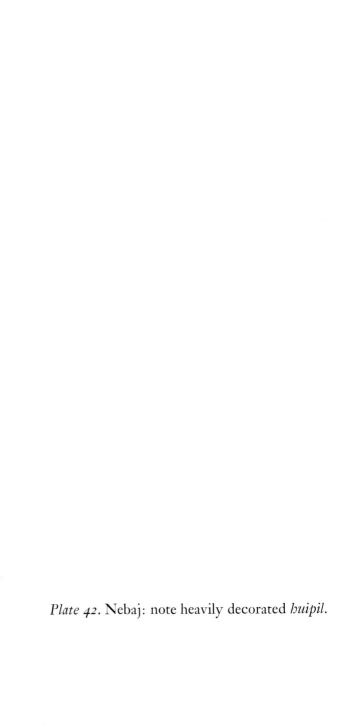

Plate 42. Nebaj: note heavily decorated *huipil*.

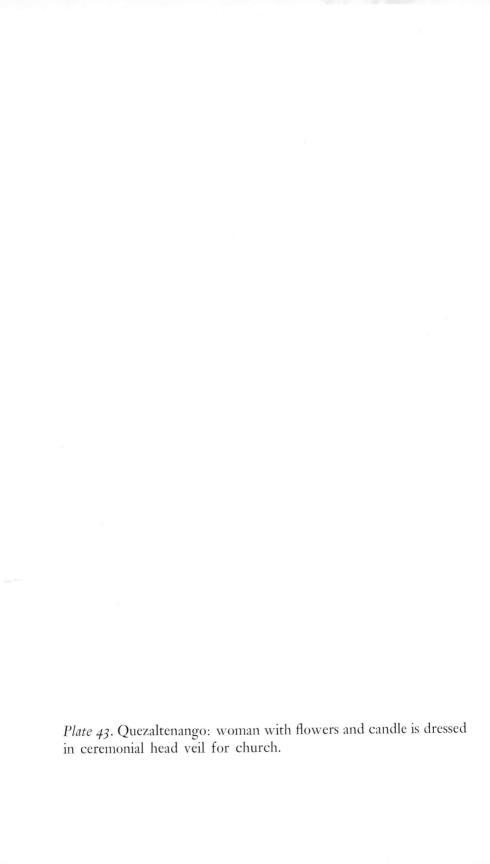

Plate 43. Quezaltenango: woman with flowers and candle is dressed in ceremonial head veil for church.

Plate 44. Sololá: man with knitted bag, *tzut* over shoulder.

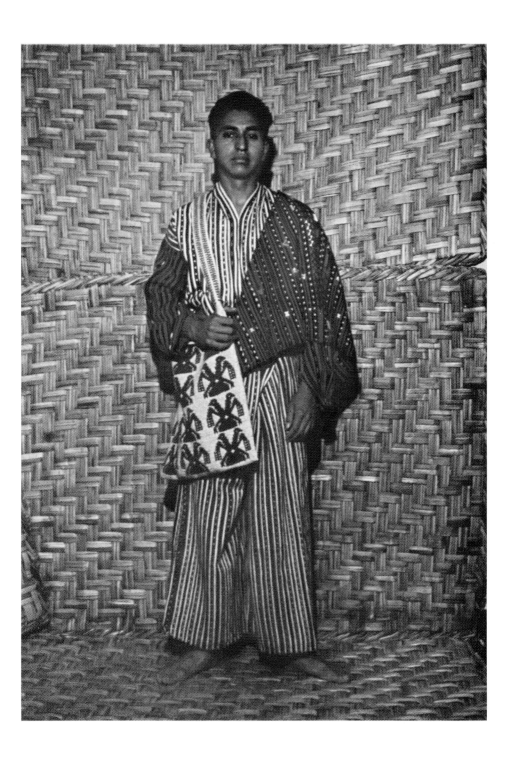

Plate 45. San Pedro Sacatepéquez: woman with heavily decorated *huipil*.

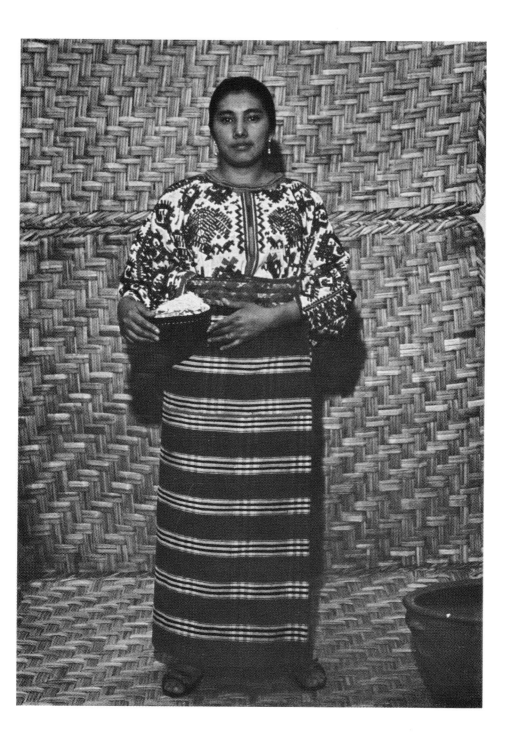

Plate 46. Cobán: Woman with *tupui* (coral snake wool hair arrange-
ment).

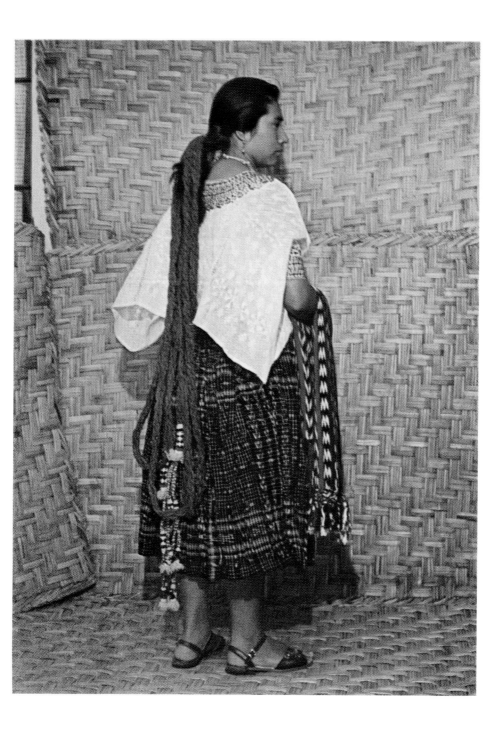

Plate 47. San Mateo Ixtatán: woman carrying basket.

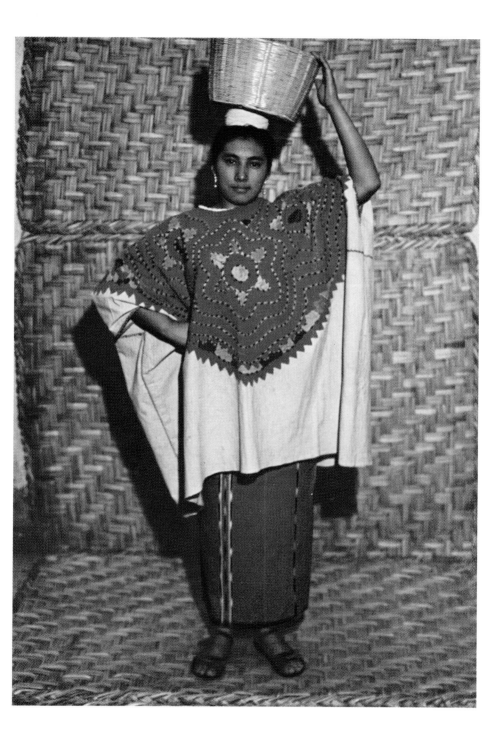

Plate 48. Chile Verde: note heavily decorated sash and cuffs.

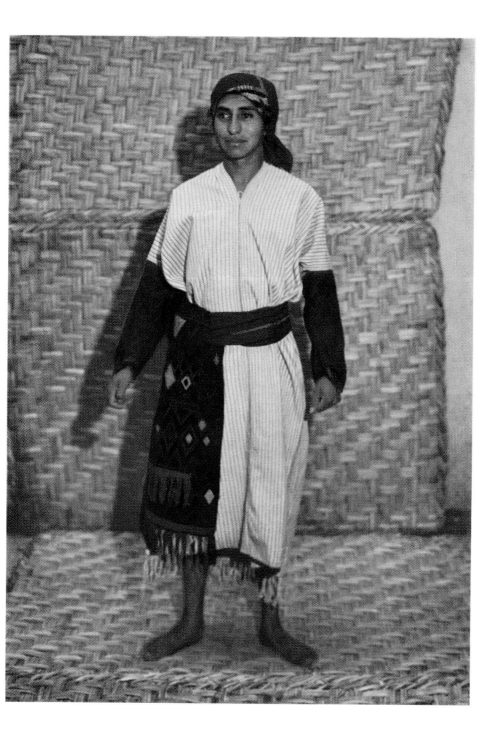

Plate 49. San Pedro Chuarrancho. *Left.* A weaver, using the primitive hip-strap loom, faithfully reproduces the textile designs characteristic of her village. Her hair is secured with wool strands. *Right.* The yellow sash worn by the man of San Pedro Chuarrancho distinguishes his costume from others of the same general style. This banana trader carries his identity papers in a string bag slung over his shoulder.

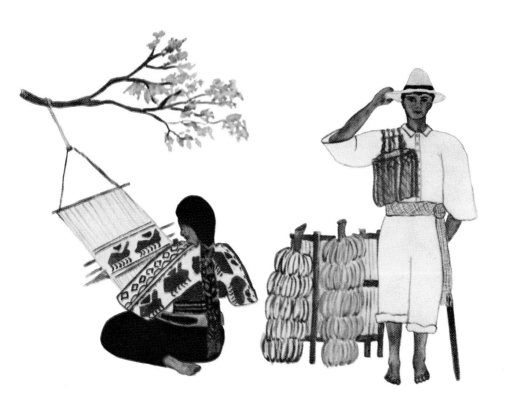

Plate 50. Comalapa (San Juan). *Left.* The woman wears a *cuyuscate huipil*, typical daily dress for this village. *Right.* The white, heavily decorated *huipil* is the second type worn here. Woven on a *palito* loom, as are the brown ones, it may now be worn at any time.

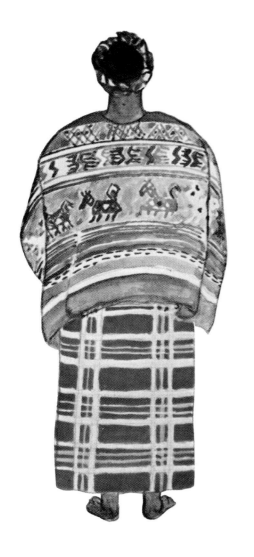
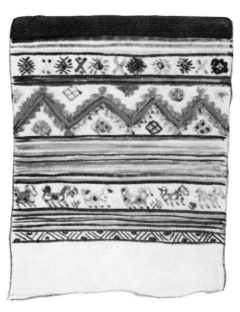

Plate 51. Tecpán. A woman and her daughter kneel in the doorway of a church. The mother wears a heavy *cuyuscate huipil* with designs woven in silk floss. The daughter wears a white cotton *huipil*, not only worn by young women but also as an undergarment for the *cuyuscate huipil* by older women. The large brown *huipiles* are most frequently seen in the Holy Week processions, and then worn by *cofradía* members.

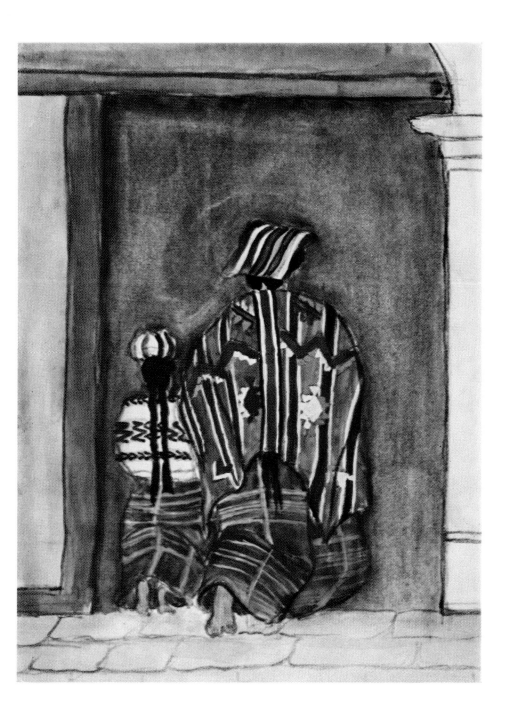

Plate 52. San Antonio Aguas Calientes. *Left.* Some of the finest weaving in the country is found in these *huipiles,* although lately designs taken from cross-stitch samplers are being incorporated into the textiles to please the tourist trade. Note the small cloth used as a head covering. *Right.* The typical men's woolen garment worn over a bare torso is known as *gaban.* The men of this village weave tule mats and trade them far and wide.

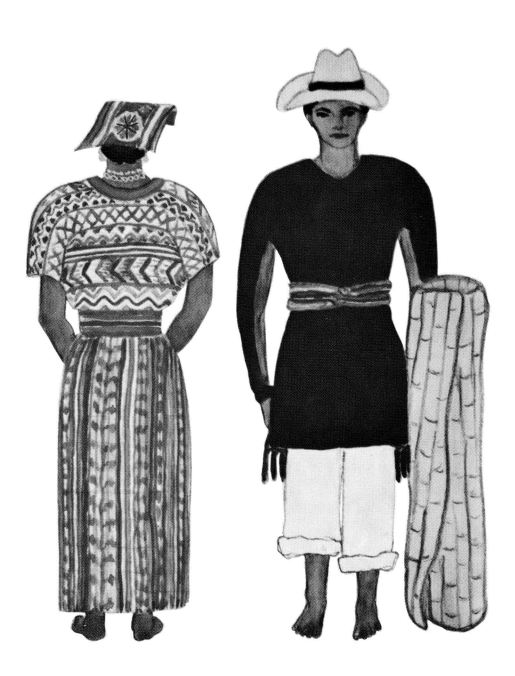

Plate 53. Santa María de Jesús. *Left*. The colorful shirt is worn for market by this flower trader in Antigua. Men's wear for ceremonial occasions in this village includes tall hats stiffened with bee's wax, ragged coats, and short, split trousers. *Right*. The most typical *huipil* of this village is worn by a flower trader in the Antigua market.

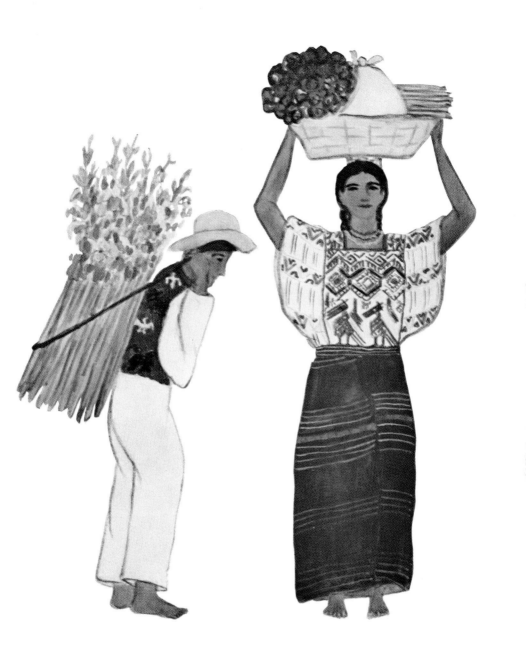

Plate 54. San Juan Sacatepéquez. Here are the costumes once traditionally worn in this village. *Left.* The woman's hair is tied with black wool *tocoyales*. Her striped *huipil* is decorated on the shoulders. Over her *refajo* she wears a broad sash. Note the *randa* on her skirt. Women from this village bring poultry and eggs to the city market. *Right.* Men no longer wear the striped cotton coat but one of dark-blue wool. The men are traders and bring fresh flowers to the city markets.

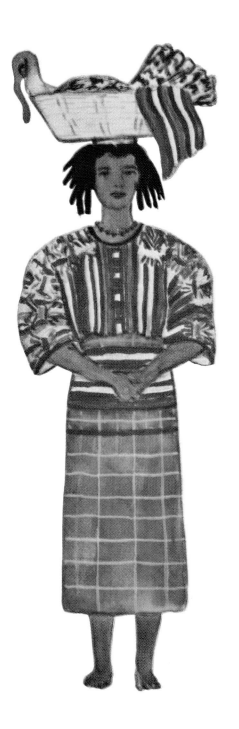
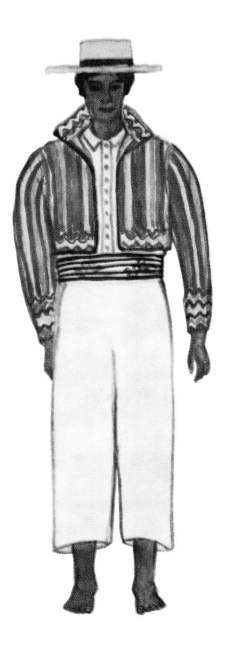

Plate 55. Santa Catarina Palopó. *Left*. Although the woman's *refajo* is plain, her *huipil* is distinguished by the small figures of water fowl and insects woven into the material. *Right*. The man wears the characteristic woolen *ponchito*, woven in Momostenango. The same figures of birds and insects decorate his shirt and trousers. He holds the peculiar basketry fish trap called *garlito*, used to catch mollusks, snails, and small fish in Lake Atitlán.

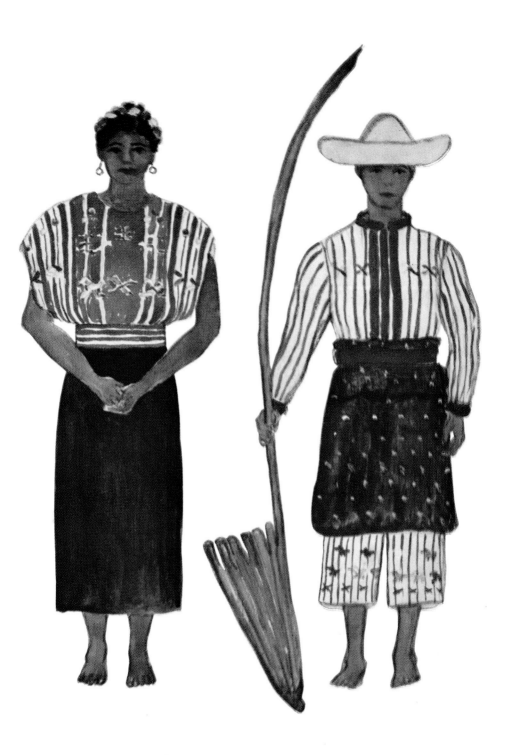

Plate 56. San Pedro Sacatepéquez (S.M.). *Left*. A poultry trader wears a *huipil* trimmed in brocade technique with silk floss and purple *Purpura*-dyed cotton thread. Her *refajo* has a great deal of silk in the warp. In this village both hip-strap and foot looms are used. Ceremonial *huipiles* from this town are considered to exhibit the best weaving in the country.

San Cristóbal Totonicapán. *Right*. The designs on this *huipil* are a fine example of needle embroidery. The extra length of the large *huipil* serves as a petticoat. This village is one of the few wherein tie-dyeing of woven textiles is done. In the past the weft threads of the *refajo* included silk floss. The woman holds a multicolored *tzut*.

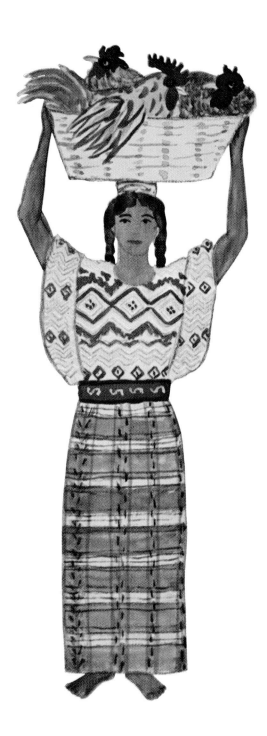
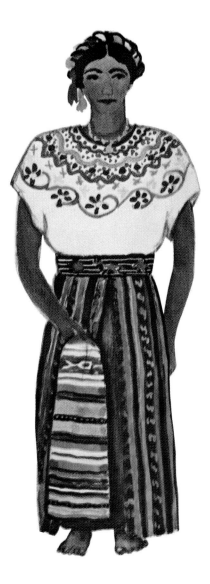

Plate 57. Momostenango. *Left*. Two blanket traders lean on their stacked wares in the Guatemala City market. These famous blankets are well known for their quality and handsome designs.

Santa María Chiquimula. *Right*. Black wool braids and large tassels compose the woman's headdress. Her long, heavy cotton costume is ill-adapted to her life on the rugged mountain slopes. Note he red and yellow *randa* which secures the sections of her *refajo*.

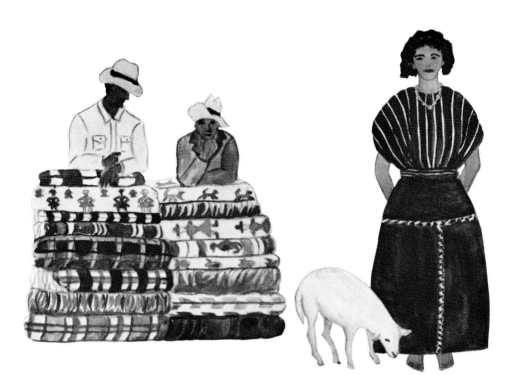

Plate 58. Chichicastenango (Santo Tomás). *Left*. This Maxeño's costume is one of the most spectacular in the country. The men themselves tailor the woolen material (woven in Momostenango) and also embroider the silk designs. The back of the jacket is finished with a thick fringe. The color and designs of the red, heavily brocaded *tzut* denote rank and civil or religious office. The shirt is an adaptation of modern Western attire. The narrow blanket (*upper middle*) is used as a pad under a heavy load to protect the back. *Right*. Women of this town wear their *refajos* short in order that they may better negotiate the mountain trails. The favorite material for the everyday *huipil* shown here is *cuyuscate*. A long, white *huipil* (*lower middle*) is thrown over the brown one for special ceremonies.

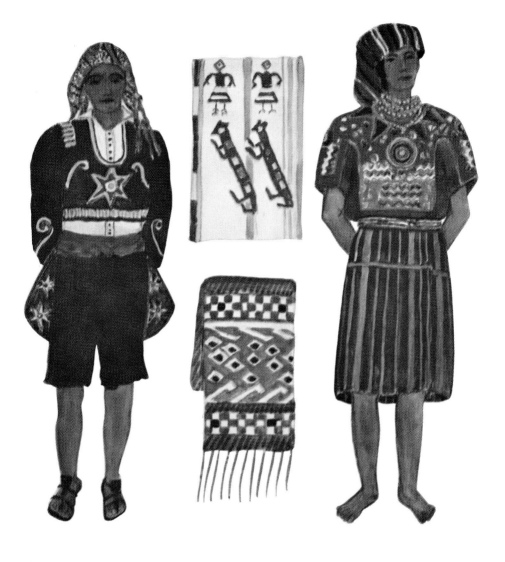

Plate 59. Almolonga (San Pedro). Men's wear in this village is very handsome, especially that for ceremonial events. On the left is everyday attire; on the right, ceremonial clothing. The designs are woven into the textiles. Note that the same sash is worn with both suits. These men are good musicians. From left to right the instruments are the *teponaztli* (drum); a fife being played by the man in green; a marimba made of gourds; and the Indian version of a harp.

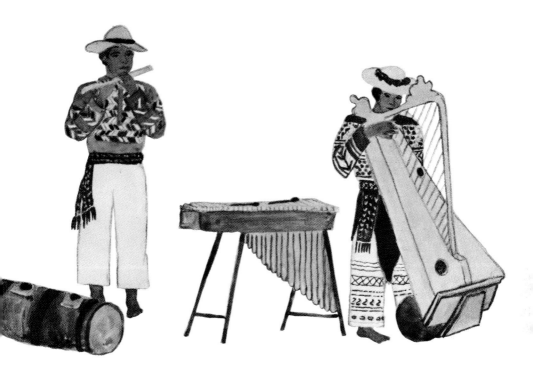

WATER COLORS

In the following pages are shown some of the traditional Indian costumes native to Guatemala as well as the crafts for which individual villages are known. The pictures are grouped by villages within departments. For most of the towns, both men's and women's attire are shown, save those where men now customarily wear European dress. The original paintings were made by Sra. Julia Ayau de Lopez Escobar.

Department of Guatemala

Plate 60. Mixco (Santo Domingo). *Left.* Women's everyday costume. This woman covers her head with a fringed *tzut* with an embroidered band. Her pleated *refajo* has velvet ribbon bands near the hem. She carries her baby on her back. Mixco women bring fresh tortillas and prepared chocolate to the city market and also work as maids in city households. *Right.* A woman wearing the typical white cotton shawl with store-bought embroidery which distinguished the wet nurses formerly employed in the city. Her hair is wound with a woolen *tocoyal.* Her *refajo* is also banded with velvet ribbon.

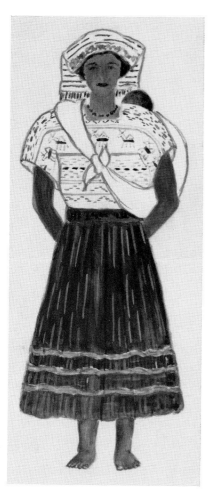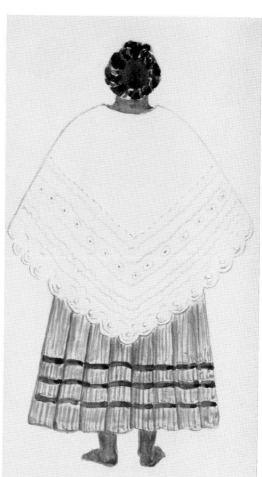

Plate 61. Santiago Atitlán. *Left*. The man wears the short trousers distinctive of almost all the villages around Lake Atitlán. His black-and-white checked *ponchito* is secured with a red wool sash. These men trade regional products among the villages of the highland and lowland alike. Here are shown the *tapas de dulce*, large loaves of black sugar, wrapped in dried leaves. *Right*. The locale of this woman's costume is pinpointed by her headdress. The long, narrow cotton band which is wound around her head is made in San Miguel Totonicapán. Note the silk tassels around the neck of the *huipil*.

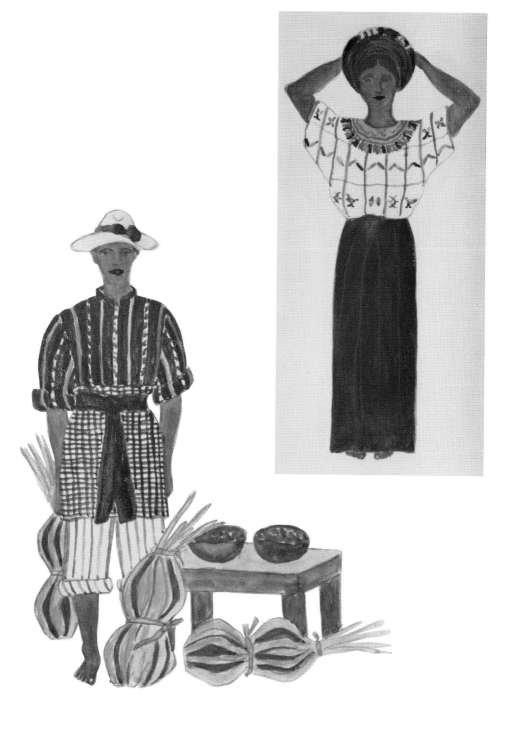

Plate 62. San Pedro Sacatepéquez (G.). *Left.* This *huipil,* with its heavy weft bands decorated in many colors, is worn daily. Characteristic of the women's costume here is the heavy, canvas-like material of the wrap-around *refajo,* known as *morga. Right.* This gay ceremonial *huipil* with figures of animals and a tree is worn as a covering for the head and shoulders. Now a scarce item, this garment is worn at any time, when one is available.

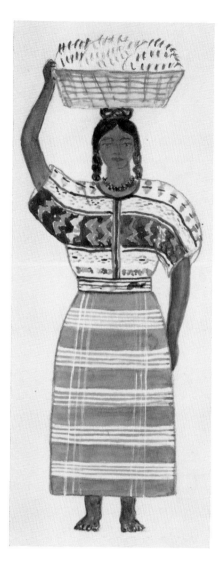

Plate 63. Chinautla (Santa Cruz). *Left.* White shirt and trousers have taken the place of traditional village attire in many villages throughout Guatemala. This man transports a load of pottery to market, his back protected by a folded *ponchito. Right.* A Chinautla potter balances one of her products on her head. Her costume is the simple one worn daily in this village.

Department of Chimaltenango

Plate 64. San Martín Jilotepeque. *Left.* This woman wears two *hui-piles*: the dark one, ornamented with colored silks is traditional ceremonial garb, while the white *huipil* is customarily worn as an everyday garment. *Right.* The man's costume is that which is customarily worn for civil or religious festivities. He uses the drum to summon the devout to church on Sunday. His blue coat and dark-brown over-trousers are of wool.

Plate 65. Santa Apolonía. *Left*. A basket trader protects her head with a cloth held firmly in place with her braids. The symbols on her *huipil* are done by needle embroidery. *Right*. A trader on his way to market with a bundle of corn husks, so useful to the Indian ménage. The man wears a *ponchito* like an apron and protects his back with another folded *ponchito*.

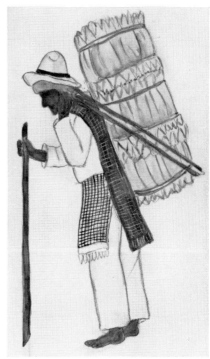
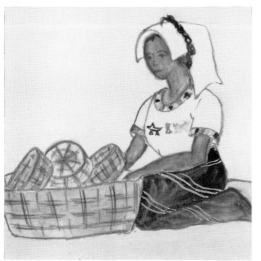

Department of Sacatepéquez

Plate 66. Santiago Sacatepéquez. *Left.* A woman wearing the typical costume of this village. Note the halo-like wool *tocoyal* in many hues and the pompoms on her sash.

Department of Sololá

Sololá (Asunción de). *Right.* The only *huipil* in the country with a noticeable set-in sleeve is characteristic of this village. *Cuyuscate* is used a great deal here in both men's and women's costumes.

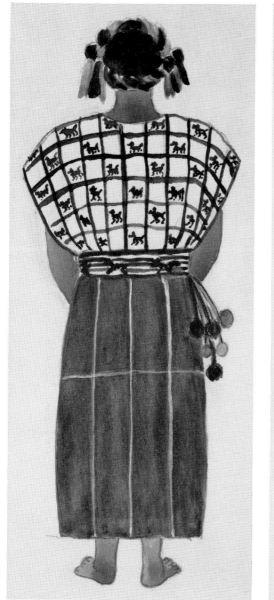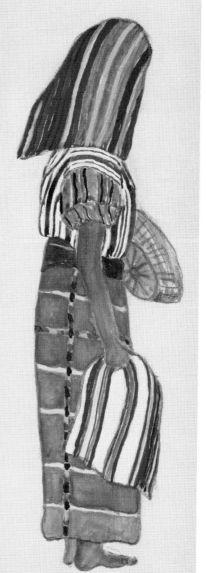

Plate 67. Sololá (Asunción de). *Left.* The everyday costume of Sololá, worn by a trader. He wears the black and white woolen *ponchito* characteristic of the Cakchiquel area. Onions from this region, carried here in a carryall (*cacaxte*), are a specialty and are known all over the country. *Right.* The costume of officials in Sololá. The man's hat is varnished black and trimmed with an embroidered ribbon. He carries a tasseled wand of office. Across the back of his coat is the bat symbol.

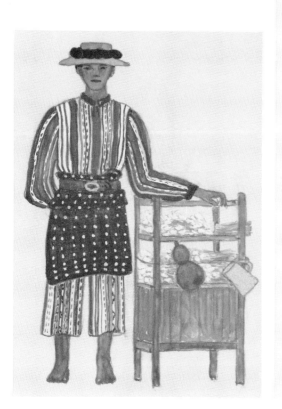
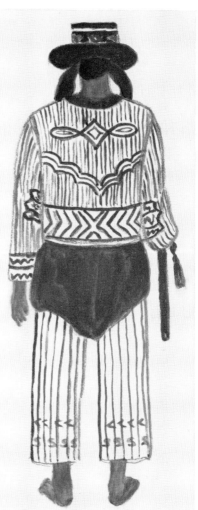

Plate 68. Nahualá. *Left.* This curious costume includes a black hat fashioned from thick black woolen cloth and stiffened with bee's wax; a dark-brown wool coat; and a *ponchito* worn like a kilt over short, white under-trousers. Over his shoulder is an extra green *tzut*. The large bag is knitted by the man as he travels around the countryside. He carries a *machete*, a tool indispensable to all Indian men.

San Pedro Laguna. *Right.* A *huipil* trimmed with store-bought lace tops a wrapped *refajo* woven in a beautiful blend of colors. Note the way the *refajo* is rolled at the waist.

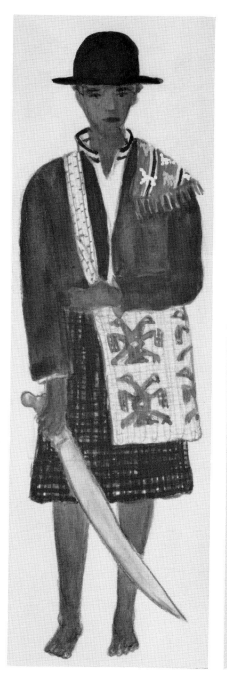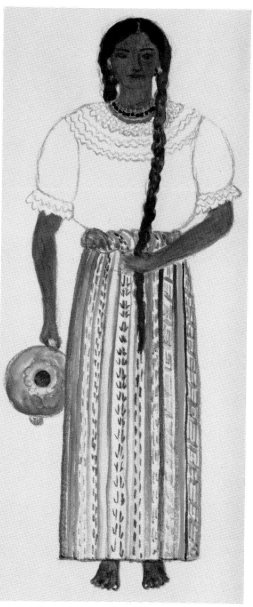

Department of Totonicapán

Plate 69. Totonicapán (San Miguel). *Left.* The woman is dressed in the costume currently worn, although there are several variations in the *huipiles* of this village. Her *refajo* is an example of *jaspeado*. This is the town where headbands are woven in various widths and lengths to be traded all over Guatemala. *Right.* This handsome costume is now reserved for religious ceremonies and is worn only by high-ranking officials. It serves also as a burial costume. Note the embroidery on the woolen coat and trousers and the silver ball fringe on the sleeves. Store-bought lace trims the white trousers.

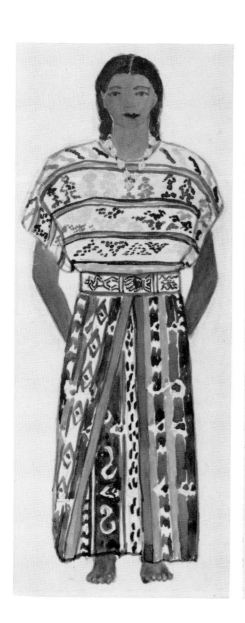
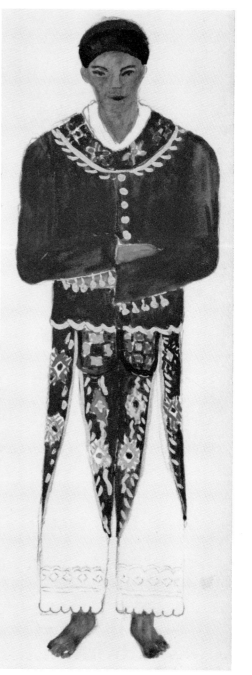

Department of El Quiché

Plate 70. Cotzal (San Juan). *Left.* The center section of this truly lovely *huipil* is brocaded. This costume is now worn only by the older women during the festivities of Holy Week. The woman's earrings are suspended by bits of red wool.

Nebaj (Santa María). *Right.* The lively designs of this *huipil* are brocaded on the loom at random on the white textile. The woman carries a bunch of bayberry candles to market.

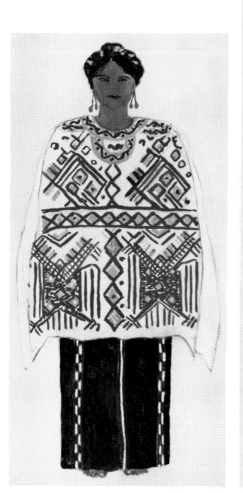
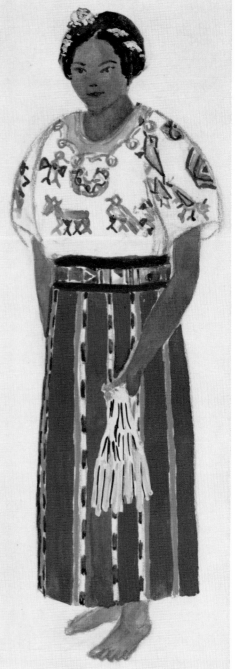

Plate 71. Nebaj (Santa María). *Left.* The hat worn with this ceremonial costume and characteristic of the region was made in nearby Chajul. Note the black braid and a number of pockets on the red cotton (crea) coat, now going out of style in favor of a cheaper dark-blue wool coat. The number of pockets determines the price. This *capitán* carries the antique silver icon of his village's patron saint, the staff wrapped in a red cotton *tzut.* *Right.* Ceremonial costume worn for religious festivals. The *huipil* (*zuquel*) is lavishly trimmed in silk, as is the *refajo.*

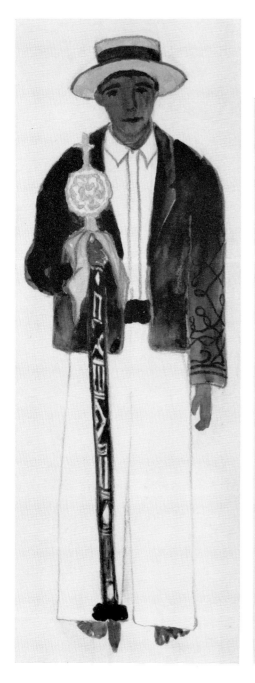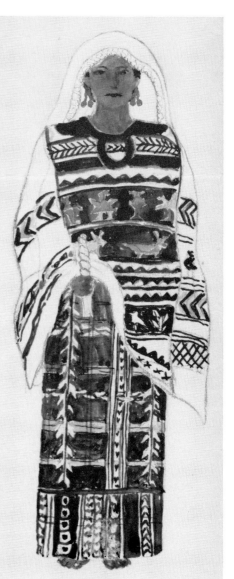

Plate 72. Sacapulas (Santo Domingo). A women displays her blocks of salt in the market. Her *huipil* is made of store-bought material which she has trimmed only across the back with tucks and a hand-made imitation of machine stitching. Note the scalloped lower edge of this short *huipil*. The woman wears a large silver plaque on a black velvet ribbon around her neck. The villagers gather salt from the shores of the Negro River which flows through the village. The salt is claimed to have curative properties.

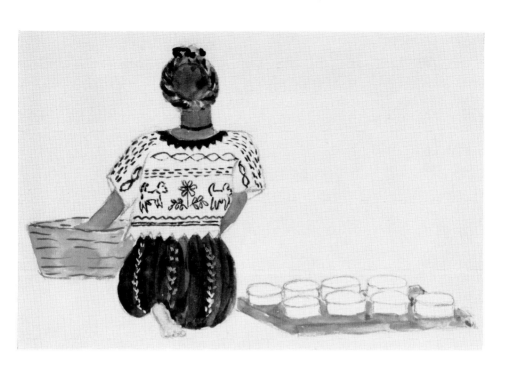

Department of Quezaltenango

Plate 73. Almolonga (San Pedro). One of the most striking costumes in Guatemala is worn by this woman. Both *tzut* and *huipil* over which it is worn are heavily decorated with silk floss, cleverly blended to form the colorful all-over design. This woman brings vegetables into the Quezaltenango market.

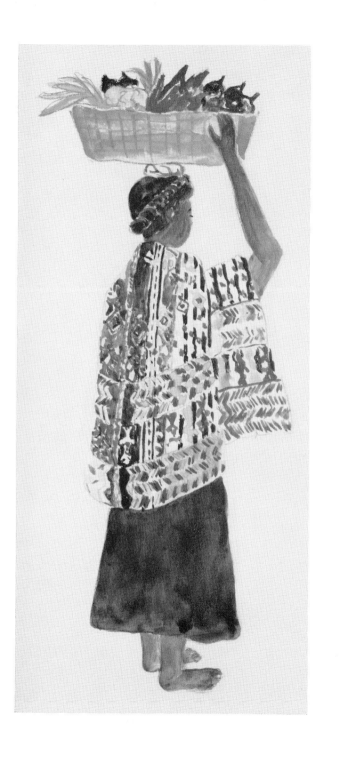

Plate 74. Quezaltenango (Xelahú). *Left.* An old-style costume is shown here. Note the broad *randas* which join the sections of *huipil* and *refajo*, the embroidered square neckband, and the enormous, unwieldly headdress composed largely of a broad, very long, closely woven ribbon. *Right.* The costume of today includes a *ranciado huipil*, embroidered in chain stitch in floral designs to hold together the three sections of the *huipil*. The *refajo* is woven of tie-dyed threads, and the sections are held together with a colorful *randa*, part of which is visible below the *perraje* which the woman is holding over her right arm. Note the gay fringe on the *perraje*, and the sandals now worn in this village.

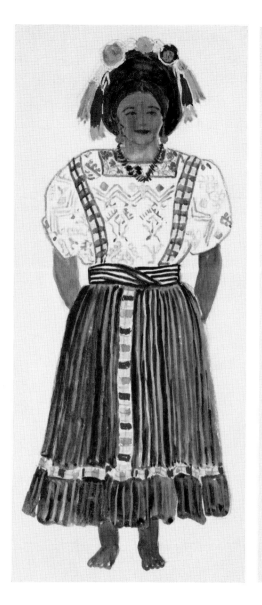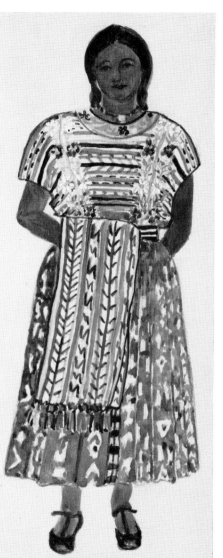

Plate 75. Quezaltenango (Xelahú). *Left.* Ceremonial costumes for men and women are shown here. The woman's *huipil,* worn as a veil over her costume, is of this gauzelike material, delicately embroidered in pale colors. Note the embroidered band which frames her face. Her *refajo* is tye-dyed, a technique which is becoming the fashion in many villages. *Right.* The man's costume (this one for a wedding) includes coat and over-trousers of blue wool woven in Momostenango. Note the embroidery trimming on the scalloped over-trousers.

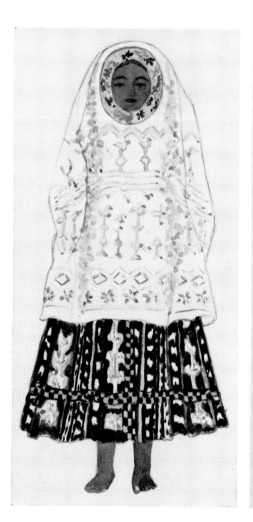
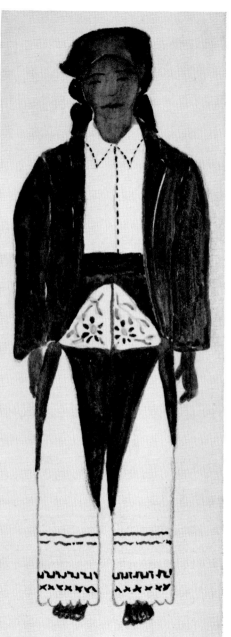

Plate 76. San Martin Sacatepéquez (Chile Verde). *Left.* This cos-
tume is usually covered by the heavy wool overdress (*see right*).
It is said that the embroidered cuffs are a wedding present from the
bride to her prospective husband, to demonstrate her ability to prop-
erly execute the weaving techniques of their village. *Right.* The
thick wool *capixaij* is worn by these men at all times, even when
they are at work in the hot coastlands. A red crea *tzut* tops the
costume. Note the brocaded sash ends and the fringe on *tzut*, sash,
and *capixaij*.

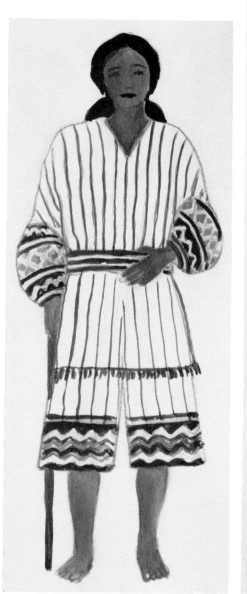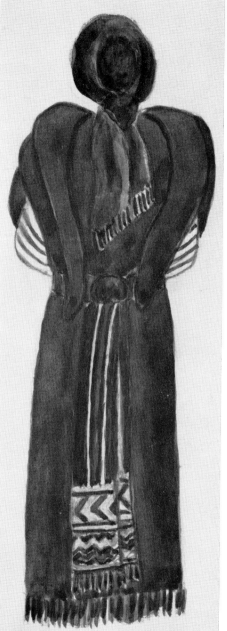

Plate 77. Olintepeque. *Left.* The dark-blue *huipil* is for festive occasions or for use by the older women of the village, while the red *huipil* (*middle*) is for everyday use. Note the complicated headdress, composed of wool *tocoyales* made into a huge braid and worn like a coronet with tassels at the sides. The women of this village are adept at embroidery and use baskets as frames to hold their work.

San Martín Sacatepéquez (Chile Verde). *Right.* This costume is rarely seen outside this village. The *tzut* and *refajo* are essentially the same pattern of weave; the *huipil* is made in three sections, the center section decorated on the loom in colorful geometric patterns, the three sections held together by a red and white *randa*. The wrapped *refajo* is secured by a black-and-white striped sash.

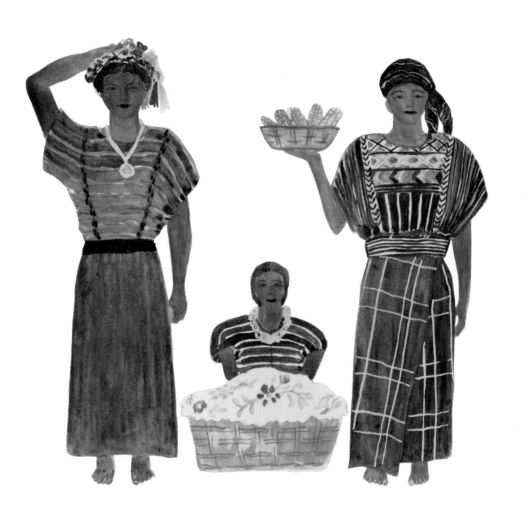

Department of Huehuetenango

Plate 78. Todos Santos (Cuchumatán). *Left.* A woman shepherd spins heavy wool yarn as she tends her flock on the steep mountain pastures. Her cotton upper garment is of heavy cloth, for it is cold at these altitudes. Note her unusual hat and her silver earrings, suspended from her ears by wool loops. Her wool *refajo* is wrapped, turned back on itself, and tucked under her sash. *Right.* The man's costume includes a hat worn over a *tzut*, black and white cotton jacket, and woolen over-trousers worn over long cotton trousers. Note the wide collar on his shirt. The jacket is now often replaced by one of heavy dark-brown or dark-blue wool.

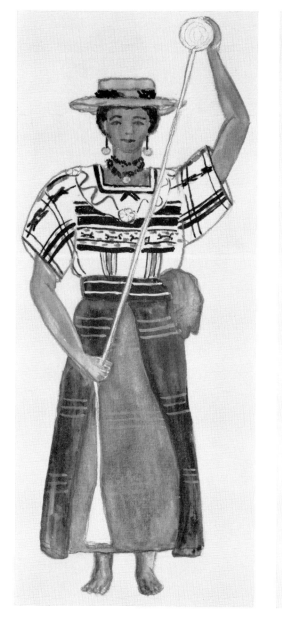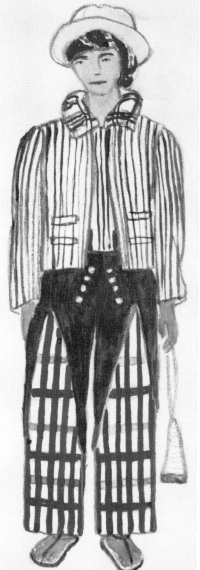

Plate 79. San Miguel Acatán. *Left.* This woman's costume is very different from those seen in the lowlands. Local variations include the number of ruffles on the yoke or the color of the stitching on these long ungainly *huipiles*. A cloth worn over the head surmounted by a hat enhances the pyramidal effect of these women, who seldom leave their highland villages except to attend a fair such as the yearly ones at Chiantla or Huehuetenango. *Right.* The typical man's attire of the highlands. Village variations include a fringe on the woolen overdress, the crown height or brim width of the palm-leaf hat, or the color of the hat band. Men of the mountains aways carry a bag, whether netted fiber, as is this one; netted cotton, or knitted wool. Sandals with heel cups are worn only in the mountains.

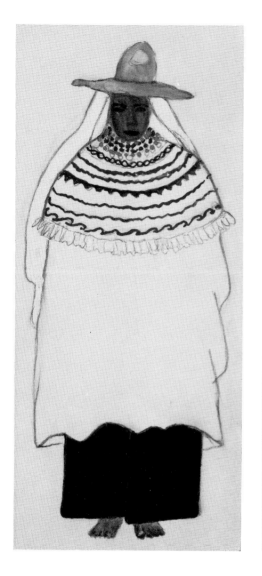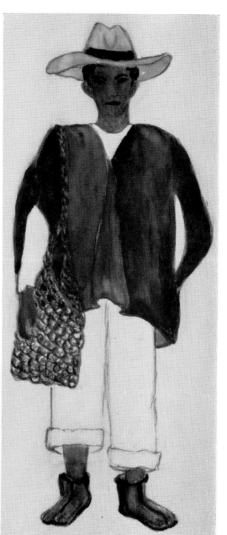

Department of Alta Verapaz

Plate 80. Cobán (Santo Domingo). *Left.* An often-seen woman's costume which is enhanced by many silver chains, earrings, and rings. The *huipil*, worn over the *refajo*, contains figures in white woven in a lacelike technique. This town is the silver-working center of the country. *Right.* A matron of the *principales* wears one of the typical white, lacelike *huipiles*, with collar and armholes trimmed with traditional Cobán designs in needle embroidery. The headdress is the *tupui* (coral serpent), made of wool. This ornament is being supplanted by such alternates as ribbons, for the heavy *tupui* is said to cause the hair to fall out.

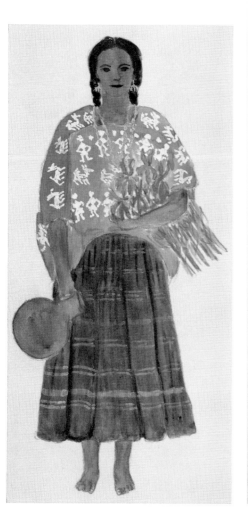
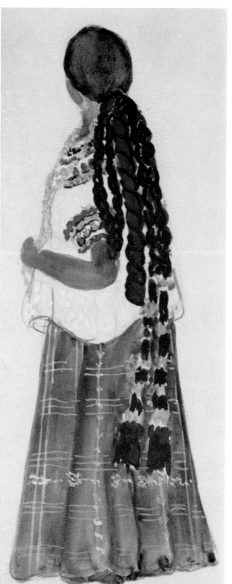

Department of Baja Verapaz

Plate 81. Rabinal (San Pablo). This couple is shown carving and decorating gourds, traded at all the yearly fairs. The woman's costume shown here is being replaced by store-bought clothing; material in the brightest colors is bought and made into a semi-blouse. The man's Westernized clothing retains but a slight trace of the Indians' love of color: the blue-and-white striped trousers. Rabinal men are known country-wide for their skill in gourd decoration.

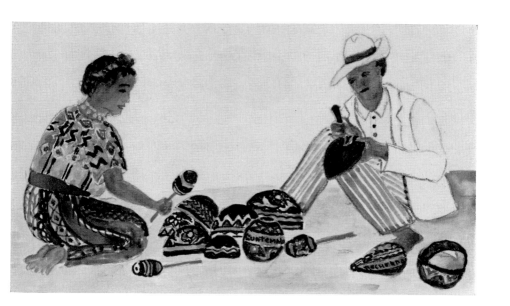

Department of Retalhuleu

Plate 82. San Sebastián (San Cebolla). *Left.* The men and women of this village do not cover the torso except when coming into town. Store-bought cloth in vivid colors is made into shirts and *huipiles*, although the women weave their own skirt material and utility cloths. Note the way the *refajo* is secured at the waist by a twist and a tuck.

Department of Escuintla

Palín. *Right.* The fruit vendor in the Guatemala City market is shown wearing the old-style, short *huipil*, now reserved for ceremonial use. Palín women weave and decorate their own unusual textiles. The woman holds a gay utility cloth *(manta)*. The short-style *huipiles* have been prohibited, and the women now wear longer ones. Clearly seen here is the *yagual*, a roll of odd textile pieces which serves as a protective pad and also helps balance the heavy basket on the women's head.

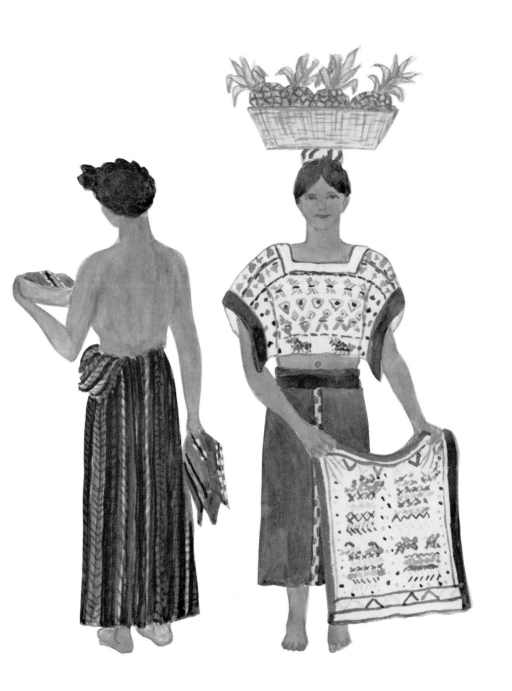

APPENDIX A

*

Places Mentioned in the Text

Guatemala

Town	*Department*
Acatenango	Chimaltenango
Aguacatán	Huehuetenango
Almolonga (Ciudad Vieja)	Sacatepéquez
Almolonga (San Pedro)	Quezaltenango
Amatitlán (San Juan)	Guatemala
Antigua (La Muy Noble y Muy Leal Ciudad de Santiago de los Caballeros)	Sacatepéquez
Atitlán (Lake)	Sololá
Azacualpa	Santa Rosa
Barberena	Santa Rosa
Cahabón	Alta Verapaz
Camotán	Chiquimula
Cantel (San Buenaventura)	Quezaltenango

Town	Department
Cerro de Oro (Colonia de San Andrés)	Sololá
Chajul	El Quiché
Chamelco	Alta Verapaz
Chehul	El Quiché
Chicalajá	Quezaltenango
Chiché	El Quiché
Chichicastenango (Santo Tomas)	El Quiché
Chimaltenango (Santa Ana)	Chimaltenango
Chinautla (Santa Cruz)	Guatemala
Chiquibul, or Siquibul	Quezaltenango
Chiquimula de la Sierra	Chiquimula
Chiquimulilla (San Isidro)	Santa Rosa
Chivinal (formerly Xivinal)	San Marcos
Cobán (Santo Domingo)	Alta Verapaz
Colotenango	Huehuetenango
Comalapa (San Juan)	Chimaltenango
Comitancillo	San Marcos
Concepción Chiquirichapa	Quezaltenango
Concepción Huehuetenango	Huehuetenango
Concepción Tutuapa	San Marcos
Cotzal (San Juan)	El Quiché
Cubulco	Baja Verapaz
Cunen	El Quiché
Dueñas (San Miguel Milpas Altas)	Sacatepéquez
Escuintla	Escuintla
Esquipulas (Santiago)	Chiquimula
Estancia Chiquita	Guatemala
Estancia Granda	Guatemala
Estanzuela	Zacapa
Flores (formerly Tayasal)	El Petén
Guatemala City (Nueva Guatemala de la Ascunción) Capital of the Republic	Guatemala
Ilom	El Quiché
Itzapa (San Andrés)	Chimaltenango
Ixchiguán	San Marcos

236

Town	*Department*
Izabal	Izabal
Jacaltenango (La Purificación)	Huehuetenango
Jalapa	Jalapa
Jicaro, El	El Progreso
Jocopilas (San Pablo)	Suchitepéquez
Jocotán	Chiquimula
Joyabaj	El Quiché
Jutiapa	Jutiapa
Lacandón	El Petén
Lanquín	Alta Verapaz
Magdalena (Milpas Altas)	Sacatepéquez
Malacatán	San Marcos
Mazatenango (San Bartolomé)	Suchitepéquez
Mixco (Santo Domingo)	Guatemala
Mocá (Finca)	Suchitepéquez
Momostenango	Totonicapán
Nahualá	Sololá
Nebaj (Santa María)	El Quiché
Niño Perdido	Baja Verapaz
Olintepeque	Quezaltenango
Olopa	Chiquimula
Palín	Escuintla
Palmar	Quezaltenango
Pampujilá (Finca)	Sololá
Panajachel (San Francisco)	Sololá
Parramos	Sacatepéquez
Patzicía (Santiago)	Chimaltenango
Patzún (San Bernardino)	Chimaltenango
Purulhá	Baja Verapaz
Pueblo Nuevo	Retalhuleu
Quezaltenango (formerly Xelahú)	Quezaltenango
Quezaltepeque (Santa Catarina)	Chiquimula
Quiriguá	Izabal
Rabinal (San Pablo)	Baja Verapaz
Retalhuleu (San Antonio)	Retalhuleu
Sacapulas (Santo Domingo)	El Quiché

Town	Department
Salamá (San Mateo)	Baja Verapaz
Salcajá (San Luis)	Quezaltenango
Samayac	Suchitepéquez
San Andrés Sajcabajá	El Quiché
San Andrés Semetabaj	Sololá
San Andrés Xecul	Totonicapán
San Antonio Aguas Calientes	Sacatepéquez
San Antonio las Flores	Guatemala
San Antonio Palopó	Sololá
San Antonio Sacatepéquez	San Marcos
San Bernardino de los Montes	Totonicapán
San Cristóbal Totonicapán	Totonicapán
San Cristóbal Verapaz	Alta Verapaz
San Felipe	Quezaltenango
San Francisco El Alto	Totonicapán
San José Nacahuil	Guatemala
San José Nejapa	Chimaltenango
San José Pinula	Guatemala
San José Poagil	Chimaltenango
San Juan Atitlán	Huehuetenango
San Juan Bautista	Suchitepéquez
San Juan Chamelco	Alta Verapaz
San Juan Hermita	Chiquimula
San Juan Ixcoy	Huehuetenango
San Juan La Laguna	Sololá
San Juan Ostuncalco	Quezaltenango
San Juan Sacatepéquez	Guatemala
San Lorenzo El Tejar	Chimaltenango
San Lucas Sacatepéquez	Sacatepéquez
San Lucas Tolimán	Sololá
San Luis Jilotepeque	Jalapa
San Marcos (known as El Barrio)	San Marcos
San Martín Jilotepeque	Chimaltenango
San Martín Sacatepéquez (Chile Verde)	Quezaltenango
San Mateo Ixtatán	Huehuetenango
San Miguel Acatán	Huehuetenango

Town	*Department*
San Miguel Chicaj	Baja Verapaz
San Miguel Ixtahuacán	San Marcos
San Miguel Totonicapán	Totonicapán
San Miguel Uspantán	El Quiché
San Pablo La Laguna	Sololá
San Pedro Ayampuj	Guatemala
San Pedro Carchá	Alta Verapaz
San Pedro Chuarrancho	Guatemala
San Pedro Jocopilas	El Quiché
San Pedro Laguna	Sololá
San Pedro Pinula	Jalapa
San Pedro Sacatepéquez (Cakchiquel)	Guatemala
San Pedro Sacatepéquez (Mam)	San Marcos
San Pedro Yepocapa	Chimaltenango
San Raimundo (de las Casillas)	Guatemala
San Ramón	Guatemala
San Sebastián (San Cebolla)	Retalhuleu
Santa Apolonía	Chimaltenango
Santa Catarina Ixtahuacán	Sololá
Santa Catarina Palopó	Sololá
Santa Catarina Pinula	Guatemala
Santa Cruz del Quiché	El Quiché
Santa Eulalia	Huehuetenango
Santa Isabel Huehuetenango	Huehuetenango
Santa María Cauqué	Sacatepéquez
Santa María Chiquimula	Totonicapán
Santa María de Jesús	Sacatepéquez
Santiago Atitlán	Sololá
Santiago Sacatepéquez	Sacatepéquez
Santo Domingo Xenacoj	Chimaltenango
Santo Tomás Chichicastenango	El Quiché
Senahú	Alta Verapaz
Sololá (Asunción de)	Sololá
Soloma (San Pedro)	Huehuetenango
Suacite	Guatemala
Sumpango	Sacatepéquez

Town	Department
Tacaná	San Marcos
Tactic	Alta Verapaz
Tajumulco (Santa Isabel)	San Marcos
Tamahú	Alta Verapaz
Tecpán	Chimaltenango
Tejutla (Santiago)	San Marcos
Tesoro, El	Chiquimula
Todos Santos (Cuchumatán)	Huehuetenango
Tonimchun	San Marcos
Totonicapán (San Miguel)	Totonicapán
Tucurú (San Miguel)	Alta Verapaz
Uaxactún	El Petén
Uspantán (San Miguel)	El Quiché
Villa Nueva	Guatemala
Zacapa (San Pedro)	Zacapa
Zacualpa	El Quiché
Zunil (Santa Catarina)	Quezaltenango

El Salvador

Town	Department
Aculhuaca	San Salvador
Ahuachapán	Ahuachapán
Apaneca	Ahuachapán
Apopa	San Salvador
Ataco	Ahuachapán
Ateos (San Antonio)	La Libertad
Cacaopera	Morazán
Cojutepeque	Cuscatlán
Costa del Balsamo	La Libertad
Chalatenango	Chalatenango
Chilanga	Morazán
Chirilagua	San Miguel
Cutuco	La Unión
Guatajiagua	Morazán
Ilobasco	Cabañas
Izalco (Asunción)	Sonsonate

Town	*Department*
La Rabida	San Salvador
La Unión	La Unión
Lolotiquillo	Morazán
Mejicanos	San Salvador
Nahuizalco (de los Dolores)	Sonsonate
Olocuilta	La Paz
Paleca	San Salvador
Panchimalco	San Salvador
Quezaltepeque	La Libertad
Quezaltepeque (Concepción)	Chalatenango
San Antonio Masahuat	La Paz
San Isidro	Cabañas
San Miguelito	San Salvador
San Juan Nonualco	La Paz
San Pedro Nonualco	La Paz
San Juan Yayantique	La Unión
San Pedro Perulapán	Cuscatlán
San Pedro Puxtla	Ahuachapán
San Rafael	Cuscatlán
San Salvador (Capital of the Republic)	San Salvador
San Vicente (de Austria o Lorenzana)	San Vicente
Santa Ana	Santa Ana
Santa Catarina Masahuat	Sonsonate
Santiago Nonualco	La Paz
Sensembra	Morazán
Sensuntepeque	Cabañas
Sonsonate (Santísima Trinidad)	Sonsonate
Suchitoto	Cuscatlán
Tenancingo	Cuscatlán
Valle de Jiboa	San Vicente
Zacatecoluca	La Paz

APPENDIX B

✾

List of Indian and Spanish Terms
Found in the Text

acapetates	mats woven of grass
achiote	yellow-red coloring matter from fruit of *Bixa orellana* L.; used to dye cotton and color food
acolchonado	padded-like
ajitz	sorcerer
alcalde	mayor
alguacil	constable
alhajas	jewelry
amole	root of plant containing saponin; used in many ways
añadidos	ordinary mats in El Salvador
añil	indigo dye
anillos	rings
apaste	large open-mouthed cooking pot with two side handles
aporreado	felting process for wool

argana	saddlebag in El Salvador; made of fiber, string, or leather
aritos	earrings
atolada	corn-and-water starch for cotton thread used prior to weaving
azulejos	originally blue and white ceramic tiles made by Indians for Spanish use in Colonial period, but now term is applied to plain tiles without designs
banda	see *cincho*
barrios	suburban fringes of large towns where Indians prefer to live
bastón	wooden staff used by men of upper class as walking stick on rough terrain
batea	flat wooden tray used by laundresses to carry wet clothing
batidores	medium-sized jugs
blusa	*ladino* blouses
bolsa	see *guangocha*
bordón	stick used by Indians, usually older men
brujo	shaman
cabecera	offering of food placed on grave
cacaxte	carryall; wooden crate used by traders
cacique	chief; head man
cafetero	basket used by women to harvest coffee
caites	everyday sandals
camisa	man's shirt
camisa, camiseta	blouse in El Salvador
canasta	basket with handle; preferred by *ladinos*
canasto	basket without handles, shallower than *canasta*
canasto cajero	smaller than *panadero;* holds 25 lbs. of string beans or equivalent in other market produce
canasto panadero	large, wide baker's basket
cañón	spindle holding ten hanks of cotton; 18 spindles to the pound

cantaro	large water jar
capixaij, gabán	cape; from Spanish *capa y saya*, cape and skirt; worn by men
capotera	large needle for inserting pattern-filler yarns
Castilla	Indian name for Spanish; the *lingua franca* of Guatemala and El Salvador
ceñidor	see *faja*
cestillas	baskets made outside San Salvador; with handles, reinforced edges, bands of color
cestillo	basket made from morning glory vine
chacs	Mayan gods of agriculture, wind, rain
chachales	necklaces
chajales	Indian servants of village priest
chaqueta, saco	man's jacket
cheles	Salvadorean term for foreigners; undecorated gourds used in El Salvador as household utensils
chilate	starch for woven cloth; drink made of chocolate mixed with dark purple corn
chillote	loom for weaving fiber saddlebags
chim	Maxeño's bag
chinchin	rattle
chivo	goat; *servilleta* used to wrap tortillas to keep them hot; material with loops from selvage to selvage; people from region of Quezaltenango where goats roam
choconoy	Quiché word for black-worm symbol woven into textiles near hem
chuchumite	red and/or blue dyes; term dating from pre-Colonial times
chuchuxeles	women chosen for *cofradías*
chucubal	*perraje* used as sling for Quezaltenango baby to ride on mother's back
cibaque	Guatemalan name for rush used for fire fans, handbags, and saddle blankets
cincho, banda, cinturón	man's belt

cinta	hair ribbon, woven band, wool strands twisted and braided into the hair; woven band used to hold up loose folds of *huipil*
cinturón	see *cincho*
cochaj	*tzut* of heavy material used as pad under heavy load carried on back
cofradía	church organization; members chosen from *principales*
coladores	textile strainers from San Pedro Sacatepéquez (G.)
colero	basket to sieve cooked corn for tamales
coles	square baskets with fitted covers
colonos	workmen who live the year round on coffee estates
comales	flat dishes used for cooking tamales
corte	standard skirt length
corte plegado	pleated length of material used for skirt
corvo	Salvadorean term for *machete*
costumbre	custom
cotón	old-style man's jacket without an opening down the front
cuajatinta	see *jiquilite*
cuartillero	basket which holds one *cuartilla* of black beans or corn
cuyuscate, ixcaco	tawny brown native cotton used without dyeing
debanadera	reel in El Salvador
enagua	*ladino* skirt
enagüilla	skirt in El Salvador
encomiendas	original Spanish land grants of Colonial period, now abolished
envuelte	wrapped skirt or *refajo*
escudilla	small clay dish, base for spindle
espada	see *peinador*
faja, ceñidor	woman's belt
frazada	usually a wool blanket
fustán	*ladino* petticoat

gabán	see *capixaij*
garlito, xucubil	cornucopia-shaped basketry fish trap, Lake Atitlán region
golas	wide ruffles
gorra	see *montera*
gringo	Guatemalan term for foreigner
guacal	bowl-shaped gourd
guache	large, round basket used by coffee pickers in El Salvador
guangocha, morral, bolsa, matate, red	bags used by men
gusano	see *choconoy*
guira	see *jícara*
hilo de carrizo	spool yarn, two or more ply
hilvanadora, malacate	reel used to hold spun cotton
huipil	woman's blouselike garment
huipil ranciado	*huipil* with tie-dyed stripes or bands
huiscoyol	hardwood used for tools
huso, malacate	spindle for cotton
ikat	Indian term for tie-dyeing
incensarios	pottery incense burners
irayol, guaitil	Salvadorean terms for *Genipa americana* L., producing dark blue dye
ixcaco	see *cuyuscate*
ixtle	maguey fiber
jaboncillo	vegetable soap
jaspe	tie-dyed yarns
jaspeado	cloth made from tie-dyed yarn
jicaques	wild men of Honduran jungle
jícara, güira	ellipsoid gourd used for cups; term *jícara* used also for cup itself
jiquilite, cuajatinta	indigo plant in El Salvador and Guatemala
kaperraj	Maxeño term for *perraje*
ladino	person of mixed blood who speaks Spanish, follows Spanish customs, and wears European clothing
lazo	rope about six yards long

maceguales	see *plebeyos*
machete	man's long-bladed knife (Guatemala)
madeja	cotton strands
malacate	see *hilvanadora, huso*
mangas	Spanish word for sleeves; Indian term for wool blankets from Momostenango
manojo	hank of 12 cotton threads, about 53 of which are put on loom depending on weaving technique used in village
manta	white homespun or foot-loomed cloth
manta de Cantel	cream-colored cloth from Cantel factory in Quezaltenango
mantilla	*ponchito* worn wrapped like a diaper over long white trousers
marcador	sample of weaving designs used by commercial weavers to solicit orders from outlying districts of same tribe
mashaste	dye plant used when reddish-brown is desired
matates, morrales	small bags of maguey fiber
Maxeño	man of Santo Tomás Chichicastenango
maxtli	breechclout
mecapal	tumpline
medianos	middle-class Indians
mengalas	*ladino* women
merino	Indian term for cloth which contains any wool
mestizo	people of mixed blood, Indian and foreign
montera, gorra	infant's cap
morado criollo	native, or *Purpura* purple
morado de carrizo	cotton dyed purple and wound on spool (formerly *Purpura*-dyed cotton)
morgas	*corte* of thick, heavy, canvas-like cloth
morral	see *guangocha*
morro	tree whose gourdlike fruit are used for containers
mortomes	men chosen for *cofradías* in Totonicapán

mozos	Indian laborers
muñeca	doll
nahual	animal counterpart of every Indian from birth to death
nij, nije, ajin	Wax derived from an insect used for polishing gourds
nodriza	wet nurse
ocote	pitch pine
olla	open-mouthed cooking pot
palenque	round Indian hut
palito	hip-strap loom
palo peine	see *peinador*
paquiote	tiny loom for fine weaving
pantalón rejado	trousers split to the thigh
pantalones	trousers
pascón	gourd sieve
peinador, espada	principal batten of hip-strap loom
peinador, palo peine	heddle stick
pellones	wool rugs from San Pedro Solomá
pepenado	finger-weaving
perraje, tapado	shawl
pescaditos	well-known *jaspeado* woven by Salcajá Indians
petaca	see *tumbilla*
petaquilla	basket made of white rushes
petateados	well-known *jaspeado* pattern of Salcajá Indians
petate Chiapaneco	mats woven of *Palma Chiapaneca*
petate tule	Salvadorean mat made of *tule*
petate zapaluta	finest mat made in Guatemala
pichacha	round clay sieve
pichinga	Salvadorean name for two-spouted water jar
piedra del rayo	"lightning stone"; celt used to polish pottery
pilón	hardwood mallet used for beating henequen fiber
pita floja	untwisted agave fiber
pizbal-cotzil	*tzut* used to wrap offerings to deities

pixcoy	tiny silver pendants for *chachales*
plebeyos, maceguales	the lower class
plegado	pleated *refajo*
pom	Indian incense
ponchito	wool apron or kilt worn by men
poncho, ponchito	blanket, designated by various names depending on how it is worn
porrón	Guatemalan name for water jar, some with two spouts
pot	see *tapado*
principales	Indian nobility
rajador	small wooden tool for splitting rushes for mats
randa	embroidered join between woven sections of *huipiles, refajos* and *tzutes*
rebozo	light-weight *perraje* worn as head covering by women of lowlands; *ladino* cotton shawl
red	net bag of any size
redil	wool-spinning wheel
refajo	women's wrap-around skirt
rodetes	turban-like headdress
rodillera	ruglike wool blanket
rodillos	clay stamps
rosario	necklace in El Salvador
ruguma	basketry press for extracting cassava juice (Caribs)
sacatinta	Indigo plant in Guatemala
saco	see *chaqueta*
sandalias	fancy sandals for men only
sartenas, sartenes	round clay dishes with two side handles used as frying pans
seda española	reddish-purple untwisted silk used for particular designs
seda floja	untwisted silk from China, formerly used by Indians in their textiles

sedalina	mercerized cotton now used for Indian textiles
servilleta	kerchief or utility cloth serving a multitude of uses; white background and fringe
sopladores	fire fans
subalchij	ceremonial cloth
sudaderas	wool saddle blankets
tahuite	red clay slip for decorating pottery; white clay tablets for digestive ailments of children
talleres	city workshops where cloth is woven on foot looms
tapado	*mi tapado* (my covering) a term used for many garments, shawls, large *tzutes*
taravilla	small wooden implement used in twisting fiber rope
tashón	tule mats from Nahuizalco, El Salvador
tecomate	bottle-shaped fruit of "calabash vine" used for rattles
telares	foot looms worked by *ladino* men in El Salvador
teponaztli	cylindrical slotted log drum played with rubber-tipped mallets
tertulero	go-between at marriage negotiations
texeles	women *cofrades* of San Juan Comalapa
tinaco	dye pot
tinaja	water jar
tinajera	five-foot-high red jar
tiñecanasto	basket dye
tinta	general term for dye
tizate	chalk cone used by spinner to keep her hands dry
tocoyal	headdress of colored wool cords or tape worked into hair
tol	(*tarro*) vine whose gourdlike fruit are used for containers
tonalámatl	ancient Nahua calendar of 260 days

toquilla	woven palm-leaf hatband
torno	large wooden wheel used for transferring cotton from reel to spindle
trascañadera	see *urdidor*
trasquilado	the shorn technique of embroidering only through the top warp yarns
tsibal kaperraj	ritual tablecloth of *cofradía*
tule, sontul	rush used for matmaking
tumbilla, petaca	Salvadorean and Guatemalan names for rectangular baskets with covers
tupui	(coral serpent) red-colored wool strands for headdress; used by women of the *principales* in Cobán
tzolkin	Mayan sacred almanac of 260 days; used by Indians today to determine proper corn-planting time
tzut	kerchief or utility cloth, made in traditional village colors
urdidor, trascañadera	warping frame
vara	33 inches, standard measure for yard goods
viroleños	shallow market baskets in El Salvador
xucubil	see *garlito*
yuquilla	corn-paste starch for hats and textiles
zacatón	tall thick grass used in baskets
zahoris	medicine men
zambo	Indian-Negro mixture
zapatos	shoes
zuyacal	palm-leaf raincoat-umbrella worn by men

BIBLIOGRAPHY

Ackerman, Phyllis. *Tapestry, the Mirror of Civilization*. New York, 1933.

Batres, Antonio. *La América Central ante la historia*. Guatemala, 1915–20.

Belt, Thomas. *The Naturalist in Nicaragua*, 2d ed. rev. London, 1888.

Beyer, Hermann. "The Position of the Affixes in Maya Writing," *Maya Research*, Vol. III (1936), 102–104.

La Biblioteca Americana, o miscelánea de literatura, artes i ciencias. Una Sociedad de Americanos. London, 1823.

Blom, F., S. S. Grosjean, and H. Cummins. *A Maya Skull from the Uloa Valley, Republic of Honduras* (Middle American Research Series, No. 5). New Orleans, 1934.

Boaz, Franz, ed. *General Anthropology*. New York, 1938.

Brasseur de Bourbourg, Etiènne Charles, ed. *Popol Vuh: Le livre sacré et les mythes de l'antiquité américaine . . . (Collection de documents dans les langues indigènes, pour servir à l'étude de*

l'histoire et de la philologie de l'Amérique ancienne, Vol. I). Paris, 1861.

Bühler, Alfred. *Die Herstellung von Ikattüchern auf der Insel Rote.* Basle, 1939.

Butler, Mary. "A Study of Maya Mouldmade Figurines," *American Anthropologist*, n.s., Vol. 37 (1935), 636–72.

Cáceres, Eduardo. *Historia de la odontología en Guatemala.* Tipografía Nacional. Guatemala, 1938.

Calderon, José Tomas. *Prontuario geográfico-comercial estadistico y servicios administrativos de El Salvador.* 2d. ed. San Salvador, 1932.

Carnegie Institution of Washington. "Textile Arts of the Guatemalan Natives," *News Service Bulletin,* No. 3, Washington, D.C., 1935, pp. 157–68.

Clark, James Cooper, ed. and translator. *Codex Mendoza (Mendocino)* 3 vols. London, 1938.

Codex Magliabecchiano, XIII–3. Manuscrit Mexicain Post-Colombien de la Bibliotheque Nationale de Florence. Reproduit au Frais du Duc de Loubat. Rome, 1904.

Cogolludo, Diego Lopez (translated by Ethel-Jane Bunting). "Ancient History of Yucatán: Names of Deities with Comments," *Maya Society Quarterly.* Vol. I (1932), 21–23.

Covarrubias, Miguel. *Mexico South: The Isthmus of Tehuantepec.* New York, 1947.

Crawford, Morris Decamp. *The Heritage of Cotton, the Fiber of Two Worlds and Many Ages.* New York, 1924.

Díaz Del Castillo, Bernal. *Verdadera y notable relación del descubrimiento y conquista de la Nueva España y Guatemala.* Madrid, 1795.

Ekholm, Gordon. "A Possible Focus of Asiatic Influence in the Late Classic Cultures of Mesoamerica," *Asia and North America: Trans-Pacific Contacts (Memoirs* of the Society for American Archaeology, No. 9, 1953), 72–89.

———. "The New Orientation Toward Problems of Asiatic-American Relationships," *New Orientations of Aboriginal American Cultural History (75th Anniversary Volume* of the Anthropological Society of Washington). Washington, D.C., 1955.

Fernández, León, compiler. *Colección de documentos para la historia de Costa-Rica.* 10 vols. San Jose, Costa Rica, 1881–1907.

Figueroa, José Maria, compiler. "Libro verde de documentos históricos," MS in National Library, San Jose, Costa Rica, n.d.

Fuentes y Guzmán, Antonio de. *Recordación florida, discurso historial y demonstración natural, material, militar y política del reyno de Guatemala.* Tipografía Nacional, *Biblioteca "Goathemala."* Guatemala, 1932–33.

Gage, Thomas. *Nouvelle relation, contenant les voyages de Thomas Gage dans la Nouvelle Espagne.* . . . 4th ed., revised and corrected. Amsterdam, 1721.

Gann, Thomas, and J. Eric Thompson. *The History of the Maya from the Earliest Times to the Present Day.* New York, 1931.

Goette, John Andrew. *Jade Lore.* New York, 1937.

Goubaud, Antonio Carrera. *The Guajxaquip Báts: An Indian Ceremony of Guatemala* (Sociedad de Geografía e Historia de Guatemala *Anales*, Vol. XII, No. 1), 1935.

Haefkens, J. *Central America.* Dordrecht, 1832.

Hartman, C. V. "Le calebassier de L'Amérique tropicale," *Journal de la Société des Americanistes de Paris*, NS, Vol. VII (Paris, 1910), 131–44.

Iklé, Charles F. *Ikat Technique and Dutch East Indian Ikats* (Needle and Bobbin Club *Bulletin*), Vol. XV, Nos. 1 and 2 (New York, 1931).

Juarros, Domingo. *Compendio de la historia de la ciudad de Guatemala.* 2 vols. Guatemala, 1857.

Kelsey, Vera, and Lilly de Jongh Osborne, *Four Keys to Guatemala.* New York, 1939.

La Farge, Oliver, and Douglas Byers. *The Year Bearer's People* (Middle American Research Series *Publication* 3), New Orleans, 1931.

Landa, Diego de. *Relación de las cosas de Yucatán.* 7th ed. Mexico, 1938.

Landívar, Rafael. *Rusticatio mexicana.* Modena, Italy, 1781.

Lothrop, Samuel K. *The Henequen Industry of San Pablo, Guatemala* (Museum of the American Indian, Heye Foundation, *Indian Notes*, No. 6). New York, 1929, pp. 120–29.

———. *Zacualpa: A Study of Ancient Quiché Artifacts* (Carnegie Institution of Washington *Publication*, No. 472). Washington, D.C., 1936.

Lutz, Henry F. *Textiles and Costumes Among the Peoples of the Ancient Near East.* New York, 1923.

Matías de Córdoba. *Utilidades de que todos los Indios y Ladinos se vistan y calcen á la Española, y medios de conseguido sin violencia, coaccion, ni mandato. . . .* Guatemala, 1798.

Maudslay, A. C., and A. P. Maudslay. *A Glimpse at Guatemala.* London, 1899.

Mediz Bolio, Antonio. *Chilam Balam de Chumayel.* Costa Rica, 1930.

Milla y Vidaurre, José. *Historia de la América Central.* Tipografía Nacional. Guatemala, 1879–97.

Morgandanes, Dolores. "Similarity Between the Mixco (Guatemala) and the Yalalag (Oaxaca, Mexico) Costumes," *American Anthropologist*, NS, Vol. 42 (1940), 359–61.

Morley, Sylvanus G. *The Inscriptions at Copán* (Carnegie Institution of Washington, *Publication* No. 219). Washington, D.C., 1920.

———. *Guide Book to the Ruins of Quirigua* (Carnegie Institution of Washington *Supplemental Publication* No. 16). Washington, D.C., 1935.

Nuttall, Zelia. *A Curious Survival in Mexico of the Use of the Purpura Shell-Fish for Dyeing* (Putnam Anniversary Volume), New York, 1909.

O'Neale, Lila M. *Textiles of Highland Guatemala* (Carnegie Institution of Washington *Publication* No. 567). Washington, D.C., 1945.

Osborne, Lilly de Jongh. *Guatemala Textiles* (Middle American Research Series *Publication* No. 6). New Orleans, 1935.

———. "Tuipi or Coral Serpent Black Spots on Indian Children," *Maya Research*, Vol. II (1935), 179–83.

———. *Four Keys to El Salvador.* New York, 1956.

———. *Así es Guatemala.* Guatemala, 1960.

Pardo, J. Joaquín, compiler. *Prontuario de cédulas reales.* Unión Tipografíca. Guatemala, 1941.

Pineita Ibarra, Jose de. Acotaciones para la historia de un libro: "El Puntero Apuntado con Apuntes Breves." Editorial del Ministerio de Educacion Publica. Guatemala, 1960.

Recinos, Adrián, translator (English version by Delia Goetz and Sylvanus G. Morley from the translation of Adrián Recinos) *Popul Vuh: The Sacred Book of the Ancient Quiché Maya.* Norman, Okla., 1950.

———, translator (English version by Delia Goetz). *The Annals of the Cakchiquels.* Norman, Okla., 1953.

Remesal, Antonio de. *Historia general de las Indias occidentales, y particular de la governacion de Chiapa y Guatemala. . . .* 2d ed. Biblioteca *"Goathemala."* Guatemala, 1932.

Rodas, N. Flavio, and C. Ovidio Rodas. *Simbolismos maya-kuiches de Guatemala.* Guatemala, 1938.

Rodas, N. Flavio, and L. F. Hawkins. *Chichicastenango: The Kiché Indians, Their History and Culture, Sacred Symbols of Their Dress and Textiles.* Unión Tipografíca. Guatemala, 1940.

Sahagún, Bernardino de. *A History of Ancient Mexico.* Translated by Fanny R. Bandelier from the Spanish version of Carlos Maria de Bustamente. Nashville, Tenn., 1932.

Schultze Jena, Leonhard. *Mythen in der muttersprache der Pipil von Izalco in El Salvador.* Indiana. 3 vols. Jena, 1933–38.

Shook, Edwin, and Alfred Kidder II. The Painted Tomb at Tikal (University of Pennsylvania *Bulletin*, Vol. IV, No. 1). Philadelphia, 1961.

Smith, A. Ledyard. "Report on the Excavations at Uaxactún During 1935," MS report to the Guatemala government, 1935.

Spinden, Herbert J. *Ancient Civilizations of Mexico and Central America* (American Museum of Natural History *Handbook Series*, No. 3). New York, 1928.

———. *Art Finds a Way: The Story of Human Skills.* Brooklyn, N.Y., 1940.

Stephens, J. L. *Incidents of Travel in Central America, Chiapas, and Yucatán.* 12th ed., 2 vols. New York, 1846.

Stoll, Otto. *Etnografía de la república de Guatemala.* Translated from German with introduction and notes by Antonio Goubaud. Guatemala, 1938.

Symonds, Mary, and Louisa Preece. *Needlework Through the Ages.* London, 1928.

Termer, Franz. *Zur Etnologie und Ethnographie des nördlichen Mittelamerika* (Ibero-Am. Archiv. 4). Berlin, 1930.

Vázquez, Francisco. *Crónica de la provincia del Santísimo Nombre de Jesús de Guatemala. . . .* 2d ed. Biblioteca "Goathemala." Guatemala, 1937–44.

Whetten, Nathan L. *Guatemala, the Land and the People.* New Haven, Conn., 1961.

Whitlock, Herbert P. "Familiar Symbols in Jade," *Natural History*, Vol. 45 (New York, 1940), 7–15.

Ximénez, Francisco. *Historia de la Provincia de San Vicente de Chiapas y Guatemala de la orden de predicadores.* 3 vols. *Biblioteca "Goathemala."* Guatemala, 1929–31.

INDEX

258

266

Parrot (designs): 95; in silver, 123
Pascón: 207, 230
Pattern-filler yarns: 51, 58, 63, 65, 69, 70, 71, 74, 80; in silk, cotton, and wool, 33
Patzicía, Guatemala: belts, 112; jewelry, 121
Patzún, Guatemala: 66; *huipiles,* 89, 104, 105; *refajos,* 108; baskets, 199
Pavo: 97
Peacock (designs): 96
Peinador: 52; *see also* Batten *and* Heddle stick
Pellones (rugs): 140
Pendants: 12
Pepenado: 62
Perrajes: 47, 48, 53, 66, 112–14, 149; *merinos,* 47, 112; for trade, 48; manufacture of, 112; styles of, 113; wearing of, 113; *rebozos,* 113; *kaperraj,* 114
Persea gratissima: 42
Pescadito: 46
Petacas: 201
Petaquillas: 202
Petateados: 46
Petate Chiapaneco: 187
Petate de sala: 186
Petates de agua caliente: 188
Petates de agua fria: 188
Petates o esteras de helecho: 188
Petate tule: 182, 183, 183n., 187, 188, 189; *see also* Mats
Petate zapaluta: 187
Petatillo: 77
Petticoats (*fustán*): 111, 138
Pharomacrus mocino: 97
Pheasant (designs): 91
Philip II of Spain: 15
Phytolacca decandra: 43
Pichacha: 216
Pichinga: 207
Picking: 62
Piedra del rayo: 208
Piedras Negras: 205
Pilón: 174
Pinabete: 52
Pine tree (designs): 88, 94, 95, 106, 155
Piñon: 223
Pinula: *see* Santa Catarina Pinula
Pipil: 5, 6, 60, 88n., 160, 229
Pishiquin: 106
Pita floja: 32, 174, 175, 176

Pithecolobium albicans: 178
Pithecolobium pachypus: 38n.
Pitón: 174, 176
Pixcoy: 121; *see also Chachales*
Pizbal-cotzil: see Tzutes
Plain weave: 15, 33, 54, 64, 65, 66, 67, 70, 73
Plantains: 38
Plants (designs): 76, 77, 78, 81, 83, 92
Plastic: 134, 232
Plates: 215
Plazón: 195
Plebeyos: 7, 16, 144, 149; *huipiles,* 149
Plegados: 19, 108
Plumed serpent (designs): 87, 88, 101
Plumilla: see Feather stitch
Pockets: 112, 125, 126, 127, 129, 130, 151, 156, 167
Pokeweed: 43
Pokomán: 5, 160, 161
Pokonchí: 5, 6, 152
Políticos: 15
Polychrome ware: 205; *see also* Ceramics
Polygala floribunda: 43
Pom: 94, 94n.
Ponce, Domingo: 55
Ponchitos: 33, 65, 127–29, 134, 139; ceremonial, 88; lengths, 128; colors, 128–29
Ponchos: 59, 127, 128, 135
Pop (mat): 86, 99, 182
Popol Vuh: 165
Porrones: 207
Porta y Costas, Don Antonio: 55
Pot: 103
Potters: 206
Potter's wheel: 204, 205, 206, 213, 217; Salvadorean, 209, 210; Guatemalan, 212, 213
Pottery: 9, 12, 13, 49, 135, 180, 204–17, 224, 232; lost-color process, 225; *see also* Ceramics
Prayer mat: 188
Pre-Columbian period: 22; tie-dyeing, 46; survivals from, 64, 97, 144; gauze, 66; ceramics, 204, 213, 213n.; gourds, 219
Pre-Conquest: 11–20, 21, 91, 99, 162, 180, 218; spindles, 25; dances, 161
Principales: 7, 16, 18, 19, 44, 96, 104, 105, 115, 126, 132, 142, 144, 148, 149, 225

The text for *Indian Crafts of Guatemala and El Salvador* has been set on the Linotype in 11-point Janson, a charming book type which derives its name from its founder, Anton Janson of Leipzig. The paper on which this book is printed bears the University of Oklahoma Press watermark and has an effective life of at least three hundred years.